KU-797-865

LOOKING TO SEA

LOOKING TO SEA

Britain Through the Eyes of its Artists

LILY LE BRUN

SCEPTRE

BI4 840 597 4

First published in Great Britain in 2022 by Sceptre
An imprint of Hodder & Stoughton
An Hachette UK company

1

Copyright © Lily Le Brun 2022

The right of Lily Le Brun to be identified as the Author of the Work has been asserted by her in accordance with the Copyright, Designs and Patents Act 1988.

Extract from *Findings* by Kathleen Jamie (Sort of Books, 2006) reproduced here by permission of Sort of Books.

All rights reserved. No part of this publication may be reproduced, stored in a retrieval system, or transmitted, in any form or by any means without the prior written permission of the publisher, nor be otherwise circulated in any form of binding or cover other than that in which it is published and without a similar condition being imposed on the subsequent purchaser.

A CIP catalogue record for this title is available from the British Library

Hardback ISBN 9781529309218
eBook ISBN 9781529309225

Typeset in Sabon MT by Born Group

Printed and bound in Malaysia

Hodder & Stoughton policy is to use papers that are natural, renewable and recyclable products and made from wood grown in sustainable forests. The logging and manufacturing processes are expected to conform to the environmental regulations of the country of origin.

Hodder & Stoughton Ltd
Carmelite House
50 Victoria Embankment
London EC4Y 0DZ

www.sceptrebooks.co.uk

For my parents

And as she dipped into the blue paint, she dipped too into the past there.

Virginia Woolf, *To the Lighthouse*

CONTENTS

LOOKING TO SEA

ILLUSTRATIONS

I

INTRODUCTION

In spring 2016, I went to Tate Britain to look for the sea. Commissioned to write a magazine article about its presence in contemporary British art, I was on the hunt for artists past and present who had chosen the sea as a subject. Hung chronologically, the permanent collection began with a room full of Tudor portraits. No sea there. Nor was it anywhere to be found in the following room, among the seventeenth-century aristocrats. It made its first appearance in the middle of the eighteenth century, as the setting for a warship firing a salute. John Constable brought it into the centre of the action in his study for *Hadleigh Castle* in 1828–9, and soon images of lonely shorelines, fisherfolk and cheerful families on beaches began to make their entrance. By the twentieth century there were cruise liners, fishing towns and more sunny coastlines. And then, in this century, the sea disappeared.

Beyond the walls of the Tate, a different narrative was unfolding. It was the run-up to Brexit, when how Britain thought of itself as a nation was being discussed an unusual amount. The sea, suddenly, had become freighted with significance. For many, the presence of a sea between Britain and the continent was largely irrelevant. To others, it was vital part of the country's identity. As well as existing as a physical barrier and a political border between Britain and the

rest of Europe, the sea represented an intangible, deeply felt sense of difference. Contrary to what the curation at the Tate suggested, the sense of Britain as an island, its self-image sculpted by the sea along with its physical geography, had persisted into the twenty-first century.

The role that the sea continued to play in contemporary life had also been reflected in several recent high-profile artworks, which drew attention towards its entanglement with weighty, worldly issues such as travel, trade, colonialisation, globalisation, immigration and global warming. In 2010, Yinka Shonibare placed a miniature HMS *Victory*, fluttering with dozens of colourful batik sails, in a bottle for the Fourth Plinth in Trafalgar Square; a comment on British imperialism and trade facilitated by Nelson's victories. Wolfgang Tillmans photographed the Atlantic Ocean in *The State We're In, A* (2015) to reflect upon global political tensions. That same year, Icelandic-Danish artist Olafur Eliasson installed huge hunks of glacial ice outside the Place du Panthéon in Paris to draw attention to rising sea levels.

In the wake of the referendum, I kept thinking back to these portrayals of the sea. The sight we see today from the shore is almost exactly the same as it has ever been. Here, the boundaries between the past and the present are at their thinnest. Yet if the sea was so ageless, why had it inspired such a diversity of creative responses? Showing the many ways a single, unchanging subject could be seen and understood, those artworks echoed one of the fundamental questions that had arisen after Brexit: why do people view the same places so differently?

We tend to think of the sea as unassailable fact, an unchanging and eternal presence at the end of the land. But art reveals a different relationship with the shoreline, one that is as shifting and slippery as water itself. It shows us how there is a sea for war and a sea for play; a sea that provides a livelihood and a sea that rests and soothes. It tells us of seas that are loved and seas that are feared; seas that can carry

you away and seas that will not let you leave. Every artwork that takes the sea as a subject is showing how a place has interacted with a person; it is a collaboration between an environment, a body and a mind. Images of the sea reveal, in a uniquely simple way, the fluidity with which the world is experienced and imagined.

~

The way in which physical places are shaped and formed in the imagination becomes clear if you turn to the past. The ocean cannot be found on artist's canvases before the eighteenth century because of a simple truth: they did not go looking for it. For much of this country's history, especially after Christianity rooted itself in these islands two thousand years ago, the shoreline was a place largely to be avoided. The Book of Genesis begins with an image of a dark, formless, watery deep, from which God creates land and life. The story of the return of this primordial abyss as the great flood struck terror into the hearts of the pious, for whom the sea was a reminder of the fate of the sinful first humans. Lapping at the edges of civilisation, threatening to reclaim humankind, the sea has been feared for far longer than it has fascinated. 'It is so little of a friendly symbol', W. H. Auden pointed out in *The Enchafèd Flood*, a lecture he gave in 1949, 'that the first thing which the author of the Book of Revelation notices in his vision of the new heaven and earth at the end of time is that *there was no more sea.*'

The instability and unknowability of the ocean made it a powerful symbol to the medieval mind. 'To attempt to fathom the mysteries of the ocean bordered on sacrilege,' Alain Corbin writes in his 1994 book *The Lure of the Sea*, an exploration of the sea in the early European imagination. In the original French, the title of Corbin's book is *Le Territoire du Vide*, empty territory, reflecting the predominant attitude towards the sea before the nineteenth century. Monastic communities and hermits were attracted to the remotest

coasts – Lindisfarne, Iona, the Orkneys, Shetlands and Faroes – the frontlines of the spiritual battle against evil. Since the successful navigation of such treacherous territory was believed possible only by grace of God, mariner-monks were considered the saintliest.

Even as fears of divine retribution faded over the years, the threat of invasion, pirates, smugglers and wreckers continued to reinforce the idea of the coast as a vulnerable, dangerous zone: somewhere that was inherently different to inland places. Houses were built with their backs to the sea; thick-walled defences bristled along the coastline. Gradually, however, more reflective understandings of the ocean began to occupy the collective imagination. While imperial, mercantile and naval expansion caused port towns such as Bristol and Liverpool to prosper in the eighteenth century, the sea also slowly began to be equated with leisure. Enlightenment thinking encouraged curiosity in oceanography and the natural history of the shore, while increasing numbers of physicians and medical writers became per-suaded of the therapeutic benefits of sea-bathing. Sea towns began to usurp spa towns in popularity, aided by a growing body of Romantic literature and imagery extolling the sublime aesthetics of the shore. Over the following centuries, tiny fishing ports all along the coast of Britain transformed into thriving, fashionable resorts, many of which continue to attract holidaymakers today.

Dread of the sea may have mellowed in recent decades, but the sense of the shoreline as a threshold between known and unknown worlds has lingered. Where feelings of awe, fear or humility that arose at the sight of the ocean might once have been interpreted as a religious experience, in more recent times they have been invested with different but equally powerful meanings. What is it that draws a person to the sea today? There are as many answers to this question as there are people who have ever stood at the shoreline. You will have your own feelings and memories connected to the sea, just as I have mine. The ten artists you will meet in this book reflect this mul-titude. As each chapter traces the personal, philosophical and prosaic

threads that wove their art into being, it will become clear how many ways there are of thinking about the sea.

~

As I began my research, I started to discover British artists working inside nearly all the major trends and movements of the twentieth century – including abstraction, surrealism, pop art, abstract expressionism, land art, conceptual art, video art – who had at some point chosen the sea as a subject. Even more intriguingly, these were often the works that they were best remembered for, where a stylistic breakthrough had occurred, or a new pattern of thinking had begun. Why was one of the first Post-Impressionist pictures ever painted in Britain, heralding the arrival of modernism, inspired by a quiet sandy bay in Dorset? Why did a fishing town in Cornwall begin to lure abstract-inclined artists from across the Atlantic? Some of these works connected presciently to forces beyond the artworld too. How did Bridget Riley's monochrome, abstract paintings, made in London during the swinging sixties, resonate with the first stirrings of the modern environment movement? Why did Martin Parr's photographs of a northern seaside resort in the 1980s reveal so much about class? It started to become clear that not only does the sea reflect shifting human concerns, but it is also, somehow, a *stimulus* to new ways of thinking.

In the past few years, there has been a rising tide of art shows themed around the ocean that are, again, more than just reflections of social and cultural paradigms. Many contribute to the growing global list of exhibitions, artists and artworks that have attempted to tackle the dizzying consequences of the climate crisis. In other words, artists and curators are increasingly using the ocean to effect change, to actively try and reassess assumptions and patterns of behaviour. A recent editorial in the *Journal of Curatorial Studies*, for instance, argued that art exhibitions were 'uniquely positioned in understanding the complex relationships between ocean ecosystems, marine wildlife

and human activity at this time of environmental crisis'. It pointed out how the exhibition context is well placed to embrace the myriad ways in which the ocean is seen, imagined and experienced across different cultures, localities and timespans. By placing artefacts alongside artworks, man-made objects beside specimens of marine life, old narratives and frameworks might be challenged, and new visions, dialogues and understandings of the natural world might be revealed.

~

My hope is that this book will behave a little like an exhibition, setting up visual conversations between ten disparate ways of looking at the sea. Journeying from the 1910s to the present day, I have kept my focus trained on the last hundred years or so. The ways in which we relate to the sea and the natural world have shifted significantly over this period; I have included works of art that have helped me think about why these changes have taken place so quickly and dramatically relative to the rest of history. I have also chosen artworks that represent an art historical development, and that can be found in public collections across the country (aside from Hamish Fulton's work, which takes the form of a walk, and is not an object to be displayed in a conventional way). This decision was made partly in the hope that one day you will be able to see these works of art in the flesh, but also because I am interested in how ideas gain traction at certain times. In being kept in public hands for posterity, the implication is that these works are seen as belonging to – and even shaping – the national narrative: I have tried to understand why.

If anything, I have written this book not by looking at the sea but *from* the sea, back to the people that have watched it from the shoreline. I am not motivated by a desire to tell you *about* the sea, nor am I qualified to do so: I am a Londoner, born and raised, and there is nothing extraordinary or expert about my knowledge of the ocean or my affection for the coast. What I have tried to do, how-

ever, is think *with* the sea, to use it as a prism into lives and habits and feelings other than my own. For someone trained in history and art history, fascinated by why we look and how we see, the sea is a gift, for it throws differences of human behaviour into sharp relief. As a group, these works of art map a broad genealogy of perception, rooted in the meanings that have been seen or sought in the ocean. As a book, they tell the vital story of humanity's ever-changing relationship to the natural world. Alone, they are an invitation to see through someone else's eyes.

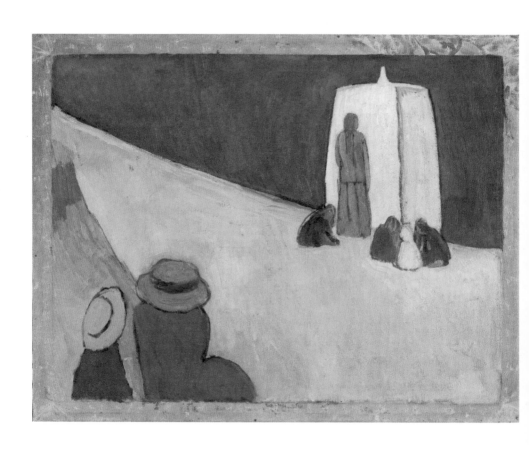

Vanessa Bell, *Studland Beach*, *c.*1912

STUDLAND BEACH

Vanessa Bell

September again, back on Studland beach. Sitting in the shallows of the dunes, she can see the full sweep of the bay. The sand, pockmarked with shadows where the children have left footprints, swells out wide in front of her and disappears in pincers to her left and right behind thickets of marram grass. The sea glitters in the midday heat. She holds her hat against a cooling gust of wind, noticing how every broken wave darkens a fresh strip of sand. Why did she think she could paint here? A canvas would become a sail. And the light is as temperamental as a child; passing clouds brighten or dull the scene with the rapidity of a mood.

She sees her son Julian and his nursemaid returning slowly from a walk. They settle at her feet, and turn their attentions towards the children on the shore. Putting her worn wooden painting box on her lap, she knows she should try to work while her toddler is absorbed. Opening it, she finds the familiar company of oil tubes, strips of rag and a yellowing bottle of turps. How pointless it is to describe a colour with words, she thinks, checking for her blues. Colbalt blue.

Cerulean blue. Prussian blue. She takes a board from its slot inside the box and props it against the lid, where it is shielded from the wind. Working quickly, she lays out her paints along the palette's palimpsests, from the large white ghost to the small shadow of black. She wets her fattest brush with turps and looks up. A canvas bathing tent is being pushed awkwardly on small wheels towards the shore, close to where the children cluster. It will help define them against the bright sea, so she waits for it to rumble to a stop before beginning the painting.

Go. Her brush obeys her eye, swooping down the sloped dune, moving diagonally back and forth over the beach, and then vertically up and down for the fluttering tent. She uses a fat upward-thrusting curve to draw the woman standing next to it, and slithering lines to conjure the children playing at her feet. She swiftly describes the silhouettes of Julian and his nurse in blocks of blue in the bottom left-hand corner of the board, and their hats as ovals of gold ochre and pale green. She uses a touch of black for their thick bands of ribbon, and for the shape of the brim. She wipes her brush thoroughly on a rag before going over the tent again in pure white, making sure it is brighter than the murkier pale of the beach. Her models by the tent are standing up. They've seen something . . . the dog, perhaps, or have they been called for lunch? As they disappear from sight, she sets down her brush. That will have to do for now.

Sometime after Vanessa Bell returns home to London, the hasty sketch of the beach becomes the seedling for a much larger painting: *Studland Beach*. The canvas she picks to work on is just under a metre tall and just over a metre wide. She covers its surface with a brown-red ground, to intensify any blue laid on top. Then she outlines the scene she sees on the oil-on-board sketch, copying the child and woman wearing large hats in the left-hand corner, the woman standing beside a bathing tent with a pinched roof, the group of four children playing close to her feet, the diagonal shoreline dividing the scene in half.

As she builds up the painting in layers of colour, she simplifies the composition: removing a suggestion of rocks or boats further down the shoreline and cropping out the horizon. The figures in the left corner acquire Venetian red clothing to counterbalance the cornflower-blue sea to their right. She lowers the arms of the woman standing by the bathing tent, swaps her pale pink dress for a sky-blue tunic, loosens her hair and turns her to face the sea. Using small, compact brushstrokes, she makes the edges of shapes neat and better defined. The sand becomes an elongated white triangle roughly bisecting the canvas. Sky and sea merge into a single fat wedge. The bathing tent no longer flaps in the breeze. It juts into the blue, rigid as a lighthouse.

~

Studland Beach is in the collection of Tate Britain, where it normally hangs at the hinge of the nineteenth and twentieth centuries in their chronology of British art. One floor below is the archive, where Bell's family photograph albums are kept. She had the future in mind when she compiled them, for on each concrete-grey cardboard page she has written a place and a year, and a name or initial beneath every person in each snapshot. Under 'Studland 1909', there are three pictures of Julian Bell tottering happily across the sand in a cotton tunic and straw sunhat, clutching a spade. Vanessa kneels beside him in one, reaching out her hand to steady his back. She is dark-haired and slender, with a gentle expression and large hooded eyes. She has recently turned thirty.

'Studland 1910': more snapshots of Julian, and many images of Clive Bell: Vanessa's husband, Julian's father. Friends and family who accompanied the Bells to Studland also start to make an appearance, including Vanessa's younger sister, Virginia Stephen (not yet married to Leonard Woolf), and a little later, on the pages headed 'Studland 1911', the art critic and painter, Roger Fry.

13

To connect these photographs to the painting – to discover how Studland beach became *Studland Beach* – I need more words than names and places. But in the *Biog. Bell, Vanessa* section of the London Library, I only find four books: Frances Spalding's 1983 biography; Bell's selected letters, edited by Regina Marler in 1993; and *Sketches in Pen and Ink*, a collection of memoirs Bell wrote in the 1930s and 1940s. The other, Jane Dunn's *A Very Close Conspiracy*, concerned Bell's relationship with her younger sister, Virginia Woolf, who herself is the subject of enough biographies to fill two long shelves. The art section also reveals that Bell has seldom been studied in her own right. Her work is there, but shares its pages with the coterie of English artists and intellectuals known as Bloomsbury. There is a catalogue from her solo retrospective at the Dulwich Picture Gallery in south London that took place earlier in the year, the first ever to be staged. But even that had opened with her portraits of family and friends. The curators were eager to establish a new independent identity for Bell, arguing passionately in their essays that her art was pioneering and that she was by nature progressive. Even so, by showing her first and foremost at the centre of a social circle they re-emphasised the main reason she has been valued in the past.

~

Vanessa Bell is a central character in the often-told tale of Bloomsbury: the group of free-spirited creatives who challenged the social and aesthetic conventions of their day, or so the story goes. Perhaps unsurprisingly, given that it was initially chronicled by Woolf, Bell comes across in the narrative as the perennial older sister: grounded, caring, capable, loved. Her key contribution to the group was not so much to do with her talent as a painter or her intellect, but with her abilities as a hostess. It was she who prepared the stage for the drama to begin; plotting, after her father's death in 1904, her and her siblings' flight across London from 22 Hyde Park Gate in Kensington

to 46 Gordon Square in Bloomsbury: 'the most beautiful, the most exciting, the most romantic place in the world', so it seemed to Woolf at the time. There, life would begin afresh. 'We were going to paint; to write; to have coffee after dinner instead of tea at nine o'clock. Everything was going to be new; everything was going to be different. Everything was on trial.' Later on, Charleston Farmhouse in Sussex, Bell's home from 1916, became the centre of Bloomsbury activities, and remains a kind of shrine to the group today.

Studland Beach emerges from all the writing on Vanessa Bell as something of an anomaly. Hardly any of her works have been treated by posterity so well. Despite a growing curiosity about her career, the general consensus is that her drive to experiment and innovate faded after the First World War and with that went her chances of being recognised as a truly important artist. *Studland Beach*, however, has been praised by leading art historians for being an 'outstanding contribution to modernism in Britain'. It is owned by the Tate and is normally part of the small selection of works from their collection chosen to be on public display. 'Of the many works we have borrowed from the Tate, only the one of Studland beach is regularly on the walls, the rest were all in storage,' the director of the Dulwich Picture Gallery told the *Guardian* in advance of the retrospective. 'We had lots of the family in for an early look – there are scores of them, all ravishingly beautiful, it's in the genes – and they were running from wall to wall remarking on how many of the pictures they'd never seen before.' In the exhibition, it was hung proudly in the final room, as if it was crucial proof that Bell deserved a retrospective. The wall text described the work as her 'modern masterpiece'.

Though it is probably her most famous painting, neither in her brief memoirs nor copious letters (she kept no diary) does Bell mention *Studland Beach* directly. Scholars do not even know the exact date it was painted: 1912–13 is an estimate calculated by the Tate and by Frances Spalding, her biographer, based on an assessment of its style in relation to the rest of her work, and what her relations have

said. Of course, her thoughts on the painting might easily have been lost. If she was not valued as a painter at the time, then there would have been no reason to treasure every piece of correspondence or note every conversation. She also might not have realised the painting was particularly important. It is not known to have been exhibited during her lifetime, and it first attracted the attention of art historians in the 1970s. There is a danger too of being anachronistic: artists then were not expected to explain their work to the extent they are today.

There is a mystery, though, to this painting, that has little to do with lack of information. When I first saw *Studland Beach* at Tate Britain, I noticed how it bore hardly an affinity to the sentimental seaside scenes and hazy seascapes hanging nearby. Without knowing its title, in fact, it might be difficult to see the beach in it at all. Its dusty red, white and blue colour scheme resembles an antiqued tricolour flag: graphic and subdued. When I last saw it within the context of the rest of her work its oddness was pronounced. It carried a strange melancholy not shared with any other painting in the whole show. Like a person afflicted by loneliness, it was taciturn and self-contained, reluctantly radiating waves of the wrong kind of feeling.

I was curious: here was a painting widely seen as leading the charge towards modernism, a movement premised on novelty, experiment and contempt of nostalgia; and a painting of a day at the beach, an activity linked to pleasure and play. Why, then, did it seem freighted with sadness?

I am not the only one who has sensed its brooding mood. I've spoken to people who say that it makes them think of death, or the pain-stricken landscapes of Edvard Munch. I've read descriptions of its 'fundamental solitude', 'other-worldliness' and 'pared-down mysticism'. Explanations have been offered. The Dulwich curators suggest that the painting involuntarily picks up on a period of unhappiness in Vanessa's marriage, when her husband and her sister – the two people she cared most for in the world – grew dangerously close for a period after Julian was born. Frances Spalding connects

the painting's 'austere and remote' feeling to the static and separate nature of its shapes. She also suggests – as others have too – that it might be related to the artist's experience of being a mother. Women and children were a motif that Vanessa returned to time and time again, especially around this period, when her children were young (her second son, Quentin, was born on 19 August 1910). According to Spalding, she was a devoted and interested mother to her boys (although her daughter, Angelica Garnett, born in 1918, told a different story in her memoir, *Deceived with Kindness*); but also, throughout her life, she revered her own mother, Julia, who died when she was a teenager. But none of these other pictures seem to share *Studland Beach's* particular sense of melancholy. Might the setting have anything to do with it?

~

Virginia Woolf's memoirs are laced with reminiscences of childhood summers spent on the Cornish coast, when the whole household from 22 Hyde Park Gate in London – including servants, nursemaid, cook and dog – decamped for months at a time to Talland House, on the hills above St Ives Bay.

Her father, Sir Leslie Stephen, an eminent writer and critic, had discovered it on a walking holiday. Virginia imagines him munching a sandwich, perhaps high up on a hotel terrace, looking over a town largely untouched since the sixteenth century, and thinking how well this would do for his growing family. Its attainable remoteness appealed to the once obsessive mountaineer, now grounded by fatherhood. 'Did I tell you I have bought a little house at St Ives, down at the very toe-nail of England?' he wrote to a friend in January 1881. 'The children will be able to run straight out of the house to a lovely bit of sand and have good air and quiet.' After his first wife died, he had married the widowed Julia Duckworth in 1878. This gave Laura, his daughter from his first marriage, who had developmental

disabilities, three half-siblings: George, Stella and Gerald. Julia gave birth to Vanessa in 1879. Thoby and Virginia followed in quick succession. By the time his final child Adrian was born in 1883, Leslie Stephen had gained seven children in five years.

In choosing St Ives, Sir Leslie rejected the bustling seaside resorts that had attracted most other upper-middle-class Victorian families since the expansion of the railways in the early nineteenth century. He desired something more rustic and removed; somewhere to hike vertiginous coastal paths, not promenade along crowded esplanades. Few of his friends would have chosen a pilchard-smelling working fishing village as a holiday destination. Those that did would have likely stayed away in one of the hotels high above it, such as Tregenna Castle Hotel up the road where Henry James based himself when he came to visit. St Ives was far from wealthy, and Julia Stephen – by all accounts a relentless do-gooder – spent much of her summer tending to its poor and sick.

Vanessa and Virginia spent their summers as tomboys, outdoors and in plimsolls. They played cricket, scaled trees, abandoned woollen stockings for icy water, tucked up their skirts and crouched by rock pools, found they could float in the waves, learned to keep up on marathon afternoon walks. As night fell, they set out rags soaked in rum and treacle to trap moths, and rinsed away salt water and sand to find their skin darker by the day. Years later, Virginia remembered her elder sister teaching herself to draw and paint: 'She was a happy creature! Beginning to feel within her the spring of unsuspected gifts, that the sea was beautiful and might be painted someday.'

Life at Talland House felt so different from life in London that Vanessa once asked her father whether St Ives was a separate world with its own sky. At 22 Hyde Park Gate – a tall, dark house in the pit of a cul-de-sac in Knightsbridge – the children's days were regular and habitual: a cycle of tutors and nannies, twice-daily walks along the straight paths of Kensington Gardens, father reading to them in the drawing room, bath and supper in the night nursery. London

was cosy, cosseted, laced into routines; Cornwall was hearing your name called and knowing you would not be found if you did not choose to return.

~

Like her parents, Vanessa also seems to have been drawn to the coast for the sake of her young children. The first summer after Julian was born, on 4 February 1908, the family spent a short time in St Ives. The following year, she was looking to return. 'Is there any chance that the cottage you had in Cornwall would be to let for a month from Sept. 10th?' Virginia wrote to a friend in July 1909. 'Nessa thinks Cornwall wd. be much nicer than Northumberland. They want 5 bedrooms, and to be a near a beach for Julian.' That Cornish cottage, for some lost reason, did not work out; Studland, a beach-side village on the Isle of Purbeck peninsula in Dorset, was chosen instead.

The Bells returned to lodgings in Studland at least four times between 1909 and 1912. According to the 1914 edition of the *Thorough Guide to South Hants and Dorset*, it was 'a most rural and charming place at present unspoiled but certainly discovered'. Other than a beach-side cafe and the odd bathing tent, it had so far managed to avoid the tourist developments seen in the nearby resort towns of Weymouth, Swanage and Lyme Regis, whose sands were riddled with large white timber bathing huts and food stalls, and lined by tarmacked esplanades and lodging houses. At Studland, the guidebook promises, 'all ceremony and conventionalism are thrown aside, and it is to be hoped will long remain so, ensuring real enjoyment without any boredom.' In other words, it would have resembled Cornwall when Vanessa was young.

She did not pick this place because she wished to paint the sea. She painted it because she was there – she always painted wherever she could – and she was there because the beach was one of the few places where families spent time, informally, together. She did not

seem to care that Dorset was being 'surreptitiously appropriated by artists', as another guidebook from the time warned. She did not choose, as these other artists did, to paint the towering cliffs or rolling farmland, sprinkled with convenient romantic details: ruined castles, tumbled-down cottages, abandoned quarries. Nor did she seek to socialise with any artists there other than those she invited herself. The snapshots in her family albums suggest that she spent most of her time on Studland's sandy beach with family and friends, her watchful eye trained on her children.

Descriptions of days there carry an echo of those from her child-hood. 'We are in the quietest of regions,' Sir Leslie had written from Talland House in 1882, 'where a tourist is a rarity and the news that a horse is in sight, sends the children rushing to the garden wall for a view of the phenomenon. Julia & the little ones spend most of the mornings on the beach & in the sea; and they are all putting on fat & getting sunburnt.' Nearly three decades later, Virginia wrote to a friend from Studland, telling her how 'Julian rushes straight into the sea, and falls flat on his face. Nessa tucks her skirts up, and wades about with him. Clive meanwhile dives from a boat, in a tight black suit. Yesterday, I hired a . . . bathing-dress and swam far out, until the seagulls played over my head mistaking me for a drifting sea anemone'.

The picture that emerges of the Bell's happy family holidays does not help me make sense of *Studland Beach*. I have a postcard of the painting, and each time I look at it my eye scoots from the woman and child on the left straight to the woman standing by the tent, where it lingers. She is so strange and isolated, standing on the threshold of that ice-white tower. It's a white of oblivion – white-out, white-noise, white-wash – she is zoning out, not joining in. How to reconcile the two accounts? Then I find Lisa Tickner's close, scholarly study of *Studland Beach*, and I read: 'Studland would have been resonant with memories of her mother . . . because holidays with her own chil-dren at Studland invoked the memory of St Ives, and St Ives had come

to stand for a childhood bliss cut off peremptorily with the death of Julia.' The place reminded Vanessa of her mother, Tickner suggests, and the painting registers her feeling of bereavement.

~

In the spring of 1895, the year Vanessa turned sixteen, Julia Stephen became ill and died on the morning of 5 May. According to Virginia's memoir, 22 Hyde Park Gate grew thick with grief; changed awfully by a continuous drizzle of visitors, the strong scent of flowers in the hall and her father's open distress. He mourned with exhausting Victorian melodrama – crying and groaning, flinging out his arms and calling his children to him. 'With mother's death, the merry, various family life which she had held in being shut for ever,' she writes. 'In its place a dark cloud settled over us; we seemed to sit all together cooped up, sad, solemn, unreal, under a haze of heavy emotion. It seemed impossible to break through. It was not merely dull; it was unreal. A finger seemed laid on one's lips.' She describes Julia's death as 'the greatest disaster that could happen'.

The period that followed compounded the family's unhappiness. Two years later, Stella, newly married and pregnant, died of an infection after what Vanessa always remembered as 'a time of horrible suspense, muddle, mismanagement, hopeless fighting against the stupidity of those in power'. Now the eldest daughter, Vanessa became burdened with the emotional demands of her father as well as domestic responsibilities: keeping household accounts; playing hostess to callers; caring for Virginia, who was showing signs of deep mental unease.

A month after Julia's death the lease on Talland House was sold. The sudden severance had its greatest – or most obvious – impact on Virginia, only thirteen when her mother died, who became infected by a profound nostalgia for Cornwall. She was enchanted by the sea; it ebbs and flows throughout her diary, correspondence and work.

Not only did it provide the setting for some of her most celebrated novels – *The Voyage Out* (1915), *Jacob's Room* (1922), *To the Lighthouse* (1927) and *The Waves* (1931) – but its imagery seeped into her most landlocked stories. Cornwall lured her back time again: mind, body, pen. As an adult, she visited whenever she could. 'Beloved,' she wrote to Vanessa on Christmas Day 1909, 'I went for a walk in Regents Park yesterday morning, and it suddenly struck me how absurd it was to stay in London, with Cornwall going on all the time.' She went directly to the station and caught a train, arriving in the county with 'no pocket handkerchief, watch key, notepaper, spectacles, cheque book, looking glass, or coat.' She was perfectly aware of the reasons for its powerful attraction. 'Why am I so incredibly & incurably romantic about Cornwall?' she wrote in her diary on the eve of another trip to the county. 'One's past, I suppose: I see children running in the garden. A spring day. Life so new. People so enchanting. The sound of the sea at night.'

Did the sea rush into Vanessa's life and work with the same urgency? Not in any obvious way. Her choice of subject matter in her surviving paintings does not suggest so; to my knowledge, *Studland Beach* was the last time she painted the sea, even though Charleston, where she lived until her death in 1961, is only a few miles from the coast. Landscape and the particularities of place did not really interest her. ('I know you think it don't matter much where one is, and theoretically you're right,' Roger Fry once wrote to her, guiltily relaying his love of painting Provence). It is understandable, though, that when Vanessa became a mother herself, she sought one of the places from her own childhood where she had felt closest to her parents. And, like most city-dwellers, she experienced the sea in parentheses. It appeared in short, discrete pockets of time within her normal life; there was little overlap between her London life and her summers on the coast. As an adult watching her own children on the beach, the passage of time must have felt acute; her present and her past intermingling before her eyes.

For it is rare to be able to see far away in a city; the edges of the sky are continually irritated by trees and lampposts and buildings. What you see from a beach, by contrast, is unadulterated deep-distance. The sea derives its very colour from this fact. 'Blue', as Rebecca Solnit has so beautifully written, 'is the light that got lost. Light at the blue end of the spectrum does not travel the whole distance from the sun to us. It disperses among the molecules of the air, it scatters in water. Water is colourless, shallow water appears to be the colour of whatever lies underneath it, but deep water is full of this scattered light, the purer the water the deeper the blue.' In the fifteenth century, a trick was discovered for conveying distance in painting: warm colours – brown, yellow, gold – should be used for the foreground, while cool colours – grey, blue, silver – should be reserved for the background. *Studland Beach* uses this formula – browns and reds are loaded onto the larger figures nearest the painter, while the blues are kept for the sea and the figures furthest away.

Blue, the colour of distance, has become the colour of longing and of the unknowable too. For Solnit, it is a mark 'of where you can never go. For the blue is not in the place those miles away at the horizon, but in the atmospheric distance between you and the mountains'. Children, she points out, aren't interested in distance. 'Their mental landscape is like that of a medieval painting: a foreground full of vivid things and then a wall. The blue of distance comes with time, with the discovery of melancholy, of loss, the texture of longing, of the complexity of the terrain we traverse, and with the years of travel.'

I look at Vanessa's painting again, and notice how the children play close to the ground, concentrating on the sand immediately before them, while the woman near them stands, soaking up the distance.

~

The more I learn about Vanessa Bell, however, the more uncomfortable I feel about pinning stories to her painting. Her infrequent dis-

cussions of her own work around the period she visited Studland are self-effacing, pragmatic and often technical; there is little self-analysis. Instead, she conveys a deep suspicion of symbols and sentiment in art, as well as a relief that she feels it is not her duty, as an artist, to theorise or think too hard about what a painting means. This is in keeping with the general tone of her letters, which is overwhelmingly light-hearted and self-deprecating. In contrast to her sister's letters, there is little introspection or intellectual athleticism, more optimism and ready wit. Yet where she must give advice or reprimand, she is wise and careful, rarely flippant. Virginia once described her letter-writing as 'something unexpected, like coming round a corner in a rose garden and finding it still daylight'. (Vanessa's response: 'I had a charming long letter from you this morning with flattering hints of rose-gardens and daylight round corners and I don't know what all. I purr all down my back when I get such gems of imagery thrown at my feet and reflect how envied I shall be of the world some day when it learns on what terms I was with that great genius . . .')

I begin to suspect that the silence surrounding *Studland Beach* is significant. Reading *Sketches in Pen and Ink*, a collection of autobiographical essays Vanessa wrote to read to Bloomsbury's Memoir Club in the 1930s, it quickly becomes clear how the 'silent kingdom of paint' (Virginia's words) was always Vanessa's domain. She could not remember a time when she was not going to be painter and Virginia a writer. From childhood, so she always claimed, 'life apart from human beings was almost completely visual.' It was something that set her apart from her literary family, and it developed into an enduring method of escape.

One of the essays shows that her abiding memory of the art classes she took as a teenager was of somewhere 'one could forget oneself and think of nothing but shapes and colours and the absorbing difficulties of oil paint'. Another reveals one of the most important events of her life to be an art exhibition. When *Manet and The Post-Impressionists* opened at the Grafton Galleries, just off Bond

Street, on 7 November 1910, she felt: 'Here was a sudden pointing to a possible path, a sudden liberation and encouragement to feel for oneself which were absolutely overwhelming. It was as if at last one might say things one had always felt instead of trying to say things that other people told one to feel.'

What had others been telling her to feel? What had she been trying to say? Though prestigious, Vanessa's art education had been utterly conventional; appropriate for a talented daughter of the upper-middle classes. In 1901, she became one of twenty-one students accepted to the Painting School of the Royal Academy ('A gloomy great place, even on its festive nights', according to her sister's teenage diary). For three years, two of which were spent in gender-segregated classes, she followed a syllabus barely changed since the School's founding in 1769: anatomy, portraiture, perspective and composition, drawing from life and from plaster casts of antique sculptures.

There was little opportunity to see anything that deviated very far from the Royal Academy's tastes. Its exhibitions were enormously popular, and other galleries in London followed its lead. There had been attempts to challenge its hegemony: artists who refused to become Royal Academicians, or were not invited to join, formed independent groups and organised their own shows. Many, though, settled into styles that were more acceptable by the mainstream, leaving more progressive members and aspirant outsiders frustrated. Long after graduating, Vanessa had the oppressive sense that, 'above one were the professors saying, "Draw for seven years – learn anatomy and chemistry and the use of the stump [a drawing tool]" and in the galleries, were their works.'

Yet there are seeds of rebellion in her letters from this time. When George Frederick Watts – a painter celebrated by the Victorians and a proud acquaintance of her parents – gave her a long lecture in front of a painting of his that was, he told her, 'a protest against Impressionism', she concludes witheringly that his ideas 'don't come to much'. She pored over a book of tiny reproductions of paintings

by French artists such as Manet, Degas and Monet; images that made her realise, strangely late, that 'living painters might be as alive as the dead and there was something besides the lovely quality of old paint to be aimed at.' By her final year at the RA, she was confident enough to dismiss John Ruskin – preeminent critic of the Victorian era, author of the book that taught her to draw as a child – as generally amusing, but no good on art: 'He never cares for anything unless it is a symbol or has several deep meanings, which doesn't seem to me to be what one wants.'

When she graduated in 1904, she quickly concluded that more of the same sort of teaching would be a waste of time. She began at the Slade School of Fine Art, a younger and slightly more progressive institution than the RA, but nonetheless left after a term. 'One always must have something of one's own to say that no one else has been able to say,' she explained to a friend, 'but the moment one imitates other people one's done for. It's allowable while one's a student, learning the language and trying to find out what one does think of it all, but when once one starts alone one must be oneself.'

The developments in her own life must have seemed increasingly out of step with the slow pace of change in her profession. Earlier in the year Vanessa and her siblings had moved to Bloomsbury, where they behaved largely as they pleased, and socialised with whom they liked. Her letters show her addressing friends by their Christian names, speaking of sex more freely, and revelling in bawdy language. 'I think it is safe to say that at this time,' writes Regina Marler, who edited and compiled her letters into a book, 'no other middle-class woman in London wrote letters like Vanessa's'.

Vanessa married in 1907, but still enjoyed considerable freedoms. Clive Bell had been a friend for years (she accepted his third proposal of marriage) and respected her desire to paint. He came from a wealthy family, which allowed him to write art criticism and her to paint without the pressure of needing to earn much of an income from either. They also could afford one or two servants – crucial,

in Vanessa's case, for continuing to work. Yet in doing so she was 'making social history', as Frances Spalding points out. 'A wife in Vanessa's position was expected at this date to be a monument of virtue and chastity, denied a profession, devoid even of those minor domestic talents that in earlier times had been cultivated as crafts, a conspicuous consumer of her husband's wealth. She was expected to be largely ignorant not only of the sources of that wealth but also of the baser male instincts . . .'

This must be why, all those years later, Vanessa remembers her experience of the 1910 Grafton Gallery exhibition, *Manet and The Post-Impressionists*, as a personal and not just artistic epiphany: 'here was a sudden pointing to a possible path; freedom was given to be oneself.' For the first time, she saw work by people who seemed to speak *her* language of form, colour and line. Rather than using painting as a vehicle for storytelling or for showing off technical skill, they showed a vivid faith in the world contained within the painting. They were not just a minority either – this was a movement. The curators had gathered over two hundred pictures by the most innovative artists on the continent, including eight paintings by Manet, at least forty-two works by Gauguin, twenty-five by Van Gogh, twenty-one by Cézanne, three paintings by Picasso and two by Matisse, and many more of their drawings and sculptures. It was an astonishing group of pictures. Today, they would be valued at well over a billion pounds – many are now in museum collections.

But to most Edwardian eyes these pictures were no better than children's doodles: the colours were ridiculously untrue, the drawing was crude and the subjects dull and unattractive. However much the curators argued that Post-Impressionism was a natural development from what had gone before – hence its name – most of the 25,000 visitors to the exhibition could not see it in those terms. Regarded by many as a wounding assault on the old order, it provoked an outcry of a kind that is almost impossible to imagine today. The pictures prompted vomiting, accusations of evil, fainting fits, laughing fits,

vigorous umbrella shaking and a flood of impassioned letters to the newspapers. A woman writing for the *Daily Herald* gleefully grouped the artists with the 'Great Rebels of the World', the suffragettes and the socialists, who were 'both Post-Impressionist in their desire to scrap old decaying forms and to find for themselves a new working ideal'.

Quietly rebellious, Vanessa saw a path unfurling before her. 'The autumn of 1910 is to me a time when everything seemed springing to life,' she remembered, '– a time when all was a sizzle of excitement, new relationships, new ideas, different and intense emotions all seemed crowding into one's life.'

~

There was something else too. Guiding her through the galleries, when possible, was the man responsible for the show: Roger Fry. 'I remember those times very clearly,' she wrote in another essay for the Memoir Club, a month after his death, '. . . I think I was uneasy at first, distrustful no doubt of my own taste and afraid to give myself away. All the same that cannot have lasted long, for though I did not agree with much of what I understood to be his theories then – I certainly said so – I found it easy enough to listen and to talk to someone whose feelings about most of the actual works were so largely in agreement with one's own.'

Vanessa had not really known Fry before 1910, except by reputation. Thirteen years older than her, he was a famous lecturer on the Italian Renaissance, and vaguely associated in her mind with the intimidating men of the New English Art Club, rivals of the Royal Academy. They'd met briefly some years before at a dinner party, and then again in January 1910 while she was waiting with Clive for a train at Cambridge. On the way back to London, the men's conversation continued unceasingly, leaving Vanessa free to observe Fry properly for the first time. 'As he sate [sic] opposite me in the corner,' she vividly remembered, 'I looked at his face bent a little down

towards his MS but not reading, considering, listening, waiting to reply, intensely alive but quiet. "What astonishing beauty" I thought looking at the austere modelling in the flat bright side lights from the train windows. I do not think I talked much but he was becoming a real person to me . . .' Soon after, Fry enlisted Clive Bell to be one of his picture-gathering accomplices for the gap he'd been entrusted to fill in the winter exhibition program at the Grafton Galleries.

The inspiration for *Manet and The Post-Impressionists* stemmed mainly from Cézanne, whose paintings Fry first truly noticed in a group exhibition in London in 1906, the year of the artist's death. (Vanessa had also seen this show and been impressed by his work 'without knowing why'.) Born in Aix-en-Provence in 1839, Cézanne was the same generation as the Impressionist painters, and shared their desire to give a true sense of perception through close, honest observations. But Fry saw a difference: 'I gradually recognised,' he recalled in 1920, 'that what I had hoped for as a possible event of some future century had already occurred, that art had begun to recover once more the language of design and to explore its so long neglected possibilities.' He saw in the work of Cézanne – and a little later, Gauguin and Van Gogh – a sense of design that he valued so highly in the work of past masters, and could not see in the Impressionists, who predominated avant-garde thinking. The Impressionist emphasis on representing surface appearances had made their work flimsy, he thought, lacking in the underlying structures that gave an artwork its strength. Rather than creating a suggestive haze of shimmering colour with short, thick brushstrokes, Cézanne painted taut blocks of strong colour with slow and decisive marks.

In addition to his excitement about Cézanne, Fry had become increasingly fascinated by non-European art. He was particularly intrigued by its ability to convey a strong visual message without bearing any similarity to an image that a westerner might consider more 'real'. How could these artworks, so different from anything he had previously seen, provoke in him such familiar reactions? He

concluded that the value of a work of art must lie in the feelings it evoked in the viewer, not in its fidelity to its subject matter.

Fry began to formulate a theory that was to have a lasting influence on art in England. In 'An Essay in Aesthetics' (1909), he argued that form – the lines, colours, tones, angles and shapes that make up how a painting looks – could convey emotion in itself. An artist is drawn to an object not for its associations, he wrote, but for its 'pure form' alone. 'Who has not, once at least in his life, had a sudden vision of landscape as pure form?' he asks. 'For once, instead of seeing it as fields and cottages, he has felt it as lines and colours. In that moment has he not won from material beauty a thrill indistinguishable from that which art gives?' His conclusion was radical, unlocking the door to pure abstraction – something that no artist in Europe had yet attempted. 'We may, then,' he wrote, 'dispense once and for all with the idea of likeness to Nature, of correctness or incorrectness as a test, and consider only whether the emotional elements inherent in natural form are adequately discovered.' The meaning and power of an artwork, Fry was beginning to suggest, was independent from what it was trying to depict.

Vanessa Bell may not have read Fry's essay yet, but she discussed and challenged his theories as they slowly made their way together around *Manet and The Post-Impressionists,* looking carefully at the pictures. 'Gradually he would seem to see new meaning, new relations: he would talk about them, asking, questioning, saying what he thought, but always anxious to know what you thought. It is true that I have learnt to see many things through looking at them with him, but I think I can truthfully say that I have learnt to see them, not only to know that they were there. It was a delight to share his feelings and have him to express them – but it was not un-delightful to differ, to stick perhaps to one's own stupid prejudices but to try to understand why he felt as he did.'

Fry became mesmerised by what he once described, in reverential terms normally reserved for art, as Vanessa's 'miracle of rhythm'.

She did everything, he noticed, with a soothing ease that encouraged an atmosphere of freedom. Over the coming months their friendship deepened. In the spring of 1911, he accompanied the Bells on a holiday to Turkey. Vanessa fell ill and suffered a miscarriage. Fry became Vanessa's nurse and, soon after, eased perhaps by Clive and Virginia's closeness, her lover. The relationship ended, to Fry's distress, in 1913 when Vanessa became infatuated with the painter Duncan Grant, but they always remained close. Many years later, she wrote to Fry that 'the first part of our affair' was 'one of the most exciting times of my life, for apart from the new excitement about painting, finding for the first time someone whose opinion one cared for, who sympathised with and encouraged one, you know I really was in love with you'.

~

There is a photograph in Vanessa's album of Roger Fry on Studland beach in September 1911, sitting on a stool with a painting box on his lap, a stray child's sandal and flapping newspaper at his feet. He is smiling and his mouth is open, as it is in most pictures of him, as though he was always on the cusp of saying something. (He sounded exhausting. Virginia Woolf observed: 'Under his influence, his pressure, his excitement, picture, hats, cotton goods, all were connected. Everyone argued. Anyone's sensation – his cook's, his housemaid's – was worth having. Learning did not matter; it was the reality that was all-important.') When he left Studland, Vanessa felt his absence keenly. She wrote to him in her typically self-derogatory, and flirtatious, way, 'I've really been painting so little and so badly since you went that if it weren't for what you say I should be very gloomy about it. I succeeded this morning in making my yesterday's failure still more of a failure and have given it up in despair.'

As momentum for a second Post-Impressionist exhibition gathered over the year, they seem to have discussed art endlessly, her theories and his theories. This time English painters were to par-

ticipate, Vanessa among them. Four of her pictures were eventually included. *Studland Beach* was not – the show opened in October 1912, and it might not yet have been painted. In the catalogue, Fry kicked back against the furious reaction to the first exhibition, pushing his own ideas on even further. 'The feeling on the part of the public may, and I think in this case does, arise from a simple misunderstanding of what these artists set out to do,' he wrote. 'The difficulty springs from a deep-rooted conviction, due to long-established custom, that the aim of painting is the descriptive imitation of natural forms. Now, these artists do not seek to give what can, after all, be a pale reflex of actual appearance, but to arouse the conviction of a new and definite reality. They do not seek to imitate form, but to create form; not to imitate life, but to find an equivalent for life.'

Criticism of the show was again heated, fuelled by more bafflement, and it became clear that a more substantial manifesto for Post-Impressionism was needed. Chatto & Windus asked Fry to write a book on the movement. He was too busy, and suggested Clive Bell instead. *Art* (1914), read and edited in manuscript and proof forms by his wife, became his most well-known work. 'The one quality common to all works of visual art,' he asserts in its opening pages, was 'significant form', that is, how 'lines and colours combined in a particular way, certain forms and relations of forms, stir our aesthetic emotions'. The book advocated a total separation between art and life – something that Fry, especially later on, was never completely certain about.

One of the most quoted passages from *Art* is that 'to appreciate a work of art we need bring with us nothing from life, no knowledge of its ideas and affairs, no familiarity with its emotions'. In 1913 certainly, Vanessa Bell shared this view: 'I often look at a picture – for instance I did the Picasso trees by the side of a lake – without seeing in the least what the things are,' she wrote to her brother-in-law, Leonard Woolf. 'I got quite a strong emotion from the forms and

colours, but it wasn't changed when weeks afterwards it was pointed out to me by chance that the blue was a lake. This happens as often as not. The picture does convey the idea of form . . . but not the idea of form associated with anything in life. But simply form, separated from life.' She ends by thanking her stars she 'needn't really bother' about this 'very confusing' subject.

According to Clive Bell, biography and history have no relevance to the artwork; they are completely redundant. 'To appreciate a man's art I need know nothing whatever about the artist; I can say whether this picture is better than that without the help of history.' It's an opinion that artists express time and time again. 'Whoever wishes to devote himself to painting should begin by cutting out his tongue,' said Matisse. Louise Bourgeois believed that to be an artist, you need to exist in a world of silence. Lucian Freud remarked that any words that came out of his mouth concerning his work would be as relevant to it as the grunt a tennis player makes when he hits a ball.

An artist's reticence can be a defence mechanism: if we know their intention, then we know where they have failed. But Bell and her circle seem to regard surrounding an artwork with silence as a gift to the viewer, allowing them to respond to it in the purest and most personal way. It is, above all, an indication of the authority of the image over the word. In the catalogue for a solo show of her sister's work in 1930, Virginia Woolf wrote: 'One defies a novelist to keep his life through twenty-seven volumes of fiction safe from our scrutiny. But Mrs Bell says nothing. Mrs Bell is as silent as the grave. Her pictures do not betray her. Their reticence is inviolable. That is why they intrigue and draw us on; that is why, if it be true that they yield their full meaning only to those who can tunnel their way behind the canvas into masses and passages and relations and values of which we know nothing – if it be true that she is a painter's painter – still her pictures claim us and make us stop. They give us an emotion. They offer a puzzle.'

33

Studland Beach is not a conscious attempt, then, to express a particular memory or feeling about a person or a place. Unlike the oil-on-board sketch that it is based on, which was made in hot pursuit of a sight that would soon disappear, there is no attempt to describe the scene as it was, full of action and air and life. Instead, it is a tentative step towards the new kind of art that is just beginning to emerge in the early years of this decade, where what matters most is colour, shape and line. The people and the place in the picture do not represent anything; they are devices, not symbols. Her focus is on the way each shape and colour and curve relates to each other, and how they hang – as if poised on a set of scales – together. The colours have been altered to make each other sing, the figures simplified into silhouettes to give the composition strength, the lines exaggerated to pull the eye in a particular path across the painting – a chain of lookers leading from us to the figures on the left to the figures on the right and then to the sea. Everything in it is a *significant form*, nothing is superfluous to the design. It is her attempt to distil an experience of sitting on the beach, looking out to sea, down to its visual essentials.

All you need to know about the painting is there in front of you, she might say, if she was standing at your side; don't think about who I am or who they are or what I am trying to do. What do *you* feel?

~

Not long ago, I returned to the Tate Britain to find that Vanessa Bell's *Studland Beach* had been replaced by her *Abstract Painting* (*c.* 1914). Consisting solely of blocks of flat colour, all narrative had been vanquished from the canvas. It is the idea of significant form taken to its limit, and was one of the first fully abstract paintings ever to be made in Europe. The work is amazingly prescient, but somehow the image does not stick in my mind as *Studland Beach* does. To write this, I have to find an image online to remember that is composed of pink,

blue, teal, orange and red oblongs floating against a chrome yellow background. It is not a surprise to read in the accompanying text that it was part of a private experiment that went no further after the war. When Quentin Bell asked his mother why she had given up on abstraction, she replied: 'Having done it, there seemed nothing else to do . . . and then one discovered that one was, after all, in love with nature.'

I wonder, as Vanessa Bell strived to portray the 'emotional elements inherent in natural form', as Fry believed artists should, could *Studland Beach* have tapped into something more fundamental? Long before it became the colour of distance, blue was used to symbolise a mother in mourning. The sea in her painting is close to the blue made from lapis lazuli found in the frescoes of Giotto and Piero della Francesca, when the precious pigment was reserved for the Virgin Mary's robe. The Bells and Roger Fry admired these early Italian painters almost above all others: if Vanessa knew these images by heart, these allusions would have been intuitive. In the soft peaked shape made by the bathing tent, you can see an echo of the curtains parted by angels above the pregnant Mary in Piero della Francesca's *Madonna del Parto*, and also the parted cloak in his *Madonna della Misericordia*. That may explain why her bathing tent looks so different to the hard-roofed huts seen in the background of the Studland snapshots.

The connection of the sea with motherhood goes deeper still. In psychoanalysis, the sea is connected with origins, beginnings and birth. Freud used the phrase 'oceanic feeling' to describe the sensation of being at one with the world, or the perception of something without limits. The feeling, he believed, was the survival of the sense of union between the breastfeeding mother and child, before the child is aware that other people exist. In Jungian analysis, the sea can be a symbol of the mother, one of the archetypes that express the collective unconscious. While Clive Bell's theory of significant form has no time for psychology or symbolism, it does rely heavily on the idea of the universal. It believes that something visual can

give rise to an emotion felt by everyone, regardless of time or place; that painting was a quest, as Woolf writes in *To the Lighthouse*, 'to get hold of that very jar on the nerves, the thing itself before it has been made anything'.

Rebecca Solnit expresses a similar idea in *A Field Guide to Getting Lost*. A memory written down ceases to be its true shadowy self, 'it loses that mobile unreliability of the live', risking its beauty. There is a fragility and a mystery to memory that evades language. Woolf knew this: she often expressed her envy of artists not having to mediate through 'impure words'. When she eventually came to write an 'elegy' to her parents, *To the Lighthouse*, she chose a painter to be the central character. She told Roger Fry that if she had dedicated the book to anyone it would have been him, saying, 'you have I think kept me on the right path, so far as writing goes, more than anyone.'

Set in a house by the sea, *To the Lighthouse* draws extensively on childhood memories of summers spent in Cornwall – so much so that the flora and fauna she describes are entirely unsuited to the Hebridean location of the novel. Vanessa was deeply moved when she read it, praising her sister for summoning, through the figure of Mrs Ramsay, 'a portrait of mother which is more like her to me than anything I could ever have conceived possible'. And she teases her about her own similarity to the painter in the book, asking: 'By the way, surely Lily Briscoe must have been rather a good painter – before her time perhaps, but with great gifts really?'

The book is structured around the Ramsay children's desire to sail to the lighthouse, a wish that stretches across many years. In the final part, they return with Lily Briscoe to the house on Skye where they had all stayed years before. (Mrs Ramsay has since died, we are informed in parentheses). As the Ramsays finally set sail for the lighthouse, Lily pitches her easel on the edge of the lawn and begins to paint a view she had struggled with during her previous visit. 'Lily stepped back to get her canvas – so – into perspective. It was an odd road to be walking, this of painting. Out and out one went, further

and further, until at last one seemed to be on a narrow plank, perfectly alone, over the sea. And as she dipped into the blue paint, she dipped too into the past there.' As she works, the Ramsays close in on the lighthouse. Memories of Mrs Ramsay surface in Lily's mind, cresting to a wave of grief that recedes only as her painting moves towards its resolution. 'She saw it clear for a second, she drew a line there, in the centre. It was done; it was finished. Yes, she thought, laying down her brush in extreme fatigue, I have had my vision.' And with that final sentence, Woolf lays down her pen, leaving us alone with hers.

It is tempting to see Vanessa Bell in Lily Briscoe, and *Studland Beach* as Lily's grief-grained painting in *To the Lighthouse*. As we have seen, though, that would go against the flow of ideas swirling around Vanessa while she conceived the painting. And it would also be too straightforward. The introduction of my copy of *To the Lighthouse* quotes a sharp warning from Woolf not to try and decipher imagery so simply. 'I meant *nothing* by The Lighthouse,' she wrote to Roger Fry, knowing that he was continually confronted with similar misunderstandings about painting. 'One has to have a central line down the middle of the book to hold the design together. I saw that all sorts of feelings would accrue to this, but I refused to think them out, and trust that people would make it the deposit for their own emotions – which they have done, one thinking it means one thing another another.' Just as Vanessa rejected symbolism in painting, Virginia insisted that the central motif in her work should not be interpreted any one way. The lighthouse did not represent anything; it was a device, not a symbol.

Woolf, like many people since, never assumed the uncompromising position Clive Bell took on the separation between aesthetics and experience. How could she, when she believed that 'the present when backed by the past is a thousand times deeper than the present when it presses so close that you can feel nothing else'? Her oblique, shimmering way of writing reflected her fascination with the slippery

behaviour of time; she loved that her sister's art was a *puzzle*. She understood perception to be a paradox, and one that did not – and should not – need to be resolved. The lighthouse, James Ramsay notices when he eventually reaches it, was a stark column striped with black and white, and not the 'silvery, misty-looking tower with a yellow eye' seen so longingly from the house. But instead of giving one image authority over the other, Woolf has him think: 'So that was the Lighthouse, was it? No, the other was also the Lighthouse. For nothing was simply one thing.'

Studland Beach offers a glimpse into Vanessa's world, not Lily Briscoe's, not her sister's. It is her vision of the beach that we can see when we look at the painting today, her family, her impressions, her memories. But nothing is simply one thing: it is also the other world she had been building for herself since childhood, a realm of her own making composed of brush strokes and oil paints. As she transposed her recollections of Studland onto canvas, she was striving to communicate the 'pure form' of what she had seen in her language of shapes, colours, line and shade. She was seeking to create a new reality on the canvas, in Fry's words, to find an equivalent for life, not just an imitation of life. But both intermingle in the image she made. For it was through the process of painting, and through art itself, that she found a way to live.

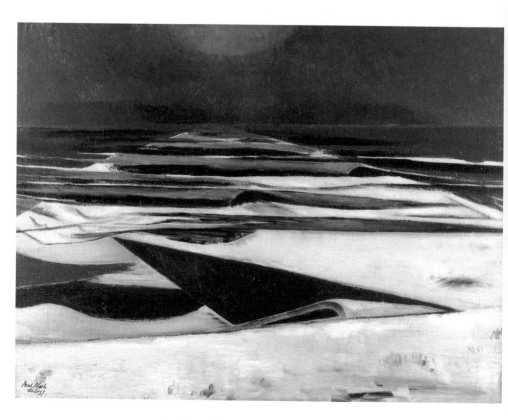

Paul Nash, *Winter Sea*, 1925–37

2

WINTER SEA

Paul Nash

In the spring of 1925, the painter Paul Nash and his wife Margaret decided to leave Dymchurch, a small seaside town in Kent. They had first visited in 1919, staying with friends for long periods until they eventually rented a small white cottage of their own on the high-street. They were a peripatetic couple and rarely settled in places for so long; now it was time to move on. They packed up their lives on the coast and headed inland, to a friend's farmhouse near Rye.

In the time he spent living on the shore, Nash had returned to the sea as a subject again and again. He painted it in watercolour and in oils. He sketched it in ink, chalk and pencil. He cut its likeness into etching-plates, he turned it into wood-engravings and lithographs. He rendered it large, on canvas; small, on coarse watercolour paper or smooth sketchbook pages. He showed it enraged, spewing waves, and placid, smooth as an ice rink. He painted the sea under moonlight and sunshine, battered with buckets of winter rain and graced by golden sunshine.

As he prepared to leave, Nash looked back on the body of work he had made at Dymchurch and noticed something strange about it.

'A place like that and its effect on me – one's effect on it,' he told his first biographer, Anthony Bertram. 'I shall never work there anymore, but it's a curious record formally and psychologically when you see the whole set of designs together.'

It's true. These images are not like the later seaside pictures he made at Swanage, Dungeness, Toulon or Nice. Normally the sea-wall is the giveaway. It is present in most of them, curving like a protective arm around the beach. Marking an abrupt end to the land, and an oddly urban beginning to the wilderness of the sea, the wall transfixed Nash. When he first mentions Dymchurch in his autobiography, *Outline*, he refers to it as 'Dymchurch-under-the-wall'. When he mentions it again, it is part of a list of principal subjects: 'The Sea. The Shore. The Wall.'

The Dymchurch pictures are distinguished by something else, too: a brooding, wary feeling that appears as frequently and as surely in paint, ink and pencil as the bulky concrete sea-wall. Regardless of the weather depicted, it is as though they were conceived under a permanently gloomy sky. Of all of them (there are around thirty in total), this chilliness emanates most troublingly from one he began painting just before leaving: *Winter Sea*. It is a bleak picture, there can be no doubt of that. The sea is the only focus. There are no figures, no sun, no moon. No beach either, only a suggestion of the wall. Bands of breaking waves tug the eye far out to the horizon and then return it grudgingly back to shore. The water is strangely solid: the waves' chalky foam is indistinguishable from the pale concrete wall they eventually break against; the final rearing wave has sharpened into a sleek black blade. The colours are sallow, muddy – hardly colours at all. Though plenty of white has been used, the painting leaks darkness.

If you consider the period that Nash was in Dymchurch, the uneasy mood of these pictures becomes temptingly significant. These were images that were made in the wake of a war that killed one in ten of an entire generation of young British men. This is an image of a country whose every village and town would soon have a memorial

to missing fathers, sons, brothers, husbands. This is the sea of a nation who had built the world's largest empire on an assumption that Europe, as it was, represented a high point in the inevitable advance of human history. Now it had to face the damning fact that the Empire's dead were so numerous that if they were to march four abreast down Whitehall, it would take them three and a half days to pass the Cenotaph. It is little wonder that one of the bestselling books of the twentieth century was the *Outline of History*, written by H.G. Wells in 1919, which ignored the progress of European civilisation and told a global story that would, Wells hoped, galvanise the human species towards unity. Vanessa Bell retreated to a modest farmhouse in the Sussex countryside in the middle of the war and never returned to London and her life there. The years following the First World War were, in Nash's words, 'another life, another world'.

The outlook for Britain held little comfort. By the early 1920s there were already signs of the mass unemployment, inflation, wage stagnation and crippling industrial action that lay ahead. Within two decades, the world would be on its way to another conflict. This time, war would claim over 50 million lives. 'What is to be done?' Virginia Woolf wondered in 1936. 'It's rather like sitting in a sick room, quite helpless.' As this sinister trajectory began to feel inevitable, Nash responded by looking to his past. He started to write his memoirs and revisited a handful of earlier paintings. But when his 'whole vision was eclipsed by the abrupt darkness of war', he found that he could not continue *Outline* and, perhaps wishfully, halted the narrative in 1914. He did complete the paintings, however. One of these was *Winter Sea*.

Framed so neatly by two world wars, *Winter Sea* is often interpreted in terms of its historical context. To quote only a few examples, writers and art historians have described it as a statement of the 'torments of war and post-war uncertainty', an 'acceptance of the violent and repressive side of modernity' and an 'exploration of threat and defence'. The ocean has been taken to symbolise 'destructive feminine

wiles' and the wall a barrier 'against the emotional pressure of the war'. I've already said that I think it is a bleak scene, but look again. See how little it really gives you, in terms of action or storyline. Unlike *Studland Beach*, with its small cast of characters, it lacks people and it lacks narrative. So why is it so often read in terms of human emotion and drama? Those qualities are not intrinsic to the sea, its sole subject. The answer has little to do with what is actually there, and everything to do with what is imagined to be there.

~

Born in 1889, Paul Nash was slow to find his vocation. Emerging from a run of brutal boarding schools with little more than an enthusiasm for football and a hatred of institutions, by eighteen he had, in his own words, shown 'no apparent *natural* talent' for art. But when his middle-class family's middle-class career plans for him (Navy, architecture, banking) were each disappointed by his ineptitude at maths, he tentatively proposed earning his living as 'a black-and-white artist or illustrator of some kind'. He studied illustration at the Chelsea Polytechnic in 1906, transferred to a more commercial art school in Fleet Street in 1908 and spent a year studying drawing at the Slade, where his fellow students included future stars, such as Ben Nicholson, Stanley Spencer and Richard Nevinson. When he left, he made his living mainly from design work – including a spell working with Vanessa Bell for Roger Fry's decorative arts studio, the Omega Workshop – and was beginning to have some success with his watercolours, which were mainly of gentle green landscapes and anthropomorphic trees.

Though initially reluctant, Nash was one of nearly a million men who volunteered to fight within the first eight weeks of Britain declaring war on Germany in August 1914. He joined the Artists' Rifles as an infantryman and was stationed on the home front. When he was eventually sent to Belgium in 1917, he was energised by the novelty and wrote breathless letters to Margaret filled with lyrical descriptions

of the 'strange beauty of war'. He had never left England before, and his eye, always closely tuned to landscapes, was thrilled by the oddness of his new surroundings, the vivid clashes between nature and man's machines, the full days spent out under the spring sky.

Shortly after telling Margaret that he was 'happier in the trenches than anywhere out here', Nash fell into one, raising a 'roar of laughter' from his men, injured a rib, and was promptly sent back to England. Undignified perhaps, but lucky. Not only did the tumble spare him from some of the deadliest fighting, but it gave him the chance to rally support in London for an appointment as a war artist. In September, a few ink and watercolour drawings he had made from the trenches attracted, among others, the crucial attention of Fry. Seeing them in a magazine he wrote to Nash, 'I think you have a very special talent for rendering certain poetical aspects of such scenes in a way that no other artist could.' In October, Nash returned proudly to Belgium as an official war artist, complete with a military valet and a chauffeur-driven car.

By then the Third Battle of Ypres, or Passchendaele, had been shambling on for three terrible, rainy months. Nash pushed to go to the most famous battlefields, and as close to the action as he could. When he made it to the front line, armed with brown paper and coloured chalks, he was struck dumb by what he saw.

Paul Nash to Margaret Nash, 13 November 1917, somewhere near the Western Front

I have just returned (last night) from a visit to Brigade HQ up the line & I shall not forget it as long as I live. I have seen the most frightful nightmare of a country every conceived by Dante or Poe – unspeakable, utterly indescribable. [. . .]

The rain drives on; the stinking mud becomes more evilly yellow, the shell holes fill up with green white water, the roads & tracks are covered in inches of slime, the black dying trees ooze & sweat and the shells never cease. They whine & plunge overhead, tearing away the rotting tree stumps, breaking the plank roads, striking

*down horses & mules; annihilating, maiming, maddening; they
plunge into the grave which is this land, one huge grave, and cast
up the poor dead. O it is unspeakable, Godless, hopeless. I am no
longer an artist interested & curious, I am a messenger who will
bring back word from men fighting to those who want the war to
last for ever. Feeble, inarticulate will be my message but it will have
a bitter truth and may it burn their lousy souls.*

How do you describe the indescribable? The boyish enthusiasm of
earlier letters was grossly inappropriate for a messenger of the apoc-
alypse. Shells are no longer gay 'silver darts', as he once described
them, nor are the trenches 'wonderful'. There is no strange beauty
here. While his choice of words remains consciously poetic, ('the
black dying trees ooze & sweat'), as does their rhythm, ('annihilating,
maiming, maddening'), Nash is now firm in his condemnation of the
fighting and unambiguous in his revulsion for those who perpetuate it.

On his return, he told the *Weekly Dispatch*: 'I have been jolted.'
Before the war he had taken little interest in modern art: he was
suspicious of Bloomsbury, did not follow the developments in Europe
and was left 'untouched' by the Post-Impressionist exhibitions of
1910 and 1912 that were so transformative to Vanessa Bell. During
the war, however, his letters and drawings start to reveal a growing
respect for Futurism – a radical Cubist-inspired Italian movement
that strove to capture the dynamism of the modern machine age –
and Vorticism, its British equivalent. 'How interesting in form these
once stiff houses look, a rhythmic river of tumbling forms – what
wonderful things are ruins. I begin to believe in the Vorticist doc-
trine of destruction – almost,' he wrote to Margaret in March 1917.
Sketching in perilous situations quickened his mind and loosened his
hand. His use of colour became stronger, more decisive. Hard edges,
zig-zag lines and definite shapes began to enter his work, propelled
onto paper by his encounters with stark battlefields, stripes of trenches
and columns of uniformed men.

Back in London, he developed his prolific rough chalk drawings into a handful of powerful large oil paintings, having never painted in that medium before. The titles of the last of these were cries of disillusionment: *Void* and *We are Making a New World*.

~

Many have seen the body of work Nash made at Dymchurch, especially *Winter Sea*, as thinly disguised war pictures. Margaret, who attempted to complete her husband's half-finished memoir after his death, encouraged this idea. Remembering 1921 as a 'fatal year', she describes how soon after their move Paul experienced the sudden death of a friend and acute anxiety over the health of his father, to whom he was very close. In September, he fell into a state of unconsciousness for a week. At the Queen Square Hospital for Nervous Diseases it was judged, Margaret wrote, that 'the whole thing had come about as the result of a continuous series of frightening images presented to a highly imaginative mind, starting from the period of his work as a War Artist, and ending in the emotional shock of his father's illness'.

It's a neat fit, given the sombre tone of the Dymchurch pictures, but subsequent biographers have found Margaret's account inaccurate: hospital records say that Nash was diagnosed with some form of meningitis, not mental illness. Reading the section of *Outline* written by her, I get the impression that her memories are heart-led, with a tendency to place blame on external incidents and play up her husband's war experiences. (She also believed that gassing in the trenches caused the chronic asthma that Paul developed in later life, despite no evidence that this ever happened.) Biographies also tell a story of a testing marriage, which was strained by poor health, Paul's infidelities and financial pressures: issues that first reared their head a few years into the marriage, straight after the war, around the time Nash first became interested in Dymchurch. It is understandable that Margaret might play down these tensions in her own version of events.

But now you know of Nash's experiences at the front, do you, like me, find it difficult not to notice the way the waves in *Winter Sea* resemble lines of trenches, or how the sky is the colour of khaki uniforms, or the way the sea-wall defends against continual bombardment? The unending, lifeless expanse could easily be no-man's land, stained sickly green by creeping poisonous gases, eerily reminiscent of Wilfred Owen's lines, 'Dim through the misty panes and thick green light, / As under a green sea, I saw him drowning'.

When Nash's war paintings were first exhibited in 1918, they were noticed not for being radical or rebellious, but for their empathy and truthfulness. Herbert Read, a critic who had himself just returned from the front, was 'immediately convinced' by the pictures he saw, believing Nash had perfectly described 'the outrage on Nature'. The painter William Rothenstein wrote to Nash, 'Until I went to Ypres and saw the Passchendaele landscape I scarcely realised how closely you interpreted the character of the particular drama of the Salient . . . you have managed to set down as no one else I think has done an eloquent statement of the peculiar conditions around Ypres.' Antony Bertram, who had also fought in the trenches, said simply, 'We knew this landscape. It was like that and, which is far more important, it felt like that.'

Within days of the first infantry attack at Passchendaele, the heaviest rains in thirty years began to fall. Water lurked just beneath the surface too, seeping upwards from the ground after shallow digging, flooding shell craters within minutes. Soldiers, like Lieutenant J.W. Naylor of the Royal Artillery, bore witness to the way the battlefields became 'a sea of mud. Literally a sea. You can drown in it'. Jokes were made about bringing in the Navy. Lifejackets from cross-Channel ferries were issued. 'Water,' as Philip Hoare has evocatively written, 'had become a fetid medium in which war bred.' Maybe *Winter Sea* is more than a metaphor for war. Perhaps it is the watery wasteland that Nash once saw, vividly recalled as conflict loomed once again.

~

In his early twenties – before he had been to war, before he had spent much time by the sea – Nash had been captivated by a William Blake poem that taught him to 'look up, to search the skies'.

> *Over sea, over land,*
> *My eyes did expand*
> *Into regions of air,*
> *Away from all care*

He began to seek regions of air, vast open spaces that gave flight to his imagination. Faces and figures articulated by stars formed in the night sky as he cycled home from the train station after art school. He heard voices in burbling streams, imagined a river of sleeping people slowly winding its way between fields of poppies. He drew meadows being scythed by winged reapers, and a woman with blue-black hair woven with feathers streaming across the sky.

In 1911 – right between the two Post-Impressionism exhibitions, when Roger Fry was becoming increasingly vocal about insulating art from life – Nash's interests began to develop in a distinctly unfashionable way. He began to bestow an almost metaphysical importance upon certain landscapes, celebrating – not denying, as Fry would have – their hidden histories. He started to believe that certain places could provoke an emotion not just from the stories associated with them, the ghosts of people or events past, but that their resonance was somehow concentrated in their appearance. '[A place's] magic lay within itself, implicated in its own design and its relationship to its surroundings,' he explains in *Outline*. This realisation was not only pivotal to his painting, but it was, he says, life-changing. It was 'this reality of another aspect of the accepted world, this mystery of clarity which was at once so elusive and so positive, that I now began to pursue and which from that moment drew me into itself and absorbed my life.'

Once Nash realised the significance of the spirit of a place – what he called the *genius loci* – supernatural characters started to disappear from his landscapes. He became more attentive to the land itself, drawing trees as if he was doing their portraits, observing the contours of a landscape as closely as those of a life-model. He used colour for the first time and became more selective in what he included in the final composition, refining the design until he captured a landscape's spirit through shape, colour and line. Figures and fantasies retreated, allowing the 'inner design of very subtle purpose' of certain places to come to the fore. But he continued unashamedly to paint pastoral places in pale watercolour washes and careful ink lines, betraying his lingering fondness for Blake and Dante Gabriel Rossetti, the Victorian painter-poet, whose lyrical work was inspired by poetry, myths and fantastical visions.

At heart, Nash was a Romantic, knowingly following a long tradition of artists, writers and poets who allowed landscapes to lure their minds and bodies to exotic extremes. Wide-open spaces never lost their power over his imagination, their ability to coax associations from his mind. In later life he would place outsized objects at the forefront of his landscapes – a tennis ball, a piece of flint, the head of a sunflower – objects that emphasised the expanse between the viewer and the horizon, showing how you can be in one place and yet long for what is over there, and how you can exist in the present and feel enveloped by the past.

Since the early 1700s, a certain type of place has cast a spell over imaginations in the West, still influencing how it is perceived and represented today. 'Sublime' had long been in colloquial use to describe something exalted, or that inspired dread and awe, but in the eighteenth century that feeling became specifically attached to nature. Following the publication of Edmund Burke's *A Philosophical Enquiry into the Origin of Our Ideas of the Sublime and Beautiful* in 1757, a swelling number of tourists began to seek landscapes with a challenging, awe-inspiring kind of beauty that elicited a very particular

sensation of, in Burke's words, 'delightful horror'. Artists seeking to replicate this feeling in paint sometimes integrated historic or Biblical events into a landscape to allude to its dreadful power; others, especially as the century progressed, left nature to speak for itself, painting erupting volcanoes, snow-capped mountains or storm-ravaged seas.

For Burke the sea was one of greatest sublime landscapes man could encounter. 'A level plain of a vast land, is certainly no mean idea; the prospect of such a plain may be as extensive as a prospect of the ocean; but can it ever fill the mind with any thing so great as the ocean itself? This is owing to several causes, but it is owing to none more than this, that the ocean is an object of no small terror. Indeed, terror is in all cases whatsoever, either openly or latently the ruling principle of the sublime.'

Burke was not just writing about a type of landscape, though; he was writing about what a type of landscape could suggest to your imagination. The sublime feeling came from standing on a cliff as waves thundered against the rocks beneath you or being at the bow of a ship as it pitched and rolled through the surf. The thrill lay in the proximity to danger; the closer the danger the bigger the thrill. Landscape painters became daring travellers and intrepid seafarers; Turner even claimed that he had got sailors to lash him to the mast of a ship for four hours during a storm. Though the truth of this has been questioned, it hardly matters given the astoundingly evocative picture he produced: *Snow Storm – Steam-Boat off a Harbour's Mouth* (1842). Gone are any anchoring distinctions between sea and sky. The horizon has evaporated, leaving a vortex of swirling waves and a lingering sensation of sea-sickness.

By the mid-nineteenth century the imagination had become increasingly vital to the perception of landscapes. In John Ruskin's words, landscapes were now more to do with the 'spirit of the place' than the 'image of the place'. A story goes that a wife of a friend of Caspar David Friedrich, the archly Romantic German painter, was disappointed to find that his latest painting, *The Monk by the Sea*, was of,

well, nothing. By earlier standards she was correct: Friedrich's painting consisted of little else but the silhouette of a man, a strip of rocky land and an abundance of white mist. No view, no action: nothing. But as the eighteenth century tipped into the nineteenth, perceptions began to change; nothingness began to accrue meaning. Rather than places to be shunned in fear, wild and expansive landscapes such as the ocean were percolating through the wider imagination as sites of intense emotional experiences and introspection. Lonely shores became places of humble contemplation, somewhere to confront man's insignificance in the face of nature's vast indifference. This was the era, after all, of Shelley's 'deep wide sea of misery', Keats's eternal whisperings and desolate shores, Coleridge's haunted mariner and Byron's Childe Harold, who finds the ocean 'Dark-heaving; boundless, endless, and sublime – / The image of Eternity – the throne / Of the Invisible'.

Nash's relationship to the ocean was cast in a sublime mould. As a dreamy, wary child on holiday in Yorkshire and Devon, he found that the sea's 'cold and cruel waters' held 'a fascinating but rather fearful joy' and, when staying in lodgings near the shore, that he 'could never grow tired of listening to the sound of the crash and roar of the waves'. In adulthood, the sea remained a source of both fascination and fear. Only in recalling Swanage in the 1930s does the sea appear to him more benign; only then can he describe it as 'blue and beguiling'. In the pre-war pictures *The Pyramids in the Sea* and *The Cliff to the North*, the sea is a menacing presence. And Dymchurch, whose waves he once described as sounding 'spiteful', certainly held a horrifying allure. On the whole he portrays the sea there as a vast, isolating and unwelcoming spectacle, best viewed from the safety of the beach or the sea-wall. To him, in other words, the sea was 'an object of no small terror'.

Nash was not alone among his contemporaries in choosing a richly Romantic symbol – the sublime sea – to help articulate what he could, in Byron's words, 'ne'er express, yet cannot all conceal'. Looking across film, graphic art, prose, poetry and art of the post-

war period, historians have tracked a rise in the use of religious motifs – notably of the resurrection and of the apocalypse – as well as Romantic imagery from the eighteenth and nineteenth centuries. The unprecedented scale of mourning that followed in the wake of the war seemed to have necessitated expression in such universal symbols. While some artists responded with attempts at a clear, clean break with the past – rallying to the Futurists' call to stand on the extreme promontory of the centuries and not look back – there was also an equally passionate return to tradition. By finding that the sea could articulate his state of mind after the war, Nash takes his place in a line of twentieth-century romantics who, in Jay Winter's memorable phrase, walked 'backwards into the future'. Winter writes, 'A complex traditional vocabulary of mourning, derived from classical, romantic, or religious forms, flourished, largely because it helped mediate bereavement.'

In 1940, appointed an Official War Artist for a second time, Nash turned once again to the sea to help convey the wreckage of war. He painted what was ostensibly a field of dumped aircraft debris in Oxfordshire. Depicting waves of crushed blue metal hemmed in on one side by a sandy bank, Nash named it *Totes Meer* (*Dead Sea*) after *Das Eismeer* (*The Sea of Ice*) by Caspar David Friedrich. 'You might feel,' he explained, '– under certain influences – this is a vast tide moving across the fields, the breakers rearing up and crashing on the plain. And then, no: nothing moves, it is not water or even ice, it is something static and dead.'

~

The story of this twentieth-century Romantic becomes more complicated, however, when I visit Dymchurch. The day I choose to go it rains to an almost comical extent. It rains on the sign saying, 'Welcome to Dymchurch, The Children's Paradise!' with a picture of a sun. It rains on the yellow outdoor exercise bike that weirdly obscures the

sign. It rains on the seagulls. It rains on me. I take shelter in an empty fish-and-chip restaurant on the high street until the downpour eases. When I emerge, hardly anyone is around. I soon begin to feel self-conscious. What was I expecting to find? Clearly much has changed in the century since Nash lived here. The high street now doubles as a busy A-road, and many of the buildings look as though they were built in the last fifty years. I walk past a few more fish-and-chip shops, a Tandoori Hut, a Chinese takeaway and a shop with fluorescent plastic beach buckets piled up in the window. Should I be trying to feel this place's *spirit*? Now I'm here, being splashed by a quick flowing stream of passing cars, that seems like an embarrassing, hopeless idea.

I reach a small amusement park, fluttering with Union Jack flags, promising candy floss and family fun. It is shut, the rides are vaguely covered with red tarpaulin. It is then that I spot a terrace of white houses across the street. They seem older than the buildings around them, and I am sure I recognise them from a snapshot I've seen of Nash, standing in the doorway of one of the three places he lived in Dymchurch. The photograph is black and white, of course, and he is a bit blurry, but you can see the trace of a smile, the hint of a bow tie, and how slickly his thick dark hair is swept back from his brow. You can also see the whole row of cottages, tiny and wobbly-roofed: these could be them.

Crossing the road, I see that one of the houses has on it a round blue sign:

Paul Nash
Artist
Noël Coward
Actor/Playwright
Edith Nesbit
Author
Stayed here

Which makes Dymchurch sound like the French Riviera, not the

isolated fishing village I imagine it was when Nash lived here. But even if it was an unlikely fashionable retreat, it was still a strange choice of place for Nash to end up. Sandwiched between two great flat expanses – Romney Marsh to the west; the English Channel to the east – I am already struck by how little resemblance it bears to the other *genius loci* he describes in *Outline*. The first 'authentic place' he remembers was a wild patch of Kensington Gardens that he loved as a boy, whose threshold was guarded by an ancient beech that was 'dangerously like a witch'. The next, his father's meadow-garden in Buckinghamshire and the wooded valleys surrounding it. And then there were the mysterious Wittenham Clumps in South Oxfordshire, 'a beautiful legendary country haunted by old gods long forgotten', which he returned to over his lifetime. What was it about Dymchurch that got under his skin?

Drifts of sand have gathered in the gutter and on the pavement outside the cottages. The sea must be close. I follow the road that leads out of the village until a steep grassy bank replaces the buildings on the left. I take the first path that climbs over it, and as I reach the top I feel a great rush of white space, as though the sky has suddenly unfurled like a paper fan. There they are: *The Sea. The Shore. The Wall.* I am standing on a high pebble-dash wall; below me is a broad sandy beach. When I raise my phone to take a photo, one of Nash's most well-known paintings of Dymchurch, *The Shore*, appears very clearly framed by my screen: the sea-wall, carving purposefully to the south like a road; the sloping black triangles made by the groynes; the cold blue shadow underneath the wall; the coral pink of the sand, pretty against the grey sky.

As I start walking along the wall, I begin to notice how organised, even artificial, the beach is. I think back to those 'authentic places' Nash lists in *Outline*. They were Romantic idylls, steeped in sentiment or richly evocative of the past. This place could not be more different. It is a far cry from the isolated, rugged coastlines sought out by tourists in search of the sublime. There are no wind-blown

dunes, no crumbling cliffs and hardly anywhere for roots to cling. You reach the beach via concrete steps and slopes and metal rails, passing signs that warn of *wave action, underwater obstacles* and *slippery surfaces*. Wooden groynes punctuate the length of the four-mile beach to prevent it from disappearing, while at the same time making it difficult to follow a continuous path along the shore. Everywhere I look there are geometric shapes, sharp angles and clear areas of light and shade. In short, its appearance lends itself very naturally to the cool language of modernism.

A place like that and its effect on me – one's effect on it. If Dymchurch was a *genius locus*, a place that resonated deeply with Nash, then it must have set up a correspondence with his mind. Thinking back on the pictures he had made of this coastline, Nash believed that, somehow, they were in sympathy with his thoughts and feelings at a particular time in his life. Crucially, he also noted how distinctive they looked. *It's a curious record formally and psychologically when you see the whole set of designs together.* Seeing Dymchurch, I realise that his attraction to the sea was not what was curious, given his early predilection for sky-gazing and nineteenth-century painter-poets. What was strange was his pull to a place that encouraged him to portray it in a modern way.

Because that's the other unusual thing about the Dymchurch pictures. Compared with his earlier landscapes, whose soft contours and gentle colouration could belong to another age, this body of work reveals a growing modern sensibility – they are most similar, in fact, to the cutting-edge graphic design of the period. The lines in them are often so straight they might have been done with a ruler. The juxtaposition of dark and light is clear and strong. Angles are more defined. Some of the compositions are nearly abstract in their design; one or two figures make an appearance in some of the earlier works, then drop out altogether.

I wonder whether Nash may have found something soothing in Dymchurch's contemporary rhythms, its clean lines and sleek shapes.

Though he could never bring himself to relinquish representation entirely, on several occasions he described how therapeutic he found design work, describing the freedom from mimesis as an 'escape', a 'refuge', a 'release'. His interest in design never faded as he became a more successful painter. Throughout his career – like Vanessa Bell, like Matisse, Picasso and many other artists of his generation – he hopped happily between the solitary canvas and the printing press, designing book jackets, book plates, magazine covers, textiles and posters, as well as interiors, glassware and ceramics. He designed for the theatre too, and he spent most of his first winter in Dymchurch making model stage sets. When he returned to painting, his subjects were *The Sea. The Shore. The Wall.* Repetitive waves. Open space. Sloped lines. And the wall, elevated above it all like a stage.

I walk down the steps to the beach. From here, the people walking along the sea-wall – halted town on one side, approaching sea on the other – look less like actors on a stage, and more how I imagine sentries look patrolling castle ramparts. Soldiers and guards are more in keeping with the disciplined character of the place. Being so close to France, this part of Kent is riddled with look-out points and fortifications. There are several Martello towers in the town, built as fortresses in the early nineteenth century during the Napoleonic wars. There are also Second World War pillboxes and airfields on the marshes, and MoD firing ranges just off the road from Dymchurch to Folkestone. Later, when I come across something E.M. Forster wrote on Britain's vanishing wilderness, I think of this stretch of coastline. 'Two great wars demanded and bequeathed regimentation,' he observes, 'science lent her aid, and the wildness of these islands, never extensive, was stamped upon and built over and patrolled in no time.'

I am realising that war affected Nash's art like it had Kent's coastline: regimented it, stamped on it, patrolled it. Trying to communicate the reality of the battlefield to those who might never experience it must have focused him in the moment, made him more attentive to

his feelings at that time and in that place. He became surer of the messages he needed to convey and reached for new techniques and materials to help him do so. Oil paints to command authority. Vivid colour contrasts to bring the deathly drama. Severe diagonals to lead the eye on strict paths around the picture. It makes sense that Nash would find Dymchurch creatively stimulating, if its disciplined, muscular architecture was in sympathy with his disciplined, muscular new aesthetic.

The strange and unique thing about *Winter Sea,* though, is that it has little to do with the land. The sea is painted front on, with only a suggestion of sea-wall at the bottom. And yet there are the crisp angles and ruler-straight parallel lines; there are the vivid tonal contrasts, created from a restricted palette of barely three colours. It would have been easier to paint those forms, those colours, that style, if he had included the wall or the sand or the steps, as he did in most of the other pictures of Dymchurch. Instead, he has transposed the geometry of his surroundings on to the expanse of the sea. He has found form in what is formless, given order and shape to a wilderness. *A place like that and its effect on me – one's effect on it.* That's what he must mean by that strange phrase: this place did not only give shape to his art; in turn, it was shaped by him.

~

A couple of weeks after my trip to Dymchurch I visit Margate, a few towns up the Kent coast. I'm on my way to see an exhibition at Turner Contemporary called 'Journeys with The Waste Land'. I don't know T.S. Eliot's poem well, so I've borrowed a friend's copy to read on the train. The poem is roughly contemporary with *Winter Sea*; I am hoping it might give me a better understanding of the period, but it evades me, slipping between voices and languages with a shape-shifting ease, never settling on a tempo, always setting off on the wrong foot. This copy has pencil notes in different handwriting scribbled all over it.

I read them thirstily, hoping they will help me pin it down. THIS IS THE POEM, someone has written next to the opening verses, and drawn a line to 'A heap of broken images'.

At the entrance to the exhibition, I learn how T.S. Eliot wrote around fifty lines of poetry in October and November 1921, sitting in an Edwardian timber shelter overlooking Margate sands. I think I passed the shelter on the way to the gallery from the station. It sits above the beach, with its back to a busy road and a clear view to the sea. It has a deep, curlicued roof, good for providing shade . . . but in November? The seats are wide open to the whipping east wind. Eliot told a friend that he was spending full days there. He must have been utterly absorbed by his poem. Or very unwilling to return to his hotel room, and his wife, with whom he had a strained relationship.

Either way, it was in Margate that he began to pull together the fragments, a few lines here and there, he had been gathering ever since he was at Harvard. 'I want a period of tranquillity to do a poem I have in mind,' he told his mother in 1920. At the English seaside and then the Swiss mountains, he found peace enough to write *The Waste Land*.

The poem became a symbol of the new world wrought by the First World War, an existential anthem for the post-war generation. So much so that Evelyn Waugh had the extrovert aesthete Anthony Blanche proclaim a few of its verses through a megaphone in *Brideshead Revisited*. As the exhibition was at pains to show, the poem has continued to resonate with readers ever since. (Copies of the poem are sold out in the gift shop, where I am told that even the publishers are unable to replenish stocks.)

In the exhibition, two Paul Nash pictures stand out to me like familiar faces in a crowd. First, an almost monochrome watercolour of a blackened, blown-open tree with barbed wire for branches. Painted in 1918, it is clear why it is there. Even though Eliot, an American, did not experience action first hand, war imagery litters *The Waste Land*. Paul Fussell puts it succinctly in *The Great War and Modern Memory*: 'Consider its archduke, its rats and canals and dead men,

59

its focus on fear, its dusty trees, its conversation about demobilisation, its spiritual practitioners reminding us of those who preyed on relatives anxious to contact their dead boys, and not least its settings of blasted landscapes and ruins . . .'

Nash's second appearance in the show is more of a mystery. The work is *The Shore* (1923), one of his more peaceful, pastel-coloured pictures of the coast at Dymchurch; the one that appeared nearly fully formed in my phone screen when I was there. That afternoon, Margate didn't look dissimilar from the scene described in the painting. The sea was sandy, the sand was dark-gold and the sky was so hazy that it obscured the wind-turbines normally visible far out at sea.

As I become more familiar with Eliot's poem, though, such a serene image finds no place in my own visual annotations. It is *Winter Sea*, its moody sibling, that my mind draws lines to when I read through the poem again. There it is, in the '*Oed und leer das Meer*' (wide and empty sea) in the second stanza, and there, in the brown fogs and winter noon, and there again, in its drowned sailor whose bones have been picked in whispers. It is there in the relentless flow of office-workers over London Bridge and also in its unbroachable silences between unhappy couples. It is there in the endless plains, cracked earth, flat horizons and obsessive search for water. To me, Eliot's dead land and stony rubbish is as barren as Nash's *Winter Sea*, yielding nothing and going nowhere.

~

On hearing *The Waste Land* for the first time, Virginia Woolf, like many people, could not grasp what it was about. 'Eliot dined last Sunday & read his poem,' she wrote in her diary on 23 June 1922. 'He sang it & chanted it rhythmed it. It has great beauty & force of phrase: symmetry; & tensity. What connects it together, I'm not so sure.'

She had no doubt of its importance, though. In 1923, *The Waste Land* was published by the Hogarth Press, which she and Leonard

had founded six years earlier. Long, fragmented, many-voiced; Eliot's poem was startling and new, certainly, but not so far removed from her own interests. When composing *The Waves*, she had written of 'A sight, an emotion, creates this wave in the mind, long before it makes words to fit it; and in writing (such is my present belief) one has to recapture this, and set this working (which has nothing apparently to do with words)'. Like her, Eliot sought new ways to bridge the divide between words and reality: 'The poet is occupied with the frontiers of consciousness where words fail though meanings still exist.' Like her, but to a greater extreme, he used allusion, rhythm and resonance to penetrate those frontiers.

Eliot was alive to the ancient beats that pulsed beneath the clamour of the day to day. He was impressed by Stravinksy's *Rite of Spring* for transforming 'the rhythm of the steppes into the scream of the motor horn, the rattle of machinery, the grind of wheels, the beating of iron and steel, the roar of the underground railway, and the other barbaric cries of modern life; and to transform these despairing noises into music.' And he profoundly admired James Joyce, who had underpinned *Ulysses* a year earlier with the pattern of Homer's *Odyssey*, praising him for finding 'a way of controlling, of ordering, of giving a shape and significance to the immense panorama of futility and anarchy which is contemporary history'.

In later life, Eliot tried to dismiss the idea that *The Waste Land* offered social criticism, protesting that it was no more than 'rhythmical grumbling'. Yet it is difficult not to see shards of a freshly shattered society embedded within its verses. 'I will show you fear in a handful of dust' the poem promises, before smashing canonical narratives to smithereens and mixing them with the grubby residue of modern life; its abortions and assault and crippling *aboulie*. The purpose of the disintegration though, is creative, not destructive. Eliot once explained, 'When a poet's mind is perfectly equipped for its work, it is constantly amalgamating disparate experience; the ordinary man's experience is chaotic, irregular, fragmentary. The latter falls in love, or reads

Spinoza, and these two experiences have nothing to do with each other, or with the noise of the typewriter or the smell of cooking; in the mind of the poet these experiences are always forming new wholes.'

I do not know how aware Nash and Eliot were of the other's work, I've found nothing to suggest that they knew each other, but this vivid description of the way life enters poetry is significant. The amalgamation of disparate experience into new wholes was exactly what Cézanne had begun with his shimmering still lifes, Picasso and Braque and Duchamp had continued with Cubism in the years before the war, and the Futurists had also embraced. Showing multiple perspectives and moments all at once, these avant-garde artists also called time on the paradox of using a static form to convey life, with all its noise and motion and transience, and went in pursuit of new ways of depicting reality. In Eliot's work, historical and religious experience were thrown into the mix. He borrowed words, narratives and imagery freely and openly from other writers and thinkers in full knowledge that they trailed their own powerful associations. Gathered into poems to form new wholes, broken images did not lose their coherence, or their strength. 'These fragments I have shored against my ruins,' Eliot writes in the final lines of *The Waste Land*. They were the dust of a desiccated culture, reassembled and reimagined into a more generous and honest vision of how life really was.

At Dymchurch, Nash too began to use the sea to gather fragments of history, memory and personal experiences into a sleek, richly resonant new form. For all its affinity with the sublime, *Winter Sea* is no clichéd imitation of a Romantic sea: it is shockingly original. Edmund Burke believed sublime landscapes shared seven qualifications: darkness, obscurity, privation, vastness, magnificence, loudness and suddenness. The first four qualities can all be found in *Winter Sea*, but the final three? I am not at all sure that any exhilaration arises from it. This is a quietly terrifying sea, predictable and relentless. No surprises lie in wait, just a pervasive sense of unease. Far from being an exalted homage to the magnificence of nature, this picture

appears to be a helpless observation of its indifference. The viewer may be safe on the shore, but there is little relief.

Like Eliot, Woolf and other leading modernists who harnessed older idioms and yoked them to contemporary concerns, Nash has linked a traditional sublime trope with a newer currency of fear, derived from imagery that he himself had helped create. War artists' images of First World War battlefields – as well as the letters, poetry and memoirs that proliferated from those desolate places – have become a well-known source of fascinating horror, a new kind of sublime. Unlike the Romantic sublime, which exalted in man's vulnerability before nature, this imagery warns of the opposite situation, and takes no pride in it. Blasted trees and rat-ridden trenches and seas of mud have come to stand for stunned misery, disillusionment, desperation; the wastes of war and the new world it forces into being. These images are so familiar to us in the West, in fact, that even when reduced to their barest forms they are recognisable: the straight lines of troops on the march, the zig-zags of duckboards and rifles held against shoulders, the sickly colour of gas and the sepia of life-sapped landscapes. Encouraged into paint by the architecture of Dymchurch and the sea itself, they linger over *Winter Sea* like an after-image that will not fade away.

~

But although the ghosts that haunt it are chilling, *Winter Sea* is not without hope. Nash may have been at the vanguard of modernism, but Romanticism had taught him that painting is never a mirror to a landscape, reflecting back what it sees. It is a landscape recreated in the mind of a person, made richer and stranger by interactions with memory and feeling. Through *Winter Sea*, you are seeing the mind of someone who has discovered a different way of looking at the world. You are seeing coherence battling chaos, structure imposed on instability. You are seeing something absolute risen from shattering experiences: fragments shored against ruins.

As the 1920s progressed, Nash became increasingly convinced by this way of seeing. 'Law and order was in his blood,' an old friend of his once observed. 'And not only social law and order: the perceived law and order of the universe, which can only be divined intuitively.' By the time he returned to *Winter Sea* in 1937, the case for visual order had become even more compelling. Could a purer aesthetic help whitewash a muddied past? As we shall see in the next chapter, in the 1930s abstract art was widely hailed as the natural counterpart to a more purposeful, cooperative society.

Nash's attempts at visual clarity were not driven by a desire to reduce his painting's complexity: the opposite is true. 'The greatest mystery is obtained by the greatest definiteness,' he had once been told, and never had cause to doubt it. He was guided by a respect for mystery and by a profound belief that the things we see cannot easily be explained. How do you continue to live in a meaningful, moral way when you have witnessed the harm humans are capable of inflicting on each other? You would want to believe in the existence of other realities and greater purposes. You would be acutely aware that life is rife with paradoxes and that truth can change. Making peace with this knowledge might even restore your faith in humanity. Because to believe that some things will never be understood will broaden your view and stretch your horizons. It will give you the freedom to live without pitching one way of seeing against another; for, as Woolf said, nothing is ever simply one thing.

~

In the years after leaving Dymchurch, Nash became more deeply embedded within the British art world. He had a string of successful exhibitions, became a respected teacher and art critic, co-founded a group of British Modernists called 'Unit One' and helped introduce European Surrealism to Britain by organising the International Surrealist Exhibition in 1936 – a show that attracted 23,000 people in one month to puzzle over work by Dalí, Ernst, Magritte, Miró. His

work reflected a new confidence: it was bolder, stranger, more able to incorporate challenging new ideas. It had also become more urgent: he was often laid low by a weak heart and asthma that would, in 1946, prove fatal.

Nature continued to be at the heart of his work, though now he described his attraction to it in language that had absorbed Surrealist notions of interpenetration, associations and disquietude. In Surrealism, which he largely understood as 'the release of imprisoned thoughts, of poetry and fantasy', he had found an echo of his own faith in the *genius loci*, and in the artist's ability to unlock secreted spirits. It had also strengthened his belief that two images might be able to exist at once. Describing a painting called *Circle of the Monoliths* (1937–8), for instance, he said 'I do not say I dreamed the picture. It is simply a painting concerned with two landscapes or a landscape and a seascape of particular character and peculiar beauty with whose appearance I was intimate, even enchanted. The paralogism of dream frees me to paint a picture where the two images are fused.'

And so, confident that he would be able to enhance the sense of enchantment he had once felt for a place, he selected a few pictures from his past to bring back to life. Aged forty-eight, black hair turning to grey, he pulled *Winter Sea* into line with his more recent work, thickening up its paint work, sharpening up its forms. A shadow of a circle found in an X-ray suggests that a sun, or perhaps a moon, was in the original composition: this was vanquished. Newspaper was applied to the lower half canvas and painted over; a way to lighten something once dark.

Once the reshaping and reordering was complete, Nash signed it in the bottom left corner. In his clear copperplate handwriting he wrote his name and two dates. He does not deny its split origins, for he knows that painting does not need to. It can let the past sit alongside the present, show the views of many through the eyes of one, and exist as something definite in a world that was beginning to slip away.

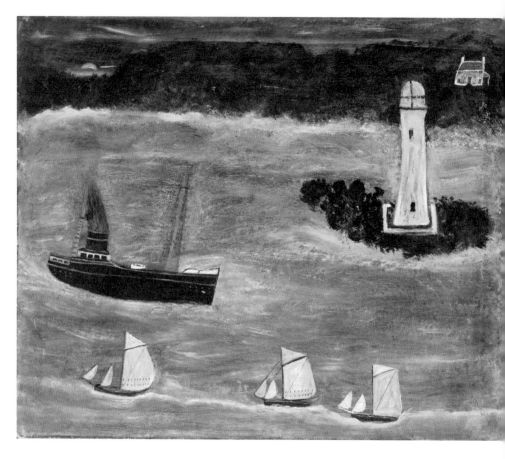

Alfred Wallis, *Seascape – ships sailing past the Longships, c.*1928-30

SEASCAPE - SHIPS SAILING PAST THE LONGSHIPS

Alfred Wallis

The walk to Kettle's Yard from Cambridge train station cuts through the centre of the city, where the university colleges are clustered among the crowded shopping streets. It is a muddle of over-lit shops and drifting tourists, narrow pavements and pristine lawns, tangles of bikes and soggy flyers. Kettle's Yard, however, keeps this twenty-first-century confusion firmly at bay. It was once home to the exacting curator Jim Ede, who renovated four dilapidated cottages in the mid-1950s to provide permanent housing for his art collection. If you ring the bellpull in the narrow passage outside the front door, as you would have done in his day, you will find it is all still there, in the precise positions Ede chose for each piece all those years ago.

Wherever the eye might naturally come to rest in the house there are pictures: some are even hung just above the skirting board, to look at while sitting in certain chairs. And yet the house still feels a home; a monastic and ascetic one, but a home nonetheless, welcoming and alive. There are vases of seasonal flowers, thriving pot plants and candlesticks with candles in them. On the mantlepiece

Alfred Wallis

and windowsills there are gatherings of shells, pebbles, driftwood and fossils. There are cabinets filled with imperfect china and shelves laden with well-thumbed books. When I visited last, it even smelt as though somebody had recently roasted a chicken.

Even though Ede in 'no way' meant the house to be regarded as an art gallery or museum, but instead a 'way of life', Kettle's Yard has exerted a particularly strong influence over generations of British art historians and curators. For the fifteen years he and his wife Helen lived there, they kept an open house between 2 p.m. and 4 p.m. every day. A passionate educator, Ede particularly welcomed undergraduates, to whom he would not only offer tea, toast and marmalade, but artworks to borrow for their rooms.

It was an extraordinarily generous offer. Ede owned work by more than one hundred artists, among them some of the most well-known European artists of the day. While working as a curator at the Tate in the late 1920s and early 1930s he often visited Paris, where he got to know Pablo Picasso, Marc Chagall and Constantin Brancusi. At his then home in Hampstead, which harboured a considerable group of intellectual émigrés from the continent, he welcomed a near daily stream of visitors from all over the world, including Sergei Diaghilev, Georges Braque and John Gielgud. Pioneers of British modernism, including Ben Nicholson, Barbara Hepworth and Henry Moore, were his good friends too. Over the years, largely through gifts or buying at cost price, he gathered one of the most comprehensive collections of twentieth-century modern art in private hands.

Yet the artist whose work Ede owned more of than any other, whose presence can be found in nearly every room, could not have come from a more different world to the carefully curated white rooms of Kettle's Yard. Throughout the 1930s, Ede would regularly receive lumpy parcels of paintings, bound with excessive amounts of string, marked with the sender's address: 3 Back Street West, St Ives. 'They would come by post,' Ede once recalled, 'perhaps sixty at a time, and the price fixed at one, two or three shillings according

to size. I once got as many as twenty but usually could not afford so many.' Though he never met the sender, Ede bought over 120 pictures in this way, accumulating the largest collection of works by Alfred Wallis in the world.

One of the first works by Wallis that you see at Kettle's Yard is on display just inside the front door, beside an old wooden cider press screw from Normandy and an elegant blue abstract painting by Joan Miró. Sitting on a low wooden chest, leaning against the wall, is *Seascape – ships sailing past the Longships*, painted sometime between 1928 and 1930. The painting shows a stormy sea, tossing with scumbly dark greys, whites and black. Three small sailing boats travel steadily along the bottom edge of the canvas, while a larger ship with a black hull passes above them. A grubby white lighthouse stands tall and proud from a cluster of coal-like rocks, by far the biggest object in the whole scene. The sea looks rough because the brushstrokes are thick and churning; you do not have to look too closely to see the individual hairs of the paintbrush. Only the hulls of the boats are smooth and glossy – as they would be if they were slick with sea water and everything else was agitated by wind. A single white cottage sits just above the lighthouse – above, not beyond – for there is little sense of perspective. Where the waves hit land, the water rages white. The painting is a sharp blast of sea air within this calm, ordered space.

~

The sea has swept upstairs at Kettle's Yard too, where Ede hung the largest group of Wallis's works. A few of the pictures show cottages and trees, harbours and lighthouses, but most have a ship or a boat – of all kinds of variety. Some are full sail in the open water, others are docked at harbour. Wallis painted black steamships sitting low in the water trailing smoke, small fishing boats with thick ochre sails, and grand yachts chequered with rigging. Like *Seascape*, these paintings are rich in colour and texture, except where Wallis has left the

background bare – knowing that the existing colour will work just as well. The paint is thick and glossy because he used house paints and boat paints, and he has clearly painted on any material or surface that was to hand: scraps of card, old timetables and panels extracted from greengrocer's crates. *Seascape* is unusual for being painted on a canvas. But any expectation of roughness or imprecision given by the pictures' irregular shapes and ragged edges is quickly corrected if you look in close to see how the miniature almond-shaped nets are filled with fish, and every tiny window of a steamship is illuminated by the careful application of orange paint.

In a book-lined nook, close to where these pictures hang, is a slim file of photocopied letters that gives a further glimpse of Alfred Wallis. Sent to Ede throughout the 1930s, Wallis refers mainly to packages of pictures – checking they have arrived, thanking Ede for sending a cheque, promising he will post more soon – most signed 'your true friend'. In a similar way to how he matched his compositions to suit the shape of whatever surface he was painting on, Wallis's rounded copperplate handwriting follows the shape of the paper, unchecked by punctuation. Often, he mentions how he paints from his memory and from the past. 'What I do mosley is what use to Bee out of my own memery what we may never see again as thing are altered all together,' is a typical sentence, written exactly as he must have spoken. As the letters progress into the decade, his writing gets looser and wobblier, sharpening the poignancy of this recurring refrain: 'I do most what used to Be what we shall never see no more', 'All I do is houtht of my own head And past tim', 'most all i do is what use to Be.'

These vignettes from Wallis's life make a stark contrast with the surroundings in which they are kept. Not only does he share walls with some of the most celebrated innovators of their day, but the architecture of the house is informed by modernist principles too. The area where most of Wallis's pictures are hung and his letters are found is in an airy, early 1970s extension, which unfolds almost imperceptibly from the cottage rooms in the first part of the house. Designed by

Sir Leslie Martin, its plain white walls, bare wooden floors, emphasis on natural light and open-plan design bears all the hallmarks of the modernist style of architecture with which he is associated. Whenever I think of Kettle's Yard, it hovers gently in my mind: uncluttered, warm and white; intolerant of disorder, sealed off from time. How had Wallis ended up there, deep inland, securely moored in this harbour of modernism?

~

Wallis was seventy when he began to paint. Having worked since the age of ten, first as a cabin boy, then as a fisherman, and finally as a scrap merchant, he was used to hard physical graft giving pattern to his days. Casting about for something to do once he started receiving his old age pension in 1926, he bought a couple of water-colour brushes, and some housepaint. He began painting on whatever material he had to hand – including his dining table and his bellows – seated at the table in the downstairs room of his two-up two-down fisherman's cottage. He painted every day, except for Sundays when he would cover over his pictures with newspaper and read the Bible instead. While his neighbours soon got used to his new occupation, it was not always understood. 'We used to laugh at it really,' one woman recalled in an interview in the 1960s, 'because mother used to say: "Well that's just like a child's picture. Always boats, nothing but boats." And every time, practically, I went in he used to say: "There you are, carry this home." I used to carry them home and mother used to say to me: "Well don't, for heaven's sake, Emily, bring any more of them in. Throw them in the dustbin." I've had scores of them. I've only got one today.' One biographer, researching his book in the early 1960s, said that he was grumpily told time and again, 'I could 'ave 'ad 'undreds ob'm, and I'd be rich now.'

One afternoon in late summer 1928, the painters Ben Nicholson and Christopher Wood happened to walk past Wallis's cottage after

a day's painting at Porthmeor Beach. Intrigued by what they glimpsed through his stable door, they introduced themselves to the 5-foot-tall old man within. As their eyes adjusted to the dusty gloom of his tiny front parlour, they noticed how each picture seemed to be painted on oddly shaped boards, and how the largest nails had been used to secure the smallest works to the wall. They were intrigued enough to buy a few pictures each; the first, they believed, he had ever made. Having swapped addresses, they headed back into the network of narrow lanes to their motorcar. When he returned to London after his Cornish holiday, Nicholson did not keep his purchase to himself. He showed Wallis's work to visitors to his Hampstead flat and studio, hung it alongside his own art in group shows, and encouraged others to start collecting, including Jim Ede.

Like Ede, Nicholson would remain in touch with Wallis until his death in 1942. In an article written for the art magazine *Horizon* remembering his Cornish friend, he recalled exactly what it was that had first arrested his attention that afternoon. First, the colours: 'lovely dark browns, shiny blacks, fierce greys, strange whites and a particularly pungent Cornish green.' Then, the vision: 'a remarkable thing with an intensity and depth of experience which makes it much more than childlike.' He goes on to praise the pictures' 'formidable organisation' and 'rhythm', before reaching a graceful conclusion: 'his imagination is a surely a lovely thing – it is something which has grown out of the Cornish earth and sea, and which will endure.'

~

In theory, what happened that day was not at all unusual. If anything, buying art from St Ives at that time was becoming slightly clichéd. Built on a west-facing isthmus, the hilly town is surrounded on three sides by the sea, meaning that the light there is unusually rich and golden for England. After a railway line was built in 1877, artists were often found perched with their easels about its harbour, town and

sandy beaches, painting *en plein air* in the manner that was popular in Europe, creating studios out of the large sail-making lofts on the waterfront. In 1889, Vanessa Bell's father Leslie Stephen wrote proudly of getting to know 'the school of artists wh. has strangely sprung up here with the last 3 or 4 years. We have even a little picture gallery!' By the late 1930s, whole railway carriages had to be set aside to convey paintings from St Ives to London for the Royal Academy's annual summer exhibition. Wallis was aware of the town's peculiar allure to outsiders. St Ives was 'all Right to make But not to sell,' he wrote to Nicholson in 1933, 'inlan Towns is the Best for sellin ships.'

But Wallis also knew that he wasn't considered to be a 'real artist' like those scattered throughout his town, even though the picture gallery Stephen mentions in his letter was only a few doors down from 3 Back Road West. In common with others who have become known as outsider, folk, naive or primitive artists, Wallis made his art at the edge of society, without any education in art or art history, with little knowledge of its customs or values. 'i am self taught so you cannot me like Thouse That have Been Taught Both in school and paint,' he once wrote to Ede. It was obvious to him he was different; he did not work outdoors as they did, he painted in his house and from his memory. Nor did he have any artist's paraphernalia. He popped an apron on to keep his jersey clean and used his supper table as a support. He did not seem to have ever desired canvases, easels, oils or smocks. When asked by a neighbour why he worked with paints normally used for yachts, he replied 'Well I don't use paint artists use, mine's real paint'.

It is telling too that in their descriptions of him, the early champions of Wallis's work emphasised his experience as a mariner – even though he had not worked on a boat since 1887. The fact that he was more of a mariner than a 'real artist' was part of the appeal. By the time Wood and Nicholson met Wallis in 1928, 'primitive art' – as it was predominantly known then – had long been attracting the attention of forward-thinking artists and critics. Roger Fry and Clive Bell had

looked at children's art and art from non-European cultures to try to develop their understanding of 'significant form'; the most success-ful artists of the day, Picasso and Matisse, were openly inspired by African art; Henri Rousseau, a tax-collector and self-taught painter, was the mascot of the Parisian avant-garde. The interest in artists who made their work without a conventional Western education lay in the belief that the connection between conception and execution was more direct, and that their work was therefore more truthful. Art generated unselfconsciously, unshaped by the stiff moulds set by art schools or historical convention, became synonymous with crea-tive freedom. Wood and Nicholson, both rebellious and ambitious young artists, had been painting in a deliberately naive style several years before they encountered Wallis.

Nicholson, the son of William Nicholson, a famous Edwardian painter of still lives, was desperate, as he once said, to 'bust up all the sophistication around me'. At the Slade, which he attended unenthu-siastically for a year, he became friendly with Paul Nash, who later remembered Nicholson as 'not conforming to the general attitude', while Nicholson remembered Nash being 'much more serious than I was – I was in the painting world and trying to get out and he was out and trying to get in'. In 1924, he had a solo exhibition of work that was almost totally abstract, a style still rarely seen in England. (The few that have survived from this show are like collages in paint, featuring irregular, overlapping blocks of colour, not dissimilar from Vanessa Bell's tentative abstract paintings.) By the early 1930s, he would become a vocal champion of pure abstraction once again. But at the time he met Wallis, he had reverted to landscapes and still life, not yet ready to abandon nature entirely.

Christopher Wood, who had recently returned from living in Paris, was meanwhile filled with a desire to suffuse his paintings with 'English character'. Seeking an antidote to the years he had spent partying with the continent's social and artistic elite, Wood returned to St Ives soon after that holiday in 1928, where he often saw 'Admiral

Wallis', as he fondly called him. He was open about the effect he was having on his work: 'More and more influence de Wallis, not a bad master though,' he wrote to Ben's first wife, Winifred, as he painted picture after picture of fishing boats and harbours with shapes and colours that echo the Cornishman's. *Seascape* belonged to Wood, and after his premature death in 1930 it came to Ede. In homage to his friend, at Kettle's Yard Ede hung *Le Phare*, one of Wood's paintings, directly above the Wallis. A similar size, both show sailing boats on a rough sea, seen from a beach. Wood's sea is breathily painted; you can see parts of the white canvas underneath as well as each choppy brushstroke. The water is a shadowy blue-black, and the sky a thunderous white. The resemblance between the two is uncanny. Apart from the elegantly lettered newspaper and pack of cards that lies in the foreground, *Le Phare* could almost have been painted by 'Admiral Wallis' himself.

Wallis's intimacy with the sea and the St Ives landscape was funda-mental to his initial enticement. Ede loved the 'ship-feeling' that his paintings gave, the sense of a 'pitching and a tossing and a passing of lighthouses and other ships'; Nicholson, remember, was drawn to his 'depth of experience' and how his imagination seemed to have 'grown out of the Cornish earth and sea'. While they admired the originality and distinctiveness of Wallis's painting style, they were also arrested by the idea that he somehow had an especially pure connection with the natural world, that he was better than others at translating actual experience into art. Ede, for instance, often used the word 'universal' in relation to Wallis – a word that was in common usage among art-ists and critics at the time referring to ideas of purity and abstraction. '[He] captures the universal aspect of his picture as opposed to its local one,' he wrote in *A Way of Life*, his book about Kettle's Yard. 'Wallis is never local.' To be local was a criticism, for it meant that a vital connection between the work and the artist had been com-promised by outside influence. Winifred Nicholson respected Wallis's 'utmost sincerity'. Barbara Hepworth admired how 'extraordinarily

integrated' he was. Ben Nicholson marvelled at how 'real' Wallis's pictures were, noting how he talked of his work 'not as paintings but as events and experiences'. It was almost as though they believed he was more at one with the landscape than them, or as if his work was an expression of nature itself.

~

The interest in 'primitive art' in the late nineteenth and early twentieth centuries had accompanied a growing desire among painters to turn away from cities towards the peripheries, towards wilder, more uncultivated environments. Across northern Europe, artists' colonies had emerged in remote rural and coastal locations like St Ives, enticed by the idea of a more 'authentic' life. By the time Wallis's work began to become popular within the elite artistic world of Nicholson and his friends, the lust for nature and authenticity was only becoming more ardent and more broadly shared.

The period after the First World War was one of the most unsettled times in British history. Industries that had once reliably generated great wealth – shipbuilding, coalmining, agriculture and textile-manufacturing – were suffering. The empire was retracting. The country's share of world exports began shrinking, as they would continue to do for the rest of the twentieth century. When economic depression hit in 1929, the fault lines running through British society became manifest. Unemployment rose dramatically; by 1933, a quarter of the labour force was out of work. The Labour Party had its first prime minister during this time, but was crippled by the crisis of depression, and had its hands tied by a coalition government. In this uneasy climate socialism took root; men bearing hammers and sickles on their flags marched to parliament petitioning for alleviation from hunger. All the while, authoritarian regimes were tightening their grip over a growing number of countries in Europe, as well as in the Soviet Union.

Against this backdrop of uncertainty, the English countryside became an ideological anchor, at once a site of spiritual renewal, national solidarity and a paradigm of peace. Rambling clubs, for instance, became incredibly popular: during the 1930s around 100,000 people were regularly walking across England. Its popularity was in part a reaction to intense urbanisation: over 4 million houses – a third of the total amount – were built in Britain between the wars. But many people were also driven by the hope of discovering a mystical connection with the land, a communion with something larger than themselves. The demand for moonlit walks became so intense that the Federation of Rambling Clubs introduced 'The Owl's Calendar' of full moons; railway companies laid on 'mystery trains' to drop London walkers in the middle of the countryside. For one midnight train-ride to Sussex, sixteen thousand people showed up. Unlike their wandering Romantic forebears, these modern hikers weren't seeking solitude and self-knowledge, but shared values and a sense of community.

Guided by an earthy spirituality, Jim Ede was certainly among this growing group of people that saw natural beauty as an antidote to wider instability. Like Paul Nash, he had been among the millions who enlisted as soon as war broke out in 1914. He was invalided out two years later, suffering from physical and mental exhaustion, and like many others, turned to nature as a balm to soothe and console him in the troubled years that followed. He treated pebbles with a similar reverence to paintings; he thought sunlight was as sacred as sculpture. He had an acute sense of harmony and equality, choosing and positioning everything in his house with deliberation and care: in his eyes each object was a *miracle*. If he had another name for God, he would tell visitors to Kettle's Yard, it would be balance. Therefore, he had enormous faith in in the healing power of one's environment. 'It is salutary that in a world rocked by greed, misunderstanding and fear, with the imminence of collapse into unbelievable horrors,' he once wrote, 'it is still possible and justifiable to find important the exact placing of two pebbles.'

Wallis once grumbled to Nicholson that he was running short of colours, specifically 'rock-colour' and 'sand-colour', and at Kettle's Yard he is accompanied by others who also seem to have dipped their brushes in nature's palette. There is a William Scott painting that looks as though a cool-grey winter sky has seeped into it through the windows. The gentle coral tinting of a shell has found its way into a warm sandy beach by Winifred Nicholson. A bright yellow circle in a Miró painting is reflected in a lemon placed on the pewter plate nearby. Even the copper-green rim of china plates is shared with the stems of fresh flowers. Nature also creeps into the texture of the art; Brancusi's cement sculpture of a head that rests on the piano is so smooth it might have been handled for centuries by the sea. These works have fluid boundaries; like Wallis, their makers have not tried to imitate nature, as landscape painters had done in the past, but have invited it to slip beneath the skin of their creations.

~

But it is hard to square Ede's utopian vision of a home, and of his belief in the soothing effects of nature, with the raw reality of Wallis's days, especially towards the end of his life. He had been widowed in 1922 and both his children had died as babies; Nicholson always remembered him as being a 'very fierce and lonely little man'. Among locals he was remembered for being quiet, industrious and intensely religious, but also 'piggy-'eaded', 'a hermit', 'awful queer', not 'exactly right in his head'. As he grew older, his behaviour became increasingly odd. He began sleeping in a wooden box behind the table in his parlour, too afraid to climb the stairs to his own bedroom, which he thought harboured devilish spirits trying to corrupt his faith in the Bible. He grew fearful of the fireplace and the wireless too. In fact, anything with wires worried him, as he believed spirits travelled through them. The local antiques dealer, Mr Armour, concocted a special contraption from an old clock weight, straw and cord to pass

down Wallis's chimney every few months to clear it out and calm him for a while. Sometimes his fear of the spirits got so bad that he would wake neighbours up with his raving and shouting, emerging the next morning exhausted and pale; sometimes he would grow paranoid, and accuse old friends of being a 'sender of messages'. In July 1938, he wrote to Ede saying he was thinking of giving up 'the paints' altogether as he got nothing from it but 'Persecutin and gelecy'.

In June 1941, neighbours noticed that he hadn't been seen for a while and called a doctor to 3 Back Door West. Finding him frail, deaf, suffering from bronchitis and living in a state of filth, the doctor recommended to the authorities that he be taken to the Madron Public Assistance Institution – known locally as the workhouse. When the time came for him to be taken away, he was ready and dressed in clean clothes (though he refused to put on his socks). He took nothing with him except his watch, magnifying glass and scissors. He died, fourteen months after arriving, aged eighty-seven.

A pauper's burial was planned, but the Madron Institute gave no notice of it to anyone until the day before it was due to take place. Adrian Stokes, a critic who lived in St Ives, just managed to intervene in time, paying the Salvation Army to officiate over a funeral in the cemetery overlooking Porthmeor Beach. He and Nicholson, who had moved to St Ives on the outbreak of war, also only just managed to rescue the paintings left his in cottage at the last minute. In St Ives, possessions of the deceased poor were traditionally disposed of in a huge bonfire on the beach.

Beholden to the shames and stigmas of his Victorian youth, Wallis had dreaded two fates above all others: the workhouse and a pauper's burial. Those who knew him would have known this; Barbara Hepworth (who married Ben Nicholson in 1938) once described a tirade he gave against the Poor Law and the pauper's grave as 'simply magnificent – just like an epic poem!' Yet Wallis did not avoid the first fate, and only narrowly escaped the second. By then his work had been exhibited in some of London's most esteemed contemporary

art galleries and written about in books and magazines; Nicholson had even donated one of his works to the Museum of Modern Art in New York. He had patrons and supporters; how had it come to this?

Nicholson, who was challenged on this at the time, maintained that the war made it difficult for any alternatives to the Madron Institute to be found. He and Stokes had visited, bringing painting materials, and reported to Ede that the Master and the Matron looked after Wallis well. Defending the low prices they paid for his paintings, Hepworth said she and Nicholson had once tried to send more pictures back and give him the same money, but soon stopped because Wallis thought they no longer liked the work. They also had little money themselves: their abstract work was not commercial, especially as war approached. Wealth and fame were not desired by Wallis, they argued, and would have compromised his work. Once, when Nicholson showed him a reproduction of one of his paintings in the prestigious journal *Cahiers d'Art*, Wallis had pushed it away, saying, 'I've got one like that at home.'

The situation was unquestionably complicated, but Nicholson did acknowledge more could have been done. In a letter written to the author of the first biography of Wallis, published shortly after his death, Nicholson wrote: 'Of course, there is the possibility – a very real possibility – that one might have given Wallis all kinds of security and removed his urge to work. A friend of mine, who lives in the Scilly Isles, says how soft the Islanders have become through leading soft lives.' He concludes in support of a basic level of security provided by the welfare state, an idea that had been recently outlined in the Beveridge Report of 1942: 'All the same we must have at least Beveridge!' I have no doubt that Nicholson had genuine affection and respect for Wallis, but I can't help feeling that he would not have had the same fears about his own work, or that of his cosmopolitan peers, if it began to generate unexpected wealth.

As he felt Wallis's art was a direct product of his experience, Nicholson did not want to risk influencing any part of his lifestyle, in case the

work changed for the worse or stopped altogether. This idea was not uncommon in the discourse on 'primitive' art in this period, but it does lead to some uncomfortable conclusions. If you believe that instinct rather than skill or talent is responsible for an artwork, it takes the agency away from the creator and gives it to those who think they are more able to appreciate its value. As in Wallis's case, there is then a greater chance that the conditions in which the maker lived and worked are deliberately not improved. Secondly, if taken to an extreme, as for example Clive Bell did in *Civilization: An Essay* (1928), it would justify the existence of an authoritative elite who judge themselves able to identify and maintain those values. Virginia Woolf witheringly pointed out in her review of his book that 'in the end it turns out that civilization is a lunch party at No. 50 Gordon Square'. Later Quentin Bell would go further, describing his father's political views as almost 'Fascistic'.

When I visited St Ives, however, it became clear that without the chance encounter with Wood and Nicholson in 1928, Wallis's work would likely have been thrown on a beach bonfire and vanished forever from view. The world he once knew is long gone. The Cornish fishing industry has deflated; the harbour is thick with holidaymakers; the seagulls have grown fat and fierce on a diet of chips and ice cream. 3 Back Door West, like so many other houses in the town, is now a holiday rental with reproduction prints of his paintings hanging on its clean cream walls. Wallis himself has not disappeared: his grave can be found in a grassy cemetery overlooking Porthmeor Beach, marked by ceramic tiles hand-painted with an elegant image of a lighthouse. Just behind his old house, you can see a few of his paintings hanging as part of a permanent display of paintings in Tate St Ives. In the town's many small galleries and art shops you find reproductions – and shameless imitations – of his pictures.

The fact he still has a presence there, however, is surely connected to the lingering existence of those who are associated with his 'discovery'. While Wallis's cottage is now largely anonymous, Hepworth's studio, where she worked from 1949 until her death in 1975, has

been perfectly preserved. Her and Nicholson's circle of friends and acquaintances have become so synonymous with the town that it was not a surprise to learn that the idea of having a Tate gallery in St Ives was initiated by Sir Alan Bowness, who was married to one of their daughters. Nor did it seem to be coincidence that the gallery had opened in 1993 under his successor as Director of the Tate, Sir Nicholas Serota, who had been a disciple of Ede's while studying as an undergraduate at Cambridge.

Standing outside Wallis's former home, it was impossible not to notice how close it was to the sea; it would have been part of the fabric of his days. I realised the sea was never going to be an object of sentimental affection for Wallis, something that soothed. It was his livelihood and an everyday reality, which his pictures reflect with uncompromised lucidity. The lighthouse in *Seascape* that Wallis painted again and again – the very same that inspired Woolf's *To the Lighthouse* – was also slighter, and far less visible from the town than I had imagined it to be. But thinking of the experiences that gave the sea in *Seascape* its muddy grey colour and its churning texture, it became easier to understand why it loomed so large. What else would be more prominent in a mind that once negotiated treacherous rocks in rough water? And look at the careful way each sail is connected to a mast by a rope, and how the deck of the larger steamship carries radiantly white lifeboats. Those with knowledge of sailing at the end of the nineteenth century have testified to the technical accuracy not only of the boats Wallis painted, but also of the places they go. Lighthouses, mooring points, dangerous rocks: his work maps the concerns of a Cornish mariner. It is difficult to see how you would achieve the level of detail in these works with no knowledge of boats or fishing at all. The extraordinary deliberation in Wallis's work is not decorative; it is the difference between life and death.

~

The reason I could not find enough of a sense of Wallis in St Ives, but instead saw him best through his work, reflects a bald truth. For most of his long life, Wallis's vision of the sea was not valued as highly as the pretty harbour views, scenes of the lives of local fisherfolk and Impressionistic seascapes painted by the artists that had been colonising St Ives and Newlyn's old sail-making lofts since the late nineteenth century. Their outsider's perspective, trained to look at nature in a specific way, was widely regarded to give more truthful representations of the place than Wallis's uneducated efforts. By the late 1930s, however, there was a growing feeling that a greater diversity of perspectives on Britain were needed.

It was not by chance that the lives of artists such as Vanessa Bell, Paul Nash and Ben Nicholson overlapped: they had similar educations, exhibited in the same London galleries, shared mutual friends, read similar books and magazines and attended the same shows. Their careers were buoyed by the privileges of their social class. But how had this affected what they looked for and how they saw? From childhood, their encounters with the seaside were interludes to an inland life. They were spectators, not participants. They did not depend on the sea to make a living, they could not sail, or fish, or read currents and tides; I am not even sure they could swim. An artist such as Wallis was able to present a refreshingly different view on the world, the importance of which was starting to be appreciated.

In 1938, Wallis's work was included in an exhibition called *Unprofessional Painting*, which toured from Gateshead community centre to Peckham health centre, Fulham public library and the Mansfield public gallery in the Nottinghamshire coalfield. It showed 'pictures by people all of whom have earned, and earn, their livings by the ordinary jobs of industrial civilisation', and included work by miners, gardeners and bus drivers. The exhibition reflected a mounting desire to document the nation, and not just for reasons of nostalgia. It was organised by one of the founders of Mass-Observation, a social research organisation that turned a dispassionate, ethnographic

gaze on the habits and lifestyles of the British people. By gathering information on the minutiae of life across the social classes, Mass-Observation hoped that ordinary lives would be better understood and, ultimately, transformed.

As war grew imminent, the Neo-Romantic ardour for the countryside was accompanied by more pragmatic attempts to take stock of places and lives that might once have been overlooked. In 1927, H.V. Morton struck gold with *In Search of England*, a chronicle of touring 'ancient towns and cathedral cities, to green fields and pretty things', which sold so well it was into its twenty-first edition by 1934. This was countered, tellingly, by J.B. Priestley's less rose-tinted but equally influential travelogue *English Journey* (1934), which embraced the unlovely industrial towns that Morton chose to overlook. In a similar spirit, the photographer Bill Brandt journeyed into the heart of working-class Britain, as did as George Orwell, who wrote *The Road to Wigan Pier* in 1937 about poverty in Lancashire and Yorkshire. Although Orwell thought Priestly too sentimental, both men had a socialist desire to alert wealthy southerners to the plight of workers hit hard by the depression. A crucial question was beginning to be asked: if you live in a landscape, not just look at it, how might that alter your understanding of place?

Distinguishing between what was authentic and what was fake was beginning to feel very urgent in this decade. In *The Work of Art In The Age of Mechanical Reproduction*, published in 1936, Walter Benjamin outlined the vital importance of context in understanding a work of art. Pointing out the risks inherent in isolating an artwork from its ideological framework, or the 'ritual' function that it serves, Benjamin writes: 'In even the most perfect reproduction, one thing is lacking: the here and now of the work of art – its unique existence in a particular place where it is at this moment.' A German-Jewish Marxist writing in exile from the Nazi regime, Benjamin was acutely aware of the ways this 'aura' – this genuineness, this authenticity – could be manipulated. 'From a photographic plate, for instance,

many prints can be made; the question of the genuine print has no meaning. However, the instant the criterion of genuineness in art production failed, the entire social function of art underwent an upheaval. Rather than being underpinned by ritual, it came to be underpinned by a different practice: politics.'

It is difficult to imagine work that feels further removed from the turbulent global politics of the 1930s than Wallis's. His work spoke so clearly of the 'here and now', a place and a moment, that I can see why his pictures must have seemed so refreshingly incorruptible during a time of growing extremism. Not only was visual art weaponised as propaganda in this period, but nature itself was being yoked to political agendas. The idea that the landscape was a repository of the national spirit had a shadow, the darkness of which was becoming ever more apparent. In Britain, there was a back-to-the-land organicist movement with fascist sympathisers at its helm, while abroad, 'blood and soil' was a cornerstone of Nazi ideology. Indeed, it has been recently argued that 'Nature, with all its violence and beauty, was the primary model for conceiving German history and identity in the Third Reich'.

As authoritarian regimes began to gain control over Europe and Russia, artists across Britain began to explore motifs and techniques that rooted their work in time and place. In the first volume of the modern art journal *Axis*, published in January 1935, Paul Nash alone had doubted the feasibility of total abstraction; he was 'For, but Not With' abstract painters, because he cared too much, he said, about stones, leaves, trees and waves. A year later, the tone of the journal was very different. Myfanwy Evans, *Axis*'s editor, recalled that with the onset of the Spanish Civil War and Stalin's Show Trials, 'real politics' rather than 'art politics' began to dominate. By Volume 6, published in the summer of 1936, the painter and critic S.J. Woods was able to voice unequivocally: 'It is time we forgot Art and Abstract, time the "movement" ceased and manifestos were burned, time we cut our beards, ceased to be artists and became men

85

and painters,' he wrote. 'Art has chased out life, and now life must come back if art is to remain.'

~

Seen in this light, Wallis's place within Kettle's Yard assumes a greater significance. At the heart of Ede's vision for his home was the 'fusing of art and daily living', a place where he could marry 'the inspiration I had had from beautiful interiors, houses of leisured elegance and to combine it with the joy I had felt in individual works seen in museums and with the all-embracing delight I had experienced in nature, in stones, in flowers, in people'. This trinity of interiors, art and nature, Ede hoped, would create 'a home and a welcome, a refuge of peace and order' for future generations.

A spherical stone, a mottled Venetian mirror, a Javanese puppet, Wallis's pictures of *what we shall never see no more*: each thing within the house has been chosen for the histories they carry and the feeling they give. Somehow, its diversity is key to its harmony. For while it is a highly idealistic place – an exercise in control and restriction – operating exacting aesthetic filters on the kind of world it allowed in, on the other hand, it is remarkably inclusive, a place where furniture, textiles and art from all over the world and different periods of history happily cohabit. In this hybrid place, Wallis's paintings are not outsiders at all. And that is not because they are a companionable presence in almost every room, but because he achieved in his work a fundamental aspiration of Ede's: to conjoin feeling with form, and art with life. Wallis was unrivalled in his ability to channel the truth of his experience – to get to the 'fundamental character of things' as Ede put it. His paintings show nature not as something to be contained, tamed or romanticized, but – radically for his time – as a living part of daily life.

To the end of his days, Ede never thought of Wallis as a passive vessel, unthinkingly pouring out a life in paint. In a note scribbled

to himself following a solo exhibition of Wallis's work in 1962, he expressed his frustration that some critics still characterized the work as child-like. He wrote: 'Alfred Wallis was experienced in the ways of ships and the sea, and had an immense discipline and instinct for selection and happened to express these things in terms of paint . . . It is unfortunate that the realm of painting is still subject in its critics (who are not themselves painters) to that lack of humility which thinks that the eye sees all there is to see.'

Wallis used to point out that artists were wrong to paint the sea blue: if you put sea-water in a glass and hold it to the light, he would say, it has no colour at all. 'I do not put collers wha do not Belong I Think it spoils the pictures,' he once wrote to Ede, 'their have Been a lot of Paintins spoiled by putin collers where they do not Blong'. At Kettle's Yard, although we find him many miles from the sea, he has carried its presence deep inland, and along with it a feeling of a world now vanished. Every painting of his is a reminder that the eye does not see all there is to see. His seas were individual, mercurial, animated by weather and waves and currents. As any mariner would know, the sea is more than its surface.

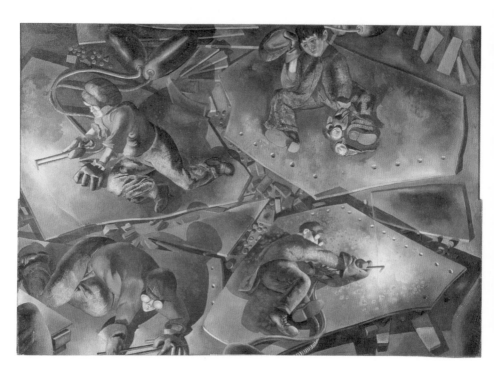

Stanley Spencer, *Shipbuilding on the Clyde: Burners* (detail), 1940

SHIPBUILDING ON THE CLYDE: BURNERS

Stanley Spencer

In early May 1940, the workers at Lithgow's shipyard on the banks of the River Clyde were joined by curious-looking recruit. Wearing a shabby suit that seemed to hang off him, a threadbare sweater and no hat, the visitor was woefully underdressed for the weather of west Scotland, even in early summer. While most men were shod in sturdy hobnail boots appropriate to their long days spent outdoors, he was wearing light shoes more adequate to pacing city streets than navigating slipways. And at only 5 foot 2 inches tall, with dishevelled, peppery grey hair, he looked spectacularly ill-suited to the hard physical graft of working in a shipyard. For a while, most of the workers simply assumed he was a tramp who had managed to sneak in at the gates.

But word soon spread that this was no vagabond. He was the artist Stanley Spencer, whose epic, quasi-religious figurative paintings had been celebrated since his days as a star pupil at the Slade – where he had studied alongside Paul Nash. In 1912, at the age of twenty-one, his work was included in Roger Fry's landmark *Second Post-Impressionist Exhibition*, and in 1918, in the final months of the First World War,

he was made an official war artist. In 1927 a work purchased by the Tate Gallery was described by a critic at *The Times* as 'the most important picture painted by any English artist in the present century'. At the end of the decade, his First World War memorial chapel in Burghclere brought him to public attention. Widely considered his masterpiece, it recalled his own experiences of the war, which he spent as a medical orderly, then as an infantryman in Salonika, before he was finally released from the army to work on painting the conflict.

When war broke out again twenty years later, Spencer, like Nash, was invited to become a war artist once more. Except this time, both artists would go nowhere near the fighting. Back then, they had painted from memory, based on first-hand experiences of the battle-field and hasty sketches made on duty. Now the War Artists' Advisory Committee wanted to keep their two most senior artists firmly focused on the domestic front. Nash was attached to the Royal Air Force, painting the bizarre sight of dogfights in the sky over the English Channel and the fields flooded with wrecked German planes that would become *Totes Meer*. Sent north to the famous shipyards just outside Glasgow, Spencer was posted in the opposite direction to the action swiftly spreading across the continent and, as was becoming rapidly clear, towards England's south coast.

~

The same week Spencer arrived in Port Glasgow, Germany invaded Holland, Belgium, Luxemburg and France. Neville Chamberlain resigned as Prime Minister and Winston Churchill was invited to form a wartime coalition, offering his country nothing but 'blood, toil, tears and sweat'. Within less than a fortnight, as Spencer prepared to return home, the bulk of the British army found themselves on the harbour and beaches of Dunkirk, trapped between the advancing German army and the English Channel. In tunnels buried deep within the chalk cliffs below Dover Castle, an unusual plan was hatched to

evacuate as many troops as possible. By 31 May, a flotilla of 700 civilian boats had arrived in Dunkirk to help ferry the waiting men from the shallow waters out towards the larger Royal Navy ships. Within a week, 330,000 allied troops had been rescued. The evacuation was a major victory for the Germans: within three weeks, France would surrender. But the image of hundreds of pleasure steamers, fishing boats, dinghies and lifeboats leaving their peaceful holiday harbours to save British soldiers, of plucky civilians uniting against a formidable enemy, became a valuable and enduring symbol of what would be known as the 'Dunkirk spirit'.

The evacuation made another new reality of war clear too. After the fall of France, Britain's dependency on the sea became stark. All that lay between it and aggressively advancing Nazi forces was a sliver of water – barely twenty miles at its slenderest. As Spitfires and Hurricanes held the Luftwaffe at bay in the skies over Sussex and Kent, the country prepared for an invasion. On the day 15 million households received a leaflet with the title *If the Invader Comes*, Churchill made one of his most stirring speeches: 'Let us therefore brace ourselves to our duties, and so bear ourselves that, if the British Empire and its Commonwealth last for a thousand years, men will still say, "This was their finest hour".' Although best remembered for those concluding words, Churchill used the main body of the speech to hammer home the image of Britain as a lone bastion of strength, referring to it again and again as 'this Island'. Just as the War Ministry would begin churning out propaganda films filled with inspiring scenes of the coast to remind the country of its proud maritime history, for the next five years, Churchill would draw continually upon an 'Island nation' rhetoric to stoke a sense of national unity and togetherness.

And yet while the geological quirk that placed a sea between Britain and the rest of Europe had never felt more fortunate, the disadvantages of being an island were becoming manifest. For as well being a borderland and battlefield, the sea was also a crucial supply route. With Europe overrun with fascists, Britain was now dependent on

the safe passage of food, troops, oil and other raw materials across the North Atlantic from the US, Canada and other parts of the commonwealth. Strict rationing had been in place from January 1940, yet still, the country needed a million tons of imported goods every single week. On 14 February that year, Britain declared its merchant ships would be armed. The following day, Germany announced all merchant ships would be treated as warships. Although Britain's merchant ships had been grouped into convoys and escorted by warships and aircraft since 1939, many began to fall prey to 'wolf-packs' of German U-boats – groups of submarines would surround the ship, then wait until nightfall to surface and attack. In the second half of 1940 alone, 3 million tons of allied shipping was sunk. 'The only thing that ever really frightened me during the war,' Churchill later said, 'was the U-boat peril.'

Although not as glamourous as the daring dogfights taking place in the skies or the fierce fighting unfolding on the ground, those in power knew that victory depended on the merchant navy and the safe passage of its fleet across the Atlantic. To Churchill, it was the 'dominating factor all through the war'. President Roosevelt agreed. 'I believe the outcome of this struggle is going to be decided in the Atlantic,' he wrote to Churchill in April 1941, ' . . . unless Hitler can win there he cannot win anywhere in the world in the end.' Once the Germans occupied France the U-boat threat grew more severe. Submarines were now being launched from bases on the Atlantic coast, massively increasing their reach. Almost impossible to defend against, the U-boats were effectively placing the country under siege. Before the war, 3,000 ships brought 68 million tons of imports to the country each year. By the end of 1940, the U-boats had sunk more than 1,200 ships – about five years' worth of shipping construction in peacetime. Britain had hardly any other option but to ensure it had enough merchant ships to keep attempting the crossing. The country could feed itself without imports for 120–160 days; after that, its 45 million people would slowly begin to starve.

Looking to Sea

~

The Clyde shipyards became so crucial to the war effort that it would have been hard for Spencer to see that until recently, they had been threatened with closure. Once, a fifth of all ships constructed in the world began their journeys from the River Clyde; every kind of naval, merchant and passenger vessel had been launched from its slipways. But the retraction of Britain's empire and the global depression had set in motion a slow decline of shipbuilding. At the height of the depression in 1931, eleven out of twelve men in Port Glasgow could not find work. But when Spencer visited, war had made the yards buoyant with busyness once again. Its workers were so invigorated by their new purpose that they routinely got to work two hours early to stoke their fires in order to begin promptly when the horn blasted at 8 a.m. There was so much work that women were now being recruited as crane drivers, welders and electricians to fill the gaps that conscription had pried open. By the end of the war, Lithgow's shipyard had produced an unprecedented total of eighty-four merchant steamers – the greatest number built by any firm during the conflict.

Given the amount of work that went into making steel come alive in water, their output was especially impressive. The ships were vessels of contradictions, which its architects and engineers had to balance. Once launched, a ship would never again be completely still, but it had to be stable. Its curves needed to accommodate the sea in all its moods, able to both resist forceful waves and be at ease in calm straits. To pierce through water some parts of the ship had to be as slender and flared as an arrow, while others needed to be swollen with air to provide buoyancy. It needed to carry enough ballast to match the rough weather of the Atlantic and to adjust to the coming and going of cargo, machinery and men. Little wonder the drawings alone for a single vessel could take twenty people nine months to complete.

During his first few weeks at the shipyard, Spencer was left to roam about its vast outbuildings and offices with his sketchbook, fixing on

paper anything he might need for the eventual painting – or paintings, as he increasingly began to think. He was a gifted musician, and as he familiarised himself with the complex rhythms of the production line, he was reminded of a Bach concerto; the workers' different skills harmonised like chords. He got to know how the platers marked up the steel plates in chalk and paint according to the engineers' drawings, like a tailor's pattern-cutter, and how the loftsmen drew the designs life-size directly onto the huge floor of the loft. He saw the marked-up steel then pass to the burners, who traced their lines with their torches, cutting out complex contours that the shearing machines could not manage. He then watched as the reshaped steel plates continued on their journey to be manipulated into new forms by ferocious furnaces or sheer force, pierced with holes or welded with other plates. Eventually he would see them manoeuvred outside to the building berths, and winched, welded and riveted into position, giving the ship its enormous final shape.

The workers soon got used to the sight of Spencer squinting at them squarely from behind his wonky round spectacles, pencil and sketchbook always in hand. He was a very skilled draughtsman, swift and accurate, and they liked to be given the portraits he did of them as they worked. He was not showy, though, preferring to blend into the background as he worked. One welder remembered him as 'quiet, no brash, no push. He was more or less like a scared wee man'. Despite initial shyness, it did not take long for Spencer to become fascinated by his subject. There was so much he wanted to record that he began to make most of his sketches on sheets of toilet paper, leaving the rest of the roll to trail either side of him as he worked, like a ship's wake. While this might not have done anything to dispel his reputation for eccentricity, he returned to England brimming with ideas after his first visit. By the end of August 1940, the first of what would become a cycle of eight paintings, executed over six years, was complete.

~

Like most of the works commissioned by the War Artists' Advisory Committee during the Second World War, Spencer's *Shipbuilding on the Clyde* is now in the collection of the Imperial War Museum. Intended to be displayed in one room, and hung in double layers, Spencer chose a long, narrow format for nearly all the paintings in the series. The composition he completed first, *Burners*, is over five metres long and just over one metre tall, with a larger central panel. (Ironically, its triptych shape is similar to a 'square submarine, conning tower and all', as a press release pointed out at the time.) Depicting the part of the shipbuilding process when the steel plates are cut, it shows a group of men utterly focused on the work at hand. Painted in Spencer's characteristically curvy, almost cartoonish style, they are bathed in the rusty brown glow of the steel that surrounds them. The bright hot tips of their oxyacetylene torches illuminate faces masked with goggles, concentrating on the line they are cutting. Each man has arranged himself so that he is as close to the torch's tip as the heat will allow. Their torches trail thin ribbed tubes, which curl around their bodies like rat tails. Tightly packed within the narrow boundaries of the canvas, Spencer has made them seem more like miners in an underground tunnel, even though they probably would have been working outdoors, or in a cavernous shed. There is a clear sense of collective effort, and in the skill, the time and the labour the process involved, but none of the ships they are making, or why.

Despite the intention of the commission, when I first became aware of the cycle of paintings, at a retrospective exhibition of Spencer's work, they did not announce themselves as anything to do with the war at all. Each painting in the cycle shows a different part of the shipbuilding process, giving attention to the men who worked with iron and steel: the 'black squad' of riveters, welders, plumbers, riggers, blacksmiths. They were obviously a paean to the shipbuilding trade, but not to the purpose. Even now, combing through the books

and online archives for the drawings Spencer made in preparation for his paintings, I still find it difficult to locate any sense of the finished product. It is evident from these drawings that the more time he spent at the yards, the more preoccupied he became by the endeavour and not the achievement. His pencil recorded the details of the many unfamiliar materials and machines, and also how they are used. He has looked hard at the shapes the workers' bodies make when they use their tools; and thought about where their trousers fall into folds. It is clear how long he has dwelt on the faces of the men and women as they work, trying to recapture their focused gaze and the confidence of their gestures.

His writings also reveal how the details steal his attention. By the 1940s he had been gathering material for his autobiography for over a decade, keeping diaries, filling notebooks with thoughts and essays on art, being an artist and his highly unique spirituality, which was informed by his Christian Methodist upbringing and his father's Anglicanism as well as Eastern religions, which fascinated him. He admires how good the managers look as they stride authoritatively around the yard, overcoats flapping open, wearing their assertive bowler hats, while the workmen are the colour of iron, 'somewhat rusty'. He becomes attuned to the sounds of the yard and the rhythms of the men's work; noting, for instance, the brief suspension in noise just before a mallet is brought down hard upon an iron peg. He admires the teenage platers who draw chalk lines on the sheets of steel with 'an assurance which tell me what artists they could be'. He marvels at the imposing appearance of the factory, but really, he is most drawn to the 'very cosy spots' he finds inside, and not to the vast ships taking shape outdoors.

In painting ships during wartime, Spencer followed in a long tradition of artists turning to the sea and shore to evoke patriotic pride, stretching back to the Willem van de Veldes, the Dutch father and son who were employed by Charles II to paint his fleet. But with the sea nowhere in sight, and barely a sense of the war, Spencer's Second

World War paintings show a very different side to this nationalistic trope. Rather than depicting the might of the Royal Navy, the bravery of the merchant fleet, or even using the coast as a visual metaphor for the dark forces battering at Britain's defences, as Nash did after the First World War at Dymchurch, Spencer has drawn our attention away from those more obvious symbols of hope and resilience towards more intimate, everyday acts of war.

In the past, Spencer's idiosyncratic figurative style, combined with his unorthodox spirituality and eccentric personal life, have seen him dismissed by the art establishment as parochial. Even in his own lifetime, with modernism in the ascendence, he would have seemed old-fashioned, a little naive – more akin, to some minds, to Alfred Wallis than a thrusting modernist like Ben Nicholson. Did he get distracted by the details and miss the point of the commission? Or was he a quaint reactionary, innocently detached from the reality of the modern world? At a time when Nicholson believed the 'liberation of form and colour is closely linked with all the other liberations one hears about' and, therefore, that abstract art should 'come into one of our lists of war aims', Spencer found himself drawn to human details with an almost Romantic zeal. He attended to form and colour, yes, but only when it was tethered firmly to people and objects, gloves and boots, frowns and earlobes, flames and steel.

~

Yet in being neither wholly modernist nor overtly traditional, Spencer's vision for his shipbuilding paintings was entirely in keeping with the aims of War Artists' Advisory Committee and its chairman, Sir Kenneth Clark. They did not want bombast and bravura, nor did they want esoteric abstraction. Over the course of the war, WAAC commissioned more than six thousand works of art. The works were based on eyewitness material, and the majority were focused away from the battlefield: hardly any WAAC artists saw active combat. This is why,

in a world war of unparalleled destruction where more than 50 million people died, only three British war artists were killed while carrying out their duties: Eric Ravilious, Albert Richards and Thomas Hennell. This was in part because Clark went into the war wanting to make sure artists were kept safe and employed. But the Committee also showed a clear bias in their support for subjects that the ordinary British person might relate to, ranging from Londoners sleeping in the underground, to military hospitals, to piles of rubble in the aftermath of bombing raids, to factory production lines, to shipyards.

Images that showed 'an authentic scrap of experience plucked red-hot from an epic too big for any man to grasp', as one critic put it, were widely deemed best to bolster morale, ennobling and celebrating even the most mundane aspects of warfare. Tellingly, when he was initially approached by the committee, Spencer's keenness to paint a large crucifixion scene depicting the Nazi conquest of Poland was gently rejected in favour of a something a little closer to home. Relatability and authenticity were crucial to WAAC's aims. Overt propaganda and the politicisation of art was associated with totalitarian states, while reserved stoicism in the face of exceptional challenges was celebrated as an especially British quality. 'Though the English are energetic in action, they are restrained in expression', wrote the influential art historian Herbert Read in 1941. 'In all these respects the war cannot change us; and we are fighting this war precisely because in these respects we refuse to be changed. Our art is the exact expression of our conception of liberty: the free and unforced reflection of all the variety and eccentricity of the individual human being.' It was very important to Clark and WAAC that artists should capture for posterity a sense of what the war years actually felt like, but also that the British people should be regularly reminded of what they were fighting *for*.

Clark was particularly adamant the work they commissioned should have an aesthetic value over and above a propagandist one. A strong believer in educating public tastes, when he became Director

of the National Gallery in 1934 at the age of thirty-one, he made it his priority to make the gallery more welcoming. He urged the trustees to abolish admission charges, extended its opening hours so people could visit after work, and hired a PR firm, using advertising, photography, the popular press and even film to encourage the public to get know the national collection. During the war, his faith in the value of art and culture to the British public only strengthened. In June 1940, under pressure to export the entire National Gallery collection to Canada for safety, he went over the heads of his trustees to the new Prime Minister. Mindful not only of the U-boat threat but also, surely, the symbolism, Churchill told him: 'Bury them in the Bowels of the Earth, but not a picture shall leave this Island.' By the following summer, 1,800 priceless pictures were safely ensconced in an abandoned slate quarry in Wales, where they sat out the rest of the war unscathed.

The rooms of the National Gallery were not left echoing and bare, however. At a time when most other cultural institutions in the London were closing, Clark decided to extend its opening hours and fill it with life. Sensing there would be 'a hunger of the spirit', the pianist Myra Hess organised lunchtime concerts every weekday lunchtime priced at one shilling each. Always packed, they provided 'proof', in Clark's view, 'that although we are at war we do not want an unrelieved diet of hearty songs and patriotic imbecilities'. There were rotating displays of work by the war artists and, when bombing eased in 1942, a single masterpiece was retrieved from its hideout in Wales each month and placed in an isolated display. Visitors swarmed around these pictures, one journalist observed, like a 'beehive'. John Constable's gentle Suffolk pastoral *The Hay Wain*, was among the pieces chosen, as was Turner's *A Frosty Morning: Sunrise*, a quiet rural scene of farm workers and their horses. Over a thousand people a day came to see the Turner, looking with war-weary eyes for a reminder of what they were fighting for. 'There are certain things in life so serious that only a poet can tell the truth

about them,' Clark had written shortly after war was declared. As visitor numbers to the National Gallery swelled over the following six years, it appeared many others agreed.

Clark and the WAAC made it clear they did not want art to be enlisted in service of propaganda. Yet until 1941, Clark also worked for the Ministry of Information, overseeing many of the wartime publicity campaigns – including helping to write the leaflet *If the Invader Comes*. He would have known that the state's approach to culture provided another useful way of differentiating the British from their enemies. Any attempt to actively refine public tastes stood in clear contrast to Goebbels' emphasis on the 'unchanging taste of the masses', while the WAAC's tolerance for (moderate) modernism and their hands-off approach to how the artists carried out their commissions contrasted with the Nazi Party's labelling of avant-garde art as 'degenerate' in the 1920s and 30s.

In 1944 Clark organised and participated in a film called *Out of Chaos*, which posed the question: 'Why, in the height of a world war, should there be this terrific interest in painting?' Featuring shots of war artists – including Spencer – at work, plus many examples of just how popular art was becoming, it makes a great show of ordinary members of the public being encouraged to debate art and its purpose.

Either way, the war certainly nurtured a growing sense that art should reach as wide an audience as possible, and that it could help support wider national objectives. Between 1941–5, nine exhibitions of work by war artists were circulated to almost 150 villages, towns and cities throughout the country, as well as to far flung reaches of the commonwealth. And in 1940, an exhibition of British war art was shipped to the Museum of Modern Art in New York, as part of the effort to encourage the Americans to enter the conflict. By 1945, the groundwork had been laid for the greater involvement of the state in the arts after the war. With funding from the foreign office, the British Council (founded in 1934) was greatly expanded with the explicit aim of using cultural activities as 'an arm of the

foreign policy'; the Council for the Encouragement of Music and the Arts, formed in 1942, became the Arts Council, which still distributes Treasury money to the cultural sector today.

The interest the government was beginning to show in art and its dissemination was, in itself, symptomatic of a general softening in attitudes towards state intervention. In winter 1942, just after the first major allied military success, the Beveridge Report was published, promising a cradle-to-grave welfare state in the event of victory. Although it was a Labour initiative, even the Conservatives could see that the public would expect a serious plan of social reconstruction after the war. In J.B. Priestley's words, Britain was being 'bombed and burned into democracy'. Images of ordinary Britons doing their duty, united across class, gender and wealth divides in their fight against tyranny and fascism, were welcomed by Clark, WAAC and the general public not only because they were relatable, but because they were resonant with hope for post-war Britain too.

When *Burners* went on view at the National Gallery in October 1940, just after the Blitz began, it was praised not only by Clark and the War Artists' Advisory Committee, meaning more commissions were forthcoming for Spencer, but visitors responded encouragingly too. The *Illustrated London News* reported: '"Extraordinary" and "magnificent" are words not infrequently used by visitors to the exhibition to describe the effect on the spectators of the set of three panels entitled "Shipbuilding on the Clyde" by Stanley Spencer.' A lithograph made of the central panel was one of the bestselling prints of the whole war. Even the Admiralty wrote specially to him to say they hoped that he would 'produce more masterpieces of this kind throughout the war'.

The WAAC's decision to commission good-quality war art and to favour, as Spencer had done, depictions of endeavour and not achievement, seems to have paid off. As the critic Eric Newton observed in a December 1940 edition of the *Sunday Times*, it was difficult to interest people in pictures of war – and for good reason. 'Whereas in 1917

war was something far away and mysterious,' he wrote, 'in 1940 it is close at hand and rather sordid. To the average man it consists mainly of things in their wrong places – noises in the silent night, holes in the smooth road, bedrooms on railway platforms.' But good art, he argued, could make tired eyes see afresh. To his mind, the best of the war pictures were more than records of the war; they were a 'renaissance in English art'. He singled out *Burners*: 'No party of demons in the stokeholds of hell could look more dedicated or purposeful. Here is the true glamour of industry in war-time, its sweat and glitter turned into paint by a man who can see beneath its surface.'

~

But could Spencer really see beneath the surface? His fondness and fascination for the shipyards was undeniable, but he was there principally as an observer, and was as much an outsider to the workers' lives as the London-based civil servants and politicians on the Committee who had set him the commission. When the series was finally finished in 1946, he was criticised for infusing the commission with too much of a personal agenda, muffling the voices of the people he had been sent to represent. The workers were bemused that Spencer sometimes dressed them in colourful knitted Fair Isle jumpers and jauntily checked tweeds, when the reality was that their clothes were rough and plain and blackened by filth. He gave little sense of the danger inherent to their work either; the way hands stuck to steel in the frost, how men pulled white-hot lengths of iron out of the furnaces with nothing to protect them from the heat except hessian bags tied around their legs, or how red-hot iron rivets were tossed to the riveters as they worked, with no hard-hats or overalls to shield anyone working underneath if a catch was fumbled. It was disappointing, too, that none of the women whom Spencer had drawn and admired as they welded and riveted alongside the men, ended up in the final paintings. On the rare occasion women do appear, they are in traditional

domestic roles: looking after children or sewing in the rigging loft. And even though the shipbuilders were no strangers to the brutal side of war – Glasgow and the Firth of Clyde were viciously bombed – Spencer kept its miseries firmly at bay in his paintings.

In fact, the *Shipbuilding on the Clyde* series seems so focused on the satisfaction of collective enterprise, that it might even be tempting to connect Spencer's war work to Socialist Realism, the highly figurative, relentlessly positive artistic portrayals of Soviet life promoted during the 1930s by the communist government. But Spencer had always carved a resolutely independent path with his art: there is little sign that Post-Impressionism or Constructivism or neo-Romanticism any other trending -ism ever affected his painting over his career. This wasn't because he was incurious, or especially conservative. It was because he was too interested in human nature, manifest in observed interactions between people, to renounce figuration in favour of someone else's intellectual ideas. And just as he never tried to align himself to a broader social or artistic movement, he was never especially political – even during the war. Although he did remind himself as he embarked upon the commission that it was war work, to be done in a spirit of service to his country, he seemed never to have truly engaged with why the public might want to know about the merchant ships, or why their rapid production was so vital to Britain's war effort.

But what he was able to connect with, resonating deep in the marrow of his bones, was perhaps, in the end, even more important than any of that. He was never going to be able to understand the shipyards in the same way as those who worked there did, but he related passionately to the sense of belonging and the sense of purpose that emanated from the yard. If WAAC ever wanted reassurance that Spencer would embrace the project, that he would try hard to get under the skin of the place, they need not have worried. Writing to them not long after his first visit, he laid his whole-hearted commitment to the shipyards bare. 'Many of the places and corners of Lithgow's factory,'

Spencer wrote, 'moved me in much the same way as I was by the rooms of my childhood.'

~

Brought up in a close-knit, cultured family in Cookham-on-Thames, a rural village in Berkshire, the idea of home had a special significance to Spencer all his life. At the Slade, he quickly attracted the nickname 'Cookham' on account of his habit of missing classes to be back home by tea-time. After the First World War, he became even more devoted to his village, investing it with mystical significance and using it in his work as an allegory for all human experience. His breakthrough work was *The Resurrection, Cookham* (1924–6), a scene of the resurrection transposed to his village churchyard. For the rest of his career, Cookham rarely shifted from his thoughts, paintings or conversation. In 1954, picked to travel to China as part of a cultural delegation, he startled everyone by telling the communist Premier he felt at home in his country, 'because I feel that Cookham is somewhere near, only just around the corner'.

Yet for an unhappy period in the late 1930s, Spencer found himself cast out from his 'earthly Paradise'. By 1932 he had earned enough money to buy his own house in Cookham. Five years later, he had lost it, along with his studio and much of his income. He had been married to Hilda, a fellow artist and mother of his two children, but had become infatuated with Patricia Preece, a newcomer to the village. Convinced she was the source of his creative inspiration, he and Hilda divorced in 1937 so he could marry Preece. (He hoped to stay in a relationship with Hilda at the same time, but she understandably refused.) The marriage was an immediate disaster. It was never consummated, and Preece drained his finances. She did not allow Spencer to live at his house, which she now owned. Meanwhile, she stayed elsewhere in the village with her female lover. She insisted he painted landscapes which tended to sell, but which he

found terribly dull. He wanted to make pictures with religious and erotic overtones, which did not go down so well with collectors. By the time the Second World War broke out, he was miserably in debt, creatively and sexually frustrated, longing for Hilda and his children, and exiled from his beloved Cookham. 'I seem to have got shelved or caught up,' he wrote in one of his notebooks, 'like a leaf that has got caught up in the bank of a stream.'

Far away from the thatched cottages, hedgerows and meadows of Berkshire, he discovered another home. In the noisy, dangerous, 'realm of iron & steel' on the Clyde, he sensed a community spirit that was kindred to village life. 'I keep finding places & things that are personal to me,' he wrote to his lover, Daphne Charlton, one evening after he returned from the yard. 'I look for myself . . . everywhere & find it everywhere.' In this colossal place, he kept noticing the small things: how the workers gave a 'homely touch' to their 'immediate surroundings of angles, bars, structure, braces, corners and whatnot', balancing teapots on steel ledges, toasting bread on the braziers, warming tea urns with their industrial torches. 'People generally make a kind of home for themselves wherever they are and whatever their work,' he observed in his convoluted way, 'which enables the important human elements to reach into and pervade in the form of mysterious atmospheres of a personal kind the most ordinary procedures of work or place.'

He sensed this all-important 'Cookham-feeling', as he sometimes called it, on a grander scale too. Admiring the multitude of actions united in one larger purpose, Spencer thought the men seemed 'most spiritually themselves when they were working'. He compared the shipyards to the Garden of Eden, where the welder's tubes were snakes and the cranes were the trees, silently swinging over everybody's heads; he likened the workers to the angels in Paradise Lost, hurling rocks at Satan's invading army. This spiritual reading of the shipyards was not, Spencer makes clear in his writings, a metaphorical reframing. Describing the rigging loft, where all the ships' ropes

and canvases were prepared, he wrote, 'It is not that the coils of rope suggest halos, it is that all these items, men, hawsers, strings hanging from the ceiling, as all forms, have a hallowing capacity of their own . . . I was as disinclined to disturb the atmosphere as I would be to disturb a religious service.' He was intoxicated by the communal spirit of the place, which manifested themselves in the details of people's lives. This is why when he came to piece together the composition of the series, it was coordination, camaraderie and commonality – not war, not ships – that had lingered most tenaciously in his mind.

Spencer was keen that all the pictures in the cycle would flow into each other, reflecting the continuity he felt between all the different activities he had seen, wanting to 'preserve the impressions one gets in the shipyard itself, as in wandering about among the varied happenings.' He was enamoured with those he met on his visits, often calling on workers in their homes after a day at the yard, drawing them and their children as they sat in their kitchens. He wrote a few times to WAAC asking to be sent photographs of the finished paintings to show the men and women. Not only did he feel that they had collaborated with him in his work, but he felt indebted to them for more practical reasons – he once found his landlady attempting to patch up his hopelessly leaky shoes with odd bits of leather. 'It is only through the great kindness of the Scots people at Port Glasgow that I had a comfortable time,' he told an acquaintance in 1944. He made unlikely friends, who treated his different approach to life with amused tolerance. 'Sometimes when I had let fly to a considerable extent on my "peculiar" views,' Spencer once recalled, 'you know the sort of thing "I'm married to everybody really in varying degrees, marriage of the conventional kind is only one kind of marriage" etc. etc., Joe's boxing champion face looked up from poking the fire & in quiet voice said, "Yee'l go oot of your nut".'

In several of the paintings, including *Burners*, Spencer included a discreet self-portrait of himself in the guise of a worker; I wonder if these are statements of feeling he belonged. You only have to look

at a pre-war painting like *A Village in Heaven* (1937) to see that the *Shipbuilding on the Clyde* series is entirely consistent with Spencer's long-standing vision of an ideal world, forged from a deeply personal and complicated set of symbols and spiritual beliefs. Though smaller, this painting is also a crisply painted panorama, composed on a long, narrow canvas. The scene is set around the war memorial on Cookham Moor, the common land at the heart of his home village. It is alive with small, homely details; the floral pattern on a dress, the individual stones in a flint wall, the vase of flowers tucked into an alcove of the memorial. But the intensity and energy of the picture is found in the crowd of villagers who populate it. Rather than taking a modernist's interest in the interaction of colour or the balancing of forms, Spencer is absorbed by the way a look between two people can make them oblivious to everything else around them. How a child reaches up towards her mother or pulls her skirt into the shape of a triangle. The way hands spread broadly across a back during an embrace. The quick movement of a jealous glance over the shoulder; the heavy bowed head of a lonely person. In the foreground of *A Village in Heaven*, figures literally tuck themselves underneath and around the capacious roots of a tree. Like the shipyard paintings, this is also a painting about rootedness, what it is to feel hefted to a place and its people. Painted when Spencer's relationship with his home was becoming agonisingly complicated, it is about the redemption to be found in the embrace of a community.

~

Of course, Spencer was projecting his own preoccupations onto the shipyards. But in marrying Lithgow's so closely in his mind to the village of Cookham, he managed to reveal a vision of community that was captivating many other artists and writers in the 1930s and 1940s. In 1939, George Orwell published the novel *Coming Up for Air*, exploring a middle-aged, middle-class man's tenacious feeling

of connection to the countryside village of his childhood. As war looms, the ennui-afflicted protagonist drives from his suburban London home to go back to 'Lower Binfield', only to find it subsumed by bland new housing developments, tawdry teashops and enormous factories. 'I had the feeling of an enemy invasion having happened behind my back,' he laments. Drawing upon his own boyhood in Oxfordshire, Orwell made the irrevocability of the changes painfully clear. During the war, he turned again to small English towns and villages to help reconcile his socialism with his patriotism. For him too, national values were located not in stately homes, war memorials or gilt-framed masterpieces, but in small everyday acts. In *The Lion and the Unicorn: Socialism and the English Genius* (1941), he wrote: 'All the culture that is most truly native centres round things which even when they are communal are not official – the pub, the football match, the back garden, the fireside and the "nice cup of tea".' Like Spencer, Orwell believed that even in extraordinary times, it was routine places and activities that were most deserving of attention and respect.

In *Romantic Moderns*, a cultural history of this period, Alexandra Harris illuminates how 'the fight against rural development sometimes got imaginatively entangled with the fight against Fascism, producing a bizarre fusion of the two most pressing forces that seemed to threaten the liberty of individual and community life'. Guaranteed to raise hackles, the fantasy of Nazis marching through an English village was repeatedly drawn upon in film and book plotlines as well as propaganda. Clark later recalled that during his years heading up propaganda campaigns at the Ministry of Information he would draw upon a 'clear vision of a small English town' to help articulate what the fighting was for. It is telling that in spite of his patrician upbringing and deep admiration for British history and culture, it was the thought of the Germans marching past 'the church, the three pubs, the inexplicable bend in the road, the house with the stone gate where the old lady lived' that made him angriest of all.

The attraction to the village as a subject for Orwell and others was fuelled in part by nostalgia, a desire to fix in paintings and novels and poetry and drama an old way of life that was under threat from urbanisation, modernity and foreign invasion. Equally compelling, at a time when it seemed as though the countryside might be subsumed by suburban sprawl, was the idea that the traditional village unit might be a good blueprint for thinking about alternative future living arrangements. In 1941, Edmund Blunden wrote a volume on 'English Villages' for the popular Britain in Pictures series, launched by the Ministry of Information during the war to catalogue national culture in short, accessible books. The pages are filled with images of chocolate-box thatch cottages and muddy lanes, as you might expect for a book designed to stir the nation's protective instincts. But it also contains a manifesto for the future. Villages were not redundant vestiges of the past; they had a job to do. In uncertain times, they might be the 'salvation and fulfilment of England'.

Appealing to Tories and socialists alike, the idea of the village community became a key part of the post-war rhetoric of reconstruction. In a speech to the House of Commons in 1948, the Labour Minister of Health Aneurin Bevan, architect of the NHS, spoke of trying to 'recapture the glory of some of the past English villages, where the small cottages of the labourers were cheek by jowl with the butcher's shop, and where the doctor could reside benignly with his patients in the same street'. In the drive to literally and imaginatively rebuild the country after the war, 'community' became a guiding principle.

Whether or not it was his intention to do so, Spencer's attention to the close community of the Port Glasgow shipyards did not only capture a sense of what the daily reality of war was like for those who worked there. By attending to the specificity of experience, his paintings ended up reflecting a wider optimism about what shared values and communal endeavour might achieve. 'It is a strange, but I think true, thing, where human activity is arranged and organised to some constructive end (such as shipbuilding) it will . . . form another

structure, a construction of designs and spiritual harmony,' he once wrote. It is true that his interpretation was idealised, skimming over the rougher realities of the day-to-day life in the yards. But what Spencer understood – in a way that was prescient not only of the broader social reforms to come, but of the way in which landscapes would be understood by artists in the future – was that places become meaningful only through how they are experienced by the people who know them best. 'I need people in my pictures as I need them in my life,' he once wrote. 'A place is incomplete without a person. A person is a place's fulfilment, as a place is a person's.'

~

Peace in Europe was declared almost exactly five years to the day Spencer first arrived in Port Glasgow. By then, he was increasingly absorbed in what he thought of as 'Part Two' of his visit, a monumental scheme of oil paintings depicting the resurrection, an idea that made him 'rigid with wonder'. It was to consist of a triptych, plus further pictures that showed the people of Port Glasgow waking up, tidying themselves, rejoicing in their resurrection and reuniting with their friends and families. Spencer began work on the central section of the triptych, known simply as *The Resurrection: Port Glasgow*, in 1947. It took him three years to finish and was twenty-two feet long. In 1956, three years before he died, he reflected, 'When the end of the 1930s drew near I felt I would never win my way back to Cookham, and the discovery of Port Glasgow was a great joy, so much so that I felt at rest when I came to the Port Glasgow resurrection. It did what it could to satisfy a loss I knew I had'.

In his last major painting of the decade, Spencer once again made a work that was all about connection, all about what it is to feel at home. He showed the people of Glasgow rising from graves in a grassy cemetery, helped by those who have heaved away tombstones and held out their hands to pull them out. He showed the resurrected

stretching their limbs and resting in the daisy-dotted grass, watching as more and more people clamber free of death. As they emerge, they reach out to each out to other, embrace, kiss. Close to the centre of the scene, a group of men and women raise their hands and faces to the sky, in wonder at being reborn.

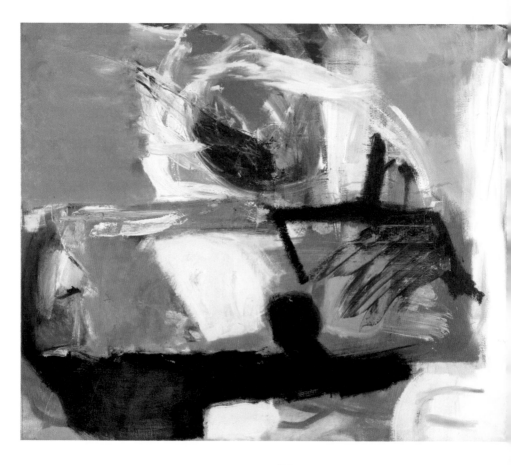

Peter Lanyon, *Offshore*, 1959

5

OFFSHORE

Peter Lanyon

The breakers pile in towards him, one following the other, diminishing in size as they get closer. A small fishing boat bobs in and out of view, just shy of the horizon. As he watches it grapple with the bullying winds, he guesses it must be about two miles offshore. Out there the water looks hard and dangerous, like chipped flint. He pulls his beret firmly down over his thick blond hair, holds his collar close to his throat with both hands, and continues along the beach towards the rise of granite in the west. He keeps the water close, where the beach is flattest, trying to cheat the sand from swallowing his steps.

At the base of the rocks, he finds his footing and begins to climb, pulling himself up its slippery black face with ease. The sea quietens as he rises and he becomes acutely aware that it is no longer at his side, but somewhere below his feet. Soon he reaches a grassy path, which he follows up to the crest of the hill. The gale crescendos while he walks and then strikes him straight on, forcing him into a bow. At the edge of the cliff, he lies down to rest in the lee of the wind and watch the waves beneath him crash land.

All this was in his bones, Peter Lanyon was fond of telling interviewers. The sea, the stones, the oldness. He'd been born in St Ives to parents whose families had both grown wealthy from the metals and minerals mined from Cornish rock. He shared his surname with the Lanyon Quoit, a prehistoric stone monument that had stood for thousands of years in the West Penwith moorland not far from where he lay that day. Now in his early forties, he had spent most of his life on this western-most tip of England, his love for it deepening with each passing year. In conversation he referred to Cornwall not as a county, a region, or a landscape, but as his *country*.

His appreciation of his country had been sharpened by the war, as had starting a family of his own. Returning home in 1946, he saw reflected in the hard granite cliffs the strength and courage he had discovered in himself after six years of service. Marriage soon after and the six children that followed nurtured a greater awareness of his origins, tempting his imagination to the subterranean places where the region's history was rooted. He began to see surface and depth as integral to the life of Cornwall; fishing and mining, both of which pierce the earth's skin to extract its resource, had been its core industries since the Bronze Age. He would come to see the agitative, turbulent way these activities interacted with the land mirrored not only in the action of weather against sea and sea against shore, but also in physical and emotional relationships between men and women.

Lying on his front that day in June 1959, watching the wind and sea paw at the land and then retreat, he felt a profound sense of loss. A long love affair had recently ended, and his mind returned obsessively to the story of Europa being snatched from the beach by Zeus disguised as a white bull, carrying her far away from everything she had known and loved. For woven tightly into Lanyon's personal mythology was the inseparability of places from the bodies that inhabit them. The ruined mines that pitted the landscape were more than monuments to the past, they were 'wounds in the character of the

native Cornishmen'. He felt that every painting he made of the land-scape was a kind of self-portrait, a revelation of injuries and scars, joys and desires, histories and secrets.

~

Returning from Portreath Beach, Lanyon begins an audio recording of his thoughts that morning. His intention is to detail each step in the making of a new painting he had in mind, which he decides to call *Offshore*. He was getting frustrated at others thinking his paintings emerged unpremeditated, as an automatic consequence of the action of painting. It was more complicated than that, but he could not eas-ily explain why. If he recorded his thoughts as he makes this new painting, perhaps it would illuminate the process not only to others but also to himself.

'The place I went to was Portreath,' the tape begins, 'I don't stand and look at it from one point of view.' He describes his blustery walk along the beach and his climb onto what he calls the Western Hill at its far end. Then he records what he does in the studio, where the painting begins with blue. He mixes the colour himself, selecting the pigment from one of the grubby jars that line his studio wall, pounding it into powder, stirring in linseed oil until it has the sheen and smoothness of softened butter. On his palette he lightens the blue with white, before spreading it pleasurably on the canvas, allowing the colour to swell into the corners. He creates an off-green grey section in the middle and uses his brush to establish some structure to the left-hand side. But when he steps back to look, he realises that what he has done is both too little and too much; he has made something oppressive, the opposite of what he intends.

He needs more information, specifically about the green section, which is supposed to be the grass on the top of the hill. Not wanting to travel the twelve miles back to the beach, he drives instead towards St Ives and then takes an inland road that sends him over field-covered

hills. It is a clear day, but his hunt for green does not involve actually getting out of the car. As he drives, he tries to memorise how the sunny fields move, shifting from the front of his vision to the left, then to his back, then above him, until he turns his car up the hills towards his home in Carbis Bay and they are below him and then gone.

~

In the days that follow his pursuit of green, Lanyon experiences what he thinks is a break through. He gives more structure to the sea section and the hill section, then slowly immerses them in blue, so that it appears as if four shores surround an island. Thinking the picture was probably now complete, he takes it inside the house and hangs it, to get a fresh look. Almost immediately he feels ashamed of himself: how vain to think it was finished, when it is now obvious that he has almost eliminated the very image he was after! He immediately takes it back to the studio and works at it ferociously for five hours straight until, as he is restoring roughness to the sea, something clicks. 'The image really begins to form,' he tells his tape recorder, 'to establish itself in time and space.'

He could now remember the ease he felt on the hill above Portreath Beach, he continues, and how he had noticed things as vividly as if he were under the influence of drugs. He was aware that the flowers were actually *happening*, he says, and that the car sitting by the building he passed on his way down the hill contained great strength and stillness. Then there was the gate that seem agitated by its own bars, and the gaunt house next to it, and the hedge that lined the route back into town, and the way the grasses bowed and twisted in the wind coming off the sea.

This intense consciousness spreads into his studio. Paint slab and muller, jars of powdered pigment, turpentine and oil, his knife, rags and brushes: all developed an extreme, unignorable presence. Movement becomes automatic. He does not need to think about how liquid

he must make the paint, or whether to set aside the rag that he will later drag in a line down the centre of the picture. He has not lost himself, though. The opposite. He has become hyper-aware of who he was then in Portreath and who he is now in the studio. The two selves correspond through eye, arm, hand and brush, until he is left with the uncanny sense that he has created an image that he has never seen before and yet, somehow, he has always known.

~

Soon after its completion, *Offshore* was priced at £500 and included in the first of many exhibitions. The painting was purchased by the Friends of Birmingham Museums and Art Gallery, who still own it today. It sits in their storerooms as I write, sadly unavailable for the public to view because of staffing shortages. Any image I can find of the painting is at least a hundred times smaller than the real thing and is, I suspect, cropped a little harshly at the edges. Even so, looking at the image now on my computer screen, I find I can map onto it the actions and thoughts Lanyon detailed on the tape. There is the band of white that he swept across the base of the canvas like a blast of cold wind, and the two red dashes that were his final action, there, in that central circle in the top half, is the north-easterly gale sweeping and twisting its way inland. And there is the bright green grass against cold blue water, and the shadow of a body with its head sharply silhouetted against the land.

The audio diary is the only known occasion that Lanyon left such a detailed first-hand account of his process, so *Offshore* is uniquely knowable. Nevertheless, his other paintings often convey that same physical feeling of being within a landscape, especially those works made from the late 1950s onwards. There is a large painting currently hanging in Tate Britain filled with seaweed greens, fierce reds and rusty yellows, which really does seem to capture the violence with which a ship is broken by the force of the sea. I still remember the

breezy feeling of an exhibition at the Courtauld a few years ago that focused on the paintings he made after he took up gliding in late 1959, how they seemed the perfect medium to express the peculiar combination of levity and vulnerability felt in flight.

Despite their apparent abstraction, Lanyon's paintings are known above all for their deeply personal intimacy with place and locality – a quality that distinguishes him not only today, but also marked him out in his own time. Lanyon was always proud to call himself a landscape painter, even though landscape was a risky subject for an ambitious young artist to be attracted to at a time of national redefinition, when long-held values were being questioned and plans for a modern Britain were being laid. Although some of the country's most successful contemporary artists, such as Henry Moore, Barbara Hepworth and Ben Nicholson, were inspired by nature, enfolding elements of treasured places into their abstract work, they did not see themselves as landscape artists in the traditional, representational sense. By the time Lanyon painted *Offshore*, the genre had become associated with innocence and nostalgia, best suited to the rooms of nineteenth-century painting at the National Gallery or the easels of Sunday painters, not the walls of the most contemporary galleries.

The post-war reassessment of the subject was not simply a question of aesthetics or changing tastes. In the chilly early days of the Cold War, art assumed a greater political importance to a nation weakened by conflict and threatened by the growing strength of the Soviet Union. The British Council became increasingly important in supporting foreign policy through festivals, biennales and other international exhibitions. 'The "Cold war" is in essence a battle for men's minds,' a member of the Foreign Office wrote to a colleague in 1951. 'The British Council is one of our chief agencies fighting for it.' In America too, the Congress for Cultural Freedom was founded in 1950 to encourage an anti-totalitarian consensus among international artistic and intellectual communities. Cultural diplomacy had not

only become a vital tool in Britain's national reconstruction kit, but also in the battle for the supremacy of the individualistic ideals of the 'free world'.

An illustration of how conceptions of landscapes were becoming aligned with political policy in the post-war era was provided by the Festival of Britain in 1951, which aimed to 'demonstrate to the world the recovery of the UK from the effects of the war in the moral, cultural, spiritual and material fields'. The first pavilion that the 8.5 million visitors came to on London's South Bank was dedicated to 'The Land of Britain', emphasising the nation's geological history and its agricultural innovations. The framing of the subject of 'The Land' within a context of scientific fact and technological progress was very much in keeping with the overarching ambition of the festival. Meanwhile, the emphasis on how nature interacted with human concerns – rather than being something to simply marvel at – demonstrated an important shift in attitudes that artists were increasingly beginning to reflect. Since the war, landscape art was valued less for being symbolic of national identity, and more for its ability to express individual experience.

For too long, the countryside had represented a nostalgic vision of the world as it used to be. In Britain, war had only strengthened this association, knitting the idea of nationhood even more closely with a certain picturesque ideal – of which the veneration of the village was part. Alongside their support of war artists, the government had funded a project instigated by Sir Kenneth Clark called 'Recording Britain', which had elevated topographical watercolours to a matter of national significance. These traditional images of country life and vernacular architecture were important because they were seen to demonstrate 'exactly what we are fighting for', the critic Herbert Read articulated, '– a green and pleasant land, a landscape whose features have been moulded in liberty, whose every winding lane and irregular building is an expression of our national character.'

But after 1945, even Clark struggled to see how landscape painting could remain relevant. In his 1949 history of the genre, *Landscape into Art*, he argued that part of the reason for its diminishing relevance was its incompatibility with both the shallow space that interested Cubists and the formal austerity of abstract art. He also believed that science had 'radically altered our concept of nature'. Not only had new knowledge opened the artist's imagination to the possibilities of microscopic and macroscopic perspectives, but it had become impossible, he lamented, to still believe nature was harmonious and friendly now 'science has taught us the reverse' – referring to the way that humans had devised vicious ways of destroying the 'natural order' with concentration camps and atomic bombs. The loss of faith in landscapes as an artistic genre was partly to do with disillusion, as Clark identified; and partly because nature seemed an anachronistic subject. As the Festival of Britain had showed, if science was the future, why would you want to root the essence of a people in its past?

To a progressively minded person in the 1950s, leaky thatched cottages and roads best suited to horses were not going to help humanity solve the urgent crises of the present. Lanyon for one was acutely aware of the disappearance of working mines from West Penwith. This was a symptom of the beginnings of globalisation, when Britain would become more outward looking and reliant on other powers in the west. This period saw the founding of the United Nations, the International Monetary Fund, the Council of Europe and, in 1957, the European Economic Community. This was a world newly enthralled by the promise of America, which had emerged from the war more wealthy, glamourous and powerful than ever before. Art reflected that shift. By the end of the decade a dynamic new movement was underway. Pop art celebrated, in Richard Hamilton's famous summation, all that was 'popular, transient, expendable, low-cost, mass-produced, young, witty, sexy, gimmicky, glamorous, and Big Business'. In other words, everything that landscape painting was not.

The year *Offshore* was painted, the critic Lawrence Alloway declared that for contemporary artists, landscape painting – Britain's 'strongest national convention' – was no longer usable. That is, for all artists except one. 'As nature gets demoted from the centre of British aesthetics, which is now happening,' he wrote, 'Lanyon may turn out to be our last landscape painter.'

~

Named after the Cornish words *pen*, meaning headland, and *wydh*, meaning at the end, West Penwith is defined by its extremity. The southernmost tip of the British Isles, it is the last landmass before America. Battered by the Atlantic Ocean on all three sides, this is a place of high, hard cliffs, heavy rainfall and blasted moorland. There are few trees to provide shelter, its sparse population is connected by narrow lanes and unmetalled farm tracks, and its secluded golden coves, many of which are reached only by steep footpaths, have signs warning swimmers braving icy waves to watch out for rusty shards of steel left by wrecks.

I visited West Penwith around the summer solstice, when silver-lilac evening light melted the sea and sky together so that ships in the far distance looked like they were sailing to the moon. We stayed with a shepherdess near Morvah in a small brown cottage tucked deep within the moorland. A path from the house led across Bronze Age walls through low scrubby heather to an Iron Age hill fort and a Neolithic quoit, a chamber consisting of four huge stones and a capstone that had balanced there for 5,000 years. History is never far away: there is a greater concentration of archaeological sites in this region than almost anywhere else in Western Europe. It is a fiercely beautiful landscape, but it was clear to me it was neither a sweet nor obliging place. It does not welcome you as its equal or beguile you into thinking you belong.

Lanyon, however, thought differently. He was teasing and fearless, leaning into gales with his arms spread, prancing about on beaches

with a seaweed tail, peering upside-down at the view through his legs or running at it suddenly, trying to catch it by surprise. This was flirtatious and familiar behaviour; I can see why he used to liken it to dancing with the place. His playfulness was typical of his desire to feel a physical connection with the land. Despite suffering from attacks of vertigo, claustrophobia and hay fever, he would clamber into old mining adits, linger at the edge of cliffs and muck in with the harvest. His son Andrew once described how his father used a car like it was a brush, tightly tracing the landscape's contours. Others remembered the artist steaming down the narrow Cornish lanes as if he were under fire from snipers.

It was a performance of a profound sense of belonging. Despite his public-school accent, no one who met Lanyon could fail to realise how much his heritage defined him. His cheeky, irreverent nature was considered quintessentially Cornish, as was his overt masculinity – which he chose to display in his robust love of the outdoors and many lovers. Long into the twentieth century there was a strong sense – keenly shared by Lanyon – that the 'real' Cornwall was rooted in the courageous masculine spirit of its fishing, farming and mining men. Yet the area's mines were now fatally outpaced by those abroad, once abundant shoals of fish had mysteriously vanished from its waters and farming machines were replacing muscle power. All the while, opportunities for women to work were more and more plentiful as tourism continued to flourish. By the late 1940s, the difference in prospects for men and women seeking work in the region was among the starkest in the whole of Britain. In his work, Lanyon envisioned the relentlessly active sea as masculine. He imagined the land, which he saw as resilient and passive, as female. Modern life seemed to threaten that age-old balance. Painting was a way of preserving it.

Intensely proud of his origins, Lanyon's loyalty to West Penwith was hardened by fear of an increasing tide of incomers. In 1930 a survey by the Council for the Preservation of Rural England, the Cornish author wrote that though the aim of the survey was to protect the

county's 'natural beauty', it should also help 'preserve the independent character of its sons: for it is unhappily certain that any people which plays itself out to exploit the stranger and the tourist runs a risk of deteriorating in manliness . . .' Post-war schemes for national parks, county planning and better transport connections across Britain compounded many people's worries that an old way of life was being eroded. Though careful not to fall for the myth of a pre-industrial, mystical Cornwall that had in recent decades been peddled by the tourist industry, Lanyon strongly believed in conserving the region's sense of independence. He felt intense shame about the way miners had been exploited in the past, but he also saw that the mines had been a valuable source of working-class self-definition and dignity – a position that sometimes placed him in opposition to his middle-class friends.

~

Despite his regional loyalties, Lanyon was always interested in the art scene beyond St Ives. He travelled frequently, read widely and taught at the Bath Academy of Art for most of the 1950s. Nonetheless, St Ives was no provincial outpost. Its artistic community had continued to thrive after the war, becoming a close rival to London. American gallerists even visited the Penwith Society's summer exhibitions; one even wanted to create an equivalent to Peggy Guggenheim's Venice collection in St Ives. Alongside Hepworth, Nicholson and Heron: Naum Gabo, Terry Frost, Bernard Leach, Wilhelmina Barns-Graham and others were operating successful careers from the deep Cornish countryside. The challenges Lanyon faced in pursuing landscape painting in this period were therefore not lost on him. He wanted to make art that felt fresh and relevant, but had no choice. He could not abandon his very bones. He would paint landscapes and would take pride in doing so. The best path left available to him, then, was to abandon convention instead.

Having grown up in a cultured, sociable, middle-class family, Lanyon was familiar with what he needed to rebel against. The colony of landscape artists settled in St Ives and Newlyn was well-known to him; he had even taken lessons from some of its most esteemed members as a teenager. They had not ignored the importance of the working life of the region; sentimental paintings of fisherfolk such as Stanhope Forbes' *A Fish Sale on a Cornish Beach* had been enormously popular with London audiences. But Lanyon now regarded this kind of work as a relic of the past. It may once have been of 'cultural value in the last century,' he said, 'but no longer has any significance except as a commodity of any sort.' He was equally unimpressed with the more recent abstract efforts of the Hepworth-Nicholson circle – with whom he was well acquainted – feeling they lacked a crucial sense of humanity and locality. Although he did not know him well, he likely felt more companionship with Alfred Wallis, whose work he bought just before he went off to war, for being a true native of Cornwall.

In his 1967 book, *A Fortunate Man: The Story of a Country Doctor*, John Berger wrote, 'Sometimes a landscape seems to be less a setting for the life of its inhabitants than a curtain behind which their struggles, achievements and accidents take place. For those who, with the inhabitants, are behind the curtains, landmarks are no longer geographic but also biographical and personal.' This was Lanyon's position too. Like Berger, he understood that landscapes were a deeply complex terrain: they were never simply *scenery*. Both understood that places have properties, not just appearances. That was why Lanyon first started to allow his bodily sensations to inform his visions of the landscape and to develop, as the art historian Michael Bird has put it, his own highly distinctive 'painterly version of Method Acting'.

Berger saw a kindred spirit in Lanyon when he came across his work in his early days as a critic. In 1954, he praised him for revealing 'a sailor's knowledge of the coastline, a poacher's knowledge of

the cover, a miner's knowledge of the seams, a surveyor's knowledge of the contours, a native's knowledge of the local ghosts, a painter's knowledge of the light'. But he also pointed out a crucial flaw. At that time, Lanyon was preoccupied with mining history, making semi-abstract works that addressed the disasters that still haunted West Cornwall. Singling out as an example Lanyon's painting of a terrible accident at the Levant Mine in 1919, Berger questioned whether an audience would really be able to understand anything about the subject without prior knowledge of the place or the story.

At the time, Lanyon dismissed Berger's criticism of him as populism. Yet over the next few years, he began to make work that tried to empathise less with other people's experiences and instead connect more closely to his own personal experiences. That was, after all, the only truth he could ever really claim to know. He worked hard at recreating the illusion of space, creating three-dimensional 'constructions' to aid him in thinking his physical experiences through. What was the feeling of dizziness dissipating as he retreated from the sharp edge of a cliff? What was it like to lean into a gale and find it will support your full weight? Which were the colours that sang out most vividly, that seared themselves into an after-image? These were questions to which only he could respond. By the end of the 1950s, his answers would leave him standing, in Alloway's words, 'head and shoulders above his rivals'.

~

Lanyon's decision to bring the focus back to himself, back to the land beneath his feet, would in fact become the very thing that connected his work to ways of thinking that were gaining currency far beyond St Ives. In the 1940s and 1950s, the French philosopher Maurice Merleau-Ponty was eloquently carrying forth a practice called phenomenology that bore a close resemblance to Lanyon's bodily approach to painting. Originating in Germany with Edmund Husserl and Martin Heidegger, phenomenology prioritised describing lived experience as

precisely as possible, as it presents itself – exactly as Lanyon narrated his painting of *Offshore*.

In *Phenomenology of Perception* (1945), Merleau-Ponty wrote of the way that knowledge is received through the body, arguing against the idea that any experience comes to us 'raw'. Not only do we learn to notice most keenly what is relevant to our interests, he argued, but our bodies also respond unconsciously to phenomena, like bowing to walk more easily in a gale, or positioning your car in the centre of a lane as you drive. He rejected the Cartesian dualism between mind and body, likening individual consciousness to a fold in a cloth: part of the world's fabric yet private, nonetheless. 'Inside and outside are inseparable,' he wrote. 'The world is wholly inside and I am wholly outside myself.' In his later work Merleau-Ponty refined the way he thought of consciousness, describing it as a 'chiasm', something intertwined and reciprocal with the world around it. He put it this way: 'It is as though our vision were formed in the heart of the visible, or as though there were between it and us an intimacy as close as between the sea and the strand'.

The correspondence between Merleau-Ponty's description of embodied knowledge and Lanyon's physical way of engaging with his surroundings indicates the originality of his approach to landscape painting. He did not think of Cornwall in the way that Paul Nash regarded his *genius loci*, believing it held a mystical significance that he tried to make manifest in paint. Nor did he see nature as providing an echo for a mood. And while he appreciated that places were ingrained with social and historical meaning, his work pushed beyond the idea that the way a person sees a landscape is shaped by their preconceptions. Through his physical, sensory engagement with the landscape, he challenged the binary between the body and its surrounding environment. Like Merleau-Ponty, he believed that knowledge flowed the other way too, from place to person, from the perceived to the perceiver. 'Here,' Lanyon wrote about his beloved West Penwith, 'sea and land answer the deep roots of man and present him with a face.'

Patrick Heron once spoke about the way there are 'certain landscapes that are immensely potent in their relationship to certain periods of art'. The critic Adrian Stokes also wrote of his eerie sense that living in Cornwall after the war was like watching a 'projection of pictures in my head as if I were a cinema reel and the outside world a screen'. Their words ring true in the work of Lanyon, for it was by connecting more intimately to the landscape of Cornwall that he tapped into wider currents of thinking not only in Europe, but America too. Heron thought the popularity of St Ives among painters around the mid-twentieth century was because 'semiabstract painting had certain underlying rhythmic alliances with this kind of terrain'. I don't think one should dismiss how attractive the social scenery of St Ives was to many artists at that time – but I do agree with Heron that there were subtler, subliminal reasons why a place defined by edges, surrounded by sea, was especially resonant in the uncertain post-war years.

As the 1950s progressed, Lanyon's work began to sell well across the Atlantic, where a new school of painting known as Abstract Expressionism was energising the New York art scene. Like Lanyon, these serious-minded painters treated their brushes as if they were spiritual mediums, channelling energy, physicality and feeling into every gesture. Mark Rothko likened the activity of painting to a religious experience; Jackson Pollock compared one of his own works to a stampede: 'Everything is charging across that goddam surface.' Comparisons were easily drawn with Lanyon's work, especially the unctuous, loosely figurative paintings of Willem de Kooning. Like his, these were powerful abstract paintings with action and emotion at their core.

When the Abstract Expressionists first exhibited in Britain in 1956 and then again in 1959, they electrified the art world like nothing else since the Post-Impressionist shows nearly half a century earlier. In 1959 *The New American Painting* broke all visitor records at

the Tate and was reviewed over thirty times in the British press. Some visitors hated the minimalism on display. 'A vertical black line against a grey background does not come within [the description of a painting],' one irate visitor complained. 'It remains a vertical black line against a grey background. It also remains an imposter.' Others were deeply moved, sensing a profound contemporary relevance. One reviewer saw in Rothko's work 'unnaturally luminous fields, tranquil yet ominous after some nuclear convulsion'; another wrote that the Americans had 'hit on symbols expressive of this age of foreboding, of unnatural forces and discoveries in space'. The new American paintings were, this critic said, 'clearly attuned to the phenomena of our time'.

While in New York for a solo show in 1957, Lanyon befriended many in the group, including Rothko, who came to stay with him in Cornwall. Rothko praised Lanyon's vitality, calling him a 'poet' and a 'beautiful Romantic'. It was a telling turn of phrase. Abstract Expressionism had a clear affinity with Romanticism; Rothko even joked that Turner had 'learned a lot from me'. Visually, their work contained many of the qualities Edmund Burke had identified as sublime in the eighteenth century, such as darkness, vastness and obscurity. Ideologically too, there was a shared concern with immensity, the centrality of the individual and of the spiritual solace to be found in transcendence. In the press, these artists were depicted as bold bohemians grappling in solitude with questions of authenticity and existence. Evocative of tortured Romantic heroes gazing out at uncompromising landscapes, their image reverberated with audiences in America and Europe struggling to make sense of moral, political and personal voids wrenched open by the war.

Through placing himself at the mercy of the natural world, actively pursuing a sense of his own human vulnerability, Lanyon was also coaxing the Romantic sublime into a new age. He was becoming obsessed with Turner and Constable, referring to them frequently in his writings and letters. Yet there was a crucial difference between his

interest in these Romantic painters and their perceived affinity with Abstract Expressionism. What Lanyon admired about Turner and Constable was their identification with the *landscape*, their understanding of nature as 'an equal, a mirror, and a source of man's desires', and their bold innovations in attempting to represent it. It was Turner, remember, who claimed to have lashed himself to the mast of a ship to truly experience a storm, and Constable who had said 'we see nothing truly till we understand it'.

This was where a key distinction between Lanyon and Abstract Expressionism lay. 'I believe that landscape, the outside world of things and events larger than ourselves, is the proper place to find our deepest meanings . . .' Lanyon said in a lecture given for the British Council. 'Landscape painting is not a provincial activity as it is thought to be by many in the United States, but a true ambition.' While the shimmering horizontals of a Rothko and the craggy forms of a Clyfford Still make it difficult to agree that landscapes were unimportant to his American peers, none venerated them so openly as Lanyon. Their pictures emerged unpremeditated from the activity of painting, whereas he needed to look beyond himself in order to see more clearly inwardly. Asserting this difference, in fact, was one of the reasons he felt compelled to make a detailed record of painting *Offshore*, where he tried to articulate the extreme extent to which body, place and painting were entwined.

By the early 1960s, Lanyon's professional success bore testament to how relevant his work was at the time. His paintings were included in big international touring shows with confidently canonical titles like *European Painting and Sculpture Today*, *British Painting 1700–1960* and *British Art Today*. He had solo exhibitions in New York and in London. The Tate Gallery bought the painting *Thermal*, and the British Council purchased one of his early fifties pictures, *Bojewyan Farms*. In 1960, *Offshore* took second place in the prestigious John Moores Painting Prize; in September 1961 he was chosen to represent Great Britain at the Sao Paolo Biennale. He was invited to write

articles, sit on prize committees and undertake lucrative commissions for wealthy collectors and public institutions. Landscape painting, it turned out, was not so redundant after all.

~

I cannot deny how much Lanyon's own account of the making of *Offshore* has influenced my reading of the painting. It reveals private meanings and messages tucked into layers that ordinarily would have remained concealed. His work is evasive, something of which Lanyon himself was well aware. He elevated feeling over thinking; he respected the obscure and the hidden. He did not want to make statements; he was reluctant to attach messages to his work. Mystery lingers in Lanyon's paintings because they do not convey how *any* body relates to a place; they record how one body existed in a place and a time. If they ever feel unknowable that is, I suspect, because these pictures were not created only for us. Lanyon used his personal experiences to draw in the viewer, to allow us share in the feeling of being within these landscapes. Yet the more familiar you become with Lanyon's life, the clearer it becomes that he also painted for himself, almost as a matter of survival.

Lanyon said that he found the act of making 'therapeutic'; that 'hands making an object release meaning'. It wasn't just the activity that was cathartic, though, it was the product. It was the 'purpose of Art,' he thought, 'to create from the substance of life an image of life in the form of an object.' Art was not there to 'console or to teach', it was instead an 'assurance of reality'. Lanyon was no stranger to depression, and although painting could drive him to 'struggle, disillusionment, distress and disgust', it was also the means by which he which he slowly climbed free of depression's 'dark pit'.

In 1949, he told Naum Gabo that he felt the only means to manifest his 'real' identity was through paint. A decade later, he discovered another powerful way to feel restored, to get back to himself. At

the time he painted *Offshore*, Lanyon's eyes were fixed firmly upon the sky: he wanted to be up there, among the clouds and wind and birds, *alone*. That year, he enrolled in a gliding club and in the autumn logged his first flight. It swiftly became a passion, inspiring the richest seam of paintings of his career. 'These things take us in to places where our trial with forces greater than ourselves, where skill and training and courage combine to make us transcend our ordinary lives,' he wrote of it, infatuated. Lanyon described gliding as something intensely serene and quiet. His sons, however, speaking recently on a radio programme, remembered an altogether different experience when they accompanied him as boys to the airfield. The roar of the wind in an open cockpit, the rattling flimsiness of the plane, the queasy moment when the tow cable retracts and the glider is left to hurtle off some high cliff: 'It's scary as hell,' one said. 'A shocking experience,' said the other.

I wonder whether Lanyon's attraction to danger stemmed from his desire to seek the same *assurance of reality* that he existed in the world. What else but fear makes you live so intensely in the moment, and so aware of being alive? In 1954 Lanyon predicted, 'I would not be surprised if all my painting now will be done on an edge – where the land meets the sea where flesh touches at the lips – a point of thinness which adds up all of preparation before committing the nearest thing I believe to death.' Pushing himself to the tip of terror, testing his physical limits, aggravating his vertigo and claustrophobia, driving recklessly. To what end? Sylvia Plath said it best in *The Bell Jar*. A survivor hears nothing more clearly than the old brag of the heart: I am, I am, I am.

In August 1964, while on a training flight, Lanyon brought his glider in to land in a crosswind, something he had been told never to do. (His sons half-joked that they thought he had probably been trying to look three ways at once.) The plane clipped a tree and tipped, catapulting him from the cockpit, fracturing his spine. Though his injuries were not thought to be life-threatening, he died days later of a blood

clot. He was forty-six. 'It was a death he was expecting', his wife Shelia told Ben Nicholson, 'and by his paintings seemed to be expecting daily.' In a moving elegy to Lanyon called 'The Thermal Stair', the poet W.S. Graham addressed his friend as an 'Uneasy, lovable man' and wrote, 'The poet or painter steers his life to maim / Himself somehow for the job.'

~

While Lanyon helped breathe new life into the landscape genre, helping to free it from its staler associations, painting was also a way for him to see himself more clearly, to breathe new life into himself. 'Without this urgency of the cliff-face or of the sea air which I meet alone,' he once said, 'I am impotent.' He was obsessed by *points of thinness*, the edges of sea, land and sky. That was where he felt most sharply his inseparability from the world, that he was part of its fabric, that he was alive, that he existed. As Merleau-Ponty once wrote of Cézanne, who painted the same landscapes over and over again to see them afresh each time, 'only one emotion is possible for this painter – the feeling of strangeness – and only one lyricism – that of the continual rebirth of existence.'

In the audio diary describing the making of *Offshore*, Lanyon is endeavouring to understand the ways in which the expansive seas and ancient rocks of West Penwith were experienced by his body, and why the extreme landscapes of his 'country' reverberated with every fibre of his being. 'The effort to understand and to live with and adjust to vastness calls out an equal depth in our own psyche,' he once said. On that June afternoon, no wonder he was fixated by the image of a small boat, buffeted offshore by the winds and waves: he knew how it felt. The boat was vulnerable to the sea's every whim, but it was where it belonged. As it adjusted to its vast, turbulent surroundings, it was made animate and alive.

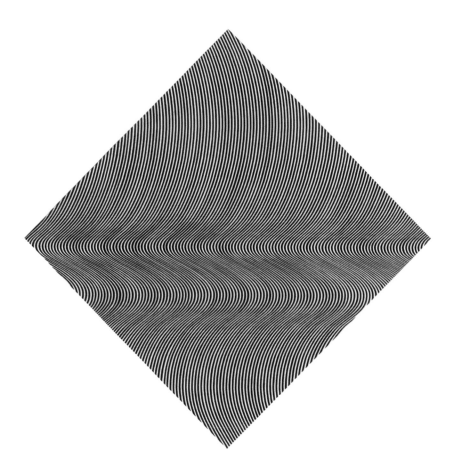

Bridget Riley, *Crest*, 1964

6

CREST

Bridget Riley

In late February 1965, Bridget Riley arrived in New York to attend the opening of the most high-profile show of her career so far. Barely four years earlier she had been working as an illustrator at an advertising agency, hiding studies of geometric shapes, structures and patterns underneath the sheath of drawings on her work easel, feeling her way slowly out of a deep personal and artistic crisis.

A chance encounter with a Mayfair gallerist had led to her first solo show at the age of thirty-one, a room of black-and-white paintings made up of squares, lines and circles. From that moment, critics and collectors began to take note. Now here she was, being driven from the airport to the Museum of Modern Art to see two of her paintings hanging as a centrepiece of a huge, international exhibition celebrating op art, 'a new, highly perceptual phase in the grammar of art', so the museum claimed. One of Riley's paintings, *Current*, had been chosen as the catalogue cover image.

But something was wrong. As her taxi drove down Madison Avenue, she began spotting versions of her paintings draped on fashion

mannequins and decorating shop window displays. 'My heart sank,' she remembered. Before the show had even opened, op art had leaked not only onto clothes, but onto everything from wallpaper to matchboxes. At the opening itself, Riley tried to avoid 'having to talk to the people who were most completely covered in "me"'. It transpired that a trustee of the museum, a dress designer and collector of her work, had turned one of her paintings into dress fabric, which had then been imitated by fashion houses all over New York. Interviewed by everyone from the *New York Times* to *Women's Wear Daily*, the press attention on Riley was intense – 'revolting, even for New York', as the UK's *Burlington Magazine* put it – catapulting her from relative obscurity to transatlantic stardom. If *Current* was the symbol of the exhibition, the artist was its poster girl.

'It was the kind of fame that would have appalled any artist,' Riley said years later. 'I fought it in every way I could.' She tried to sue but discovered in the US there was no copyright protection for artists. As a result, a copyright bill was passed through congress a year later, dubbed 'Bridget's Bill'. She also took to the press to explain the 'feelings of violation and disillusionment' she felt after her three weeks in the US. 'What had happened?' she wrote in *Art News*. 'I had had a number of conflicting experiences. My work had been hung in the Museum of Modern Art and vulgarised in the rag-trade. I had been involved in a sociological phenomenon with alarming implications, and one which was disquieting, also, to many Americans. "The Responsive Eye" was a serious exhibition, but its qualities were obscured by an explosion of commercialism, bandwagoning and hysterical sensationalism.'

What had happened, in other words, was that Riley's work had so effectively captured the zeitgeist that people had been distracted from the true intentions of the art. Yet when the topic arose recently in an interview, Riley said that it would be a mistake to think that she had seen herself as a victim, or that she was misunderstood. 'I haven't. People's reaction is their reaction.' Their reaction, she reminds us, may tell

us more about the contemporary moment than it does about her work, but is no less valid. At a time when art was becoming more visible than ever before, saturating hitherto untouched corners of everyday life, her work had clearly shown people something that they urgently wished to see. Boundaries between high and low culture were dissolving; art was becoming fashionable and fashion was becoming art. Art was now big business: commercial galleries and auction houses were flourishing; dealers and artists were celebrities. It was also becoming more accessible. Pop artists in Britain and America took the new phenomena of mass production and consumption as their subject; celebrating, questioning and parodying the soft drinks, washing detergents, motor cars, television sets, cartoons and record players that were now enjoyed by the majority and not only the educated or wealthy few. But Riley's work was different. Unlike pop art, which reflected or appropriated popular culture, her work had become popular culture itself.

~

Among the pictures of pop stars, political scandals, pixie haircuts and protests that have remained emblematic of the 1960s, there are the photographs of Bridget Riley and her black-and-white paintings. Dark haired, slight, often barefooted, wearing relaxed monochrome clothes, such as white trousers and a black polo neck, there is a satisfying symbiosis between the artist and her paintings. The overall look suited the crisp sans-serif graphic design of magazines and TV programmes of the time, and sat easily on glossy pages alongside kohl-eyed models sporting geometric Vidal Sassoon hairstyles and Mary Quant minidresses. In 1964, the year she painted *Crest*, *Tatler* superimposed a detail of one of her paintings over a photograph of her profile. They used it on their front cover, captioned: 'The shape of the 60s'.

What was it about Riley and her work that fitted so exactly with the decade? For a start, she had produced something unambiguously

new. As birth rates, quality of education and job prospects boomed after the war, 16- to 25-year-olds emerged as a distinct consumer group, exercising considerable purchasing power over music, fashion and entertainment, clearly expressing their appetite for a cultural break from older generations. The media gave a bigger platform to younger voices than ever before and it became common to see intellectuals, musicians, playwrights, comedians, TV presenters and fashion designers becoming influential in their twenties. Riley's youth was frequently insinuated in the press – in 1965 the *Guardian* described her as a 'girl, unassuming and unspoilt', despite the fact she was thirty-four – and she was included in exhibitions with titles such as 'Young Contemporaries' and 'The New Generation'.

Hard-edged, highly abstract and boldly minimal, Riley's monochrome paintings were like nothing any British artist had produced before. They were precise, cool, technical and objective (she began using assistants in 1961) and offered a dramatic alternative to the emotion-led, solipsistic, masculine paintings of the Abstract Expressionists and their followers. They were a world away from the Neo-Romantic tendency that had been popular in the 1940s and 1950s, and from the social-realist school of 'Kitchen Sink' painters too. Assuming her work was based on optical science or mathematics, some people even questioned whether it could be called art at all. In the end, given the general sense of optimism towards science and technology during the early 1960s, this probably contributed to their appeal. The race to land a man on the moon was the backdrop to the decade; Harold Wilson led the Labour Party to victory in the 1964 election with promises to embrace the 'white heat' of the 'scientific revolution'.

Equally, Riley's paintings were edgy enough to thrive within a cultural climate that actively encouraged the testing of boundaries and breaking of rules. The unnerving physical effects of her work were often emphasised by the press: the sensations of rippling movement and colour they could induce; the way they were difficult to look at

for long. Accused of attacking the eyes 'with a cold ferocity', made with a 'cruel formula', or being 'eye-irritants', 'visual torments', even 'masochistic', Riley's work was connected with a wider trend of violence in art that intended to challenge social norms. John Latham, a senior tutor at Central Saint Martin's School of Art, chewed up a copy of Clement Greenberg's *Art and Culture* and returned it to the library as fermented sputum in a glass vial. The Destructive Art Symposium brought performance artists to London from all over the world. Hermann Nitsch staged an event that involved the mutilation of a lamb carcass; Raphael Montañez Ortiz destroyed a piano with an axe; Yoko Ono performed 'Cut Piece', in which she invited members of the audience to take a pair of scissors to her clothes, sitting passively as they slowly stripped her to her underwear. Through language, Riley's work was therefore linked tangentially to the most experimental art of the day, while remaining pleasingly palatable in comparison.

Though antagonising, Riley's experience in New York gave her an opportunity to address the accuracy of these popular interpretations. In the *Art News* article, she offered some 'basic information' about her work. Firstly, her paintings were not based on 'optics' or mathematics, except at a very simple level. Secondly, the paintings had no illustrative intention; they did not directly to allude to anything else. Thirdly, it was correct to recognise an affinity between her work and performance pieces, in the sense that the visual disturbances her paintings caused were a kind of 'event' too. Finally, her work was not a 'celebration of the marriage between art and science', although she was aware that 'the contemporary psyche can manifest startling parallels' between the two. She concluded by stressing the importance of a 'visual sensibility'. Or, as she put it at the beginning of the piece, a 'state of receptive participation' that she felt was essential for looking at pictures.

If Riley had written nothing else since that article or offered no further commentary on her work, *Crest* would not be in this book, so far removed does it seem to be from anything to do with the sea.

From a 1960s perspective, it seems to be a wholly urban work, created in the heart of London and oxygenated by its swinging scene. And yet, in the five decades since *The Responsive Eye* exhibition, Riley has continued to elucidate the principles behind her work in numerous eloquent, careful essays and interviews. From these, you quickly begin to realise that her obsession with visual experiences, the driving force behind her art and desire to become an artist, sprung from a source that was the antithesis of pop culture: nature. Not only that, but you realise that her work was reflecting a new way of looking at the natural world that was entirely of its time.

~

Bridget Riley was eight when war broke out. When her father Jack enlisted, her mother thought it would be safest to move with her two daughters to Cornwall, where she had spent happy holidays as a child. In 1940, Louise Riley drove a packed car from the family's large, comfortable house in Boston, Lincolnshire, where Jack had worked for a printing firm, to a tiny slate-roofed cottage in the middle of a field in north Cornwall, on the wild Atlantic coast. They knew hardly anyone, except for Jack's sister, who came to live with them. There was no electricity and no heating, other than a single fireplace, and no running water. Paraffin for lighting was delivered every fortnight. Water was fetched from the brook that ran past their field; a rudimentary lavatory was outside, weekly baths took place by the fire in an enamel hip bath that was normally kept in the garden. The roof leaked, so they slept with tarpaulins over their beds. To Riley's young eyes, it was 'paradise'.

The landscape seeped into her daily life. Escaping from the two-up two-down cottage, she and her younger sister built secret treehouses and dens, swam with friends in the sea, conjured up games, went for long clifftop walks with their mother. Church and a makeshift school were a good three-mile walk away, along lanes lined with

dense hedgerows and thin paths at the cliff's edge. Their most well-trodden route, however, was that which led to the nearest beach, where the stream that flowed past the cottage found the sea. On these walks Louise would point out the myriad colours to be found all around them, getting the young girls to notice that the sea was not simply blue, to see how the dew sparkled, and how the colours changed when it was brushed away. 'She wasn't a painter, she was a "looker",' Riley has said. Louise continued to impress upon her children the delight and consolation to be taken from their surroundings, even after she received the news in 1942 that Jack was missing. She would not hear any update for another two and a half years, when a perfunctory postcard from the Red Cross arrived saying he was alive, a prisoner of war in Japan.

In the heartfelt essay 'The Pleasures of Sight' (1984), Riley revealed how richly her developing imagination was nourished by those walks. 'Changing seas and skies, a coastline ranging from the grand to intimate, bosky woods and secretive valleys; what I experienced there formed the basis of my visual life.' Even after four decades, she could recall a list of sensations with poetic precision. 'Swimming through the oval, saucer-like reflections, dipping and flashing on the sea surface,' she wrote ' . . . the entire elusive, unstable, flicking complex subject to the changing qualities of the light itself [. . .] Looking directly into the sun over a foreshore of rocks exposed by the tide – all reduced to a violent black-and-white contrast, interspersed, here and there, by the glitter of water [. . .] Watching the narrow dark streaks of ruffled water – violets, blues and many shades of grey – as a sudden squall swept over the sea.'

Riley had learned to feel a profound joy in sight, to open herself to the mysteries of seeing. Like Lanyon, Cornwall had revealed to her that a landscape could initiate a conversation between nature and soul. She came to believe this was not because the landscape was a source of emotion, radiating beauty to any passive passer-by. The sea, rocks, cliffs and valleys themselves did not contain 'the essence of

vision', as she wrote in 'The Pleasures of Sight', but were 'agents of a greater reality, of the bridge which sight throws from our innermost heart to the furthest extension of that which surrounds us'. It became her belief that it was an artist's job to find an equivalent for those experiences. To this day, she sets out to recreate that sense of seeing something as if for the first time, to inspire the thrill of revelation that sight can give.

With the end of the war, Riley's father returned home and the family's time in the Cornish cottage came to an end. Bridget was sent to boarding school where, sorely behind in her education, she began to find refuge in drawing. At Cheltenham Ladies' College she was at such a different stage to her classmates that she was allowed to devise her own timetable; she chose to do art every single day. School was followed by a long apprenticeship in the life-drawing rooms at Goldsmiths College. She learned how develop a drawing piece by piece, working steadily and persistently. She was taught to observe the model through an awareness of her own body, to think about how it might feel to adopt that pose: which muscles are tensing, which are relaxed? Where would they feel their weight, how are they keeping their balance? For two and a half years she drew from morning until evening, punctuated only by the models' needs for regular breaks. It instilled within her a sense of the importance of having a disciplined working day, and to have patience. She learned to not expect sudden breakthroughs but to consolidate her advances as she went along, thus gradually raising the quality of her work. If in Cornwall she learned about seeing, it was at art school that she learned how to look.

Over the 1950s she immersed herself in the art of the past, becoming especially interested in late nineteenth and early twentieth-century French painting. A copy she made of Georges Seurat's *Bridge at Courbevoie* in 1959, she claimed, was better than any teaching she had at the Royal College of Art, where she proceeded after Goldsmiths. It was 'a true masterclass . . . the best tutorial I ever had,' she said.

The copy she made has, apparently, hung in her studio ever since. Unlike earlier Impressionists, who painted *en plein air* to capture the fleeting effects of light, Seurat's approach to understanding what he was seeing was more methodical, involving small dots of colour juxtaposed in such a way that they interact in the mind of the viewer to form a shimmering sensation of light, heat and atmosphere. By analysing his technique and applying it to a small series of her own landscapes, Riley began to learn about colour, form and tone, as well as the benefits of having a strict method with which to explore something so nebulous as perception.

Her early 1960s monochrome pictures may seem to be a world away from Seurat's dotted, colourful landscapes, but to Riley they were a natural next step to understanding painting from the inside out. Like Seurat, she wanted to unpick an ancient and well-worn fabric. Could she use old threads to weave a new cloth, something with equal integrity and strength, familiar but never seen before? She did this by taking basic shapes – circles, squares, curves, triangles – and systematically put them 'through their paces', testing to see how they behaved in different combinations, patterns and rhythms. Only once she was sure she had expended all possibilities of black, white and grey did she begin experimenting with colour in 1967. Starting with the fundamental grammar of visual language was a way of detaching identifiable forms from any symbolic association, while not rendering them dull or inert. For if you look at any of Riley's paintings, you see that it is made up of recognisable shapes, and you can also often determine the logic behind the pattern. Yet what you can never predict is how the overall effect of shape and pattern will make the painting behave in front of your eyes, how it might make two-dimensional structures shiver, shimmer and ripple, or how sudden flashes of colour are conjured from black and white alone.

~

I was reminded of this in 2019, when I went to see a retrospective of Bridget Riley's work at London's Hayward Gallery. She was eighty-eight then, and clearly still absorbed by the same set of problems she set herself over fifty years ago. Each room mixed old work with the new in testament to the fact that her work engages and re-engages continually with the past, despite its insistence on affecting you in the present moment. Though I have seen her pictures many times before, I had forgotten how powerfully they put your eyes to work, heightening your awareness of the minute calibrations and adjustments involved in seeing. I was not drawn to them, so much as ensnared. Stop even briefly, and they capture you and make you watch a performance.

Crest was there, in the second room, in the company of other black-and-white paintings made in the mid 1960s. As in a scientific experiment, aspects of each had been controlled so that other parts could change. The size and orientation of the canvases varied, as did the angle and orientation of the curves, but the quality and tone of the paint was exactly the same. The widths of the lines were similar. Each curve went through a pattern of 'repose, disturbance and repose', as Riley put it once. In spite of its methodical nature, the experiment had unexpected results. *Crest*, for instance, is a square canvas tipped at forty-five degrees to make a diamond shape. It is numerous thin black acrylic lines hand-painted against a bright white background. It is curves placed at distances of less than half a centimetre, falling at first from the top of the canvas in a gentle wave, intensifying at the centre where the canvas is widest, switching direction once, then again, and relaxing before reaching the bottom of the canvas. All elements act in unison.

But this does not convey what the work *does*: the way it appeared to me to be softly three-dimensional, and moving, as though it were a silk cloth under which air was being blown. On the parts of the canvas I was not looking at directly, I glimpsed elusive pastel colours, like those seen on the surface of an oil slick. I found it impossible to follow the path of a single line. It left strong afterimage on the

surrounding white walls. Any photographs I took were not able to capture its flowing movements or illusion of depth.

Given Riley's methodological approach, so clearly visible when her work is viewed *en masse*, and the optic tricks that come into play when the paintings are seen in the flesh, it is easy to assume that Riley's work is not like the other artworks discussed so far in this book. All have been, in their various ways, attempts to translate memories of a particular place and time into a more permanent form, whereas Riley has never attempted to make a fixed image of a fixed place. *Crest* may resemble a cresting wave viewed from above, but verisimilitude was never her intention – even in her colour paintings, which glow with heat and light and have suggestive titles, like *Ra* – in homage to a trip to Egypt. Yet a quotation from 'The Pleasures of Sight' was emblazoned across one of the gallery walls: 'I wanted to bring about some fresh way of seeing again what had already almost certainly been experienced, but which had been either dismissed or buried by the passage of time; that thrill of pleasure which sight itself reveals.' In recreating treasured sensations once felt, her work connects more closely to landscape painters of the past then one might initially suppose.

There are echoes of *Studland Beach* in her lingering memories of childhood days, and of *Winter Sea*'s crisp reordering of the formless sea. Like Lanyon, she rebelled against the idea that a landscape is a passive scene to be looked at and imitated, and she thought about her work in similar terms to the way Nicholson remembered Wallis talking about his paintings: as *events*. Yet in her desire to find an equivalent for the perception of a landscape, she distils her sensations down to a radical extreme. 'I draw from nature, I work with nature, although in completely new terms,' she once said. 'For me nature is not landscape, but the dynamism of visual forces – an event rather than an appearance.'

~

Riley's interest in perception is not only metaphorical. In a conversation with the art critic Mel Gooding in 1988, Riley described how she saw in Monet's late water-lily paintings – the expansive, effervescent, all-encompassing, nearly abstract paintings in which the surface of a pond floods the entire picture plane – a parallel with what 'we actually experience in looking, the drifting and gathering of sight itself'. In Monet's paintings, as in hers, there is no single focal point. This lack of focus in her own work was, she goes on, reflective of the loss of certainty that came with the modern realisation that humanity is not at the heart of everything. Later in the conversation she talks about how her early black-and-white pictures were an attempt to say there 'were no absolutes'. That there were 'stabilities and instabilities', 'certainties and uncertainties'. As such, she is optimistic that other ways of paying attention to things that matter have to be found. 'In losing this focus we find ourselves moving in a new range of experience, open to things that were previously less accessible.' Riley picks up on the layered meanings of perception; that a shift in the way we see is intimately connected to embarking on new paths of thought.

This attitude was not unique; others were also seeking a more nuanced understanding of perception in the 1960s. Marshall McLuhan was among the first thinkers to grapple with the changes new technologies were bringing to society, coining the aphorism 'the medium is the message' in 1964 to describe how ideas were shaped by the means by which they were conveyed. Information was being transferred more quickly and widely than ever before, affecting the ways people communicated and the role that images played in society. Television in particular was enabling more people to see and hear the same thing at the same time, creating the potential to smoothen age-old divisions created by physical distance, class and culture. On both sides of the Atlantic, artists – most famously Andy Warhol – began to think about their responsibilities. What part did they now play in a picture-saturated world? In the face of easily and speedily generated visual messaging, the idea that an artwork somehow had

a unique, mystical aura, or that the artist had any special authority, needed serious reassessment – as did the role of the viewer.

How was this visual bombardment affecting the way humans perceive the world? What agency does a person have over what they make? To post-structuralist thinkers, there was little control to be had. Roland Barthes declared the author dead in 1967. Authority now lay with the reader. Cultural products were inextricable from the context in which they were formed and consumed; nothing could be said to have one single meaning. For post-structuralists, subjective interpretation was the only way forward. But other thinkers aligned more with Riley: what was needed was not more intellectualisation, but an urgent reconnection with the senses. 'Ours is a culture based on excess, on overproduction; the result is a steady loss of sharpness in our sensory experience,' wrote Susan Sontag in *Against Interpretation* (1966), the book of essays that made her a star. 'All the conditions of modern life – its material plenitude, its sheer crowdedness – conjoin to dull our sensory faculties,' she continued. 'The aim of all commentary on art now should be to make works of art – and, by analogy, our own experience – more, rather than less, real to us. The function of criticism should be to show *how it is what it is*, even *that it is what it is*, rather than to show *what it means*.' Like Riley, Sontag was fighting for sensation, for the event, for the here and now.

By the early 1960s, Maurice Merleau-Ponty's notion of consciousness not being separate from the body but part of it – that perception was a physical experience, not an intellectual one – had been developed by others working in the fields of philosophy and psychology. And it was also beginning to percolate into wider social and popular culture, notably via the medium of psychedelic drugs. Perception, as Riley quickly discovered when people told her they wanted to get high in front of her paintings, had become a loaded term. In an interview in the 1990s, she remembered how, 'even the word perception, which had hitherto had such a precise meaning both in the development of painting and in its criticism, suddenly became, thanks to the popularity

of Aldous Huxley's *The Doors of Perception*, linked with the drug culture of the 60s.' Since the 1950s, psychedelics like mescaline and LSD had been explored by radical psychiatrists, writers and artists as a means to voyage into the unconscious, believing such inner journeys had the potential to unlock creativity and provide insights into mental illness. By the early 1960s, acid had found its way onto the streets, spawning a whole hippy counterculture with its own rules of dress, language and behaviour, accompanied by a soundtrack provided by ever-more mainstream bands including the Beatles themselves, with the release of *Sgt. Pepper's Lonely Hearts Club Band* in 1967.

The growing visibility and use of drugs in the sixties thrived on a rumbling unease that was also fuelling a growing interest in eastern religions and alternative spirituality. For many, psychedelics were a way of reengaging with sensual and tactile pleasures, rediscovering a childlike way of looking at the world and rejecting the tough, inhibited post-war years experienced by the previous generation. Albert Hofmann, who in 1938 discovered the psychedelic effects of LSD, claimed that his own world view was formed by an intense visual experience as a child in a forest in Baden that sounds similar to Riley's own childhood epiphany in Cornwall. Though he later became disillusioned with its use as a recreational drug, he always thought LSD could be used for psychiatric and spiritual good. It could, he believed, help counteract the psychological damage created by modern life, with its attendant 'materialism, alienation from nature through industrialisation and increasing urbanisation, lack of satisfaction in professional employment in a mechanised, lifeless working world, ennui and purposelessness in wealthy, saturated society, and lack of a religious, nurturing, and meaningful philosophical foundation of life'. Use hallucinogens properly, he thought, and they could enhance your surroundings and make you see everything as connected. They could make you feel a profound relationship with nature, even inspire a whole new way of seeing.

In her emphasis on nature as 'an event rather than an appearance', Riley's paintings also reflect this quest for a purer, more authentic connection with the world. In 'The Pleasures of Sight' she observed how children are naturally more open to the revelations of sight, for they have seen less and tend to be more curious. She compared the way that adults see the world to looking through a window, 'through which one can certainly see but through which no vision can penetrate'. Getting rid of this extra layer in order to see more truthfully was where, she wrote, an artist's work lay.

Once, when pressed to describe the feeling her own paintings gave her, Riley reached not for cerebral emotions or specific moments in her life but for physical states, suggestive of an active sensory participation in the world: 'Running . . . early morning . . . cold water . . . fresh things . . .' It is telling that the artists Riley has admired have also pursued animate sensations. She looks very closely at the ways Constable and Turner preserved the movement and vitality of clouds and seas. She keeps returning to Seurat and Cézanne for their meticulous dissection of the sensation of seeing something for the first time, unclouded by preconceptions or expectations. She loves Monet, who towards the end of his life began making series of single subjects – haystacks, trees, cathedrals, his garden – observing each one slowly, in different lights, times of day, weather, seasons and moods. All these artists watched and recorded how things interacted with their settings, while at the same time making documents of their own environments, and how it felt to be alive in them.

~

In the 1960s it was becoming clear just how significant an enhanced awareness of your surroundings could be. From the time of the Renaissance, Western imaginations have portioned nature into landscapes: sections of the earth's surface defined by human vision. In traditional understandings, landscapes have a location and are

seen from certain, usually isolated, geographical and cultural view-points. They privilege sight above all other senses; most conceptions of a landscape are places observed from the peripheries. As the numbers of people living in cities rose, and a sense of alienation from nature spread, the predominance of this way of seeing the natural world was gradually starting to change. Nature began to be appreciated as a process, not as a picture, and soon it was not only artists who were questioning the received understanding of nature as a set of scenic landscapes.

As the world's superpowers raced to find a way for humans to exit the earth's atmosphere, a growing chorus of writers and thinkers urged people to turn their attention away from the distant stars, back to what was beneath their feet and in front of their eyes. In the UK, the unprecedented disaster of the Torrey Canyon oil spill off the coast of Cornwall in 1967, which killed tens of thousands of sea birds and affected hundreds of miles of coastline, placed words like 'environment' and 'conservation' into the mouths of the media and politicians for the first time. Unlike the static scenes associated with landscapes, the word 'environment' describes a complex setting in which a living being exists, somewhere capable of affecting the organism that lives there as much as the organism affects it. Slowly, landscapes were turning into environments.

Among the most powerful of the voices advocating this new way of looking at nature was Rachel Carson. An American marine biologist whose book *Silent Spring* (1962) is widely acknowledged to have launched the modern environment movement, Carson was expert at bridging the gulf between scientific fact and more soulful values, winning over ordinary readers and world leaders with her lyrical, learned prose. The establishment in the US of the Environmental Protection Agency in 1970, plus the passage of the Clean Air Act (1963), the Wilderness Act (1964), the National Environmental Policy Act (1969), the Clean Water Act and the Endangered Species Act (both 1972) were prompted by the revelations of *Silent Spring*, which

warned of the huge damage that synthetic insecticides were wreaking on the land less than two decades since DDT had first become available to farmers.

Carson's work, and the far-reaching, quantifiable influence it had on policy as well as attitudes, resonates with Riley's work because it was testament to the power that can be found in slow looking, and in being receptive to the pleasures of sight. As society became more individualistic and materialistic, Carson argued that it was more important than ever to be alert to nature's mysteries; its endless ability to surprise and delight, to be cleverer and more complicated than mankind could ever imagine. Never losing sight of the bigger picture, of the intricate connections between all things, she introduced readers to the relatively new concept of the ecosystem, urging them to see the part they played in maintaining its delicate balance. Her work was a lesson in appreciating the non-human perspective, in empathy and humility.

'Who has known the ocean?' Carson asked in 'Undersea', the 1937 essay that set her on the path to becoming one of the most respected nature writers to have lived. 'Neither you nor I, with our earth-bound senses, know the foam and surge of the tide that beats over the crab hiding under the seaweed of his tide-pool home; or the lilt of the long, slow swells of mid-ocean, where shoals of wandering fish prey and are preyed upon, and the dolphin breaks the waves to breathe the upper atmosphere.' It is characteristically woozy, swooning prose, weaving like a dolphin between depth and surface, granular details and universal truths. The books that followed combined expert knowledge of the sea (she worked at the US Fish and Wildlife Service for nearly two decades) with an unceasing sense of enchantment and respect for her subject. She did not enjoy sailing; nor could she swim. Her love for the sea was not an adrenaline-fuelled passion, but a slow-burning, heart-felt, humble admiration: the shore at low tide, very early in the morning, was her thrill, where 'the world is full of salt smell, and the sound of water, and the softness of fog'.

Like Riley, Carson wanted to encourage a more curious, child-like way of looking at the world. The power behind her writing, her driving ethic, was her sense of wonder. Between the publication of *Edge of the Sea* in 1955 and *Silent Spring* in 1962, the last in a trilogy of sea books, Carson wrote an essay for *Woman's Home Companion* called 'Help Your Child to Wonder'. It was so well received that she planned to expand it into a book to inspire parents to indulge their children's natural curiosity. The urgency of the pesticide crisis pushed the project to the backburner, but shortly before her premature death in 1964 she wrote that she wanted 'very much to do the Wonder book, that would be Heaven to achieve', for she considered in the end, her contributions to scientific fact were 'far less important than my attempts to awaken an emotional response to the world of nature'.

Riley's obsession with the pleasures of sight makes her work profoundly pertinent to her time, but not for the reasons that were initially supposed. For Carson, wonder was not just the engine propelling her personal ambition but something that could be fundamental to saving the planet. 'Mankind has gone very far into an artificial world of his own creation,' she said in a speech given in 1952. 'He has sought to insulate himself, in his cities of steel and concrete, from the realities of earth and water and the growing seed. Intoxicated with a sense of his own power, he seems to be going farther and farther into more experiments for the destruction of himself and his world.' Though not naive enough to think wonder alone might be the magic panacea, she did believe that it offered valuable protection against the dangers of becoming alienated from the natural world. She continued, 'the more clearly we can focus our attention on the wonders and realities of the Universe about us, the less taste we shall have for the destruction of our race. Wonder and humility are wholesome emotions, and they do not exist side by side with a lust for destruction.'

When Riley's work was swept up in the zeitgeist of the 1960s, it was easy to assume it stemmed from the same urban sources of

inspiration as pop art. This could not have been any further from the truth. The contemporary forces pop reflected upon – consumerism, urbanisation, big business, mass production, transience – were all, in fact, threats to the moments of wonder in the natural world that she has always celebrated. It was not the artificial human world that would go on to a sustain a lifetime's work, but the 'realities of earth and water', as Carson put it.

To this day, Riley continues to be absorbed and nourished by the repeated refrains of the coastal landscape. For many decades she has kept a studio in north Cornwall, recently telling a newspaper, 'I've always been moved by everything the sea does, with clouds, reflections and the good temper of the sunlight. It kindles life . . .' Of course she would be moved by everything the sea *does*, for it is in its vitality that a correspondence with her paintings can be found. The interplay of light, surface, depth and pace; the volatility occurring out of structure; the lack of predictability: it is these qualities that infuse her work with endurance and life.

WORLD
WITHIN A WORLD

A SOLO WALK
FROM THE TOP TO THE BOTTOM OF THE ISLAND
DUNCANSBY HEAD TO LANDS END
SCOTLAND - WALES - ENGLAND

A COMPLETE WALKING JOURNEY OF 1022 MILES IN 47 DAYS
AUGUST 31 - OCTOBER 16 - 1973

ON THE GROUND
BENEATH THE SKY

Hamish Fulton, *World Within a World, Duncansby Head to Lands End, Scotland Wales England, 1973*, 1973

7

WORLD WITHIN A WORLD, DUNCANSBY HEAD TO LANDS END, SCOTLAND WALES ENGLAND, 1973

Hamish Fulton

On the last day of August 1973, Hamish Fulton set out to travel by foot from the tip of Britain to its toe. Trusting that accommodation could be found along the way, the artist travelled as lightly as possible: he knew from experience that the extra weight of a tent or sleeping bag would eventually take its toll. He walked alone, plotting the route day by day. As he wound his way down through Scotland into England, dipping into Wales, staying in youth hostels, B&Bs and the occasional barn, summer turned slowly to autumn. Forty-seven days after leaving Duncansby Head, the most northern and eastern extremity of the British mainland, he arrived at its southern and westerly counterpart, Land's End. He had walked from the North Sea to the Atlantic Ocean. With the sea surrounding him on three sides, he could go no further.

Along the way he had made no detours to look at famous cathedrals, country houses or castles. He had taken hardly any photographs. He made no notes for a book; he collected nothing as he trav-

155

elled. Yet by the time he had completed the walk he knew that he had, at the age of twenty-eight, made one of the most significant works of his career. Feeling euphoric at his achievement, it was then that he made the single most important decision of his creative life. From that moment on, he would make art resulting only from the experience of individual walks. If there was no walk, then there would be no work.

~

Fulton has remained true to his word. He has made walks all across the world; some whose paths begin at his front door in Kent and return him home later that night, others that have led to the summits of the highest peaks on the planet. There have been epically long walks, taking him thousands of miles from the border of one country to another, and some that consist of a few barefooted steps. There have been walks made in wildernesses where humans rarely go, and walks made along holloways and pilgrim ways sunk indelibly into the landscape by a continuous traffic of feet. There have been walks taken at night, with no sleep, and walks that have honoured the arrival of the full moon. Some walks are made entirely alone, and some are shared with Sherpas, guides or friends. More recently he has organised group walks with hundreds of participants, setting them off to tread slow paths back and forth on broad sandy beaches, windswept promenades and bustling city centres.

Over the years, people have tried to explain these walks with labels: they are conceptual art, land art, minimalism, performance, photography, sculpture. Fulton has always felt uncomfortable with these categories. He would rather be known, quite simply, as a 'walking artist'.

Artists have always walked. They have walked to stimulate their imaginations, make sketches, take watercolour swatches of the sky, set up easels, place a sculpture, take a photograph, remove stones, wood, leaves and mud to use as materials. Yet few artists have considered

the walk itself to be the work, and it is for this reason that Fulton sees himself apart from most art historical traditions. He does not *use, take* or *place*. He does not stop once he has found a particular view, pocket it and redisplay it elsewhere. He is very careful to not leave a trace on the landscape, and any document made from the walk is a marker only. In a gallery, his work takes the form of vinyl lettering on a wall, thin lines of wooden sticks that trace the silhouette of peaks climbed, or framed photographs accompanied by the briefest and barest of facts. Days, miles and dates; place names, weather, lunar cycles and seasons. In a book, epic journeys are again compressed into bold typography and haiku-like text, occasionally accompanied by a souvenir photograph.

But although Fulton's work consists of a walk at a time, each one a highly subjective experience, they have never been entirely private missions. In the catalogue for his 2002 retrospective at Tate Britain, the largest show of his work to date, an unusual chronology of the artist's life was included at the back. In among the normal biographical and career details you might expect to find, milestones in the journey of the modern environment movement were also plotted. Immediately after the entry for his birth (1946), the creation of the first National Parks in England and Wales (1951) has been noted. There is mention of the publication in 1962 of Marshall McCluhan's *The Gutenberg Galaxy: The Making of Typographic Man*, in which the author first analysed the growing influence of mass media, and of Rachel Carson's *Silent Spring*. The first Nuclear Test-Ban Treaty in 1963 makes an appearance, as do CND and Vietnam war protests of 1968. There are also global environmental disasters, like the supertanker *Amoco Cadiz* running aground in France in 1978 and spilling 16 billion barrels of oil into the sea, the nuclear accident at Three Mile Island in Pennsylvania, and the discovery of a hole in the ozone layer in 1985. There are references to mountaineering landmarks too: the first summiting of Everest in 1953 and the first ascents without supplemental oxygen in 1978.

Fulton's career has developed in step with the modern environment movement, which has gathered pace throughout his lifetime. As with Bridget Riley, his work has also been informed by the broad shift of nature being seen less as a landscape to be looked at and more as an environment to be experienced. What the timeline chronicles above all, alongside the journey of one man's career, is a dawning realisation of the harm humankind is inflicting on the planet, and the gathering attempts to explain, understand and halt the scale of the damage. But how does walking, of all things, fit into all this? Where does the most fundamental of human activities connect with this hugely complex global story? And what role, if any, did the sea play in making Fulton realise that it might?

~

From ancient practices of pilgrimage to modern protest marches, walking has long been a way of going against the flow of mainstream culture. It is associated with those who no longer have a foothold in the world, the refugees, vagrants, tramps and dispossessed, whose numbers rise in times of economic trouble and warfare. It is linked to those who deliberately chose the life of the wanderer rather than to exist within the systems in which they were born. It is the way millions each year have chosen to journey to religious destinations, hoping for spiritual answers along the way. It is favoured by the watchful *flâneur*, who wishes to be an invisible observer in cities that swarm with people. It is chosen simply for pleasure, and by those who need a rural pause within a hasty urban life.

For the writer of the first philosophical treatise on walking, Henry David Thoreau, the chief source of pleasure and significance to be derived from a walk was its ability to heighten our awareness of the natural world. Given as a lecture in 1851 and published posthumously in 1862, 'Walking' outlines Thoreau's belief in walking as an act of opposition to the changes becoming manifest in North America in the

first half of the nineteenth century. Urban society was expanding, as was mass-scale production and industry. Looking about him, Thoreau saw fences being erected and forests being cut down near his home in Massachusetts; looking into the future he saw 'evil days' of profiteering private landowners and exclusive pleasure-grounds, 'when fences shall be multiplied, and man-traps and other engines invented to confine men to the public road, and walking over the surface of God's earth shall be construed to mean trespassing on some gentleman's grounds'. Making an impassioned case 'for Nature, for absolute freedom and wildness', he argued that walking was not only important for the benefits it can bring to spirits and health, but also as part of a crusade against the creeping claims of economic enterprise over nature and its resources. For him, walking was a way of connecting with civilisations of the past, to an idealised time when humankind was less concerned with possessions, production and profit.

A century later, many of the concerns Thoreau voices in 'Walking' had become a reality across much of the western world. As Fulton walked his way down through Scotland, Wales and England in 1973, the UK was in the midst of the severest economic crisis since the Second World War. The nation that had pioneered the industrial revolution was now demonstrating the grim reality of its decline and fallout: runaway inflation, mass unemployment, stagnant living standards, crippling strike action, power cuts and three-day weeks. Within the first four years of the decade, Edward Heath's government was forced to declare a state of emergency five times. All the while, urbanisation continued to spread as Thoreau had feared. In towns and cities across Britain, high-rise tower blocks, leisure centres, concrete ring-roads, motorways and pebble-dashed housing estates sprang up to service the future, while the vestiges of an older world – unattended churches, unloved Georgian squares, dilapidated back-to-back terraces, old-fashioned pubs and redundant marketplaces – were pulled down. In rural areas, the introduction of intensive agricultural methods meant that lethal encroachments

were made upon small farms and precious pockets of wilderness. Meadows, wetlands, hedgerows and woodlands were flattened in favour of vast, productive fields farmed by big machinery.

In reaction, the conservationist movement grew stronger and far more vocal than it had been in previous decades. Coverage of environmental issues in *The Times* increased by 280 per cent between 1965 and 1973, when Fulton would have been in his twenties. The ranks of the RSPCA, RSPB, National Trust and the Council for Preservation of Rural England swelled with new middle-class members, as did those of the newly formed Green Party and charities such as Friends of the Earth. Paying heed to worrying rises in pollution, populations, temperatures and sea-levels globally, scientists predicted imminent ecological disaster. The scientist James Lovelock forecast the start of a new ice age before the decade was out; the 'breakdown of society and irreversible disruption of the life-support systems on this planet' would occur within the lifetime of your children, *The Ecologist* magazine warned in 1972. It is only a slight exaggeration to say that such fears were justified. According to Marion Shoard's *The Theft of the Countryside* (1980), since the end of the war Britain had lost a quarter of its hedgerows, 24 million hedgerow trees, a third of its woodlands, as well as countless ponds, meadows, streams and marshes.

Closely connected to the growth of the green movement was mounting concern about the social impact of economic growth. A number of global developments had begun to nudge neoliberal ideology into political orthodoxy, which championed private enterprise, free trade and competition as the best way to order society. Many became concerned that traditional values, such as family, religion and community, were being sacrificed in favour of progress. A hearty appetite for nostalgia revealed itself in fashion, film, literature and design. Floaty, floral Laura Ashley dresses that would not have looked out of place in a Pre-Raphaelite painting became fashionable, while TV and films depicting country houses or rural life, such as *The Railway Children*

(1970), *Upstairs, Downstairs* (1971–5) and *Akenfield* (1974), about a sleepy Suffolk village adjusting to the impact of the First World War, attracted millions of viewers. In literature, *The Country Diary of an Edwardian Lady*, *Watership Down* and *The Lord of the Rings* were among the bestselling books of the decade. Though first published in the 1950s, Tolkien's classic had sold 8 million copies by 1980, outstripped only by the Bible. With a fantastical struggle to save a pastoral idyll from the evil march of machines, war and industry at its heart, the trilogy reflected some of the preeminent anxieties of the day.

~

When Hamish Fulton enrolled at St Martin's School of Art in the late 1960s, signing up to an experimental 'vocational' sculpture course, artists were already responding to such fears in their work. Conceptual art was in the ascendance, placing paramount importance on the idea behind a work rather than its material form. Concentrating on the process or activity of artmaking instead of a finished piece made it harder for art to become a tradable commodity, which many saw as opposed to the reasons they wanted to make art in the first place. As a student, Fulton became aware that art needn't be limited to notions of beauty or craft but could be about anything. Artists did not have to express themselves through paintbrushes or carving tools, but could model themselves after poets, philosophers, performers and even explorers. Art was the creative business of how humans interpret and engage with life, Fulton came to believe. Although the earlier generation of artists, such as Peter Lanyon, had brought an unprecedented level of physicality to their work, an even more radical idea was in the air: art no longer had to be about the production of an object.

The shift towards conceptualism meant that more art was being created and exhibited independently of studios and galleries, which were criticised not only for advocating a capitalist agenda but also for binding art to urban values and lifestyles. Among the most prominent

pieces to challenge the necessity of these traditional ways of displaying art were those made by land artists, or earth artists, who worked directly in the landscape – often on a monumental scale. For *Spiral Jetty* (1970), Robert Smithson constructed a 1,500-foot promontory composed of rock, earth, salt and algae that still coils elegantly like a fiddlehead into the Great Salt Lake in Utah; in 1979, James Turrell began an ambitious project to sculpt a series of chambers and tunnels into a volcano deep in the Arizona desert, ongoing today. Others gathered materials from the natural world to make sculptures which they photographed in their setting or made into interior installations, such as Fulton's St Martin's contemporary Richard Long. He shaped into artworks finds encountered along the way, such as clods of River Avon mud, slices of purple-tinted slate and sticks collected on woodland walks.

By the time he left St Martin's in 1969, Fulton knew he wanted to make work which would not confine him 'to living in the head, studio or city'. He had already been exploring the potential of walking: as a seventeen-year-old he hiked ten miles to the top of Ivinghoe Beacon to plant a homemade Native American counting stick; as a student he had organised with Long a number of group walks, including one that led from the entrance of their art school in central London out into the countryside. He had always liked being outside, being active, but he did not consider making landscape art until he took a trip to the United States after graduation.

At the age of thirteen Fulton had read the life story of Wooden Leg, a Northern Cheyenne from the Black Hills of Dakota who was named for his ability to walk tirelessly. That early encounter sparked an enduring fascination with Native American and other indigenous cultures, whose wisdom, incidentally, Thoreau had also admired. The summer Fulton finished art school, he travelled to some of the handful of reservations in the belly of the US where Native Americans had been forced to settle after centuries of sustained attack. As well as sacred sites and battlefields, he encountered their histories

and folklore, such as the belief that the earth was a sacred source of energy. To be connected with the land was to be nourished, soothed, cleansed; for its soil fed the living and sheltered the bones of the dead. Lying upon the ground brought wisdom and resolution, sitting upon it gave a sense of kinship and equality with other lives that were supported by it, while walking was a way of communicating with the earth with every step.

Fulton's exposure to Native American culture and the Great Plains of the American Southwest prompted him to seriously consider making landscape art for the first time. However, something about the genre – early glimmerings of Land Art included – bothered him. Imitating nature felt pointless; taking from it felt wrong. He was more interested in what an artwork was *about*, rather than its physical form. Importantly, he was beginning to think more and more about 'the lack of influence of nature in our lives, or the destruction of native cultures by the industrialised nations'. Leaving any trace of his presence on the natural world, let alone making a permanent intervention, was counterintuitive. By then, the environment movement was gaining momentum, especially in America. As understandings of the earth as a delicately balanced, finite resource emerged, many people had become deeply troubled by the neoliberal agenda of perpetual economic growth. Against this background, the Native Americans' harmonious, first-hand relationship with the land resonated profoundly with Fulton. Their thinking became 'part of the reason why the works I now make are about an event – passing through the landscape. It is a real experience for me'. Remodelling landscapes, a form of assertion of man's dominance over nature, was the very opposite of what he wanted to do.

Comb through any interviews or texts involving Fulton and you are far more likely to find respectful references to anthropologists, explorers, mountaineers, environmentalists, religious sects and indigenous communities than to other artists. Even today, it is the people who have a very direct involvement with nature – those who have real experiences of landscapes, rather than admire them from a distance –

who continue to appeal most to him. He has never been interested in esteemed English traditions of landscape painting or literature, knowledge of which seems to him to have less to do with respect for nature, and more to do with displaying a level of education or class. While traces of the Romantic spirit can be found in his suspicion of industrialisation and in his attraction to the natural world, I sense he would feel a greater affinity with a mountaineer setting out to scale a particular summit than with the other artists in this book, let alone the dreaming wanderers that the nineteenth century produced in such abundance.

Fulton's work challenges the notion of the natural world as something that can be understood by passive looking. Seeing nature as 'an event', his active and conscious engagement with the landscape is the most important part of his art. Whereas art has traditionally been a process of transforming a physical experience into an idea, Fulton transforms an idea into a physical experience. Pushing beyond even Lanyon's attempts to marry body and mind, he takes the idea of the walk and makes it real through the action of his body. It was through taking this approach that he was able to ensure his interest in nature did not mean he had to commodify it in a harmful way. A recent artist statement makes this clear: 'An "artwork" may be purchased, but my walks cannot be sold or stolen. A Walked Line Unlike A Drawn Line Can Never Be Erased.'

But in distancing himself both from historical traditions of landscape art and other professions that involve walking, Fulton has created a problem for himself. There are, after all, conventional ways for even climbers or explorers to tell their adventures to others, such as writing, lecturing, photography or film. What is the equivalent for a visual artist who is suspicious of using objects or images to stand in for an event, yet wants to share the experience as art? Fulton realised early on that if he wanted to be a walking artist, he had to adjust the ideas for his walks so that they could be communicated in a simple handful of words, flexible enough to easily shift medium, form and

location. Those words had to be chosen carefully too, in order not
to suggest conquest, ownership or any kind of power imbalance. He
makes walks, he does not take them. He walks *on* a place, not in a
place. If he could achieve precision with the concept, then the walk
could appear in the usual places one might go to encounter art. It
might even inspire people to do the same, or at least allow them to
become conscious of the benefits of walking.

~

When I asked Fulton about why he chose to walk from Duncansby
Head to Land's End, he replied simply: 'To get know to my own coun-
try.' We were speaking by phone barely a fortnight after Britain's exit
from the European Union, and the subject was on his mind. The first
coast-to-coast walk he made was in 1971, he said, across the neck of
England; the narrow stretch between Cumbria and Tynemouth where
he used to play on the beach as a child. The longer 1973 walk was his
next walk between coasts, and it was during this one that he became
interested in how his work might explore the idea of the British Isles.
His use of the name British Isles rather than the United Kingdom – a
consistent preference throughout his work as well as our conversation
– was deliberate, unexpectedly reminding me of Churchill's pointed
use of 'this Island' throughout the war. It became clear that Fulton
is always aware that we live on an archipelago, and that the sea is a
strong force in shaping who we think we are.

Even back then, Fulton said, long before Brexit, he was interested
in the idea of how British identity is moulded by living on a collection
of islands. Landlocked countries have a different sense of themselves,
he believes, having walked through many of them. Separation by sea
matters. The year he made the walk, the United Kingdom had been
accepted into the European Economic Community, the precursor to
the European Union, long after the six founding nations had signed
the Treaty of Rome in 1957. Its delay in joining reflected a sense of

detachment from the continent which, as the 2016 Brexit vote made clear, has never totally disappeared. Though the country chose by a majority to stay in the European Community when it was put to a referendum in 1975, opinion polls continued to record consistent opposition to membership. The UK's status as an island nation is evidently difficult to ignore.

Thanks to its natural geography, it is possible to 'get to know' much of Britain by foot. Fulton proved that any person (albeit a very fit one) could walk its entire length in less than fifty days, unimpeded by manmade or natural boundaries. There were no national borders he could not cross easily by walking; there were no forbidding peaks, glaciers, jungles or deserts that brought his path to a premature halt. Political, cultural, economic and social structures have mirrored this physical unity for thousands of years. Britain is a place where people are bound together not only by a landmass but also – willingly or not – by laws, history, customs, currency, language and nationality. It is, as Fulton says in the final text for this work, 'a world within a world'.

When Fulton thought back to the 1973 walk, his presiding memory was the euphoric mental state he felt on arriving at Land's End – the condition in which he made up his mind to then on only make art about walking. No doubt this was largely caused by the feeling of relief at completing an extraordinary physical feat of walking continuously for forty-seven days. Yet it could have also arisen out of the satisfaction of reconciling the actions of the body, the reality of the outside world, and a narrative arc dreamed up by the mind.

~

In *A Philosophy of Walking*, Frédéric Gros wonders whether the enormous popularity of the pilgrimage to the Santiago de Compostela in northern Spain can be largely attributed to its dramatic geographical position rather than its religious significance. Situated next to the sea at the continent's westernmost point, reaching the cathedral is akin to

arriving at the end of the world. He points out that any journey there, which must inevitably come from the east, mimics the path of the sun: 'Arriving at Santiago really is arriving *at the end*.' This matters, he suggests, because a pilgrimage is premised on the idea that a personal transformation might find an echo in a physical quest. Reaching such an unambiguous endpoint after a long and arduous journey has always seemed to ease along the resolution of less tangible, spiritual goals. So maybe it was not a coincidence that the walk that was to shape Fulton's creative life began and ended by the sea. A walk from the top to the bottom of an island, from one sea to another, between thresholds. It was a simple idea, but by communicating something as large as the boundaries of a nation, it hinted at what walking could achieve.

While it would be misleading to describe Fulton's walk as a pilgrimage because of its lack of religious motivation, it does share the same entwining of geography, narrative and action; its mirroring of thinking with doing. In his walks, as with a pilgrimage, the completion of the journey is as important as the experience of travelling; one does not have any meaning without the other. In Fulton's case, however, the destinations are not significant because of any mystical or spiritual association. Their significance lies instead in the shape they give the walks. In coming up with the idea for a walk and then completing it, he transforms something dreamed up in the imagination into a lived experience. When Fulton arrived at Land's End in 1973 having achieved what he had set out to do, he had turned into concrete reality something that previously existed in his mind. Not only that, but the path his body took had made manifest the idea of Britain as an island, a place where the physical boundary of the sea has also become a powerful ideological border. By travelling from one end of Britain to the other he had connected a physical space with a symbolic place: a geographical landmass with the very human idea of a nation.

The anthropologist Tim Ingold has written about movement being a form of knowledge, grouping walking along with writing, reading and drawing as types of activity he calls 'wayfaring'. All have in common

'breaking a path through terrain and leaving a trace, at once in the imagination and on the ground.' All are means through which we learn to understand the world: passing from place to place, topic to topic, image to image, we grow knowledge along the way. There are indigenous communities that do not imagine their surroundings as areas but as networks of paths, Ingold points out, citing as one example the Australian Aboriginals, for whom the words for 'country' are the same as the words for 'line'. Wayfaring, Ingold argues, is a fundamental way in which humans inhabit the earth. With its emphasis on motion, Fulton's work also embraces that idea that true knowledge of a place comes not just with observation, but with movement, inhabitation and experience.

But what happens when you arrive at the point where you can walk no further? When Fulton reached Land's End that October, the journey was done, the decision that was to shape his future working-life made: the mental and physical exertion could, for a while, stop. Reaching the sea necessitated a pause in his movements, encouraging an awareness of where he was, where he had been and where he could not go. If you agree with the idea that walking is a form of knowledge, then the limits of a walk equate to the limits understanding too. Not only was the 1973 walk a way for Fulton to get to know his country; it was also a way of getting to know how significant its edges are.

The limitations the sea places on pathways, and therefore our ability to fully know it through walking, is part of the coast's continuing allure. The sight of such apparent emptiness provides a temporary liberation from the normal world, which is so thoroughly mapped by our movements. In *The Rings of Saturn*, a meandering narrative of a journey along the East Anglian coastline, W.G. Sebald articulates the way people sometimes go to the sea in order to not think at all. Encountering a string of fishermen on the coast south of Lowestoft, he sees people who have reached their journey's end. 'I do not believe,' he writes, 'that these men sit by the sea all day and all night so as not to miss the time when the whiting pass, the flounder rise or the cod

come into the shallower waters, as they claim. They just want to be in a place where they have the world behind them, and before them nothing but emptiness.' The book was originally published in 1995 in German with the subtitle *Eine englische Wallfahrt* – 'An English Pilgrimage'. The sea has drawn clear boundaries for the waiting fishermen, the wandering writer and the walking artist, all pilgrims in kind.

The poet and essayist Kathleen Jamie, who is often found on the shoreline, also pinpoints this idea in her book *Findings*. On clearing her head by the sea, she writes, 'the reason I'd come to the end of the road to walk along cliffs is because language fails me there. If we work always in words, sometimes we need to recuperate in a place where language doesn't join up, where we're thrown back on a few elementary nouns. Sea. Bird. Sky'. Sea and sky: these are spaces that footsteps cannot join up either.

~

Since 1973, Fulton has continued to make walks that begin and end by the sea. He has never repeated the journey from Duncansby Head to Land's End, but since then he has crossed Britain many times at its girth all the way down, wrapping it in lines with his feet like string around a parcel. He has paced his way across Western Europe in this way too, walking from the mouth of the Douro River in Portugal to the delta of the River Ebro in Catalonia, from Ribadesella on the Atlantic coast of Spain to Málaga on the Mediterranean Sea, from Narbonne-Plage on the Mediterranean Sea to Boulogne-sur-Mer on the English Channel. He once plotted thirty-one of these water-guided walks between 1971 and 2010 on a map where the sea is blue and the continent of Europe has been left blank-white and border free, save for the wiggly red and black lines of his walks with little arrows showing the direction of travel.

Over the decades, the meaning of these coast-to-coast journeys has evolved. When he made the 1973 walk down the length of Britain, questions of national identity were foremost in his mind. Since then,

along with millions of others, he has become more aware of the wider environmental connotations of the water that surrounds us. 'The issue of water has become of global significance,' he wrote in an artist's statement in 2012. 'Sea levels rising, floods and droughts, this is called global warming. The water wars. As a contemporary artist – I believe the causes of global warming are humanity's lack of consideration for the diversity of species on the planet.' Water has become a key indication of global warming, Fulton is saying, alerting us to humanity's collective responsibility for the planet. Look at the map of his European water-walks a different way, and rather than the lines appearing to draw the internal spaces of the continent more firmly together, they can be seen as linking lines between places that are far away. Water does not belong to one country or another, nor does it divide them. It is something shared; it is a connection.

In the years that Fulton has been making walks, humankind has become even more connected, even more able to leave the confines of the land. The borders that have contained humanity's influence over the natural world for millennia have been breached. In an essay for the catalogue for Fulton's 2002 Tate show, the American environmentalist Bill McKibben wrote about how vanishingly rare true wilderness has become. Our species has always altered the world around us, he notes, but there were edges to our disruptions: 'the areas we had touched were small islands in a vastly larger sea'. Within Fulton's lifetime the line between the human species and everything else has started to blur. Not only have developments in transport and technology vastly expanded the places we can travel, but chemicals escaped from industrial and agricultural processes have infiltrated the flesh of animals in places as far flung as the Arctic, plastic has settled at the bottom of the deepest ocean trenches, and damaging levels of carbon dioxide have accumulated in the atmosphere. The sea no longer marks a true limit. We are found everywhere.

In a world where human presence has become impossible to bound, Fulton's light-footed, conscientious approach to making art now

seems more important than ever. Water continues to give his walks form, shape and meaning, but the message of greater consideration for the environment has always been there, written into the act of walking itself. Dating from his teenage interest in Native American culture, he has seen how walking can be both an expression of a closer, more reverential relationship with the natural world and a way to counteract the sense of detachment from other species that has developed over recent centuries. In the same way that Rachel Carson thought that her 'attempts to awaken an emotional response to the world of nature' was her most important contribution to the environment movement, and similarly to how Bridget Riley has spent a lifetime exploring the visual sensation of wonder, Fulton's walks also enact a belief that being more conscious of the natural world is vital. But while Riley sets out to achieve this via optical means, Fulton depends on an act of sustained physical exertion that can never be fully captured in any other form. As he says: No walk, no work. The desired effect, however, is similar. Both encourage a more open, involved way of being in the world. In Fulton's words: 'Walking is not about recreation or nature study. It is about an attempt at being "broken down" mentally and physically – with the desire to "flow" inside a rhythm of walking – to experience a temporary state of euphoria, a blending of my mind with the outside world of nature.'

Fulton recently described 1973 as 'my year of the unknown road ahead'. On that solo walk made over forty-seven days, on the ground beneath the sky, he decided to place his faith in the most ordinary, modest movement a person can make. That would be his contribution to contemporary art. Step by step, he would set out to show how walking ties the mind to the body, and the body to the surface of the earth. He walked, perhaps, in order to remind himself that our small worlds are contained within a far larger one. Looking out to sea from the edge of the land, he would have seen only the horizon. It was the limit of what he could see, but not of where he could go.

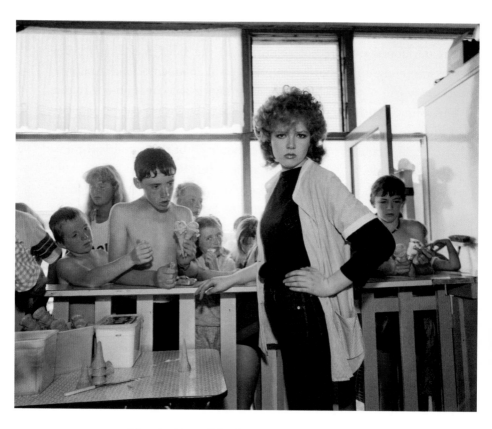

Martin Parr, *The Last Resort*, 1983–86

8

THE LAST RESORT

Martin Parr

On summer weekends in 1983, crowds of northerners flocked to the coast, keen to make the most of the sun. It was hot, unusually so. New Brighton, a large Victorian seaside resort close to Liverpool, became inundated with day-trippers determined to have a good time. Sunbathers laid down their towels wherever room could be found. Parents attempted to shield their babies from the heat. Beauty pageant contestants smiled winningly before judges. The lido was as dense with bodies as the tiered seating around it. The sea cooled hot, tired feet. There were long, hungry queues for ice creams and hotdogs. Bins overflowed with the polystyrene remains of a thousand orders of cod and chips. In the distance, huge ships navigated their way in and out of the mouth of the River Mersey.

Joining the sun-and-sand-seekers that summer was Martin Parr, a tall, affable photographer in his early thirties. Originally from Surrey, he had moved just down the road from New Brighton the previous year, when his wife had got a job in Liverpool. Unlike most of the people thronging the resort at the weekends, he was not drawn there

for the sea, the beach or the pool, nor the beauty pageant, the promenade, the fairground or the food. At least not directly. The things that attracted everyone else to New Brighton were only a backdrop to the main reason for his presence. He had come for the people.

It was on those warm, busy weekends that he began to take pictures for a new project. Using his new German-designed Plaubel camera, he crouched low on the concrete esplanade and took photographs of sea-soaked dogs and their doting owners from an animal-eye-view. He went to the car park and shot a couple reclining on the yellow bonnet of their car, the woman leaning back on the windscreen, the man resting his weight on a huge silver boombox. He got behind the counter of the ice-cream parlour and caught the lip-glossed pout of the teenage server as she doled out arsenic green cones to wet-haired kids in swimsuits. He stood behind the permed hairdos of the women judging the junior beauty pageant at the lido and shot the little girls in frilled dresses tossing their hair as they waited for a verdict. He went along to the women's beauty contest and framed the brown-limbed contestants in pristine pastel swimsuits and stilettos against the creased brown-trousered crotch of the official photographer, hands in pockets, camera around his neck, waiting in the wings. Parr was drawn to families, children and babies, and people absorbed by whatever they were doing, the more mundane the better. He chatted to his subjects, but in the photographs, they rarely seem to notice he is there.

Parr returned the following two summers to shoot, when the weather was grim, and perms were protected by clear plastic head scarfs and babies were bundled up in bonnets and snowsuits. On colder days he shot people taking shelter in the arcades, fairground rides or cafes. He noticed women persevering through the rain by balancing deckchairs on their knees, contentedly continuing their conversations under its stripey makeshift canopy. By 1985, he decided he had enough material and edited the photographs down to exhibit the following year. He called the series *The Last Resort*.

The photographs were first shown at the Open Eye gallery in Liverpool along with the work of Tom Wood, who had also photographed the resort. After that, they went on display at the Serpentine Gallery in London. It was a milestone moment in a budding career. Photography was only just starting to be accepted by the art and museum mainstream in the UK, and since graduating from Manchester Polytechnic in 1973, Parr had shown his work mainly in small photography galleries across Britain and Ireland, where he had lived for two years. Located in the centre of Hyde Park, the Serpentine was an internationally respected, fashionable contemporary art venue with the potential to bring his work to much wider attention.

But when the forty-nine photographs went on view in July 1986, the noisy, busy, litter-strewn world they portrayed met with a decidedly mixed reception. Many people took objection to what they saw as a condescending case of middle-class voyeurism. In *Arts Review* David Lee wrote that 'Our historic working class, normally dealt with generously by documentary photographers, becomes a sitting duck for a more sophisticated audience. They appear fat, simple, style-less, tediously conformist and unable to assert any individual identity'. Writing in *The British Journal of Photography*, Robert Morris described the series as 'a clammy, claustrophobic nightmare world where people lie knee-deep in chip papers, swim in polluted black pools, and stare at a bleak horizon of urban dereliction'. Such opinions of the work persist. In Travis Elborough's book *England on Sea* (2010), *The Last Resort* is described as 'an almost Bosch-ian portrait of degradation'. And when the series was shown in 2018 in New Brighton, the curator told *The British Journal of Photography* that it was still a cause of grievance within the community. For a long time, it was considered bad taste to even mention its name, with its satirical pun on desperation and hopeless nostalgia. 'You do have people who say he defeated our town and for the last 20

years we have never bounced back,' she said. 'Everything is blamed on Martin, fairly or not.'

When asked in interviews about the controversy surrounding *The Last Resort*, Parr often points out that the initial reaction in Liverpool was very different. Neither at the Open Eye show, nor when the work toured libraries and community centres in Merseyside, did it provoke much of a response. Parr says simply: 'No one batted an eyelid because everyone knew what New Brighton was like.'

When compiling the monograph that would accompany the Serpentine show, Parr commissioned a journalist and not a photography critic to contribute a text. Written at the end of the 1985 summer season, Ian Graham's observations of New Brighton are unambiguously bleak. The promenade is deserted, guesthouses and shops are boarded up. Banks of empty canvas deckchairs flap in the wind. Business owners reveal deep-seated feelings of disillusion and neglect. 'You could drop dead on this promenade and it'd take three weeks before anyone found you,' the owner of a seafront snack bar tells Graham; 'I've seen more life in a crypt,' a bingo-caller jokes to his sparse audience in The Golden Sovereign amusement arcade. With an eye on the grey and windy skies, the woman running an ice-cream parlour is convinced even the weather had been better in days gone past. The locals' grievances circle back to the suspension of a ferry service that used to make regular four-mile journeys between the resort and Liverpool centre (it stopped in 1971), and rumours that a Disneyland-style theme park was in the works (this never happened). A quiet and sorry story of a resort clinging to its past, it makes the New Brighton seen through Parr's lens seem like Saint Tropez in comparison.

Graham could, of course, also be accused of providing an unfair portrayal of New Brighton: perhaps to explain why his description contrasts with the overcrowded place Parr captured on ensuing pages, a footnote acknowledges that the weather was especially depressing that season. Yet whatever the bias, and whatever the weather, there

can be no doubt that by the 1980s, New Brighton, like many other seaside resorts across Britain, was well and truly past its prime.

~

One hundred and fifty years earlier, New Brighton had existed only in the mind's eye of a wealthy Liverpudlian merchant. Where others had seen only a large, empty, sandy beach, backed by heath, gorse and dunes and occasionally visited by fishermen, he saw the potential to create a holiday resort to rival the south's Brighton, whose popularity among fashionable elites had recently been sealed by the patronage of the Prince Regent. Sited on the north-eastern tip of the sparsely populated Wirral peninsula, the beach was approached by a network of hedgerow-lined lanes linking scattered hamlets that had changed little over the recent centuries. In nearby Liverpool, however, it was a very different story. During the eighteenth century the city had become an important trading port for tobacco, sugar, slaves and cotton from the colonies; by the early nineteenth century it was too overcrowded and industrial for the liking of its more prosperous residents. A gorgeous coastline offering fine new villas, churches, reading rooms, billiards and bath houses, restoration for mind and body, was a clever prospect. Once a regular paddle steamer service had been established to make short trips from the heart of Liverpool to the Wirral's edge, 'New' Brighton was soon being dubbed the 'Elysium of English Watering Places'.

Over the nineteenth century, the character of the resort began to change. Real income wages per head quadrupled over the century, allowing many more people from the working class to build up savings and take days off to go on holiday. Industrial work was done according to an organised schedule, so leisure time became more routine too; legions of day-trippers from Liverpool, Birkenhead and Lancashire cotton towns came to the resort on summer weekends and bank holidays, which were passed into law in 1871. The resort

acquired an impressive pier and promenade, and in 1900 became the site of the New Brighton Tower, at the time the tallest building in Britain. A strip of thriving cafes and teahouses became known as Ham and Egg Parade; a funfair, donkey rides and Punch and Judy entertained children on the beach, while a skating rink, ballroom, concert hall, landscaped gardens and aviary catered for the adults. After the First World War, the tower fell into disrepair and was removed, but the popularity of New Brighton did not fade. A colossal Art Deco swimming pool was built in 1934, which could fit 2,000 bathers and 10,000 spectators. Well into the 1950s, visitors could choose from over 150 places to stay.

In the 1960s, however, the tides quite literally turned against New Brighton. The golden sand that had lured holidaymakers for more than a century began to disappear because of tidal changes in the River Mersey, leaving an uninviting ledge of rock and stone. The theatre and ballroom complex, where once Sibelius had conducted and the Beatles had played, was destroyed by fire in 1969 and dismantled shortly afterwards. The Liverpool ferry service closed a few years later, and the pier was condemned and dynamited in 1978. A damning survey carried out in 1972 reported that although two thirds of Merseyside families had made a recent day trip to the resort, more than half would not visit again, and the majority would reject it as a holiday destination. It was given approval ratings of between 0–15 per cent for beach quality, accommodation, scenery and cleanliness, scoring highly only on accessibility and cheapness. The survey concluded, 'In the researchers experience it is rare to find . . . so black and unrelieved an image.'

New Brighton was not alone among resorts to be 'faded out', as a lady born and raised in Wallasey put it delicately to Ian Graham in the preface to *The Last Resort* monograph. All over Britain, seaside towns were facing similar issues. In 1982 the American travel writer Paul Theroux travelled clockwise around the coast of Britain for his book *The Kingdom by the Sea* and continually found himself in

impoverished seaside resorts with boarded-up guesthouses, nostalgic residents and rows of vacant deckchairs. 'The pier had been condemned,' he writes in a wry attempt to summarise 'typical' coastal town. 'It was threatened with demolition. A society had been formed to save it, but it would be blown up next year just the same. There was now a car park where the Romans had landed. The discotheque was called "Spangles". The museum was shut that day, the swimming pool was closed for repairs, the Baptist church was open, there were nine motor coaches parked in front of the broken boulders and ruined walls called the Castle. At the café near the entrance to the Castle a fourteen-year-old girl served tea in cracked mugs and cellophane-wrapped cookies, stale fruitcake and cold pork pies . . .'

It is in New Brighton, halfway into his trip, that Theroux decides that people mainly come to the sea as a way of symbolically leaving the country. Casting his eye yet again over chilly Brits 'lying stiffly on the beach like dead insects', he concludes that the chief attraction of the coast lay in escapism: 'It was the poor person's way of going abroad.' Staring longingly out to sea was a fantasy of leaving life in Britain far behind. He may have been right. The cost of overseas package tours plummeted in the 1980s, meaning that many more working-class people took their main holiday abroad and visited local coastal resorts for daytrips only. Built to accommodate big seasonal crowds who would stay overnight, many resorts were left with a painfully obvious surplus in accommodation and entertainment. In 1949, some 15,000 people came to see the debut of the Miss New Brighton beauty competition, too many to fill even the seats of the gargantuan lido. In 1985, the journalist Ian Graham is one of only sixty spectators attending the heats. Cheap package holidays, poor weather and a disappearing beach had caused the crowds to have visibly, and perhaps permanently, moved on.

~

But it was not changing holiday habits that were responsible for the outraged response to Parr's pictures of New Brighton. More controversial disruptions lay behind the decline of the resort too. Ever since they first became a phenomenon in the nineteenth century, seaside resorts have reflected the fortunes of the urban areas from which they offered escape. The determination of Margaret Thatcher's government to restructure the economy from 1979 resulted in public spending cuts and soaring unemployment in the early 1980s. During the years *The Last Resort* was shot, more than 3 million people were unemployed – the highest it has ever been – and in the north of England the problem was particularly acute. Manufacturing, shipping and heavy industries that had swelled the populations of towns surrounding New Brighton in its heyday had been in decline for years; by the mid 1980s jobs in those industries had virtually disappeared. In Liverpool, unemployment was at 25 per cent and close to 90 per cent among the youth.

Parr was certainly conscious of this backstory when he decided to shoot New Brighton, even motivated by it. '[*The Last Resort*] was a political body of work,' he told Quentin Barjac in 2010. 'During Thatcherism she was saying what a great country we were again. That was all the most shocking while living in Liverpool – one of the shabbiest and poorest cities in the UK – at that time. Yet in that shabby backdrop, people would have domestic activities, go to the seaside, play with the kids, eat ice cream, do all the things we do at the seaside. It was this contrast that I wanted to highlight in this project.' While some areas of Britain were plunging into intractable economic recession, other parts of the country were visibly benefitting from Thatcher's neoliberal, market-led policies. Many people, especially in the south, were living more affluently than ever before. Money was beginning to matter more than class; material ambition was encouraged by easy credit and increasingly accessible mass-produced luxuries.

Parr made a number of visual decisions that would help underscore these paradoxes. To reflect the abrasively bright, colourful idiom of

the ever-more-powerful advertising industry, he chose to shoot in colour rather than black and white, as was traditional for fine art and documentary photography. He used a medium-format camera that could capture fine details, and an intense daylight flash in combination with amateur film to give a high colour saturation. But he also chose not to choreograph his pictures as closely as he had done in other projects; instead, he framed his shots off-kilter, foregrounding a lamppost or litter bin, catching people when they blinked or had their mouth full or were quietly zoned out. He relished the shots that would probably not make it into an album of holiday snaps. 'Anti-postcard pictures', he has called them. Combining high-gloss glamour with colloquial banality, Parr was representing reality in the language of fantasy.

Imagining these pictures hanging on the walls of the Serpentine Gallery in 1986, I can see why *The Last Resort* caused such a commotion. Regardless of Parr's intentions, the fact remained that there, in the wealthiest postcode of the most affluent city in Britain, was one of the most run-down areas in the whole country. There for the idle weekend entertainment of gallery-goers was a way of life and leisure fast becoming obsolete. There, even, for the delectation of a thriving urban elite, were the people being sacrificed at the altar of Thatcherism. Forget the flag-waving pride that had followed the recent victory in the Falklands. Here, in these unposed and frank photographs, was the real truth about contemporary Great Britain.

~

But not all viewers saw the pictures as an indictment of Thatcherism. Some saw the opposite, especially if they knew a little about the photographer's biography. For whatever his sympathies, Parr was ultimately an outsider to New Brighton and the working-class community that holidayed there. Born and raised in suburban Surrey, he has joked about his 'perfect middle-class pedigree'. Seaside resorts

were not a part of his childhood. Family holidays for him revolved instead around his parents' passion for ornithology; his weekends were spent accompanying his civil-servant father to catch and ring birds so that their migratory movements could be tracked. He was attracted to the north: his grandfather – a keen amateur photographer – was from Yorkshire and they would explore it together. He chose to go to Manchester for university and to live in West Yorkshire for a period after he graduated. But by not being local to Merseyside, nor working class, he was accused of misrepresenting, stereotyping and othering what he saw.

If Parr was trying to make a political point about the damage government policies were doing in the north, then his background did not help. The fact that the pictures were rarely flattering was seen by some as a deliberate attempt to exaggerate the poverty of his subjects and their plight. Not only that, but any commercial success that came from these pictures looked suspiciously like Thatcherism in action. Rather than offering a critique of the political situation, some critics saw the series as yet another example of an oppressed community being exploited for profit by an upwardly mobile southern professional.

In an interview given to the *British Journal of Photography* on the eve of the Serpentine exhibition opening, Parr shows that he was conscious of this uncomfortable paradox. Whereas in later discussions of *The Last Resort* he tends to defend the pictures by saying he was shooting the reality, in this article he says that they were 'less about New Brighton than my feelings towards New Brighton'. His celebration of people's spirit and energy despite the shabbiness of their surroundings reflected his distress at the broader changes seen in the country at that time. But he acknowledges that the clarity of that message is undermined by him being yet another middle-class man shooting the working classes – of which he was aware there was a long, one-sided tradition. (Many photographers of his generation had become fascinated by the documentary photography projects

commissioned by Mass Observation in the 1930s, which formed part of the same wave of interest in the working classes that saw Alfred Wallis embraced as an 'unprofessional' painter towards the end of his life.) He resolves that a more penetrating project would be instead to turn his lens on his own tribe, a section of society that had hardly been examined by documentary photographers but was as much a product of Thatcherism as the millions of unemployed in the north of England.

True to his word, in the *Cost of Living* (1986–9) he immersed himself in the world of the 'comfortable classes' in the south – where he moved in 1986. Setting out with an aim to 'explore my own prejudices', he began by making a list of popular haunts of which he did and didn't approve, such as dinner parties, aerobics classes, Ikea, National Trust properties, health food shops, Sainsbury's, gymkhanas, prep-school rugby games, where he wheedled out the eccentricities and pretentions inherent to upper middle-class behaviour. Tellingly, the results produced what is often seen as one of the most critical and acerbic projects of his entire career.

~

But let's leave aside the controversy for a moment and go back to the images themselves. What do you really see? Rarely do photographs tell us simply about the subject and the photographer. They reflect something about the viewer too. If I examine my personal reaction to looking at *The Last Resort* today, I find my own concerns reflected back at me. I mentally sift the litter for recycling and wince at the junk lapping at children's feet as they paddle, suspecting it is all still in the ocean today. I was born not long after these pictures were taken and the fashions and the food are particularly evocative: I am reminded of a royal blue swimsuit with a big pink bow I loved as a child in the late 1980s, and of my aunt's blond-tipped highlights and my grandmother's cork-soled sandals and pastel-striped jersey dresses. The huddle over hot chips on a cold day. A sweet lolly after a salty swim.

Where is the sorry evidence of decay? There are only glimpses of tatty buildings, boarded-up shops and defunct entertainment. It is true that there is a lot of litter and awkward lounging on concrete, but these things are as much a sign of bank-holiday crowds as they are of 'degradation', as one writer had it, or a 'post-industrial hell hole', as another described. In fact, most people seem to be having a good time. The lido is packed with sunbathers and swimmers, there are cuddling couples and indulged children smeared with ice cream. Families are dipping their babies' toes in the sea for the first time and bundling their kids onto fairground rides. There are faces focused with relish at reaching the front of the queue for hot dogs, there is relief in finding somewhere to sit to eat chips before they grow cold. There's eccentricity and humour too, certainly, but not necessarily at the expense of the subjects. The woman who has chosen to sunbathe beside the caterpillar tires of an industrial digger is surely making the best of her situation, as are the resourceful old ladies having a chat under their deckchair canopies in the rain. Humour is subjective, of course, but to me the pictures read more deadpan than sardonic.

Now the heated political atmosphere surrounding *The Last Resort* has cooled, it has become easier to see what else might have caused the inflamed reaction. For Val Williams, the author of a 2002 monograph on Parr, the criticism was 'primarily a class response'. In the 2009 edition of *The Last Resort*, Gerry Badger agreed, explaining how the reaction exposed the 'parochial' nature of Britain at that time. Personal understandings of what constitutes an enjoyable experience had coloured readings of the photographs: for some the thought of spending a hot bank holiday in New Brighton sounded like normal good fun, while others could think of nothing worse. Moreover, those opinions seemed to be divided down class lines.

John Urry's sociological concept of the 'tourist gaze' is helpful in understanding why that have might been. Drawing on John Berger's landmark *Ways of Seeing*, Urry argues that the way a tourist sees is

organised and systematised according to a complex filter of personal and learned experiences: 'There is no single tourist gaze as such. It varies by society, by social group and by historical period.' One of the earliest gazes he identifies is the romantic tourist gaze, which originated in the late eighteenth century as people travelled in pursuit of picturesque and sublime sights – inspired by those which proliferated in picture galleries during this period. There was a spiritual dimension to this gaze, cultivated by the exalted imagery popularised by Romantic painters and poets, which suggested that to achieve true communion with nature it was best to be alone or with a loved one. The tourists who pursued these sorts of sights and experiences lay behind the establishment of Britain's earliest resorts, including New Brighton itself, and – eventually – artist colonies such as the one that Vanessa Bell saw establishing itself in St Ives as a girl.

This kind of solitary, Romantic adulation of the sea was clearly not what Parr photographed in New Brighton of the 1980s – yet nor was it the working sea of the kind Alfred Wallis and Stanley Spencer bore witness to. As the nineteenth century progressed and holidays became common among a greater variety of the population, new types of tourist gazes had come into being. The most significant one Urry identifies as the 'collective' gaze, which became fundamental to New Brighton. As seaside resorts across the country grew progressively popular and accessible, and more concerned with pleasure than with health, crowds and conviviality became fundamental to their allure. In contrast to the desires of the romantic tourist, the collective tourist valued the presence of others, so sharing an experience of the coastal resort with as many people as possible only heightened the pleasure to be had. Turning his back on the sea and the landscape and immersing himself in bank-holiday crowds instead, Parr was consciously ignoring the trope of the romantic tourist gaze in favour of capturing the collective gaze in action. Yet as the reaction to his photographs revealed, these gazes are not seen as equal; they are saturated with social meaning.

What people choose to do with their leisure time is an indication of their status within society, and not just because it exposes differences in wealth – such as whether or not you can afford to go abroad. In 1984, the French sociologist Pierre Bourdieu developed the idea of 'cultural capital' to understand how symbols of taste are used to display social class. He noted, for example, the tendency of those who identified as intellectuals to distinguish themselves by displaying what he called 'ostentatious poverty', favouring an aesthetic that included white walls and bare floorboards, wholesome, unadorned food, utilitarian-style clothes and 'natural, wild nature'. In other words, the antithesis of what the typical 1980s seaside resort, with its organised forms of leisure, built-up coastline, cheap cafes, junk food and kitsch entertainment would have offered. When looking for a holiday, intellectuals would more likely consult books such as *The Independent Guide to Real Holidays Abroad* (1989), whose authors were baffled by the appeal of package holidays and promised to help the 'discriminating, independent' traveller – not tourist – find places where other holidaymakers would not be.

Partly because of its literary and artistic heritage, the romantic gaze has come to imply a certain level of education and therefore, crucially, social distinction. Hence those who identify as intellectuals tend to exhibit the romantic tourist gaze. (And partly why Hamish Fulton – whose work is based on physicality, not intellectuality – has always seen himself as separate to the Romantic tradition). But cultural capital does not simply have an influence on what you choose to buy or how you behave; as Bourdieu pointed out, it is a mechanism by which 'classes and other social forces seek to establish dominance within a society'. It is about hierarchy and power. Most people in Britain in the 1980s would have been tacitly aware of the inferior cultural capital gained from spending a bank holiday at a seaside resort in the north of England as oppose to, say, renting a remote holiday cottage on the Dorset coast for the summer. They might also have assumed that Parr, a middle-class, educated artist, wielded more cultural capital

than his subjects. That imbalance is why some viewers have leapt to the conclusion that Parr was suggesting that holidaymakers at New Brighton – even though they might look as though they were having a good time – were sadly ignorant of the pleasures of *real* tourism, poor things.

~

Even if those opinions reflect more on the viewers' prejudices than the photographer's, Parr's desire to single out the collective gaze for observation shows that he was not innocent of the social dynamics that shape the way the coast is experienced in Britain. It was his upbringing that allowed him to see it as a subject in the first place. 'My parents were birdwatchers, so I didn't get to go to the glitzy seaside resorts when I was young,' he has said. 'So when I was studying at Manchester Polytechnic I absolutely loved going to Blackpool. I was all over it! Especially in the '70s – it was big and bright and brash. Terrific!' Parr's interest in seaside resorts arose from the fact that, to him, they were novel and unknown, but also because 'big and bright and brash' was the opposite of what was considered tasteful by middle-class standards. Redolent of his birdwatching past, New Brighton offered Parr fresh specimens of British life to add to his slowly growing collection. And enticingly, it carried a trace of the illicit that lingered from childhood.

The pictures carry that frisson of excitement: it is part of the reason why they are compelling and why people cared about them. Whether or not you decide that Parr was being exploitative or voyeuristic when he began shooting New Brighton in the summer of 1983, being an outsider gave *The Last Resort* a distinctive energy. If he had been raised locally, the pictures would have likely been very different. This was a point made by the Liverpudlian photographer Ken Grant, who took tender pictures of New Brighton throughout the 1990s. 'Martin was preoccupied with the untidiness and business

and immediacy of the place, for me, New Brighton has a sense of respite,' he told the *British Journal of Photography* when his work was exhibited alongside *The Last Resort* in 2018. 'I have a lot of very quiet pictures, pictures of people by the coast. I was photographing lots of people my age and older, hanging out and killing time . . . I see it differently because I grew up there.' It's true: containing more sea and far fewer people, Grant's spare and silvery pictures strike a different tone, showing a more subdued, romantic side to the place.

Maintaining a sense of detachment in order to question what people regard as 'ordinary' has remained crucial to Parr's work, even if it entails the risk of appearing judgemental. It is also one of the reasons that the beach continues to be one of his favourite places to shoot, and why it is often where he goes to test out new cameras or techniques. Because of its ubiquity world over, the seaside exposes the patterns and variations in how people choose to interact with their environment. 'You can read a lot about a country by looking at its beaches: across cultures, the beach is that rare public space in which all absurdities and quirky national behaviours can be found,' he wrote in the introduction to his book *Life's a Beach*, a 2012 compilation of what turned into a career-long preoccupation. Though British society has continued to be his main obsession, it is telling that when abroad, it is the beach, with its peculiar blend of the familiar and the strange, that enables Parr to more easily exercise the anthropological eye necessary for his work.

Paul Theroux put it well: 'Nothing is more bewildering to a foreigner than a nation's pleasures,' he concluded as he surveyed Morecambe Bay on a rainy day, 'and I never felt more alien in Britain than when I was watching people enjoying their sort of seaside vacation.'

~

The Last Resort is now no longer as contentious as it once was. Frequently described 'iconic', it is one of Parr's most known and

respected projects to date; the photographs are in museum collections across the world, the book has had several editions. If anything, the controversy surrounding its initial reception has enriched the series by exposing the charged political atmosphere of the time. Today it is seen as a landmark work, emblematic of postmodernism. Fond and unflinching, political and mundane, light-hearted and melancholy; it is a quintessential example of an ambivalent attitude at play. As well as being historically interesting, its use of colour and humour heralded an important shift in both the tone and technique of European photography.

Over time, the sharp blend of comedy and tragedy first seen clearly in *The Last Resort* has become a signature of Parr's work. Although it has perhaps softened in recent years, his singular perspective continues to divide opinion. For some people it is invigorating, penetrating and witty. For others it can feel unnerving, patronising and cynical. It is undeniably powerful, though. After spending a while looking at his pictures, I notice that it starts to infect how I see – I start to frame things in close-ups, spot dissonant behaviours, see clothes as costumes. People start to look like performers in a film of their life; everyone is playing a part they learned long ago, everyone is in on the act. It exaggerates and highlights things that I would not normally have noticed. It is a relief when it fades.

Parr's career took off in a big way after *The Last Resort* was shown at the Serpentine. Off the back of the exhibition, he was invited to show the series at Arles Festival later that year, which won him the support of the more powerful photography establishment in France. Solo shows for his next projects followed across the world, and he came to be known as one of Britain's foremost and versatile photographers. During the 1990s his inclusion in major survey shows such as 'British Photography from the Thatcher Years' at New York's MoMA consolidated his reputation within the art world, while his acceptance into the prestigious Magnum photo agency in 1994 facilitated his rise in the lucrative world of photojournalism.

His success fuelled more accusations of class prejudice, voyeurism and exploitation. One picture editor called Parr a 'gratuitously cruel social critic who has made a large amount of money by sneering at the foibles and pretensions of other people'. His election to Magnum raised strong objections from members who thought his work shunned the agency's humanistic ideals and mocked their belief in photography as a tool of justice. Henri Cartier-Bresson thought Parr's pictures were 'from another planet'; Philip Jones Griffiths said that he was 'the dedicated enemy of everything I believe in.' Even Parr's most ardent admirers acknowledge that there is something uncomfortably exposing about his pictures. 'If I saw Martin striding purposefully towards me with a camera I would be tempted to run,' Grayson Perry wrote in his otherwise glowing introduction to *Only Human*, a monograph that accompanied the show at the National Portrait Gallery in 2019. 'The few times he has taken my photo, I have ended up looking like someone in a Martin Parr photograph. I stare blankly out, my pretensions pinned like a butterfly to a card.'

This is exactly what *The Last Resort* did to Britain in the mid-1980s. It captured something visible but unspoken about society at that time and pinioned it for scrutiny. It wasn't simply a portrait of a seaside resort or a community at leisure, nor was it only a snapshot of a country at a time of political and social upheaval. It was all of those things, as well as a reflection of the viewer. Little wonder it caused hostility, for there were many ways in which it made people feel uncomfortable. Most difficult to confront of all, however, was its exposure of the way in which class could riddle and warp relationships with one another and also with places.

The Last Resort did this partly because of Parr's particular skills as a photographer, but also because of where the series was set. There are few right or wrong ways in which to interact with an environment, but there are behaviours that are considered normal by some people and irregular by others. At the seaside the existence of different realities is especially visible. So too is the way in which

normality and morality can be confused. This is why, to this day, *The Last Resort* performs an unexpectedly important function. If it can reveal how personal, social, cultural and political prejudices inflect how we view the sea, then it might help us notice how they colour all the other parts of our lives too. While they might normally be difficult to see, it does not mean they are not there. And if some are painful to confront, it does not mean they should be ignored.

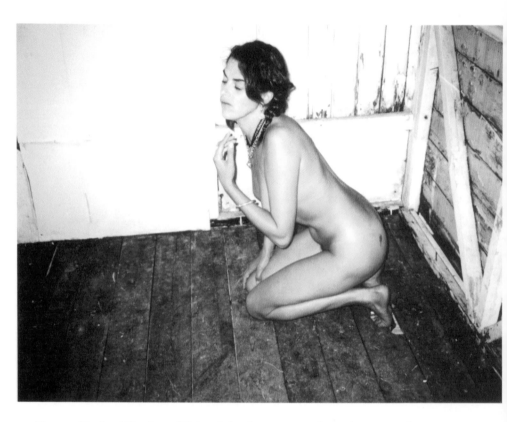

Tracey Emin, *The Last Thing I Said to you is don't leave me here*. 1, 2000

9

THE LAST THING I SAID TO YOU IS DON'T LEAVE ME HERE. 1

Tracey Emin

It was no different to any of the other beach huts that have long lined Whitstable's seashore. A simple, clapboard structure with a pitched roof and a narrow porch that might fit a deckchair or two, short stilts lifted it off the shingle and estuary mud. Once, somebody had painted it a cheery petrol blue and whitewashed its interior. But by the time the two women bought it in 1992, the blue had started to blister and peel, the white was becoming tired and grubby and its bare floorboards splintered. Was it they who decided to nail slabs of chipboard above its doorway to patch over more serious wear and tear? Either way, its new owners did not seem to mind that it was shabby. The hut was all they needed it to be. A shelter from the weather, a store for food, alcohol and foldaway chairs, a weekend retreat from their London lives. It was their very own property by the sea.

Seven years after the women bought it, the beach hut was carefully dismantled by a team of strangers. It was packed up in crates, loaded onto a plane and flown across the Atlantic to New York. In a white-walled gallery in Manhattan, it was reassembled exactly as it

had been on the seashore. It was lit carefully and one of the women arrived to pose on it for photographs. People came to look at it, but no one went inside. A few months later it was returned to Britain, where the same thing happened again. Although it looked scruffier and flimsier than ever before, a man bought it for £75,000. Back in Kent, its smarter neighbours were selling at a fraction of that price.

In 2000, the beach hut was displayed alongside two large, framed photographs. Both showed one of the women inside the hut she once owned. She is naked aside from a few pieces of gold jewellery and a couple of small dark tattoos. In one picture she sits cross-legged in the corner of the hut, on the bare rough floor, facing away from the camera. In the other, she is kneeling in the same place, with one arm raised and her eyes closed, as if mid-gesture. The first photograph was sold later to the Tate. The other was bought by the National Portrait Gallery in 2001, where it now sits alongside pictures of scientists and philosophers, generals and governors, and kings and queens in their palaces.

~

The Whitstable beach hut was not the only ordinary object being oddly displaced, repackaged and resold in the name of art during those years. The 1990s also saw Damien Hirst slice farm animals in half and pickle them in formaldehyde, Rachel Whiteread casting the empty spaces beneath tables and beds in concrete and resin, Sarah Lucas arranging food, furniture and stuffed tights in suggestive ways, and Marc Quinn making a cast of his head using nine pints of his own frozen blood. The heated controversy provoked by Martin Parr's *The Last Resort*, which largely concerned critics and fans of photography, pales in comparison to how the actions of those who would become known as the Young British Artists (YBAs), were received. Attracting applause and furious derision in equal measure, public reaction to their art was rarely indifferent.

In 2004, the beach hut was destroyed in a fire that engulfed an art storage facility in east London. It was there alongside a hundred or so other works owned by Charles Saatchi, the advertising mogul and prolific collector who bought, exhibited and championed the YBAs. Although many collectors, galleries and artists suffered huge losses in the fire, media attention was largely focused on him. For some commentators, the destruction of these works was a cause for celebration: how could anyone possibly mourn the loss of such overpriced, overhyped trash? In the *Sun*, one columnist asked: 'Didn't millions cheer as this "rubbish" went up in flames?' A writer for the *Independent* thought the works were 'perfectly replaceable'; another in *The Times* wondered, 'Why can't Brit Art's finest devote half a weekend to knocking them out all over again?' For others, it was nothing less than a national tragedy: iconic artworks from a crucial moment in British art history had vanished into vapour and ash.

The fact that contemporary art was being discussed in the national news at all was a new phenomenon. That lengthy pieces on the story ran in foreign newspapers like the *New York Times* and *Le Monde* was even more extraordinary. For most of the century the London art scene had been outshone and overshadowed by more glamorous goings-on in France, America and more recently, Germany. Until the mid 1990s there was no catch-all phrase like 'YBA' that would have meant anything to the average broadsheet reader; no private collector who could have generated so many column inches; no celebrity artists who would have made headlines in the tabloids. The hundreds of thousands of pounds that Saatchi paid for some of the artworks seemed wildly excessive for pieces created by artists barely a decade into their careers. Indeed, until the dying years of the twentieth century, hardly anyone would have been willing to recognise these objects as art at all.

The blaze illuminated how far the art world had changed since the hut had first sat beside the sea. What had happened in the ensuing years? How had a weather-beaten shack ended up in fine art storage?

The clue, of course, is the person in the photograph: a woman who embodied YBA tropes so successfully that a cruel rumour circulated that her career had been manufactured as a lucrative joke. Over the years from when she bought the beach hut to when the photograph was taken, her life had altered dramatically. In 1992, she was broke, and feeling so lost she committed what she called 'emotional suicide', tearing apart relationships and destroying all of her paintings in a fit of intense distress. By 2000, she was one of the most well-known artists in the country, appearing everywhere from *GQ* to *Art Forum*, fronting campaigns for Vivienne Westwood and Becks beer, attracting fans who ranged from schoolgirls to Madonna – as well as exhibiting her work across the world.

Even if you have never seen her work before, you have probably heard of Tracey Emin. You may know *My Bed*, one of the most controversial works of art ever to have been nominated for the Turner Prize. You may even find you know odd details about her life, like the fact she once married a rock. Was it her celebrity, then, that magicked the beach hut into a valuable piece of art? An explanation she gave for the work in 2000, delivered with characteristically blunt logic, does not do much to contradict this idea. 'Lots of people say, "this isn't art – it's a beach hut". But they didn't make it, they didn't say it was art. So it's not up to them to decide that. It's up to me. I'm telling you it's art because I say it's art.' But delve a little deeper, and it soon becomes clear that the beach hut was both significant to her personal life and consistent with the iconography of her work. Go further still, and you will see how it was elevated to art by a shifting cultural landscape, which was raising up voices like hers so they could, at last, be heard.

~

Tracey Emin wants to tell us one story above all others: her own. Fragments of autobiography appear everywhere in her work, spelled out in curling neon words, handsewn in floral capital letters

onto blankets, sketched onto paper, narrated over short films, performed in galleries, painted onto canvas. Longer narratives emerge in stream-of-consciousness prose pieces, such as *Exploration of the Soul* (1994) and *Tracey Emin's CV Cunt Vernacular* (1995), a matter-of-fact list of events in her life from her conception in 1962 until the year she made the work. She has made a feature film, *Top Spot*, that lightly fictionalises events that happened to her when she was a teenager. She has framed, exhibited and sold family photographs, letters and memorabilia, including a crumpled cigarette pack retrieved from her uncle's hand after a fatal car crash, a chair once owned by her great-grandmother, a polaroid of the artist and her twin brother. She has lifted scenes wholesale from her immediate surroundings and placed them in the gallery – most notoriously *My Bed* (1998), which consisted of her own messy bed and its detritus after a breakup. Emin's raw material has always been her own life.

The autobiographical trail left by her work has a natural fairy-tale arc, beginning with a tough, impoverished childhood and ending with her extraordinary success as an artist. She spent her childhood and teenage years in Margate, where her father once owned several guest houses. For the first few years of her life, she lived in the Hotel International, overlooking the sea. The seventy-bedroom hotel was a kingdom ruled over by Tracey and her twin brother Paul as children. Their roaming Turkish father split his time between them and another family until his business collapsed, and the twins and their mother were forced to squat in a small staff cottage on the grounds of the hotel. Keeping the family afloat by working in local nightclubs and later as a chambermaid, Emin's mother was often absent, leaving the twins free to lead an uninhibited but vulnerable existence.

In *Exploration of the Soul*, Emin relates how, for a time, she would creep out of her bedroom window in her nightdress to hang out with a group of men she had spotted living in the now abandoned hotel. At the age of ten, she was sexually abused by her mother's partner and a year later by a stranger on the beach. She consumed only

orange squash and digestive biscuits. Her teeth rotted. At thirteen, she was raped on the way home from a nightclub on New Year's Eve. 'Everyone knew he had broken in girls before,' she writes of her attacker. The police weren't called, no fuss was made. Her mother simply washed the dirt off her coat. Emin knew her childhood was over. 'I realised that there was a danger in beauty and innocence – I could not have both.'

She hated school and dropped out soon afterwards. She tried to reclaim her body with sex and dancing, entering a local disco-dancing competition in the hope it would be her ticket out of Margate. *Why I Never Became A Dancer*, a short Super 8 film she made in 1995, describes what happened next. As she performed, 'a gang of blokes, most of whom I'd had sex with at some time or other' began to chant 'SLAG' at her. 'The chant became louder – "SLAG SLAG SLAG" – until in the end I couldn't hear the music any more or the people clapping. My head was spinning and I was crying. I'd lost it. I ran off the dance floor, out of the club, down the steps to the sea.' She resolved to leave Margate, briefly returning to school to get a clutch of qualifications, before going to London with twenty pounds in her pocket and a couple of David Bowie LPs, staying where she could, 'floors, squats, cupboards', picking up work in shops. She returned to her hometown after two years, working briefly at a sex shop until she quit, after posing for some explicit photographs ('For six quid, of course. Why else?', she told a police investigation).

In 2005, Emin published a memoir, *Strangeland*, which recycled and augmented the autobiographical scenes that play out in her work. In the book, Margate quickly emerges as a steady backdrop to the ricocheting drama of her early years. This is no outsider's glimpse of a seaside resort on hot weekends in the summer, as Parr gives in *The Last Resort*, but the view from the inside. Formative events happen on its famous golden mile of sands, in among the waves washing the shore, in neon-lit alleyways leading away from the beach, in its nightclubs, on its harbour wall. As a young teenager, Emin works

in a cafe in Dreamland, the iconic 1920s fairground, wiping up the remains of chips, eggs and beans from three hundred tables. She is adopted for an afternoon by a group of punks, christened 'Baby Punk', and taken on the rollercoasters and the dodgems. She watches the seabirds during her lunchbreak from the sex shop. She sits on the sea-wall and promises herself she will get away.

By the time Emin reaches the end of her teens in the memoir, it is clear Margate means more to her story than background scenery. Like the waves pushing and pulling at its edges, her hometown both erodes her sense of self and forces her to confront it. She swings between elegiac descriptions of its sunsets and open-eyed fury at its faults. If she is ever to achieve anything, she knows she must leave behind this 'derelict seaside town where there was nothing to do but blend in with the general decay: bum around, fuck, be fucked, fight and wish your life away'. Margate pummels her into the person she is to become. And it infuses her with a desire to leave so strong that she is propelled towards a wildly different existence. One of the final scenes set in her hometown sees her at the age of twenty, when she no longer lived there. She took the train back to Margate one morning, clutching half a bottle of whiskey and a note. She sat on the harbour wall in tears, under a blue sky and above a black sea. 'I said, "Goodbye" and threw myself off the harbour wall, fully clothed.' But she floated back up, 'more alive than ever'. She swam back to the harbour and climbed out of the sea. 'And, in my sodden state, I walked away.'

~

Since her childhood, Emin has spent decades of her life living away from Margate. Yet she continues to identify herself with it, returning to memories of her time there again and again in her work. She does not discourage the association with her hometown in the media either. At one stage she referred to herself as 'Mad Tracey from Margate', using it as the title for a TV documentary in which the phrase

was towed by a plane across the sky above Margate Bay. Recently, she proudly claimed that her name was synonymous with the town – and she is not wrong. In her work, especially from the 1990s and early 2000s, there are plentiful visual references to Margate as well as verbal. The idea of working with neon, for example, was sparked by the candy-coloured lights that used to illuminate the whole sea-front in the 1960s and 1970s. She has also made huge sculptures that are symbolic of Margate and its Art Deco funfair: *It's not the way I want to die* (2005) is a gallery-sized model of the Scenic Railway – Dreamland's famous wooden rollercoaster; *Self-portrait* (2000) is an eleven-foot-high helter-skelter made from weather-worn wood that might have washed up on the beach, with a small bronze bird flying off the top.

Emin's autobiographical stories of adolescent desire and desolation are lit up by the faded glory of their seaside setting. Pain is made more vivid against a gaudy backdrop dedicated to leisure and escapism; pleasures are made poignant by the enveloping decrepitude. The town's unique aesthetic, blending determined hedonism with sentiment and fragility, also reflects the identity Emin has projected for herself in the public domain. For instance, while the giant, rickety sculptures of the helter-skelter and the rollercoaster carry more obvious metaphorical meanings about the precarious nature of the artist's life, they also suggest the weakening structures that underpin Margate's iconic seaside image. There are subtler suggestions at play here too, hinting at Emin's origins and sense of identity, her comfort with tenuous places and fleeting moments, where she is tethered more loosely to reality, freer to fly away, released into dreams.

The association of Emin's name with Margate is a reminder of how far she has come, to the extent that it can even be read as a metaphor for her personal evolution. The physical move away from a place positioned geographically and culturally on the fringe strengthens the rags-to-riches arc of Mad Tracey from Margate's journey into the hearts of the metropolitan elite. And while her work is not

about seaside resorts, in the way that Martin Parr's photographs of New Brighton are, the compelling mythology of the British seaside performs vital narrative functions in her work. 'I realise how lucky I am coming from Margate,' she has said. 'It's a most romantic, sexy, fucking weird place to come from.' She is, at one level, talking about the fun of growing up in a tourist's playground, with sea and sunsets at the end of every street and a world of illicit adult pleasures and freedoms at her doorstep. But she is also 'lucky' in the sense that for an artist whose material is her own life, Margate unspools multiple meanings, enriching her creations with colour and depth.

~

As the sodden girl who pulled herself from the sea made a new life for herself elsewhere, Margate too underwent its own process of renewal. For more than a decade now, a high-speed trainline has connected it more tightly to London, bringing more tourists, commuters and day-trippers. Where once more than a third of shops were boarded up, today a 'cultural quarter' has been encouraged, welcoming the kinds of bougie cafes, bars and lifestyle shops that have become the hall-marks of gentrification. Signs of social disadvantage have not disap-peared: Thanet, the Kent district that includes Margate, is still the most deprived local authority in the county, with the highest rate of youth unemployment in the south-east. But as you come out of the train station and make your way along the seafront – past the retro arcades, past the shelter where T.S. Eliot was supposed to have writ-ten part of *The Wasteland* – you can see the futuristic silver form of the Turner Contemporary at the far end of the beach, which has lured over 3.5 million visitors since it opened in 2011.

When Emin was growing up, the idea that a contemporary art museum would account for nearly half of all visits to Margate would have seemed laughable. Even in central London, cutting-edge shows received a pretty muted welcome from the general public. (The Tate's

purchase of a minimalist sculpture by Carl Andre, which consisted of 120 bricks, provoked collective uproar in 1976 when it was revealed to have cost the nation £2,000. They did not attempt to acquire anything so controversial again for several decades.) Yet over the years, complex and far-reaching social and economic changes began to slowly dislodge this cultural conservatism. By 1997, the extent to which attitudes had shifted was revealed by the Royal Academy exhibition *Sensation: Young British Artists from the Saatchi Collection*.

A collector since the 1970s, Charles Saatchi had exhibited his art in a former paint factory in north London from 1985 – one of the first spaces to pioneer the lofty, white-walled industrial aesthetic ubiquitous among galleries today. It was the place to go to see ground-breaking works of minimalism and conceptual artwork fresh out of New York, by artists such as Jeff Koons and Donald Judd. Art students flocked to the openings to fuel their ambitions and broaden their ideas. In 1990, feeling the effects of the global recession, Saatchi began selling off his international collection and focusing instead on talents closer to home. In 1990 he purchased Damien Hirst's work *A Thousand Years*, which involved a rotting cow head, flies and a fly killer, from a show staged by the artist and his friends in a former biscuit factory in Bermondsey. Until a crop of new commercial galleries opened, notably Jay Jopling's *White Cube* in 1993, Saatchi became the patron that Hirst and Emin's generation sorely needed. Not only was he willing to finance outlandish ideas – suspending a dead tiger shark in a glass vitrine filled with formaldehyde – but he also brandished the connections to help it all be taken seriously and the marketing savvy to package it up as the YBAs.

The work shown at *Sensation* was visceral, bypassing nuanced dialogues with art history and angling instead for direct emotional responses such as shock, repulsion, humour and irony. The most comprehensive show of YBA art so far, it generated a media sensation. The private view was packed with famous people; artists were photographed quaffing champagne alongside pop stars. Jarvis Cocker

remembered the night feeling like a whole new type of event, more of a social than artistic occasion. When the show opened to the public, visitors had to make their way past protestors who were revolted by Marcus Harvey's portrait of serial killer Myra Hindley made up of children's handprints. But none of this prevented the show from breaking attendance records at the Royal Academy. *Sensation* had revealed a vigorous popular appetite not only for this new kind of art, but also for a new breed of artist, someone who would make achingly honest work about shagging and abortions and abuse, befriend popstars and pose for the cameras in designer clothes. 1997 was also the year that Tracey Emin started to become a household name.

It was not only the public that began to express a new level of interest in contemporary art. Around this time the government began to see the arts in a new light too. Since the war, and the days of Sir Kenneth Clark, art was seen to have enough of an educational value to merit public funding via the Arts Council. But now, its function was expanding. Soon after coming to power in 1997, New Labour identified the 'creative industries' as an important driver of economic growth and social regeneration. Inspired by international successes such as the Pompidou Centre in Paris and the Guggenheim Museum in Bilbao as well as by shows staged by thrifty London art students in redundant Docklands warehouses, the arts were identified as a way of giving post-industrial areas a new lease of life.

All over England, publicly funded arts-led projects attempted to provide struggling communities with a renewed sense of identity and purpose. These ranged from establishing cultural quarters in cities such as Cardiff, Liverpool and Sheffield, to funding public sculpture – such as Antony Gormley's *Angel of the North*, erected in 1998 on a redundant coal site just outside Gateshead. Fabricated using the expertise of local steel and engineering firms, it was described by the artist as 'expressing our transition from the industrial to the information age'. Another tactic was to create an eye-catching 'flagship' art gallery – such as Turner Contemporary – which might act

as a beacon for local creative enterprise and for tourism. This was epitomised by Tate Modern, which opened in 2000 in a hulking old power station on the more industrial bank of the Thames. Not only did it help regenerate the area around it, but it came to symbolise the changing appetite for contemporary art and the way it was consumed. Encouraging a social and spending experience as much as an edifying one, its strategy has proved phenomenally successful. Today, it is the most popular modern and contemporary art museum in the world, attracting 5 million visitors a year.

While Emin's career was on the ascent, creativity and culture were not only helping instil a new sense of confidence on the domestic front, but were also reviving the country's image on the world stage. Shaking off its fusty association with royalty, empire and tradition, even the Union Jack managed to become cool in the late 1990s. It was seen on tour with Oasis painted onto Noel Gallagher's guitar, striding down the catwalk on a John Galliano jacket worn by Kate Moss, imprinted on the Alexander McQueen frock coat worn by David Bowie on the cover of his 1997 album *Earthling*. Shortly before another Union Jack made headlines as a Spice Girl's minidress at the 1997 Brit Awards, *Vanity Fair* ran a twenty-five-page feature on the 'trailblazing' models, fashion designers, artists and restaurateurs who were making London swing again. Politicians were credited too – for New Labour also tried to ally itself to this 'Cool Britannia' moment, flying the Union Jack over its party conferences and political broadcasts in an attempt to rescue patriotism from the right and hitch it to youthful buzzwords such as social cohesion, entrepreneurship and innovation instead.

Emin's appeal was tangled up in the Cool Britannia fantasy. Along with Damien Hirst, she came to epitomise all that Brit Art stood for in the popular imagination: she was badly behaved, ballsy and working class. She was also becoming very rich from art so confrontational that many openly suspected it to be a con. Clearly self-made, like many creatives newly in the public eye (if they weren't, they pretended so

with mockney accents and blokeish behaviour), she provided a timely illustration of the kind of enterprising spirit New Labour was keen to promote. She also captured the irreverent spirit of Britpop; her love of parties and drinking announced her as the ultimate ladette, her sexual confidence embodied Girl Power, and her confessional work satisfied those who wanted to indulge in class tourism of the kind Pulp sang about in 'Common People'. While her Turkish heritage reflected the changing social fabric of the country, her Margate upbringing played perfectly into this zeitgeisty image. Afterall, what could be more British than the faded glory of a working-class seaside resort? Margate was not just the place Emin came from. It was a marker of how far she had travelled and, as the town began its slow process of regeneration, a sign of where the country wanted to go.

~

Was Emin, then, simply a convenient icon for the time, a plucky celebrity who encapsulated the nation's optimism as it headed into the new millennium? If so, a shabby beach hut – nostalgic, unpretentious, unambiguously British – would make sense as an object to single out for exhibition, especially if it was an artefact transplanted unaltered from Emin's life. For many people, a private life placed on public display was not enough to make good art. In one critic's estimation, *The Last Thing I Said To You Was Don't Leave Me Here (The Hut)* was no more than 'a kind of stage-prop in the endless, dramatised retelling of [Emin's] own life,' he wrote after seeing it exhibited at the Saatchi Gallery in 2000. Emin's work had got too close to her reality, he argued, leaving no space for art to enter. Plenty of others agreed. By then, Emin had studied printmaking at Maidstone College of Art, leaving with a first-class degree, and completed an MA in painting at the Royal College of Art. But her thorough art education and obsession with artists such as Egon Schiele and Edvard Munch were often overlooked. As her fame mounted over the 1990s, Emin's

unremittingly self-centred subject matter attracted extensive criticism for being unmediated, repetitive and solipsistic. And, as the private self she revealed in exhibitions became increasingly corroborated by an ever-visible public persona, her art became judged on those terms too. That is to say, not as art at all but as an ongoing project of self-promotion, as though the confessional nature of her work prevented it from qualifying as 'work' at all, let alone something as complex as art.

To others, this lack of pretension was exactly what appealed to them about Emin. It was not by chance that her appearance on the art scene coincided with the emergence of the internet and reality TV (the first episode of *Big Brother* aired in 2000). Transparency was an increasingly valued quality; authenticity was becoming entertainment: Emin gave people both. She shared her weaknesses very publicly, and people warmed to her vulnerability. Her spelling was bad; she turned up to art fairs spectacularly hungover; she appeared on a TV panel show hopelessly drunk. Her work revealed loneliness and remorse, that she cried in the shower, that she loved her mum. Instead of ruining her credibility, her imperfections made her seem especially truthful. And she talked about art with a refreshing directness. In the press release to her first solo show in 1993 – sardonically titled *My Major Retrospective* – she said, 'art has always been, a lot of the time, a mysterious coded language. And I'm just not a coded person; I wear my heart on my sleeve . . . What you see is what I am.' At a time when contemporary art was increasingly intellectual and ironic, she remained true to this statement. In its revelation of feeling, what she made had more in common with her expressionist hero Edvard Munch than with most of her fellow YBAs. While their work could feel icily detached, hers was all soul.

In the years since she made *The Last Thing I said to you is don't leave me here. 1*, Emin's mining of her own story has begun to look more like a feminist act – or, perhaps more accurately, feminism has begun to look more like Emin's acts. In a 2012 essay, the novelist Rachel Cusk suggested a vision of feminism that serves as an uncannily

appropriate description of what Emin does. A feminist might not be someone who adopts patriarchal values, she writes, but who personalises their experiences to a greater degree than others. She is 'an autobiographer, an artist of the self. She acts as an interface between private and public, just as women always have, except that the feminist does it in reverse. She does not propitiate: she objects. She's a woman turned inside out'.

Today, reading the criticism which Emin received twenty years ago, the extent to which her gender influenced how her work was judged and received is evident. Rather than recognising how Emin's references to herself might pertain to universal experiences, feelings and sensations, all too often it was understood as distasteful over-sharing. Unlike the sympathy shown towards artists such as Paul Nash, who made art shadowed by their war experiences, there was scant acknowledgement either of the action trauma might have had upon her memory, nor of the lengths to which the mind goes in order to repair itself. It is a reminder of how pioneering and unusual Emin was. Given how established she has become, it is easy to forget that voices like hers, telling taboo tales with an estuary accent and a crooked grin, had seldom before been given such a powerful platform in the visual arts. First-person accounts of young, working-class female experiences were simply not found in art galleries before she put hers there. If they were, they certainly received far less attention. From Victorian Cornish fisherman's wives to the teenage girl serving ice cream in *The Last Resort*, before Emin, working-class women were far more likely to have found their way into galleries as the subjects of male artists than as artists themselves.

~

In light of the more troubling revelations of her past, it is perhaps not surprising that the self-portraits Emin created in her beach hut in 2000 have been interpreted as portraits of vulnerability, of a lonely

victim crouched in a corner, cowed by circumstance. In his 2015 book on portraiture, *The Face of Britain*, Simon Schama describes Emin in these pictures as looking 'abandoned', posed 'in attitudes of captive victimization, violation or punishment', while enjoying how her smooth skin and delicate gold necklace contrasts with the distressed surroundings. The National Portrait Gallery describes her nudity as 'provocative and vulnerable', and how her surroundings reinforce the 'claustrophobic atmosphere that surrounds this public artist'. In an interview Emin gave to a student newspaper at the time of the 2000 Saatchi exhibition, it is clear the male journalist has commented on how 'good' she looks in the pictures. She snaps back 'It's not about me looking good' before telling him, in a no-nonsense way, 'The hut is a bare and naked thing. I thought it made perfect sense if I was.' She also points out that it has a 'religious look in it, like I'm praying or something'.

I'm not convinced Emin is posing as a victim here. Even though the scene is lit with a forensic flash, there is nowhere to hide, and she has curled her naked body in on itself, there is something matter of fact about her nudity: like a life-model, there is nothing especially sexual or even exposing about it. She has identified with the hut in a knowing way, and the image conveys that unity. Her decision to strip bare in order to equate herself with her environment seems to have been made out of defiance, not humility, as though she is performing a private ritual. Leave me here, she could be saying, and I will make this neglected space my own. My body and my words will make it desirable. My presence alone will make it valuable. Watch me.

~

Taking stock of Emin's career over time, it is not only the gendered dimension to the criticism she received that becomes clearer to see. The work itself is revealed to be more consciously constructed and curated than I had expected: some areas of her life are not offered

for public consumption. There are tracts of time that go unaccounted for, just as there are stories that are retold repeatedly, events that are picked over mercilessly, and certain feelings that rise inexorably to the surface.

Once you start to look, visions of home and domesticity can be seen everywhere in Emin's work. Using patches of fabric taken from textiles carefully saved over the years, she hand-stitched home into her first quilts, smuggling in sentiment alongside spikey and subversive messages. Home is there in family photographs and memorabilia that she gathered and framed like prized museum exhibits in her earliest shows. Not always cute or romantic, ideas of home are also present in the squalid nest of *My Bed* and the temporary shelter of the tent dome in *Everyone I Have Ever Slept With 1963–1995* – a work that is often misinterpreted as a list of sexual conquests but is actually a more literal document of those who have slept beside her. Home is there in the short films she shot in her London flat and in the streets of Margate, and in those that explored her Turkish heritage, filming with her father in Cyprus where he was born.

The Last Thing I Said To You Was Don't Leave Me Here (The Hut) was the first of several occasions where Emin used a very basic wooden dwelling in her work. At her 2011 retrospective at the Hayward Gallery in London, visitors entering the main room were met with a life-size wooden pier on tall stilts. It looked flimsy and in imminent danger of collapse – it was broken in the middle – yet at the far end was perched a small, scrappily painted, pale green hut. A pair of hand-made curtains could be glimpsed hanging in the window. Titled *Knowing My Enemy,* and dating from 2002, the work was displayed alongside a letter written by Emin's father, describing his difficult childhood and dysfunctional relationship to gambling, alcohol and sex. The juxtaposition could have suggested criticism of her father and the legacy of his behaviour, but at the time Emin described the piece in more positive terms. The letter was an effort to get his daughter to cut down her drinking, and the hut was her

attempt to make a place where they would both be happy. As she told the Hayward's director, this fantasy consisted of 'a little hut on the beach with a corrugated-iron roof, and to hear the sounds of the rain coming down on the roof and the sea lapping up'. Out of unstable elements, she had tried to build their shared dream of home.

Yet unlike *Knowing My Enemy*, which symbolised a fantasy, the Whitstable beach hut she used for *The Last Thing I Said To You Was Don't Leave Me Here (The Hut)* was somewhere Emin had actually experienced happiness. 'It was brilliant,' she has remembered, 'having your own property by the sea.' Whitstable was Margate's more genteel, middle-class neighbour: a sign, perhaps, of Emin beginning to move up in the world, even though she had little money at the time. Emin shared the purchase with the sculptor Sarah Lucas, who she had met earlier in 1992. Although they regularly fell out – Lucas ended up sending the keys back to Emin – the friendship drew Emin more closely into the YBA circle and towards people such as Carl Freedman and Jay Jopling, who became crucial champions of her career. In 1994, the hut inspired the most buoyant entry in the whole of *Tracey Emin CV 1962–1995*. 'July to September – spend most of the time down in Whitstable – where my beach hut is – A Fantastic summer.'

Could the emergence of the wooden hut as a way to explore fantasies of home be rooted in this personal experience? It may appear as a talisman of improving fortunes, a container of fond memories, a milestone on the road to success. A homecoming, even. After all, there is a poetic resonance in the way the stretch of Kent coastline she was once desperate to escape became somewhere she chose to return to. But now combine the object of the beach hut with the self-portraits, and their shared ambiguous title, *The Last Thing I said to you was don't leave me here*, as Emin did in the Saatchi Gallery installation in 2000: the sentimental symbolism clouds over, the atmosphere turns sinister, the drama rachets up. Is the artist re-enacting a scene that took place on the bare, splintered floor of the

hut, or a memory from an earlier time? Is she sending a message to someone? Is this artwork a threat, or an act of revenge?

It is important to know too, that the beach hut appeared in the immediate aftermath of one of the most unhappy periods of Emin's life. Despite achievements in the previous decade – she gained her first-class degree from Maidstone and won a place at the Royal College of Art – she also reached some of her lowest ebbs. 'Absolutely amazing,' she writes in her work *Tracey Emin CV* about the years 1986–9, 'after all that I'd been through – I'd say – these were the worst two years of my life.' In short, disjointed sentences she describes an abusive relationship that left her 'weak, sad time of life – no self-respect – too poor', and two abortions in two years: the first went traumatically wrong; she dealt with the second 'without heart'. Soon afterwards, she was driven to her 'emotional suicide'. In the middle of 1992, she took a sledgehammer to every single painting she'd ever made, renounced friendships, 'gave up art, gave up believing'. She purged all vestiges of comfort from her studio, tearing the curtains from the windows and stripping out the carpet. In her own words, she turned a place of creativity into a 'cell'.

At first it was difficult to understand why, in the aftermath of this denouement, Emin would go on to find happiness in a place that was also as bare and blank as a cell, let alone fantasise about living there – as she revealed by making *Knowing My Enemy*. It seemed especially strange for her to dream about checking out from metropolitan living at the same time she was being restored and reenergised by friendships and networks discovered in the heart of a city that was, for the first time in decades, truly beginning to thrive. But then I came across a detail I'd never noticed before about *Everyone I Have Ever Slept With 1963–1995*, which was incinerated alongside the beach hut in the fire at Momart in 2004. Although the tent paid homage to companionship, at its heart were the words: WITH MYSELF / ALWAYS MYSELF / NEVER FORGETTING, which Emin had appliquéd prominently on its floor.

Wouldn't the ability to create a home out of somewhere as utilitarian as a hut require unusually deep reserves of imagination? Would it not challenge your inner resources, your sense of yourself? Maybe Emin's emotional breakdown lead her to realise that comfort, safety and security did not exist anywhere or with anyone. Instead, they were to be found within her, the one person who would never leave – *with myself / always myself*. She once said, 'Home is a strange place and only exists where I feel secure. Home isn't a place you go back to. It's the place where you are.' I wonder whether the creative explorations of home in her work, through domestic clichés, fantasies and her personal history, are an expression of Emin finally discovering that for her, the truest sense of home was to be found in the act of making art.

~

In 2017, Emin returned to Margate, back to the same harbour wall where she once thought she could not go on, to fulfil a request most artists would only ever dream about. She had been invited by Turner Contemporary to choose a selection of paintings by its namesake to hang alongside one of her own artworks, *My Bed*. In an interview with the gallery, she was asked to describe the moment she had made the work for which she will perhaps be best remembered. She replied, 'I just saw it in a white space, I saw it out of that environment and, subconsciously, I saw myself out of that environment, and I saw a way for my future that wasn't a failure, that wasn't desperate. One that wasn't suicidal, that wasn't losing, that wasn't alcoholic, anorexic, unloved.'

For as long as Emin has been making work, she has been shaping her life into a narrative that she controls. So successful has she been at this, that not only has she become a leading character in her hometown's story, but a narrator too. She is a vocal champion of the place she once dreamed of escaping, and it has proudly embraced its prodigal daughter. In 2012 she carried the Olympic torch through

Margate cheered on by crowds, a triumphant reversal of the time she was jeered out of a nightclub as a teenager. A few years later, 'Baby Punk' was invited to officially reopen Dreamland after it was restored with millions of pounds of public funding. Naturally, being a real-life example of how art transformed the world of a local girl, she was one of the first artists to be given a solo show at the Turner Contemporary. In the visitor's centre beside the museum there now hangs a pink neon note to Margate, written in Emin's distinctive handwriting: *I Never Stopped Loving You.*

Recently, Emin has begun a new chapter in her relationship with Margate. After her mother died in 2016, she realised that she would have no reason to return. 'I didn't feel happy with that idea. This place is in my psyche. It's part of me,' she said. The following year she purchased the derelict Thanet Press building, a 30,000-square-foot site which she has turned into a home and studio, with plans for it to become a foundation and museum. For an artist whose origins are so entwined with her creativity, it is an especially apt choice of place to house her work and archive after her death. It might even be Emin's greatest achievement: the seaside town she once needed to leave in order to survive will, one day, be the place that keeps her legacy alive.

John Akomfrah, *Vertigo Sea*, 2015

10

VERTIGO SEA

John Akomfrah

I first saw *Vertigo Sea* in Venice, during the Biennale of 2015. It was one of the most popular works that year, and I entered the screening room to find all the benches were full. Film was being projected across three broad screens, which in my memory stretched from floor to ceiling and wall to wall. I sat cross-legged, like a small child sitting at the foot of a giant TV, with my mouth slightly agape at the scenes playing out before me. There were waves breaking, whales breaching, gannets spearing the water like weighted arrows. There were explosions and avalanches and dead bodies washed up on beaches. There were black-and-white still portraits, and costumed figures standing against a dramatic backdrop of snow-capped peaks. There were belongings washed up around lonely figures standing on the shoreline, there was a recurring motif of a ticking clock, soaring orchestral music, and the constant hiss and hush of the sea. Sombre voiceovers added gravity and sadness, although I wouldn't be able to say what exactly they said. It was a disorientating experience; I was left unmoored by the mysterious editing rhythm, which sent images dancing across the

screens in their trios, leaving us viewers to pick up stories and associations like traces of scent in the air. The sense it gave of the force of the sea was immense. I remember looking back as I left the room, seeing the viewers' diminutive silhouettes outlined against a roaring, glowing sea, and knowing that it would be this work by John Akomfrah that would stay with me far longer than anything else I would see that whole, art-saturated trip.

Since that inaugural screening, *Vertigo Sea* has been exhibited and written about widely. I have been able to piece together a clearer idea of what I saw – although I am sure it is possible to see it many times and still notice something new at every viewing. A cinematic collage of archive material, footage from the BBC natural history unit and scenes shot by Akomfrah on the Isle of Skye, the Faroe Islands and Norway, most of the imagery is connected in some way with the sea. Within that broad category it is possible to discern themes of migration, conquest, travel and flight. Fishing, whaling and hunting scenes slide into narratives of slavery, migrant journeys, both human and animal, shoals of fish and flocks of birds, and finally epic natural events such as melting icecaps and erupting volcanoes. Some of the imagery resurfaces many times within the forty-eight-minute length of the film, while other ideas appear briefly before evaporating. Enigmatic snippets of *To the Lighthouse*, *Moby Dick*, Heathcote Williams' *Whale Nation* (1988), Derek Walcott's poem 'The Sea is History' and Nietzsche's *Thus Spoke Zarathustra* (1891) are heard in voiceovers or quoted on royal blue intertitles that appear sporadically throughout the length of the work.

At first, I assumed it was Akomfrah's mobilisation of the sublime – that compelling concoction of beauty and terror – that was responsible for the impression it had made, causing me to seek out *Vertigo Sea* several times since. Subtitled *Oblique tales on the aquatic sublime*, the work is soaked through with shipwrecks, storms and solitary thinkers. Informed by painters such as Caspar David Friedrich, Théodore Géricault and Turner, the work clearly shares with

the Romantics their unflinching fascination with the dangerous power of the ocean, and their vivid sense of human vulnerability when pitched against its strength. So different to Paul Nash's unnervingly still, quietly troubling *Winter Sea*, Akomfrah's work shows the sea as restless, wild and vital; a force so resistant to containment that it spills across three screens.

As I've journeyed through the twentieth century in company with those who have been bewitched by the sea, I've come to realise the sublime is not the only reason I feel compelled to explore this work in more depth. I am drawn back to *Vertigo Sea* because despite its references to historic events and ways of seeing, it feels highly contemporary. Beyond its use of obviously modern-day technology, there is something about this work that feels like it could only have been made in *this* century, something to do with its urgency, grand ambition and global scope. It shocks, but not in same way as the work of Tracey Emin and the YBAs. While they provoked controversy by trampling over present-day taboos, Akomfrah wades into history and natural history for his material. I want to know why Akomfrah is able to offer glimpses of dimensions to the sea that no other artist I have looked at so far has been able to give, and how he manages to achieve this. What is it about this particular work that speaks so directly to the current moment, and what is it saying about the future?

~

In interviews, Akomfrah speaks eloquently of how from a young age his background seeded an interest in images. Born in Ghana in 1957, he moved to the UK as a child; his parents were anti-colonial activists who were granted political asylum after the military coup in 1966. Growing up in 1970s London as a black immigrant gave him a keen insight into how stories and images leave their imprint on future imaginations. He has spoken of feeling shadowed by a 'doppelganger', something he has attributed to his racial identity. 'There

was this figure who looked like you and that behaved not quite like you, but you were aware that when other people spoke about that figure, there were trying to speak about you.' As a teenager, he would walk to the Tate from his home in west London, developing his interest in the power of imagery, working out why a painting by Constable might make him feel differently to a Rothko. Yet despite frequent visits, he has remembered how foreboding galleries and museums felt to a person of colour, how he steeled himself against the general feeling that 'if you looked, you were going to cause trouble'. Cinema became a refuge from feeling overlooked, a place where he could be fully absorbed into a world of images, without sensing that he himself was being observed.

Filmmaking united his burgeoning interest in both politics and aesthetics. While studying sociology at Portsmouth Polytechnic, he co-founded the Black Audio Film Collective with six other students. Their first film, *Handsworth Songs* (1986), responded to riots that had recently torn through Birmingham and London. It set the tone for the BAFC's subsequent work, which continued to explore the politics of representation and the experience of the migrant diaspora. Its loose documentary style, interweaving eyewitness interviews, newsreel, photographs and archival footage, also foreshadowed the multi-layered style of the work Akomfrah went on to make with the BAFC and then, after the collective disbanded in 1998, with Smoking Dog Films. In *Handsworth Songs*, we hear the words, 'There are no stories in the riots, only the ghosts of other stories'. Akomfrah is still haunted by the idea of 'ghosts of other stories'. Who tells the stories, and who can only listen? While some narratives wither untold, why do others thrive, nourished by new mouths? Questions of what has gone unsaid and unseen, what has been forgotten and what has been memorialised, continue to shape his projects to this day.

In recent years, Akomfrah has gravitated away from television and cinema towards the art world, where he has found a greater freedom to think experimentally about form. In more conventional formats,

'everything you see in the frame is only there to make "real" what the human does, says, believes', he has pointed out. 'The minute you start to give power to the other active elements inside the frame, something else starts to happen – something more pagan, less humanist. And this is not just an aesthetic question, but an ethical one, too, because it has real implications for how we operate in the world.' In films made for an art-gallery context he is able to commit thoroughly to the technique of bricolage, layering diverse imagery and ideas side by side without unifying them into an obvious narrative. Akomfrah has described this signature style as making 'affective proximities'. This phrase is a neat summation of the way he hopes these unusual juxtapositions might spark unexpected emotions and associations in the viewer's mind. But I prefer a looser analogy he sometimes uses, where he describes what he does as setting up conversations between things, but without listening in, without making any presumptions as to what might be being said.

There are so many conversations taking place in *Vertigo Sea*. Sharing the frame are different periods in history, landscapes, belief systems and living species. Facts mingle with fiction, and abstract ideas merge with vivid reality. While connections are not being drawn explicitly between these things, kinships are certainly being suggested. The impetus to make the film came from rolling news reports of treacherous sea voyages made by desperate people attempting to make a new life elsewhere. In 2015, the year *Vertigo Sea* was made, more than a million migrants entered Europe by sea, the majority displaced from their home countries by war, violence and poverty. Nearly 4,000 people died in their attempts to cross the Mediterranean in fatally unsuitable boats, mostly trying to reach Italy from North Africa. Akomfrah was disturbed by the way immigrants and refugees were met with panic, and was becoming increasingly conscious of a 'rhetoric of contagion' that was affecting discussions of immigration to a greater extent than he had witnessed before. His thinking about these issues and their

relationship to the sea began to coalesce around a story of a Nigerian migrant that he heard on the radio. He recalled that 'when one of the young crossers says: "I was in the sea and I saw these big, big fish and I thought I was going to be eaten" – [it] just seemed to spark off something in my head about the coming together of narratives that would not otherwise be in the same space'.

As he sifted through his media archives to think about the contemporary migrant experience within a wider context, Akomfrah started to see a complex, living story about hierarchy and power, technology and progress emerge. An admirer of Herman Melville's *Moby Dick*, for a long time he had wanted to 'do something on whaling and the transatlantic trade, and I hadn't realised, for instance, quite how intertwined the two were – and once you figure it out it makes perfect sense [. . .] These ships, they needed to build them bigger because they needed them for whaling – to pull ten and fifteen tons of whale – but of course, that then makes them big enough to make these huge journeys across the Atlantic to get people across. That had never entered my mind.' By hosting all these 'conversations' between different types of interactions with the sea, Akomfrah was discovering how moments of vision and capability in one situation could cause profound cruelty and suffering elsewhere. The connections, it soon became clear, were not just of a technological nature. By dissolving the conventional boundaries between time, place and species, many more sinister symmetries began to make themselves visible.

~

The first voice we hear in *Vertigo Sea* is that of the Nigerian immigrant Akomfrah heard first on the radio telling a BBC reporter in a measured way about the first time he ever saw the sea. He had travelled across the continent to reach the northern coast of Africa, where he boarded a fishing boat to take him to Europe. It was a journey he had been told by a people trafficker would take less than an hour.

But the boat was overcrowded and soon began to take on water. As the pilot swam back to shore, the migrant found himself, unable to swim, clinging to the boat's tuna cage as huge fish circled below and waves as high as houses swelled above his head. 'It was to become one of the most dramatic survival stories from this year's crossings,' the reporter says. Cut from its news context and placed into *Vertigo Sea*, it becomes the first of many other terrible tales of living beings pitched against gravely unequal forces, reaching back in time and beyond the human species. In scene after scene, we bear witness to the sea as a dumping ground, a hunting ground, a graveyard, a crime zone. A place that is complicit in enforced silences and buried secrets. A place that is uncaring, indifferent to who survives or who perishes. Death dissolves in the sea like salt.

Watching the full film is to experience a bleak sense of déjà vu. The victims, perpetrators, motivations, time period and places change, but in the nature of the suffering and method of their cruelty they share a blood-red streak of affinity. The story of the twenty-first century African migrant resonates with the footage of boatloads of Vietnamese refugees attempting to reach Hong Kong after the Vietnam War. The work's references to the Zong massacre of 1781, when the captives of a slave ship were thrown overboard for the crew to claim insurance money, find a dark shadow in later descriptions of the 'death flights' that took place during the Algerian War in the 1950s and in Chile in the 1970s under General Pinochet's military regime. An eighteenth-century account of a crying child taken from its enslaved mother and thrown overboard is echoed soon after by a news report dating from the Argentinian military junta in the late 1970s of women bundled onto death flights shortly after giving birth, and then again in the grainy black-and-white footage of a polar bear shot dead beside her cubs. Bodies washed up on a beach, a fish snared in a net, a harpooned whale blossoming blood into black water: each death haunts the others. 'The way of killing men and beasts is the same' an intertitle reads. Akomfrah has spoken of his desire to

weave a 'tapestry of empathy', and in *Vertigo Sea* this is one of the ways his belief that aesthetics can have 'real implications for how we operate in the world' is borne out.

All those lives 'lost' at sea are a very real illustration of how bodies can disappear into water without a trace, but they are a metaphor too for another kind of loss – the loss of memory that allows acts of violence and dehumanisation to be repeated. One of the ways Akomfrah challenges these processes of forgetting, which can amount to a collective amnesia, is through the use of archival material and montage. Incorporating newsreel, daguerreotypes, film stills, engravings and shoots reused from previous work, *Vertigo Sea* helps bring forgotten or overlooked lives into the light. Alongside the recycling and reshuffling of fragments of visual history into new configurations, this becomes a strategy for probing the truth of accepted narratives. 'It's one of the things I'm obsessed about with archives,' he has said, 'because on the one hand they're repositories of official memory, but they're also phantoms of other kinds of memories that weren't taken up.' It is not only recollections of human experiences being unearthed, but more ancient forms of knowledge held by the sea too: 'The accumulated knowledge of the past', of which Heathcote Williams' poem *Whale Nation* speaks. Providing a perspective on the ocean that is physically inaccessible to the vast majority of people, the virtuosic aquatic footage of the BBC natural history unit is especially significant in this context for making visible other kinds of submerged memories. As the camera plunges like a whale beneath the surface of the water, the poem reminds us of 'Rumours of ancestors, / Memories of loss; / Memories of ideal love'.

Yet one of the most pervasive phantoms haunting *Vertigo Sea* has not been restored from found footage or recovered from an archive, but has been brought to life by Akomfrah in scenes shot specifically for this work. When we first see this spectral presence he is standing on a rocky shoreline, dressed in an eighteenth-century costume of a vivid scarlet jacket, white breeches, knee-length black boots and a tri-cornered hat,

contemplating the sea. In later shots we see him looking at a clock, surrounded by period furniture that looks as though it has been swept to shore from a shipwreck. Head bowed, fingertips pressed together, standing before a backdrop of snow-capped mountains, it is *his* image that is used to publicise the work. A dignified, sombre figure, he appears at first to be the embodiment of one of the central tropes of the sublime: the solitary wanderer contemplating a majestic landscape. Yet he is not the archetypal Romantic soul. He is a black man, chosen to represent the freed African slave and abolitionist Olaudah Equiano (*c*.1745–97). Requiring a small act of excavation on the part of the viewer, his identity is not made clear by the film itself, but in texts accompanying the work. But inserted among other narratives of disenfranchised human and non-human bodies, the knowledge of his presence becomes one of the most powerful ways in which this film alerts us to who gets remembered and who gets forgotten. In fact, he is a reminder of one the greatest crimes of oblivion that has ever taken place at sea.

~

Equiano was a boy of about eleven when he was kidnapped from his home in West Africa, enslaved and taken to the coast. He was shipped to the Caribbean, then the US state of Virginia, before being sold to a Royal Navy officer fighting in the Seven Years' War against France. After six years, in 1762 he was sold again, and sent back to the Caribbean. There he was able to make enough money from trading on the side to buy his own freedom, which was priced at £40. He continued to find work aboard ships, voyaging across the world before returning to Britain, where he became involved in the abolition movement – helping to publicise the Zong massacre, for instance. He also wrote an extraordinarily vivid and moving account his life. One of the earliest first-hand accounts of slavery, *The Interesting Narrative of the Life of Olaudah Equiano or Gustavus Vassa, the African. Written by Himself*, became a bestseller, influencing the eventual abolition of

slavery within the British Empire in 1807. Reimagined for the twenty-first century by Akomfrah, he stands for explorers, dreamers; for anyone who has started a new life in a new country or wished for freedom. His presence is also a defiant act of revisionism, a life placed back into a historical narrative of the sea from which he and so many others have been excluded.

There is, as Derek Walcott articulated best, another 'subtle and submarine' history of the world to be told, a history that is not memorialised in physical artefacts, venerated heroes and legendary tales, but has largely vanished under the waters of the Atlantic Ocean. In *The Sea is History* (1978), a poem quoted on one of *Vertigo Sea*'s intertitles, he asks:

> Where are your monuments, your battles, martyrs?
> Where is your tribal memory? Sirs,
> in that grey vault. The sea. The sea
> has locked them up. The sea is History.

The ocean is not just a metaphorical store of memory, the poem reminds us, it is an unmarked grave for millions who lost their lives under the aegis of slavery and empire. Between the sixteenth and nineteenth centuries, more than 12.5 million Africans were transported from their homeland to the Americas and the Caribbean to work as slaves. By 1820, nearly four Africans had crossed the Atlantic for every European. It is estimated that 1.8 million died during the voyage known as the Middle Passage. Lasting on average sixty days, trapped in filthy, cramped and inhumane conditions, Equiano recalled the journey as 'a scene of horror almost inconceivable'.

Attempting to release the memories locked in 'that grey vault', Akomfrah joins a growing body of thinkers who use the sea as a lens through which to gain a better view of the past. In his 1993 book *The Black Atlantic: Modernity and Double Consciousness*, Paul Gilroy suggested that cultural historians should use the Atlantic itself as a unit

of analysis instead of the nation, in order to more accurately reflect the transnational and intercultural perspective of the African diaspora after the violent displacements of slavery. Identifying the image of the ship in motion as an important symbol for his thesis, Gilroy turns to Turner's painting of a slave ship throwing overboard its slaves – a work that was likely inspired by hearing about the fate of those on the *Zong*. Exhibited to coincide with the world anti-slavery convention in London in 1840, the painting contains all the tools of the sublime to exert a powerful moral force on its nineteenth-century audience, setting the ship against a fiery sunset so its mast is rendered as puny and prickly as a thorn, while the hands weighted by iron shackles desperately reaching out of the waves feel so close you could almost grab them. In Gilroy's reading, *Slave Ship* also illustrates the actual means by which far flung places and peoples were joined, and the way political, commercial and cultural ideologies were spread, bringing unprecedented interconnectedness to the globe. In other words, he implies, it was the suffering of humans transported as cargo across the Atlantic Ocean that gave shape to the modern world.

Like Turner's painting, *Vertigo Sea* mobilises the aesthetic of the Romantic sublime to allow cries sunk long ago beneath the waves to be heard, and like *The Black Atlantic*, it hints at the way modern history was forged in the sea. But Equiano's presence in *Vertigo Sea* complicates its relationship with the sublime in a very significant way. A central condition of the sublime is the dissonance that arises from witnessing danger from a place of safety. Turner was unsurpassed in his ability to convey the 'idea of pain and danger without actually being in such circumstances', which Edmund Burke deemed essential to his definition of the sublime. He painted the sea from its churning heart, not its tepid shorelines. This is why the *Slave Ship* is so affecting: the viewer is tossed into the choppy waves alongside the drowning, looking back up at a ship that will soon vanish from view. *Vertigo Sea* is also an immersive event, both visually and aurally, viewed from a place of stillness and security. Along with its

roiling rhythms and weighty narratives, the disparity between the drama on screen and the controlled gallery environment would have contributed to the sense of disorientation – a kind of vertigo – I'd felt on my initial viewing. Twenty-first century technology allows us to feel closer to the sublime sea than Turner ever could, and yet we are separated from it more efficiently than ever before.

Now contrast the experiences created by these two artworks with the first time Equiano saw the sea. His response to the sight was, he writes in his memoir, 'astonishment' – an adjective that often crops up in eighteenth- and nineteenth-century descriptions of the sublime. (In his *Philosophical Enquiry*, published thirty years before Equiano's *Interesting Narrative*, Burke wrote: 'The passion caused by the great and sublime in nature, when those causes operate most powerfully, is Astonishment'.) But Equiano's circumstances were very different to the kind Burke was envisioning. At harbour, waiting for its cargo, was the slave ship that was to transport Equiano from Africa to the Caribbean. Carried aboard, his emotions quickly turned to sheer terror, convinced he was going to be killed and eaten by the 'white men with horrible looks, red faces, and loose hair [. . .] When I looked round the ship too and saw a large furnace or copper boiling, and a multitude of black people of every description chained together, every one of their countenances expressing dejection and sorrow, I no longer doubted of my fate; and, quite overpowered with horror and anguish, I fell motionless on the deck and fainted'. A brush with danger can charge you with life, seekers of the sublime believed. In the horrific journey that followed, Equiano wished only for death.

Deeply unsafe, disorientated and scared, Equiano's astonishment was overruled by fear. Without the necessary distance from the source of terror, the 'delightful horror' of the sublime was not only totally inappropriate to his experience, but it was impossible for him to access. 'When danger or pain press too nearly,' Burke wrote, 'they are incapable of giving any delight, and are simply terrible.' One only needs to think of the figures intended as points of identification in

the most iconic Romantic products of the era, such as Caspar David Friedrich's *Wanderer above the Sea of Fog*, to see what kinds of individuals were able to be enriched and energised by the magnificence of the natural world. The introspective wanderer, an image which continues to exist as a paradigm of self-discovery, was premised on a certain kind of identity, a certain kind of 'self'. I think back to Paul Nash on the sea-wall at Dymchurch, or Peter Lanyon on the Cornish clifftops, both of whom were drawn to express the sublime in their work. When they stood in front of their canvases, they reimagined danger, they recollected fear, but from a place of security and tranquillity. Equiano's presence in *Vertigo Sea* is a reminder that the sublime feeling is not necessarily a democratic emotion: it is available only to those who have the privilege of safety.

While this is an uncomfortable realisation, it has helped me see why artists such as Akomfrah continue to be preoccupied with the notion of the sublime. The sublime could easily be seen as an irrelevance, an obscure way of looking at landscapes devised for and by long-dead men in tri-cornered hats, but it has a crucial function that is still relevant today. Without exploiting that vital space between fear and safety, between terror and delight, it would be harder to bear witness to terrible events, harder to appreciate our privileges and our pleasures. Like a pier stretching out over the sea, sublime art carries us safely towards the source of our deepest fears; it allows us to look, notice and feel without being overcome physically by forces greater than ourselves. Not only that, but if you trace the idea of the sublime back to its roots, it reveals a way of framing the natural world that continues to shape lived experiences today.

~

As we have seen again and again throughout this book, landscape art reflects the minds that make it. Whether represented in words or images, all landscapes are an abstraction from nature. The very idea

of a landscape is premised on the idea that the land is separate from the human, that it is something that *can* be abstracted by the human mind. Because of its need for a measure of security, sublime art in particular thrives on the tension between the artist and the landscape, the spectator and the spectacle. A sense of detachment, distance and difference is requisite to the experience, because this was a reflection of the way in which nature was thought about in the late eighteenth century when the genre became popular. At the time, certain land-scapes were starting to be seen as a stage for acts of becoming, for moments of self-reflection and self-revelation. By the late nineteenth century, exploring sublime landscapes had become a way of demon-strating one's emotional and physical virtues, testing one's reserves of imagination and the body's resilience. They were places where man pitted himself against nature, before returning to civilisation to retell his adventures in the language of victory and defeat. Wildernesses were to be tamed, mountains were to be conquered, waves were to be battled: nature existed to be mastered.

As the relationship between man and nature became enmeshed with imagery of war, mastery and appropriation during the eighteenth and nineteenth centuries, Britain began to exert political, military and economic influence overseas. William Blake once said, 'Empire follows Art, & not vice versa as Englishmen suppose.' For the past forty years, landscape scholars have been proving him right. Denis Cosgrove has shown how the roots of European landscape painting are entangled with early modern capitalism, but others have gone even further, suggesting that the emergence of landscape as a visual medium is 'integrally connected to imperialism'. W.J.T. Mitchell has pointed to the way landscape traditions have waxed and waned in tandem with their empires – and not only in Britain, but in places such as China, Japan and Holland too. He says, 'Empires move outward in space as a way of moving forward in time; the "prospect" that opens up is not just a spatial scene but a projected future of "development" and exploitation.' I would argue this is especially true of the ocean,

a space which facilitated imperial fantasies more than any other. The sea the Romantic wanderer typically beheld was a void, *aqua nullius*, a true wilderness. In the *Toilers of the Sea* (1866), the arch-Romantic author Victor Hugo wrote: 'The solitudes of the ocean are melancholy: tumult and silence combined. What happens there no longer concerns the human race.' But far from this vision of the sea as a vacant space, rendering it of no concern to the human race, the reality was that it left the sea acutely vulnerable to the projection of the priorities of the most powerful humans.

To Equiano, as to the millions of Africans whose lives were brutally uprooted by the transatlantic slave trade, the sea was of central concern. His life was shaped by the ocean. It imprisoned him and separated him from all he had known. As a free man, it became something entirely different again. For a long time, he did not have the luxury of the sublime experience, he did not have the privilege of distance. In the cultural battle between man and nature, he found himself on the wrong side. Dehumanised, categorised as 'other', he became part of the 'prospect' to be mastered, cultivated, dominated and exploited. If the way the ideas contained within *Vertigo Sea* are presented may seem abstract or discursive, Equiano's ghost drags it towards the painfully real. For far from being a nothingness between lands, in the sediments of the seabed lie the remnants of all those who died during the Middle Passage, finally free of their rusted iron shackles.

~

The conviction that humans are separate from nature has consequences that are still being felt today, but more terrifying still is the extent to which they will have an impact on the future. The idea of the ocean as vast and remote, with deathly still depths that supported barely any life, went largely unchallenged until the middle of the twentieth century. To this day, only 10 per cent of the ocean has been mapped with the same accuracy as the land. Out of sight and out

of mind, scarce attention was paid to the consequences of disposing waste in the sea. Alongside sewage, plastic and industrial detritus and all the other substances we would rather not see again, radioactive waste was dumped in the sea too until it was regulated in the 1970s. But instead of making these unwanted things disappear, the ocean will be efficiently circulating and dispersing these pollutants and contaminants through its global currents and food chains for decades to come.

This way of seeing the sea that we have inherited from past generations is changing; *Vertigo Sea* itself is proof of this. Since 2015, Akomfrah has made two further films, *Purple* (2017) and *Four Nocturnes* (2019) forming a trilogy with *Vertigo Sea* that his production company, Smoking Dog Films, describes as exploring 'the complex, intertwined relationship between humanity's destruction of the natural world and our destruction of ourselves'. There is nothing within *Vertigo Sea*'s title, intertitles or narration that connects the film specifically to this intention. Yet in common with several others who have written about this work, it seems clear to me that lurking beneath the surface of the film is the undertow of the current environmental crisis. Why? Because of the way certain images can be haunted by 'ghosts of other stories', because of the way, over time, imagery becomes swollen with meaning. I am reminded of the way the rich iconography of the First World War creates an afterimage of trench warfare and muddy misery to linger over Nash's *Winter Sea*, or the way Rothko's shimmering horizons became a symbol for the atomic age. As a millennial, brought up in the loudening clamour of the modern environmental movement, I find it hard to disassociate footage of whales, stranded polar bears, melting icecaps and boatloads of refugees from messages about global warming and the destruction of the planet.

Over my lifetime, a greater awareness has formed of just how integral the ocean is to the future of the planet. So much so, that the sea itself has become emblematic of the ecological crisis. Aided

by popular documentaries such as *Blue Planet I* and *II* and humbling images of earth from space – perhaps most famously the 'Pale Blue Dot' of 1990 – it is not only marine scientists who are beginning to see the planet as Heathcote Williams urged, back in the late 1980s, as 'the territory / Not of humans, but of the whale'. Where once we might have imagined an almighty deity keeping the rhythms of the world in harmony, today that task is with the sea. 'The living ocean drives planetary chemistry, governs climate and weather, and otherwise provides the cornerstone of the life-support system for all creatures on our planet,' the oceanographer Sylvia Earle has written. Or, as she said elsewhere, 'No blue, no green.'

The sea is now where we look to see the future. 'The oceans are sending us so many warning signals,' one of the authors of the latest Intergovernmental Panel on Climate Change report told the *New York Times*. In the past two centuries, the report says, the ocean has absorbed a third of the carbon dioxide produced by human activities, causing the basic chemistry of the sea to change faster than it has ever done in the previous 65 million years. Over that period too, the seas have absorbed nearly all the excess heat created by the rising concentration of greenhouse gases in the atmosphere, protecting the land from warming too rapidly. Now science is showing it is being pushed to its limits. According to the IPCC report, the rate of ocean warming has more than doubled since 1993. Marine currents are already changing. Migration habits are shifting. Oxygen levels are falling. Coral reefs are dying. Fish populations are declining. On land, the impact of warmer seas is also manifest. Ice sheets and glaciers worldwide are melting at unprecedented rates, accelerating rising sea levels. Tropical cyclones and higher waves have become increasingly common. By 2050, it is predicted that in many areas where extreme flooding was once very rare – occurring at most once a century – floods will happen at least once a year.

Since the millennium, the notion of the 'Anthropocene' epoch has been a useful way of placing human activity within the context of

geological deep time. The human obsession with conquest, explora-tion, exploitation and extraction, its insistence on thinking of nature as a resource, has caused such irreparable damage to the earth that a whole new geological epoch is now underway. Derived from the Greek for human, *anthropos*, the word is controversial for implying that all of humankind is to blame – some suggest 'Capitalocene', with its emphasis on capitalist societies, would be more appropriate. Nevertheless, the concept encapsulates the profoundly unsettling idea that it is our species alone that has caused extreme planetary changes that will endure for millions of years to come.

But I am sure you know all this: scientists and environmentalists have not changed their message for years. Still, there is a level of inac-tion from those in power that is not commensurate with the gravity of the issue. We are not only facing an ecological crisis, it seems, but a crisis of imagination too. How *do* you begin to comprehend the idea that the plastic particles that make up your water bottle will never fully disappear? How do we square the thought that every time we get in a car, we might be contributing to the sixth mass-extinction event? What do we do with the knowledge that a new type of stone called 'plastiglomerate', made up of shells, sand, wood, seaweed and molten plastic, could become the fossils of the future? The extent of the environmental crisis and its thorough entanglement with our past, present and future actions can cause what has been called the 'stuplime': an aesthetic experience in which astonishment is paired not with delight but with boredom, fatigue, numbness.

In 2010, the ecologist and philosopher Timothy Morton coined the term 'hyperobject' to try and describe such entities and events that are so vast and so dispersed across space and time that they defy comprehension. The internet is a hyperobject, as is climate change, for these are things that seem abstract in their enormousness but are omnipresent in their impact. Originally a scholar of Romantic literature, Morton is aware that there are parallels with the sublime feeling of being so overwhelmed by a sight that it impairs rational

thinking. And yet, 'Hyperobjects invoke a terror beyond the sublime,' he has written, 'cutting deeper than conventional religious fear. A massive cathedral dome, the mystery of a stone circle, have nothing on the sheer existence of hyperobjects.' The Anthropocene, Morton writes, is causing 'a traumatic loss of coordinates'.

Like Olaudah Equiano, displaced, disorientated and devasted by his enforced transportation to the New World, maybe we are all now losing the luxury of the sublime. We are losing the privilege of distance, and this knowledge is hard to bear. Once the ocean was something that existed at the edges of our land-based lives: a critical source of livelihood for a small minority of the world's population; a resource for food, transport, entertainment, reflection and healing for the rest. Now we are learning how crucial it is to the survival of humankind, how it shapes all we do and everything we will be, we are in danger of being overcome by our sense of powerlessness, rendering us stupefied and dumb.

~

Maybe the sea can help us regain our bearings. Not only can we learn from the data the ocean provides about rising water levels, oxygen saturation and volumes of microplastics, but from all the other ways it communicates with us too. 'As everyone knows,' Ishmael says in *Moby Dick*, 'meditation and water are wedded forever.' In the age of the Anthropocene, this has never felt truer. With *Silent Spring*, Rachel Carson helped a broad audience understand the profound interconnectedness of all life, and in doing so began the slow work of dismantling the cultural boundary between man and nature that had been constructed over centuries. Decades on, the sea itself is now hammering home this message, pawing at the land, reclaiming the coast, flooding towns and cities, pulling our habitats into its depths. It is literally dissolving distinctions that were once unquestioned; between land and water, human and non-human, permanence and transience, between the past, the present and the future.

The density and significance of the 'web of life', as Carson called the planet's ecosystem, first revealed itself to her in the 'series of delicately adjusted, interlocking relationships' existing between life in all parts of the sea. Scientific knowledge helped her make this discovery, but so did her sense of wonder. It was her enchantment with the sea that drove her on through ill-health and opposition, and that helped her see the complexity of ocean ecology with extraordinary clarity. And it was the feeling of amazement that helped her communicate the science so effectively to her readers that it launched the modern environmental movement.

It is only in this century that her hybrid approach has been adopted beyond the realms of environmental writing. *Vertigo Sea* is not alone in how fluidly it navigates the ocean's physical as well as poetical dimensions; a field of scholarship known as the 'blue humanities' has begun to challenge the terracentric lens through which its subjects have traditionally been seen, embracing hybrid forms of knowledge. 'Our knowledge of the sea depends equally on how it is represented, put into discourse, and interpreted, and on the sea's bio-geophysical existence embodying the materiality of its meanings,' Serpil Opperman wrote in 2019. 'Consequently, the sea's meanings always remain in the interstice between the discursive and the real.' Beyond acknowledging the importance of both the sea's material and metaphorical qualities, some have begun to ask whether the sea's slippery, volatile, dynamic form can be used to reframe how the world is seen. The Australian scholar Astrida Neimanas, for instance, has argued for bringing a more phenomenological perspective on the sea, a way of thinking not just *of* the sea but *with* it. She asks, 'if I "water" my concepts – if I invite water to be a collaborator or an interlocutor in how I imagine, or theorize, the world – might I also treat water better?'

How art can respond in any meaningful way to the ecological crisis is not a question with an easy answer. But perhaps, in the face of 'stuplimity', it can try to keep us enchanted, try to keep us amazed.

Vertigo Sea does not feel like a despairing catalogue of horrors, for it has moments of gentleness and beauty too. Akomfrah has said that in making the film, he began to see why the sublime concoction of magnificence and misery was so powerful. 'It's not enough for things to just be "beautiful",' he realised. Only in combination with terrible truths do we become vividly alert 'to the question of mortality'. *Vertigo Sea* offers a vision of the ocean as a deeply complex network of interconnections, an entity that can simultaneously inflict on the human species moments of inspiration and episodes of sheer terror. Through its interweaving of fact and fiction, past and present, species and spaces, horror and wonder, there are moments when Akomfrah's sea mimics the 'traumatic loss of coordinates' which seems to be accompanying the Anthropocene age. Yet while it may be a disorientating experience, watching *Vertigo Sea* does not let you give up hope. In gathering elements that normally occupy different temporal, physical and imaginative spaces; in its attempt to give the sea its polyphonic voice, it challenges the domineering perspective on nature passed down from our ancestors. And perhaps most crucially of all, it helps make us aware of all we stand to lose.

~

In the years since it first screened at Venice, *Vertigo Sea* has been exhibited alongside an imposing early oil painting by Turner, called *The Deluge*. Thought to have been painted around 1805, it shows the scene in the Bible where a great flood is unleashed by God in vengeance for the wickedness and corruptness of humanity. Uniting with a ferocious storm, a grossly swollen sea breaks its bounds to sweep a crowd of people away. Waves rise like cliffs, trees flex in the wind like stems of grass, while barely clothed figures, black and white, cling to each other in desperation. In the distance, the sun is a stubbed-out ember. When the painting was exhibited at the Royal Academy in 1813, a critic praised 'that severity of manner which was demanded by

the awfulness of the subject'. Two centuries later, Akomfrah agrees. 'There is no detour around form: the desire to say something is also a desire to find a way of saying it,' he has said. '*The Deluge* is not just a rendering of a disaster at sea – it's a really *fantastic* rendering of a disaster at sea.' While the subject of the painting is pertinent to the crises facing us today, it is telling that above all else, it is Turner's negotiation between narrative and form that Akomfrah respects. For this has always been the artist's central challenge: as he says, there is no detour around form.

This is especially visible in portrayals of the sea. At the beginning of this book, I wrote about how I wanted to look from the sea, back to the people standing watching the horizon from the shoreline. As each artist has stepped into view, so has their desire to say something, and so has their desire to find a way of saying it. I confess it has been harder not to be distracted too much by the messages contained within the artworks the nearer they were made to the present day. Although Akomfrah's approach to his subject matter is oblique – reflective rather than polemical – I have found it difficult to step away from the meanings carried by his work. Writing now, it all feels too close, too scary, to regard at the same cool distance as the others.

I hope, however, that art continues to allow us to take step back from the emergencies of the immediate moment; I hope that instead of only rendering a disaster at sea, future artists will still be compelled to create really *fantastic* renderings of the sea. For it is the stretching of the imagination, the departure from the known, that helps others look again, notice more and see differently. Imagining these ten artists standing side by side on the shoreline, I am reminded of Akomfrah's desire to set up conversations between unrelated things, without listening in, without making any presumptions as to what might be being said. The vision of the sea shown in *Vertigo Sea* – a troubled sea that bears the weight of past crimes and future strife – would have been impossible to imagine when Vanessa Bell took her

children and her painting box down to Studland beach one September day in 1910. It is irrelevant whether one is more important, more worth saying, than the other. Side by side, you only see that they are different expressions of the intensely human desire to say something, and the desire to find a way to say it.

In a hundred years' time, will we be able to look out to sea and allow it to take the mind on its own unique journey? Or will the sea be so entangled with urgent messages and meanings that the mystery of this voyage becomes a privilege of the past? Art offers a glimpse of where the eye takes the mind, and how the sea spirits the imagination to faraway places. These journeys are made visible by art, but I hope they never become truly knowable. For there is beauty in that distance, like the blue at the horizon that vanishes on approach.

ENDNOTES

References given in quote marks are direct quotes from the source stated, references without quote marks are where the information has been sourced but not directly quoted.

'It is so little…' W.H. Auden, *The Enchafèd Flood: or, The Romantic Iconography of the Sea* (London: Faber, 1951), p.18

'To attempt to fathom…' Alain Corbin, *The Lure of the Sea: The Discovery of the Seaside in the Western World, 1750–1840* (Cambridge: Polity Press, 1994), p.2

Mariner-monks were… John Mack, *The Sea: A Cultural History* (London: Reaktion Books, 2011), p.91

'uniquely positioned…' Pandora Syperek and Sarah Wade (eds), 'Curating the Sea, Special Issue of the Journal of Curatorial Studies, 9.2 (Autumn 2020), *Journal of Curatorial Studies*, 2020

I
Studland Beach: Vanessa Bell

'We were going to paint…' Virginia Woolf, *Moments of Being: Unpublished Autobiographical Writings,* ed. Jeanne Schulkind (Triad/Granada, 1978) pp.187–8

'outstanding contribution…' Richard Shone, ed., *The Art of Blooms-*

bury: *Roger Fry, Vanessa Bell and Duncan Grant*, exhibition catalogue (London: Tate Publishing, 1999), p.90

'*Of the many works...*' Ian Dejardin, in Maev Kennedy, 'Vanessa Bell: stepping out the shadows of the Bloomsbury set', *Guardian*, 7 February 2017

'*static mood*' Sarah Milroy in *Vanessa Bell*, exhibition catalogue, Dulwich Picture Gallery (London: Bloomsbury, 2017), p.32

'*other-worldliness*' Shone, *The Art of Bloomsbury*, p.90

'*pared-down mysticism*' Jackie Wallschlager, 'Vanessa Bell at Dulwich Picture Gallery, London – her art is indivisible from her life', *Financial Times*, 12 February 2017

'*austere and remote*' Frances Spalding, *Vanessa Bell* (London: Weidenfeld and Nicolson, 1983), p.124

'*Did I tell you...*' 23 October 1881, Leslie Stephen, *The Life and Letters of Leslie Stephen*, ed. Frederic William Maitland (London: Duckworth, 1906), p.345

'*She was a happy creature...*' Woolf, *Moments of Being*, p.36

'*Is there any chance...*' Woolf to Violet Dickinson, July 1909, *The Letters of Virginia Woolf: Volume One, 1888–1912*, Nigel Nicolson and Joanne Trautmann (eds) (London: Hogarth Press, 1975), p.400

'*a most rural...*' William Baxter, *South Hants and Dorset* (London: Nelson, 1914), p.220

'*surreptitiously appropriated...*' Lock Ward, *A New Pictorial and Descriptive Guide to Weymouth and South Dorset* (London, 1900) p.xiv

'*We are in the quietest...*' Leslie Stephen to James Russell Lowell, 27 July 1882, Stephen, Leslie, *Selected Letters of Leslie Stephen,* vol. 1, eds John Bicknell and Mark A. Reger (Basingstoke: Macmillan, 1996), p.251

'*Julian rushes straight...*' Woolf to Violet Dickinson, 21 September 1909, *The Letters of Virginia Woolf*, p.412

'*Studland would have been...*' Lisa Tickner, 'Vanessa Bell: Studland

Beach, Domesticity, and '"Significant Form"', *Representations*, no. 65 (Winter, 1999), p.77

'*With mother's death...*' Woolf, *Moments of Being*, p.109

'*the greatest disaster...*' Woolf, *Moments of Being*, p.46

'*a time of horrible suspense...*' Bell in Spalding, *Vanessa Bell*, p.31

'*Beloved...*' Woolf to Bell, Christmas Day 1909, *The Letters of Virginia Woolf*, p.414

'*Why am I so incredibly...*' 22 March 1921, Virginia Woolf, *The Diary of Virginia Woolf: Volume Two, 1920–1924*, ed. Anne Olivier Bell (London: Hogarth Press, 1978), p.103

'*I know you think...*' Roger Fry to Bell, in Fry, Roger, *Letters of Roger Fry: Volume Two*, ed. Denys Sutton (London: Chatto & Windus, 1972), p.470

'*Blue is the light...*' Rebecca Solnit, *A Field Guide to Getting Lost* (Edinburgh: Canongate, 2017), p.29

'*Of where you can never go...*' Solnit, *A Field Guide,* pp.29–30

'*Their mental landscape...*' Solnit, *A Field Guide,* p.39

'*Something unexpected...*' Woolf to VB, August 1908, *The Letters of Virginia Woolf,* p.349

'*I had a charming...*' Bell to Woolf, 11 August 1908, *Selected Letters of Vanessa Bell*, ed. Regina Marler (London: Bloomsbury, 1993), pp.66–7

'*silent kingdom of paint...*' Virginia Woolf, 'Walter Sickert' in *Collected Essays by Virginia Woolf*, Volume Two (London: The Hogarth Press, 1966), p.237

'*life apart from...*' Vanessa Bell, *Sketches in Pen and Ink*, ed. Lia Giachero (London: Hogarth Press, 1997), p.73

'*one could forget...*' Bell, *Sketches in Pen and Ink*, p.70

'*Here was a sudden...*' Bell, *Sketches in Pen and Ink*, p.130

'*a gloomy great place...*' 1 July 1903, Virginia Woolf, *A Passionate Apprentice: The Early Journals, 1897–1909*, p.176

'*above one were...*' Bell, *Sketches in Pen and Ink*, p.129

'*a protest against...*' Bell to Margery Snowden, 15 March 1903, *Selected Letters of Vanessa Bell*, pp.9–10

'*living painters…*' Bell, *Sketches in Pen and Ink*, p.129

'*He never cares…*' Bell to Margery Snowden, 6 April 1904, *Selected Letters of Vanessa Bell*, p.14

'*One always must…*' Bell to Margery Snowden, 11 January 1905, *Selected Letters of Vanessa Bell*, p.29

'*I think it is safe…*' Regina Marler in Bell, Vanessa, *Selected Letters of Vanessa Bell*, ed. Regina Marler (London: Bloomsbury, 1993), p.49

'*making social history*' Spalding, *Vanessa Bell*, p.64

'*Great Rebels of the…*' quoted in Frances Spalding, *Roger Fry: Art & Life*, p.139

'*The autumn of 1910…*' Bell, *Sketches in Pen and Ink*, p.126

'*I remember those times…*' Bell, *Sketches in Pen and Ink*, p.132

'*As he sate [sic]…*' Bell, *Sketches in Pen and Ink*, p.121

'*without my knowing why*' Bell, *Sketches in Pen and Ink*, p.129

'*I gradually recognised…*' Roger Fry, *Vision and Design*, (London: Chatto & Windus, 1923), p.289

'*Who has not…*' Fry, *Vision and Design*, p.53

'*We may, then…*' Fry, *Vision and Design*, p.38

'*Gradually he would…*' Bell, Sketches in Pen and Ink, pp.132–3

'*miracle of rhythm*' Fry to Bell, c.1914, in Spalding, *Vanessa Bell: Portrait of the Bloomsbury Artist* (London: Tauris Peake, Bloomsbury, 2018), p.26

'*the first part of our affair…*' Bell to Fry, 29 November 1918, *Selected Letters of Vanessa Bell*, p.221

'*Under his influence…*' Virginia Woolf, *Roger Fry: A Biography* (London: Hogarth Press, 1940), p.122

'*I've really been painting…*' Bell to Fry, 11 September 1911, Charleston Trust Papers, Tate Gallery Archives, 8010, in Tickner 'Vanessa Bell: Studland Beach, Domesticity, and 'Significant Form', 1999. There is a note saying 'I am grateful to The Society of Authors as the Literary Representative of the Estate of Vanessa Bell for permission to quote from Bell's unpublished letters', footnote 5

'*The feeling on…*' Roger Fry in *Second Post-Impressionist Exhibition. British, French and Russian Artists*, exhibition catalogue (London: Ballantyne, 1912)

'*The one quality common…*' Clive Bell, *Art*, 1914, p.25

'*I often look at a picture…*' Bell to Leonard Woolf, 22 January 1913, in *Selected Letters*, p.133

'*To appreciate a work of art…*' Bell, *Art*, p.99

'*Whoever wishes to devote…*' Julian Barnes, 'Hodgkin: Words for H.H., *Keeping an Eye Open: Essays on Art*, (London: Jonathan Cape, 2015), p.259

Lucian Freud remarked that any words… Julian Barnes, 'Freud: The Episodicist', *Keeping an Eye Open: Essays on Art*, (London: Jonathan Cape, 2015), p.237

'*One defies a novelist…*' Virginia Woolf, in Foreword to 'Recent Paintings by Vanessa Bell: The London Artists' Association.', exhibition catalogue, 4 February to 8 March 1930

'*having done it…*' Quentin Bell, in *Tate Magazine*, from Quentin Bell, *Bad Art*, London 1989, p.119

'*In the soft peaked shape…*' The similarity to *Madonna del Parto* and *Madonna della Misericordia* has been pointed out by Lisa Tickner 'Vanessa Bell: Studland Beach, Domesticity, and "Significant Form"', p.77, and Spalding, *Vanessa Bell*, p.124.

'*that very jar on the nerves…*' Virginia Woolf, *To The Lighthouse* (London: Penguin Modern Classics, 2000), p.209

'*it loses that mobile unreliability…*' Solnit, *A Field Guide*, p.38

'*impure words*' Virginia Woolf, 'Walter Sickert' in *Collected Essays by Virginia Woolf, Volume Two*, (London: The Hogarth Press, 1966), p.237

'*you have I think kept me on the right path…*' Woolf to Fry, in Hermione Lee, *Virginia Woolf* (London: Chatto & Windus, 1996), p.288

'*a portrait of mother…*' Bell to Woolf, 11 May 1927, in *Selected Letters*, pp.317–18

Endnotes

'Lily stepped back to get her canvas...' Woolf, *To the Lighthouse*, p.187

'She saw it clear for a second...' Woolf, *To the Lighthouse*, p.226

'I meant nothing by The Lighthouse...' Woolf to Fry, in Hermione Lee 'Introduction', *To the Lighthouse*, p.xxi

'the present when backed by the past...' Woolf, *Moments of Being*, p.114

'silvery, misty-looking tower...' Woolf, *To the Lighthouse*, p.202

II
Winter Sea: Paul Nash

'A place like that...' Paul Nash, in Anthony Bertram, *Paul Nash: The Portrait of an Artist* (London: Faber, 1955), p.137

'The Sea. The Shore.' Paul Nash, *Outline: An Autobiography* (London: Lund Humphries, 2016; first published 1949), p.153

'another life...' Paul Nash to Gordon Bottomley, July 1945, in *Outline*, p.14

'What is to be done?' Virginia Woolf to Julian Bell, 2 May 1936, *The Letters of Virginia Woolf: Volume Six, 1936–1941*, eds Nigel Nicolson and Joanne Trautmann (London: Hogarth Press, 1980), p.33

'whole vision was eclipsed...' Nash, *Outline*, p.9

'torments of war...' Leonard Robinson, *Paul Nash: Winter Sea: The Development of an Image* (York: William Sessions, 1997, p.169

'acceptance of the violent and repressive' David Peters Corbett, in *Paul Nash: The Elements*, exhibition catalogue (London: Scala, Dulwich Picture Gallery, 2010), p.156

'exploration of threat and defence' Emma Chambers, *Paul Nash*, exhibition catalogue (London: Tate Publishing, 2016), p.13

'destructive feminine wiles' James King, *Interior Landscapes: A Life of Paul Nash* (London: Weidenfeld and Nicolson, 1987), p.92

'against the emotional pressure' Anthony Bertram, *Paul Nash: The Portrait of an Artist* (London: Faber, 1955), p.140

'*no apparent natural talent…*' Nash, *Outline*, p.58

'*a black and white artist…*' Nash, *Outline*, p.57

'*strange beauty of war*' Nash to Margaret Nash, 21 March 1917, *Outline*, p.168

'*happier in the trenches…*' Nash to Margaret Nash, 21 May 1917, *Outline*, p.179

'*roar of laughter*' Nash to Margaret Nash, 31 May 1917, *Outline*, p.180

'*I think you have a very special*' Roger Fry, in Simon Grant, 'A Landscape of Mortality', *Tate Magazine*, Issue 6, Spring 2006

'*I have just returned…*' Nash to Margaret Nash, 13 November 1917, *Outline*, pp.185–7

'*gay silver darts*' Nash described the shells as '*demented silver darts… nothing could be gayer, the clear blue pierced by silver darts & spangled with baby clouds*', Nash to Margaret Nash, 21 March 2017, *Outline*, p.169

'*wonderful trenches*', Nash to Margaret Nash, late March 1917, *Outline*, p.170

'*I have been jolted.*' Nash, *Weekly Dispatch*, 16 February 1919

'*untouched*' Nash, *Outline*, p.75

'*How interesting in form…*' Nash to Margaret Nash, 21 March 1917, *Outline*, p.169

'*fatal year*' Margaret Nash, *Outline*, p.206

'*the whole thing had come about…*' Margaret Nash, *Outline*, p.206

'*Dim through the misty panes…*' Wilfred Owen, *Dulce et Decorum Est*, published 1920

'*immediately convinced*' Herbert Read, *Paul Nash* (Harmondsworth: Penguin Books, 1944), p.8

'*We knew this landscape…*' Antony Bertram, in *Paul Nash: The Elements*, p.58

'*a sea of mud….*' quoted in Lyn Macdonald, *They Called It Passchendaele: The Story of the Third Battle of Ypres and of the Men Who Fought in It* (London: Joseph, 1979), p.188

Endnotes

'*Water had become a fetid medium…*' Philip Hoare, *Rising Tide Falling Star* (London: Fourth Estate, 2017), p.282

'*look up, to search the skies…*' Nash, *Outline*, p.63

'*[A place's] magic lay within itself…*' Nash, *Outline*, p.88

'*inner design of very subtle purpose*' Nash, *Outline*, p.27

'*delightful horror*' Edmund Burke, *A Philosophical Enquiry into the Origin of Our Ideas of the Sublime and Beautiful*, (first published 1757), p.148

'*A level plain of a vast land…*' Edmund Burke, *A Philosophical Enquiry into the Origin of Our Ideas of the Sublime and Beautiful* (first published 1757), p.131

'*spirit of the place*' John Ruskin, *Modern Painters, Volume IV containing Part V, Of Mountain Beauty* (Kent: George Allen, 1888), p.24

'*deep wide sea of misery*' Percy Bysshe Shelley, *Lines Written Among the Euganean Hills*, 1818

'*Dark-heaving; boundless…*' Lord Byron, *Childe Harold's Pilgrimage*, 1812–18

'*cold and cruel waters*' Nash, *Outline*, pp.32–3

'*blue and beguiling*' Nash, *Outline*, p.33

'*spiteful*' Nash to Margaret Nash 1926, quoted in Robinson, *Winter Sea*, p.46

a richly Romantic symbol Nash was flattered when in 1945, shortly before his death, the art historian Hartley Ramsden wrote an article comparing *Winter Sea* to Turner's *Rough Sea with Wreckage*. He wrote to her saying that he had always thought it one of his best works and that he was, 'very anxious to study Turner somehow. In Turner's late work lies a great secret I believe. I feel it is for me to look for it.' (See Robinson, *Winter Sea*, pp.163–4)

'*ne'er express, yet cannot all conceal*' Lord Byron, *Childe Harold's Pilgrimage*, 1812–18

'*backwards into the future*' Jay Winter, *Sites of Memory, Sites of Mourning: The Great War in European Cultural History* (Cam-

246

bridge: Cambridge University Press, 1995), p.222

'A complex traditional vocabulary' Jay Winter, *Sites of Memory, Sites of Mourning: The Great War in European Cultural Histor,* (Cambridge: Cambridge University Press, 1995), p.223

'You might feel – under certain influences...' Nash to Sir Kenneth Clark, 11 March 1941 IWM, quoted at catalogue entry for the artwork on Tate website

'dangerously like a witch' Nash, *Outline*, p.27

'a beautiful legendary country' Nash, 1911, *The Elements*, p.37

escape, a *refuge*, a *release* e.g. 'But when I am at liberty to change my mood, and can turn to the geometrical planning of a textile or other form of industrial design, I fancy that I gain something in the release from all representational problems...' Nash, *Axis,* 1935, quoted in Emma Chambers, (ed.), *Paul Nash*, exhibition catalogue (London: Tate Publishing, 2016), p.67

'Two great wars demanded...' E.M. Forster, *Maurice* (London: Edward Arnold, 1971), p.240

'I want a period of tranquillity...' T.S. Eliot to his mother, 20 September 1920, quoted in Robert Crawford, *Young Eliot: From St Louis to The Waste Land* (London: Vintage, 2016), p.359

'Consider its archduke...' Paul Fussell, *The Great War and Modern Memory* (Oxford: OUP, 2000), p.326

'Eliot dined last Sunday...' Virginia Woolf, quoted in Crawford, *Young Eliot*, pp.423–4

'A sight, an emotion, creates this wave...' Virginia Woolf, *The Letters of Virginia Woolf: Volume Three, 1923–1928*, eds Nigel Nicolson and Joanne Trautmann (London: Hogarth Press, 1975) p.247

'The poet is occupied with the frontiers...' T.S. Eliot, *The Music of Poetry* (Glasgow: Jackson, Son & Company, 1942) p.15

'the rhythm of the steppes...' T.S. Eliot, 'London Letter', *The Dial*, September 1921, p.452–5

'a way of controlling...' T.S. Eliot, 'Book Review: Ulysses, Order, and Myth', *The Dial*, November 1923, p.483

'*rhythmical grumbling*' T.S. Eliot, Harvard Lecture, quoted in *The Waste Land* facsimile (published 1971), quoted in 'T.S. Eliot', *Poetry Foundation*

'*When a poet's mind is perfectly equipped…*' T.S. Eliot, quoted in Crawford, *Young Eliot*, pp.386–7

'*Law and order was in his blood…*' Lance Sieveking, quoted in Chambers (ed.), *Paul Nash*, exhibition catalogue, p.67

'*The greatest mystery is obtained…*' Nash, *Outline*, p.87

'*the release of imprisoned thoughts…*' Nash, *Manchester Evening News*, 1937, in Pennie Denton, *Seaside Surrealism: Paul Nash in Swanage* (Swanage: Peveril Press, 2002), p.64

'*I do not say I dreamed the picture….*' Nash, quoted in Fraser Jenkins, *Paul Nash: The Elements*, p.159

<div align="center">

III

Seascape – ships sailing past the Longships: Alfred Wallis

</div>

'*no way*' Jim Ede, *A Way of Life: Kettle's Yard* (Cambridge: Cambridge University Press, 1984), p.17

'*They would come by post…*' Ede, *A Way of Life*, p.16

'*What I do mosley…*' Wallis to Ede, 6 April 1935, in Fisher and Nairne, (eds.) *Alfred Wallis: Ships and Boats*, exhibition catalogue (Cambridge: Kettle's Yard, 2012), p.5

'*I do most what used to Be…*' Wallis to Ede, 9 February 1934

'*All I do is houtht of my own head…*' Wallis to Ede, 24 July 1935

'*most all i do is what use to Be…*' Wallis to Ede, 12 February 1934

'*We used to laugh at it really…*' Emily Woolcock, in Mullins et. al., 'Icons of the Sea – recollections of Alfred Wallis', *The Listener*, 20 June 20, 1968

'*I could 'ave 'ad 'undred…*' Edwin B. Mullins, *Alfred Wallis: Cornish Primitive Painter* (London: Macdonald, 1967), p.15

'*lovely dark browns…*' Ben Nicholson, 'Alfred Wallis', *Horizon*, vol. 7 January 1943

Endnotes

'*the school of artists...*' Leslie Stephen to Charles Eliot Norton, 8 September 1889, *Selected Letters of Leslie Stephen*, vol. 2, p.369

'*all Right to make But not to sell...*' Wallis to Nicholson, 6 June 1933

'*i am self taught...*' Wallis in Matthew Gale and Richard Ingleby, *Two Painters: Works by Alfred Wallis and James Dixon*, exhibition catalogue (London: Merrell Holberton, Irish Museum of Modern Art, Tate Gallery St Ives, 1999), p.66

'*Well I don't use paint artists use...*' Wallis in Michael Bird, *The St Ives Artists: A Biography of Place and Time* (London: Lund Humphries, 2008 & 2016), p.51

'*bust up all the sophistication...*' Nicholson in Jeremy Lewison, *Ben Nicholson: The Years of Experiment, 1919–1939*, exhibition catalogue (Cambridge: Kettle's Yard, 1983), p.12

'*not conforming to the general attitude...*' Paul Nash, 'Ben Nicholson's Carved Reliefs', *Architectural Review*, October 1935, pp.142–3

'*much more serious than I was...*' Nicholson in Lewison, *Ben Nicholson: The Years of Experiment*, p.11

'*Admiral Wallis*' Christopher Wood in Winifred Nicholson, *Unknown Colour: Paintings, Letters, Writings* (London: Faber, 1987), p.93

'*More and more influence de Wallis...*' Wood in Nicholson, *Unknown Colour*, p.93

'*ship-feeling...pitching and a tossing...*' Ede, *A Way of Life*, p.220

'*[He] captures the universal aspect of his picture...*' Ede, *A Way of Life*, p.220

'*utmost sincerity*' Nicholson, *Unknown Colour*, p.93

'*extraordinarily integrated*' Barbara Hepworth, in Whybrow, Marion, *The Innocent Eye: Primitive and Naïve Painters in Cornwall* (Bristol: Sansom & Company, 1999), p.53

'*real*' Nicholson to Ede, 29 August 1942, in *Two Painters*, p.103

'*not as paintings but as events...*' Nicholson, 'Alfred Wallis', *Horizon*, January 1943

'*It is salutary that in a world...*' Ede, *A Way of Life*, p.55

'*rock-colour...sand-colour*' Nicholson, 'Alfred Wallis', *Horizon*, January 1943

'*very fierce and lonely little man*' Nicholson, 'Alfred Wallis', *Horizon*, January 1943

'*piggy-'eaded*' '*a hermit*', '*awful queer*', not '*exactly right in his head*' – in Mullins et. al., 'Icons of the Sea – recollections of Alfred Wallis', *The Listener*, June 20, 1968 and Berlin, Sven, *Alfred Wallis, Primitive* (London: Nicholson & Watson, 1949), p.50

'*sender of messages...*' Mullins, *Alfred Wallis*, p.29

'*the paints...percecution and gelecy*' Wallis to Ede, 27 July 1938

disposed of in a huge bonfire Christopher Wood wrote to Winifred Nicholson about this: 'When someone dies here, they burn the mattress, the clothes and even the bedstead of the defunct on the beach. The male folk, these darkly dressed men, carry it all down on their shoulders and make a huge fire among the rocks and stand round with paraffin cans in hand, musing on the life of the dead person.', *Unknown Colour*, pp.94–5

'*simply magnificent – just like an epic poem!*' Barbara Hepworth n Sven Berlin, *Alfred Wallis: Primitive*, p.87

'*I've got one like that at home.*' Nicholson, *Horizon*, 1943

'*Of course, there is the possibility...All the same we must have at least Beveridge!*' Sven Berlin, *Alfred Wallis: Primitive*, p.59

'*in the end it turns out that civilization...*' Woolf, in Hermione Lee, *Virginia Woolf* (London: Chatto & Windus, 1996), p.268

'*Fascistic*' Quentin Bell in Janet Malcolm, 'A House of One's Own' in *Forty-One False Starts: Essays on Artists and Writers* (London: Granta, 2014), p.95

'*pictures by people all of whom have earned, and earn...*' T. Harrison, introduction to *Unprofessional Painting*, exhibition catalogue (Gateshead: 1938), p.1, in Michael Bird, *The St Ives Artists*, p.77

'*ancient towns and cathedral cities ...*' H.V. Morton, *The Call of England*, (York: Metheun,1928)

'*Even with the most perfect reproduction...*' Walter Benjamin, *The*

Work of Art in the Age of Mechanical Reproduction (London: 2008, first published 1936), p.5

'*From a photographic plate...*' Walter Benjamin, *The Work of Art in the Age of Mechanical Reproduction* (London: 2008, first published 1936), p.12

'*Nature, with all its violence and beauty...*' Robert G. Lee and Sabine Wilk, 'Forest as Voik: Ewiger Wald' and the Religion of Nature in the Third Reich', *Journal of Social and Ecological Boundaries*, Spring 2005, p.22

'*real politics*' rather than '*art politics*' Gardner-Huggett, Joanna P, 'Myfanwy Evans: 'Axis' and a Voice for the British Avant-Garde.' *Woman's Art Journal* Vol 21. no. 2 (Autumn 2000–Winter 2001), p.24

'*It is time we forgot Art and Abstract...*' S.J. Woods in Frances Spalding, '"Powerful Emotive Agents": The Association between Ben Nicholson and John Piper', *The Burlington Magazine*, vol. 149, no. 1255, Art in Britain (October, 2007), p.702

'*fusing of art and daily living... a refuge of peace and order*' Ede, *A Way of Life*, pp.17–18

'*Alfred Wallis was experienced in the ways of ships...*' Ede in *Alfred Wallis: Ships and Boats*, pp.7–8

'*I do not put collers wha do not Belong...*' Wallis in *Alfred Wallis: Ships and Boats*, p.5

IV
Shipbuilding on the Clyde: Burners: Stanley Spencer

'*the most important picture...*' 'Art Exhibitions', *The Times*, 28 February 1927, p.17

'*blood, toil, tears and sweat*' Winston Churchill speech to the House of Commons, 13 May 1940

'*Let us therefore brace ourselves to our duties...*' Winston Churchill speech to the House of Commons, 18 June 1940

'The only thing that ever really frightened me...' Churchill in Jonathan Dimbleby, *The Battle of the Atlantic: How the Allies Won the War* (London: Penguin Books, 2016), p.xxviii

'dominating factor...' Churchill in Dimbleby, *The Battle of the Atlantic,* p.xx

'I believe the outcome of this struggle...' F.D. Roosevelt in Dimbleby, *The Battle of the Atlantic,* p.132

3000 ships brought 68 million tons of imports to the country each year see Parkin, Simon, *A Game of Birds and Wolves: The Game that Revolutionised the War* (London: Hodder & Stoughton, 2019), p.22

the U-boats had sunk more than 1200 ships see Parkin, *A Game of Birds and Wolves,* p.60

Lithgow's shipyard had produced an unprecedented total of 84 merchant steamers see Patrick Patrizio and Frank Little (eds), *Canvassing the Clyde: Stanley Spencer and the Shipyards* (Glasgow: Glasgow Museums, 1994), unpaged

'quiet, no brash, no push...' Katie Chalmers, in *Canvassing the Clyde,* unpaged

'square submarine...' Gossip 'Press Release' for Crawford Snowdon, Evening News, Carmelite House EC4, 11 October 1940, IWM archives, Art/WA2/03/061/1/43

'somewhat rusty' Spencer, May 1940, in Andrew Glew, *Stanley Spencer, Letters and Writings* (London: Tate Publishing, 2001), p.196

'an assurance which tell me what artists they could be.' Spencer in *Canvassing the Clyde,* nd from Tate Archives 733/2/45

'cosy' Spencer in *Canvassing the Clyde,* nd, unpaged.

'liberation of form and colour...' Ben Nicholson, October 1941, in Lisa Tickner and Peters Corbet, *British Art in the Cultural Field, 1939–69* (Chichester: Wiley-Blackwell, 2012), p.24

'an authentic scrap of experience' Eric Newton, 1940, in Brian Foss, *War Paint, Art, War, State and Identity in Britain, 1939–1945* (New Haven and London: Yale UP, 2007), p.123

'*Though the English are energetic…*' Herbert Read, 1941, in Monica Bohm-Duchen, *Art and the Second World War* (Farnham: Lund Humphries, 2013), p.42

'*Bury them in the Bowels of the Earth…*' Winston Churchill, June 1940, in James Stourton, *Kenneth Clark, Life, Art and Civilisation* (London: William Collins, 2016), p.156

'*a hunger of the spirit*' Myra Hess, in 'Myra Hess's wartime concerts' on The National Gallery website

'*proof that although we are at war*' Clark, 1940, in Stourton, *Kenneth Clark*, p.167

'*beehive*' Tancred Borenius, 'The Picture of the Month', *Burlington Magazine* 82, (1943), p.55

'*There are certain things in life…*' Clark, 1939, in Stourton, *Kenneth Clark*, p.193

'*unchanging taste of the masses*' Joseph Goebbels, in Brian Foss, 'Message and Medium: Government Patronage, National Identity and National Culture in Britain, 1939–45', *Oxford Art Journal*, Vol 14, No 2 (1991), p.56

'*an arm of the foreign policy*' in Margaret Garlake, (ed.), *Artists and Patrons in Post-war Britain: Essays*, (Aldershot: Ashgate, 2001), p.5

'*bombed and burned into democracy*' J.B. Priestley in Simon Schama, *A History of Britain 3* (London: BBC Worldwide, 2002), p.404

'*Extraordinary*' and '*magnificent*' are words Official 'Records of the War' *The Illustrated London News* (21 December 1940)

'*produce more masterpieces of this kind*' in Kenneth Pople, *Stanley Spencer: A Biography* (London: Collins, 1991), p.415

'*Whereas in 1917 war was something far away…*' Eric Newton, 'The Poetry of War' *The Sunday Times*. (Dec. 29, 1940). Eric Newton was naturally predisposed in Spencer's favour, having written a short monograph on him. Thank you to Carolyn Leder for pointing this out.

'*Many of the places and corners of Lithgow's factory…*' Spencer to E. Dickey, 1 June 1940 Imperial War Museum Archive GP / 55 /31 (A)

'because I feel that Cookham' Spencer in Patrick Wright 'Berkshire to Beijing', *Guardian*, 17 March 2001

'I seem to have got shelved…' Spencer, c.1939, Notebook [1939–41], Glew, *Stanley Spencer, Letters and Writings*, p.195

'I keep finding places & things…' Spencer, 10 May 1940, Glew, *Stanley Spencer, Letters and Writings*, p.198

'homely touch…' Spencer, not dated, Imperial War Museum Archive GP / 55 /31 (A)

'People generally make a kind of home…' Spencer to E. Dickey, 1 June 1940 Imperial War Museum Archive GP / 55 /31 (A)

'most spiritually themselves…' Spencer, in *Canvassing the Clyde*, unpaged, from Spencer correspondence 1941 Tate Archives 73/3/34

'It is not that the coils of rope suggest halos…' Spencer, in *Canvassing the Clyde*, unpaged, from Spencer journal, not dated, Tate Archives 73/3/34

'preserve the impressions one gets…' Spencer, in Keith Bell, *Stanley Spencer: A Complete Catalogue of the Paintings* (London: Phaidon, Christie's and the Henry Moore Foundation, 1992), p.167

'It was only through the great kindness of the Scots…' Spencer, Spring 1944, in Glew, *Stanley Spencer, Letters and Writings*, p.219

'Sometimes when I had let fly…' Panel text – *Angels and Dirt* exhibition Hepworth Wakefield. This was likely to be Joe Buchanan, a boxing champion. Thank you to Carolyn Leder for confirming this.

'I had the feeling of an enemy invasion…' George Orwell, *Coming Up for Air* (London: Penguin Classics, 2000), p.192

'All the culture that is most truly native…' George Orwell, 'The Lion and the Unicorn: Socialism and the English Genius', 1941

'the fight against rural development…' Harris, *Romantic Moderns*, p.176

'clear vision of a small English town…' Clark, in Stourton, p.186

'salvation and fulfilment of England' Edmund Blunden, *English Villages* (London: William Collins,1941), p.32

'recapture the glory…' Aneurin Bevan, June 1948, in David Matless, *Landscape and Englishness*, p.319

'*It is a strange, but I think true, thing...*' Spencer, in *Canvasing the Clyde*, Spencer-Gleadowe correspondence, not dated, Tate Archives 733/2/37

'*I need people in my pictures as I need them in my life...*' Spencer, in *Canvasing the Clyde*, from Tate Gallery Archives 733/2/52, 1936

'*rigid with wonder*' Spencer, 12 August 1948, in Glew, *Stanley Spencer: Letters and Writings*, p.231

'*When the end of the 1930s drew near...*' Spencer, in Pople, *Stanley Spencer: A Biography*, p.445

V
Offshore: Peter Lanyon

'*wounds in the character of the native Cornishmen...*' Peter Lanyon, in Andrew Causey, *Peter Lanyon: Modernism and the Land* (London: Reaktion, 2006), p.144

an audio recording of his thoughts that morning – many details from these opening paragraphs are taken from the transcript of this recording, reproduced in Toby Treves, *Peter Lanyon: Catalogue Raisonné of the Oil Paintings and Three-Dimensional Works* (London: Modern Art Press, 2018), pp.422–3

'*The place I went to was Portreath...*' Lanyon, in Treves, *Peter Lanyon: Catalogue Raisonné of the Oil Paintings and Three-Dimensional Works*, pp.422–3

'*The image really begins to form...*' Lanyon, in Treves, *Peter Lanyon: Catalogue Raisonné of the Oil Paintings and Three-Dimensional Works*, p.422–3

'*The "Cold war" is in essence a battle for men's minds...*' in Margaret Garlake, *New Art, New World: British Art in Post-War Society* (New Haven, London: Yale University Press, 1998), p.18

'*demonstrate to the world the recovery of the UK...*' in Garlake, *New Art, New World*, p.73

Since the war, landscape art was valued less for being symbolic of national identity Michael Andrews has put it, 'the countryside represented the world as it used to be, before urbanization and industrialization, and consolidated the myth of a natural order from which modern humanity had strayed.' Andrews, Malcolm, *Landscape and Western Art* (Oxford: Oxford University Press, 1999), p.151

'exactly what we are fighting for' Herbert Read, in Garlake, *New Art, New World,* p.66

'radically alter[ed] our concept of nature...' Kenneth Clark, *Landscape into Art* (Boston: Beacon Press, 1961), p.140 [science has intervened by radically altering our concept of nature]

'science has taught us the reverse' Clark, *Landscape into Art* p.142

of destroying the 'natural order' Clark, *Landscape into Art,* p.141

'popular, transient, expendable, low-cost...' Richard Hamilton, letter to the architects Peter and Alison Smithson, January 1957

'As nature gets demoted from the centre of British aesthetics...' Lawrence Alloway in Causey, *Peter Lanyon,* p.191

there is a greater concentration of archaeological sites in this region 'NE371: West Penwith', *Natural England publications,* no. 156

'preserve the independent character of its sons...' in Causey, *Peter Lanyon,* p.115

in opposition to his middle-class friends In May 1961, the artist Patrick Heron wrote to Ben Nicholson describing a local planning tribunal to discuss the opening of a tin mine on Zennor; a stunningly wild section of the coastline where Heron lived and which he battled hard to protect. To his chagrin, the one witness called in support of the application, arguing that the coastline was 'depressing' and that a working mine would enhance it by making it feel more Cornish, was his childhood friend, Peter Lanyon. (See Emma Acker, 'Artistic Identity in a Transatlantic Age: Patrick Heron, Peter Lanyon, and the New American Painting', *The British Art Journal,* vol. 10, no. 3 (Winter/Spring 2009/10), p.168)

'cultural value in the last century…' Chris Stephens, *Peter Lanyon: At The Edge of Landscape* (London: 21, 2000), p.84

'Sometimes a landscape seems to be less a setting for the life of its inhabitants…' John Berger, in Andrews, *Landscape and Western Art*, p.21

'painterly version of Method Acting' Michael Bird, *The St Ives Artists: A Biography of Place and Time* (London: Lund Humphries, 2016), p.65

'a sailor's knowledge of the coastline…' Berger, in Stephens, *Peter Lanyon*, 2000, p.101

'head and shoulders above his rivals' Alloway, in Causey, *Peter Lanyon*, p.190

'Inside and outside are inseparable…' Maurice Merleau-Ponty, *Phenomenology of Perception* (London: Routledge, 2005), p.474

'It is as though our vision…' Merleau-Ponty, in Sarah Bakewell, *At the Existentialist Café: Freedom, Being, and Apricot Cocktails* (London: Chatto & Windus, 2016), p.236

'Here sea and land answer the deep roots…' Lanyon, in *Art Cornwall*

'certain landscapes that are immensely potent…this kind of terrain' Patrick Heron, 1998, in Acker, 'Artistic Identity in a Transatlantic Age', p.164

'projection of pictures in my head…' Adrian Stokes, in Causey, *Peter Lanyon*, p.110

'Everything is charging…' Jackson Pollock, in John-Paul Stonard, 'Abstract Expressionism – not just macho heroes with brushes', *Guardian*, 3 September 2016

'A vertical black line against a grey background…' in Frank Spicer, 'The New American Painting, 1959', in *Modern American Art at Tate 1945–1980*, Tate Research Publication, 2018

'unnaturally luminous fields…' in Spicer, *The New American Painting*

'hit on symbols expressive…our time' in Spicer, *The New American Painting*

'*poet...beautiful Romantic*' Mark Rothko, 'Lanyon's Last Flight', first broadcast on BBC Radio 4 in May 2011

'*an equal, a mirror...*' Lanyon, in Treves, *Peter Lanyon*, p.32

'*we see nothing truly till we understand it.*' John Constable, 1836, Royal Institute lecture

'*I believe that landscape, the outside world of things...*' Lanyon, January 1964, in Stephens, *Peter Lanyon*, p.23

'*therapeutic...release meaning*' Lanyon, in Causey, *Peter Lanyon*, p.219

'*purpose of Art...*' Lanyon, c.1948, in Stephens, *Peter Lanyon*, p.23

'*struggle, disillusionment, distress and disgust*' Lanyon, in Stephens, *Peter Lanyon*, 2000, p.139

'*real*' *identity* Lanyon, 1949, in Stephens, *Peter Lanyon*, p.140

'*These things take us in to places...*' Lanyon, 1964, in Stephens, *Peter Lanyon*, 2000, p.23

'*It's scary as hell*', '*A shocking experience*', 'Lanyon's Last Flight', first broadcast on BBC Radio 4 in May 2011

'*I would not be surprised if all my painting now...*' Lanyon, 1954, in Stephens, *Peter Lanyon*, p.126

'*A survivor hears nothing more...*' Sylvia Plath, *The Bell Jar* (London: Faber, 2013; first published 1963), p.233

'*It was a death he was expecting...*' Sheila Lanyon, 25 September 1964, in Stephens, *Peter Lanyon*, p.179

'*In a moving elegy to Lanyon...*' W.S. Graham, 'The Thermal Stair', *New Collected Poems* (London: Faber, 2004), p.164

'*Without this urgency of the cliff-face...*' Lanyon, 1948, in Stephens, *Peter Lanyon*, p.137

'*only one emotion is possible for this painter...*' Merleau-Ponty, 'Cézanne's Doubt', in *The Merleau-Ponty Aesthetics Reader*, (ed.) Michael B. Smith (Northwestern University Press, 1993), p.68

'*The effort to understand and to live with...*' – Lanyon, not dated, in Stephens, *Peter Lanyon*, p.22

Endnotes

VI
Crest: Bridget Riley

'*a widespread and powerful new direction in contemporary art*' press release, The Museum of Modern Art, *The Responsive Eye*, 25 February 1965

'*My heart sank…*' Bridget Riley, in Robert Kudielka, (ed.), *Bridget Riley: Dialogues on Art* (London: Zwemmer, 1995), p.69

'*revolting, even for New York*' Jerrold Lanes, 'New York', *The Burlington Magazine*, vol. 107, no. 745, April, 1965, p.219

'*It was the kind of fame that would have appalled…*' Riley, in Robert Kudielka (ed.), *Bridget Riley: Dialogues on Art* (London: Zwemmer, 1995.), p.70

'*What had happened?*' Riley, 'Perception is the Medium' (1965), in Robert Kudielka, (ed.), *The Eye's Mind: Bridget Riley: Collected Writings 1965–1999* (London: Thames & Hudson, Serpentine Gallery, De Montfort University, 1999), p.66

'*I haven't. People's reaction is their reaction.*' Riley, in Alastair Sooke, 'Bridget Riley on how nature inspired her Op Art masterpieces', *Telegraph*, 23 October 2019

'*girl, unassuming and unspoilt*', *Guardian*, 1965, in Francis Follin, *Embodied Visions: Bridget Riley, Op art and the Sixties* (London: Thames & Hudson, 2004), p.119

'*with a cold ferocity*' Robert Melville, August 1965, *New Statesman*, in Follin, *Embodied Visions*, p.157

'*cruel formula*' Robert Melville, *Architectural Review*, 1964, in Follin, *Embodied Visions*, p.157

'*visual torments*' Anon, *Time*, 1964, in Follin, *Embodied Visions*, p.157

'*masochistic*' David Sylvester, 1967, in *The Eye's Mind*, p.75

'*basic information*' Riley, 'Perception is the Medium', *The Eye's Mind,* p.66

'*paradise*' Riley, 'Personal Interview' by Nikki Henriques (1988), *The Eye's Mind*, p.21

259

'*She wasn't a painter...*' Riley, 'Personal Interview' by Nikki Henriques (1988), *The Eye's Mind*, p.22

'*Changing seas and skies...swept over the sea*' Riley, 'The Pleasures of Sight', (1984), *The Eye's Mind*, pp.30–4

'*the essence of vision*' Riley, in 'The Pleasures of Sight' in *The Eye's Mind*, p.33

'*a true masterclass...*' Riley, in Paul Moorhouse, *Bridget Riley: A Very Very Person: The Early Years* (London: Riding House, 2019), p.192

'*through its paces*' Riley, 'At the End of My Pencil', *The London Review of Books*, vol. 31, no. 19 October 2009

'*repose, disturbance and repose*' Riley, 'Perception is the Medium' (1965), *The Eye's Mind*, p.68

'*I wanted to bring about some fresh way of seeing*' Riley, 'The Pleasures of Sight', *The Eye's Mind*, p.32

'*I draw from nature*' Riley, 'Working with Nature' (1973), *The Eye's Mind*, p.88

'*we actually experience in looking...previously less accessible.*' Riley, in 'The Experience of Painting: talking to Mel Gooding' (1988), in *The Eye's Mind*, p.121

'*Ours is a culture based on excess...*' Susan Sontag, *Against Interpretation, and other essays* (New York: Farrar, Strauss & Giroux, 1967), p.10

'*even the word perception...*' Riley, quoted in *Embodied Visions*, p.64

'*materialism, alienation from nature...*' Albert Hofmann in 'Albert Hofmann Obituary', *Telegraph*, 29 April 2008

'*through which one can certainly see*' Riley, 'The Pleasures of Sight', *The Eye's Mind*, p.33

'*Running...early morning...cold water...*' Riley, 'Interview with David Sylvester' (1967), *The Eye's Mind*, p.74

'*Who has known the ocean?*' Rachel Carson, 'Undersea', *The Atlantic Monthly*, September 1937, pp.322–5

'*the world is full of salt smell...*' Carson, in Jill Lepore 'The Right Way to Remember Rachel Carson', *The New Yorker*, March 26, 2018

'*very much to do the Wonder book…*' Carson, in Linda Lear 'Introduction', Rachel Carson, *The Sense of Wonder: A Celebration of Nature for Parents and Children*, (New York: Harper Collins, 1998), p.11

'*Mankind has gone very far into an artificial world…lust for destruction.*' Carson, in Jennifer Stitt, 'For Rachel Carson, wonder was a radical state of mind', *Aeon*, 27 September 2019

VII

World Within A World, Duncasby Head to Lands End, Scotland Wales England, 1973: Hamish Fulton

'*evil days*' Henry David Thoreau, 'Walking', *The Atlantic*, first published May 1862

'*breakdown of society…*' James Lovelock, in Dominic Sandbrook, *State of Emergency: The Way We Were: Britain, 1970–1974* (London: Allen Lane, 2010), p.217

Britain had lost a quarter of its hedgerows… Marion Shoard, *The Theft of the Countryside* (London: Temple Smith, 1980), p.16

'*to living in the head, studio or city*' Fulton, in Ben Tufnell et. al., *Walking Journey*, exhibition catalogue (London: Tate Publishing, 2002), pp.85 and 113

Earth was a sacred source of energy details of Native American beliefs from Frédéric Gros, *A Philosophy of Walking* (London: Verso, 2015), p.104

'*the lack of influence of nature…*' Fulton, in *Walking Journey*, p.107

'*part of the reason why…*' Fulton, *Walking Journey*, p.25

'*An 'artwork' may be purchased…*' Fulton, *Words from Walks*, Summer 2019, p.2

'*To get know to my own country*' Conversation with the artist, 12 February 2020

'*Arriving at Santiago…*' Gros, *A Philosophy of Walking*, p.117

'*breaking a path through terrain...*' Tim Ingold, *Being Alive: Essays on Movement Knowledge and Description* (London: Routledge, 2011), p.178

'*Wayfaring... is a fundamental way in which humans inhabit the earth.*' Tim Ingold, *Lines: A Brief History* (London: Routledge, 2007), p.81

words for 'country' are the same as the words for 'line' Ingold, *Lines*, p.80, referencing Bruce Chatwin's *Song Lines*

'*I do not believe...*' W.G. Sebald, *The Rings of Saturn* (London: Vintage, 2002), p.52

'*the reason I'd come to the end...*' Kathleen Jamie, *Findings* (London: Sort of Books, 2005), p.164

'*The issue of water has become of global significance...*' Fulton, in Jonathan Watkins and Sarah Martin (eds), *Walking in relation to everything: Hamish Fulton*, exhibition catalogue (Margate and Birmingham: Turner Contemporary and Ikon, 2012), p.32

'*the areas we had touched were small islands*' Bill McKibben, 'The World as Artefact' in *Walking Journey*, p.18

'*Walking is not about recreation...*' Fulton, 'Walking Through', 1999, in *Walking Journey*, p.27

'*my year of the unknown road ahead*' Fulton, *Words from Walks*, Summer 2019, p.4

VIII

The Last Resort: Martin Parr

'*Our historic working class...*' David Lee, 1986, *Arts Review*, in Gerry Badger 'A Good Day Out: Reflecting Upon the Last Resort' in *The Last Resort: Photographs of New Brighton* (Stockport: Dewi Lewis Publishing, 2009), pp.6–7

'*a clammy, claustrophobic nightmare world...*' Robert Morris, *The British Journal of Photography*, 1986, in Gerry Badger 'A Good Day Out: Reflecting Upon the Last Resort' in The Last Resort:

Photographs of New Brighton (Stockport: Dewi Lewis Publishing, 2009), pp.6–7

'an almost Bosch-ian portrait of degradation' Travis Elborough, *Wish You Were Here* (London: Sceptre, 2010), p.223

'You do have people who say he defeated our town and for the last 20 years we have never bounced back...' Tracy Marshall, in Diane Smyth, 'New Brighton Revisited by Martin Parr, Tom Wood, and Ken Grant', *British Journal of Photography*, 12 July 2018

'No one batted an eyelid...' Martin Parr in Ayla Angelos, '"All you see is lazy photography everywhere"': Martin Parr in conversation with It's Nice That', *It's Nice That*, 9 September 2019

'You could drop dead...' Ian Graham in *The Last Resort: Photographs of New Brighton*, (Stockport: Dewi Lewis Publishing, 1998), unpaged

"Elysium of English Watering Places" – in Anthony M. Miller, *The Inviting Shore: A Social History of New Brighton, 1830–1939, Part 1* (Birkenhead: Countyvise, 1996) unpaged

'In the researcher's experience....' Survey of 1972 in John K. Walton, *The British Seaside: Holidays and Resorts in the Twentieth Century* (Manchester: Manchester University Press, 2000), p.65

'faded out' in *The Last Resort*, 1998, unpaged

'The pier had been condemned...' Paul Theroux, *The Kingdom by the Sea: A Journey Around the Coast of Great Britain* (London: Penguin, 1984, first published 1983), pp.350–1

'lying stiffly on the beach...going abroad.' Theroux, *The Kingdom by the Sea*, p.199

'[The Last Resort] was a political body of work...' Parr in Martin Parr and Quentin Bajac, *Parr by Parr: Quentin Bajac meets Martin Parr: discussions with a promiscuous photographer* (Amsterdam: Schilt, c.2010), p.37

'Anti-postcard pictures' Parr in Tamsin Blanchard, 'A Life Less Ordinary', *Observer*, 13 January 2002

'perfect middle-class pedigree' Parr in Val Williams, *Martin Parr* (London: Phaidon Press, 2014), p.271

'*less about New Brighton...*' Parr in William Bishop, 'Visions of a New Brighton: William Bishop interviews Martin Parr about the faded resort', *British Journal of Photography*, 18 July 1986

'*explore my own prejudices*' Parr in *Parr by Parr,* p.44

'*degradation*' Elborough, *Wish You Were Here*, p.222

'*post-industrial hell hole*' Robert Morris, *British Journal of Photography*, August 1986, in Williams, *Martin Parr*, p.160

'*primarily a class response*' Williams, *Martin Parr*, p.160

'*parochial*' Badger, in *The Last Resort*, p.6

'*There is no single...*' John Urry, *The Tourist Gaze 3.0* (Los Angeles, London: SAGE, 2011, first published 1990), p.2

'*natural, wild nature*' Pierre Bourdieu, *Distinction* (Abingdon: Routledge Classics, 2010), p.220

'*The Independent Guide...*' Urry, *The Tourist Gaze*, p.107

'*art and cultural consumption...*' Bourdieu, *Distinction*, p.xxx

'*My parents were birdwatchers...*' Parr, in Maisie Skidmore, 'By the Seaside', Magnum Photos

'*Martin was preoccupied...*' Ken Grant, in Smyth, 'New Brighton Revisited by Martin Parr, Tom Wood, and Ken Grant', *British Journal of Photography*

'*You can read a lot about a country...*' Martin Parr, *Life's A Beach* (New York: Aperture, 2013), unpaged

'*Nothing is more bewildering...*' Theroux, *The Kingdom by the Sea*, p.216

'*gratuitously cruel social critic...*' Colin Jacobson, in Williams, *Martin Parr*, p.271

'*from another planet*' Henri Cartier-Bresson, on Martin Parr's website

'*the dedicated enemy...*' Philip Jones Griffiths, in Phillip Prodger, *Only Human: Photographs by Martin Parr*, exhibition catalogue (London: Phaidon Press, 2019), p.30

'*If I saw Martin...*' Grayson Perry, in *Only Human*, p.11

Endnotes

IX

The Last Thing I Said to you is don't leave me here. 1: Tracey Emin

'Didn't millions cheer…' Godfrey Barker, in James Meek, 'Art into
Ashes', *Guardian*, 23 September 2004

'perfectly replaceable' Tom Lubbock, in James Meek, 'Art into
Ashes', *Guardian*, 23 September 2004

'Why can't Brit Art's finest…' Hugo Rifkind, in James Meek, 'Art
into Ashes', *Guardian*, 23 September 2004

'Lots of people say…' Tracey Emin, in Mark Lobel, 'Inside Tracey's
Bed', *Varsity Online*, 6 October 2000

'Everyone knew he had broken in….' Emin, *Exploration of the Soul*
(1994). A version of this event, with slightly different wording, is also
retold in Tracey Emin, *Strangeland* (London: Sceptre, 2005), pp.7–8

'a gang of blokes …' Emin, *Strangeland*, p.52, and *Why I Never
Became a Dancer*, 1995, Art Forum

'floors, squats, cupboards' Emin, *Strangeland*, p.54

'For six quid…' Emin, *Strangeland*, p.58

'derelict seaside town…' Emin, *Strangeland*, p.67

'I said, 'Goodbye'…' Emin, *Strangeland*, p.60

'I realise how lucky…' Emin, in Neal Brown (ed.), *Tracey Emin*,
(London: Tate, 2006), p.50

'Signs of social disadvantage…' Anoosh Chakelian, 'Whitstable,
Margate, Ramsgate and…Newington? Inside the rebrand of a "left
behind" Kent Suburb', *The New Statesman*, 23 October 2020 and
Kathy Bailes, 'Percentage of Thanet people claiming out of work
benefits rises to highest level in more than 20 years', *The Isle of
Thanet News*, 2 June 2020

'expressing our transition…' Antony Gormley, in 'The History of the
Angel of the North' on the Gateshead government website

*'it is the most popular modern and contemporary art museum in the
world…'* Charlotte Higgins, 'How Nicholas Serota's Tate changed

Britain', *Guardian,* 22 June 2017

'a kind of stage-prop…' Adrian Searle, 'Cooked Twice and Still Flavourless', *Guardian,* 12 September 2000

'art has always been…' Emin, in Brown (ed.) *Tracey Emin*, p.50

'an autobiographer, an artist…' Rachel Cusk, *Aftermath* (London: Faber & Faber, 2019, first published 2012) p.15

'abandoned…' Simon Schama, *The Face of Britain: The Nation Through its Portraits* (London: Viking, 2015), p.435

'provocative and vulnerable…' Catalogue entry for the work on the National Portrait Gallery website

'It's not about me looking good…' Emin, in Lobel, 'Inside Tracey's Bed', *Varsity Online*, 6 October 2000

'a little hut on the beach…' Emin, in 'Interview with Tracey Emin', Ralph Rugoff, *Tracey Emin: Love Is What You Want*, exhibition catalogue (London: Hayward Publishing, 2011), p.160

'It was brilliant…' Emin, in Lobel, 'Inside Tracey's Bed', *Varsity Online*, 6 October 2000

'July to September….' Emin, *Tracey Emin C.V.,*

'Absolutely amazing… Emin, *Tracey Emin C.V.,*

'Home is a strange place…' Emin, in Gill Perry, 'All at Sea: Bad Girls, Hut Myths and Tracey Emin's 'Property by the Sea', in Kokoli and Cherry (eds), *Tracey Emin: Art into Life* (London: Bloomsbury Visual Arts, 2020), p.135

'I just saw it in a white space….' Emin, 2017, in Griselda Pollock, (2020) 'Liquid culture, the art of life and dancing with Tracey Emin: A feminist art historian/cultural analyst's perspective on Bauman's missing cultural hermeneutics'. *Thesis Eleven*, 156 (1), p.17

'I didn't feel happy with that idea…' Emin, in Jay Cheshes, 'Tracey Emin's New Margate Home and Studio, Revealed for the First Time', *Wall Street Journal Magazine,* 9 December 2020

Endnotes

X
Vertigo Sea: John Akomfrah

'There was this figure...' John Akomfrah, in Henri Neuendorf, 'John Akomfrah on the Tricky Line Between Art and Cinema', *Artnet news*, 4 July 2016

'if you looked...' Akomfrah, in Rachel Spence, 'John Akomfrah: I'm not a huge fan of wars', *Financial Times*, 7 September 2018

'everything you see in the frame...' John Akomfrah and The Otolith Group, 'Blackness and Post-Cinema: John Akomfrah and the Otolith Group in Conversation', *Frieze*, 23 September 2020

setting up conversations between things – see for e.g., 'On Culture and Climate: Artist talk with John Akomfrah and Olafur Eliasson', Hirshhorn Museum website, streamed live on 10 October 2020

more than a million migrants entered Europe by sea 'Migrant crisis: Migration to Europe Explained in Seven Charts', BBC News, 4 March 2016

'rhetoric of contagion' Akomfrah, in Hannah Ellis-Peterson, 'John Akomfrah: 'I haven't destroyed this country. There's no reason other immigrants would', *Guardian*, 7 January 2016

'do something on whaling...' Akomfrah, in Jonathan Curiel, 'John Akomfrah and the Genocide on the High Sea', *SF Weekly*, 8 August 2018

'tapestry of empathy' Holly Corfield Carr, 'John Akomfrah: Arnolfini, Bristol & Lisson Gallery, London', *Frieze*, 18 March 2016

'It's one of the things...' Akomfrah, in Kieron Corless, 'One from the heart' *Sight and Sound* 22:2, February 2012, p.45

Equiano was a boy of about eleven... this is according to his memoir, although some have called the account of his early life into question. For a good overview of the uncertainties in the narrative, see David Olusoga 'Foreword', *The Interesting Narrative of the life of*

Endnotes

Olaudah Equiano (London: Hodder & Stoughton, 2021), p.xiv–xv

'more than 12.5 million Africans...' statistics taken from a variety of sources, including: Liverpool Museums; David Eltis, 'A Brief Overview of the Trans-Atlantic Slave Trade,' *Slave Voyages: The Trans-Atlantic Slave Trade Database*

'a scene of horror...' Olaudah Equiano, *The Interesting Narrative of the life of Olaudah Equiano*, with foreword by David Olusoga (London: Hodder & Stoughton, 2021), p.35

In Gilroy's reading... Paul Gilroy, *The Black Atlantic: Modernity and Double Consciousness* (Cambridge, Mass: Harvard University Press, Verso, 1993), p.18

'idea of pain and danger...' Edmund Burke, *A Philosophical Enquiry into the Origin of Our Ideas of the Sublime and Beautiful* (first published 1757), p.125

'The passion caused by the great...' Burke, *A Philosophical Enquiry*, p.130

'white men with horrible looks...' Olaudah Equiano, *The Interesting Narrative of the life of Olaudah Equiano*, with foreword by David Olusoga (London: Hodder & Stoughton, 2021), p.33

'When danger or pain press...' Burke, *A Philosophical Enquiry*, p.111

'Empire follows Art...' William Blake, in Tim Barringer, 'Landscape Then and Now', *British Art Studies*, Issue 10, 29 November 2018

the roots of European landscape painting are entangled Denis Cosgrove, *Social Formation and Symbolic Landscape* (University of Wisconsin Press, 1998, first published 1984)

'integrally connected to imperialism...' W.T.J. Mitchell, *Landscape and Power*, p.9

'Empires move outward...' Mitchell, *Landscape and Power*, p.17

'The solitudes of the ocean...' Victor Hugo, *The Toilers of the Sea*, 1866, in Mack, *The Sea*, p.17

only 10% of the ocean has been mapped... see the U.S. Environmental Protection Agency website and Sylvia Earle, 'Introduction' to

Rachel Carson, *The Sea Around Us*, 2018

'the complex, intertwined...' Smoking Dogs Films website

'The living ocean drives...' Sylvia Earle, *Sea Change: A Message of the Oceans* (G. P. Putnum and Sons, 1995), p.xii

'No blue, no green' Sylvia Earle, *Ocean Today*, Ted Conference 2009

'The oceans are sending...' Hans-Otto Portner in Brad Plumer, 'The World's Oceans Are in Danger, Major Climate Change Report Warns', *New York Times*, 25 September 2019

the IPCC report, H.O. Portner et al. (eds), 'Summary for Policymakers', in *IPCC Special Report on the Ocean and Cryosphere in a Changing Climate*, 2019, p.9

the 'Anthropocene' Heather Davis, and Etienne Turpin, *Art in the Anthropocene: Encounters among Aesthetics, Politics, Environments and Epistemologies* (London: Open Humanities Press, 2015)

'stuplime' An idea I first encountered in Robert Macfarlane, 'Generation Anthropocene: How Humans Have Altered the Planet Forever', *Guardian*, 1 April 2016

'plastiglomerate' Rachel Nuwer, 'Future Fossils: Plastic Stone', *New York Times*, 9 June 2014; Robert Macfarlane, *Underland: A Deep Time Journey*, (London: Penguin Books, 2019), p.320

'Hyperobjects invoke a terror...' Timothy Morton, *The Ecological Thought* (Cambridge, Massachusetts, and London: Harvard University Press, 2012, first published 2010) p.131

'a traumatic loss of coordinates' Timothy Morton, *Hyperobjects: Philosophy and Ecology after the End of the World* (Minneapolis: University of Minnesota Press, 2013); Alex Blasdel, 'A Reckoning for Our Species': The Philosopher Prophet of the Anthropocene', *Guardian*, 15 June 2017

'As everyone knows...' Herman Melville, *Moby-Dick, or The Whale* (London: Penguin Books, 2003, first published 1851), p.4

'series of delicately adjusted...' Carson, *The Sea Around Us*, p.19

a field of scholarship known as the 'blue humanities'... for example, Steven Mentz, 'Toward a Blue Cultural Studies: The Sea, Mari-

time Culture, and Early Modern Literature', *Literature Compass* 6/5 (2009), pp.997–1013

'*Our knowledge of the sea...*' Serpil Oppermann, 'Storied Seas and Living Metaphors in the Blue Humanities', *Configuration*s, Volume 27, Number 4, Fall 2019, p.446

'*if I "water" my concepts...*' Astrida Neimanis, 'Water and Knowledge', in *Downstream: Reimagining Water*, (eds) Dorothy Christian and Rita Wong), 2017, p.52

'*It's not enough...*' Akomfrah, in Emily Wilson, 'John Akomfrah Discusses Channeling J.M.W. Turner and Disasters at Sea', *Hyperallergic*, 8 June 2018

'*that severity of manner...*' *Morning Chronicle*, 3 May 1813, in catalogue entry for 'The Deluge', Tate

'*There is no detour around form...*' Akomfrah, in Clara Sankey and Lindsey Westbrook, 'An Interview with John Akomfrah', SFMOMA, July 2018

BIBLIOGRAPHY

Introduction

Auden, W.H, *The Enchafèd Flood: or, The Romantic Iconography of the Sea* (London: Faber, 1951)

Corbin, Alain, *The Lure of the Sea: The Discovery of the Seaside in the Western World, 1750–1840* (Cambridge: Polity Press, 1994)

Cusack, Tricia, *Framing the Ocean, 1700 to the Present: Envisaging the Sea as Social Space* (London: Ashgate, 2014)

Mack, John, *The Sea: A Cultural History* (London: Reaktion Books, 2011)

Syperek, Pandora and Sarah Wade (eds), 'Curating the Sea, Special Issue of the Journal of Curatorial Studies, 9.2 (Autumn 2020), *Journal of Curatorial Studies*, 2020

I
Studland Beach: Vanessa Bell

Baxter, William, *South Hants and Dorset: Portsmouth, Southampton, Winchester, Petersfield, the New Forest, Romsey, Bournemouth, Swanage, Weymouth, Dorchester, Wimborne, Sherborne, and Lyme Regis* (London: Nelson, 1914)

Bell, Clive, *Art* (New York: Stokes, 1914)

Bell, Vanessa, *Selected Letters of Vanessa Bell*, ed. Regina Marler (London: Bloomsbury, 1993)

Bell, Vanessa, *Sketches in Pen and Ink*, ed. Lia Giachero (London: Hogarth Press, 1997)

Bradshaw, David, '"The Purest Ecstasy": Virginia Woolf and the Sea', in *Modernism on Sea: Art and Culture at the British Seaside*, Lara Feigel and Alexandra Harris (eds) (Oxfordshire: Peter Lang, 2009)

Feigel, Lara and Alexandra Harris (eds), *Modernism on Sea: Art and Culture at the British Seaside* (Oxfordshire: Peter Lang, 2009)

Fry, Roger, *Letters of Roger Fry: Volume Two*, ed. Denys Sutton (London: Chatto & Windus, 1972)

Fry, Roger, *Second Post-Impressionist Exhibition. British, French and Russian Artists*, exhibition catalogue (London: Ballantyne, 1912)

Fry, Roger, *Vision and Design* (London: Chatto & Windus, 1923)

Gage, John, *Colour in Art* (New York: Thames & Hudson, 2006)

Kennedy, Maev, 'Vanessa Bell: stepping out the shadows of the Bloomsbury set', *Guardian*, 7 February 2017

Lee, Hermione, 'Introduction', *To the Lighthouse*, Virginia Woolf (London: Penguin Modern Classics, 2000)

Lee, Hermione, *Virginia Woolf* (London: Chatto & Windus, 1996)

Malcolm, Janet, 'A House of One's Own' in *Forty-One False Starts: Essays on Artists and Writers* (London: Granta, 2014)

Mavor, Carol, *Blue Mythologies: Reflections on a Colour* (London: Reaktion, 2013)

Milroy, Sarah and Ian Dejardin (eds), *Vanessa Bell*, exhibition Catalogue, Dulwich Picture Gallery (London: Bloomsbury, 2017)

Shone, Richard (ed.), *The Art of Bloomsbury: Roger Fry, Vanessa Bell and Duncan Grant*, exhibition catalogue (London: Tate Publishing, 1999)

Solnit, Rebecca, *A Field Guide to Getting Lost* (Edinburgh: Canongate, 2017)

Spalding, Frances, *Roger Fry: Art & Life* (London: Granada, 1980)

Spalding, Frances, *Vanessa Bell* (London: Weidenfeld and Nicolson, 1983)

Spalding, Frances, *Virginia Woolf: Art, Life and Vision* (London: National Portrait Gallery, 2014)

Stephen, Leslie, *Selected Letters of Leslie Stephen*, vol. 1, eds John Bicknell and Mark A. Reger (Basingstoke: Macmillan, 1996)

Stephen, Leslie, *The Life and Letters of Leslie Stephen*, ed. Frederic William Maitland (London: Duckworth, 1906)

Tickner, Lisa, 'Vanessa Bell: Studland Beach, Domesticity, and "Significant Form"', *Representations*, no. 65, *Special Issue: New Perspectives in British Studies* (Winter, 1999)

Wallschlager, Jackie, 'Vanessa Bell at Dulwich Picture Gallery, London – her art is indivisible from her life', *Financial Times*, 12 February 2017

Ward, Lock, *A New Pictorial and Descriptive Guide to Weymouth and South Dorset* (London: 1900)

Woolf, Virginia, *A Passionate Apprentice: The Early Journals and 1897–1909*, ed. Mitchell A. Leaska (London: Pimlico, 2004)

Woolf, Virginia, *Collected Essays by Virginia Woolf, Volume Two* (London: The Hogarth Press, 1966)

Woolf, Virginia, Foreword to 'Recent Paintings by Vanessa Bell: The London Artists' Association. February 4 to March 8 1930, exhibition catalogue (London: The Favil Press, 1930)

Woolf, Virginia, *Moments of Being: Unpublished Autobiographical Writings,* ed. Jeanne Schulkind (London: Triad/Granada, 1978)

Woolf, Virginia, *Roger Fry: A Biography* (London: Hogarth Press, 1940)

Woolf, Virginia, *The Diary of Virginia Woolf: Volume Two, 1920–1924*, ed. Anne Olivier Bell (London: Hogarth Press, 1978)

Woolf, Virginia, *The Letters of Virginia Woolf: Volume One, 1888–1912*, eds Nigel Nicolson and Joanne Trautmann (London: Hogarth Press, 1975)

Woolf, Virginia, *The Letters of Virginia Woolf: Volume Three, 1923–1928*, eds Nigel Nicolson and Joanne Trautmann (London: Hogarth Press, 1975)

Woolf, Virginia, *To the Lighthouse* (London: Penguin Modern Classics, 2000; first published 1927)

II

Winter Sea: Paul Nash

Ackroyd, Peter, *T.S. Eliot* (London: Hamilton, 1984)

Bertram, Anthony, *Paul Nash: The Portrait of an Artist* (London: Faber, 1955)

Bracewell, Michael et. al., 'From the Surreal to the Decorative', *Tate Etc.* Issue 38 (Autumn, 2016)

Burke, Edmund, *A Philosophical Enquiry into the Origin of Our Ideas of the Sublime and Beautiful* (first published 1757)

Chambers, Emma (ed.), *Paul Nash*, exhibition catalogue (London: Tate Publishing, 2016)

Crawford, Robert, *Young Eliot: From St Louis to The Waste Land* (London: Vintage, 2016)

Fox, James, *British Art and the First World War, 1914–1924* (Cambridge: Cambridge University Press, 2015)

Fraser Jenkins, David, *Paul Nash: The Elements*, exhibition catalogue (London: Scala, Dulwich Picture Gallery, 2010)

Fussell, Paul, *The Great War and Modern Memory* (Oxford: Oxford University Press, 2000; first published in 1975)

Grant, Simon, 'A Landscape of Mortality', *Tate Magazine*, Issue 6 (Spring, 2006)

Harrison, Charles, *English Art and Modernism 1900–1939* (New Haven: Yale University Press, 1994)

Haycock, David Boyd, *A Crisis of Brilliance: Five Young British Artists and the Great War* (London: Old Street, 2009)

Hoare, Philip, *Rising Tide Falling Star* (London: Fourth Estate, 2017)

Bibliography

John Ruskin, *Modern Painters, Volume IV containing Part V, Of Mountain Beauty* (Kent: George Allen, 1888)

King, James, *Interior Landscapes: A Life of Paul Nash* (London: Weidenfeld and Nicolson, 1987)

Macdonald, Lyn, *They Called It Passchendaele: The Story of the Third Battle of Ypres and of the Men Who Fought in It* (London: Joseph, 1979)

Menand, Louis, 'Practical Cat: How T.S. Eliot became T.S. Eliot', *The New Yorker*, 12 September 2011

Monks, Sarah, '"Suffer a Sea-Change"': Turner, Painting, Drowning', in *Tate Papers*, no.14 (Autumn, 2010)

Nash, Paul, *Outline: An Autobiography* (London: Lund Humphries, 2016; first published 1949)

Nash, Paul, *Paul Nash: Paintings and Watercolours*, exhibition catalogue (London: Tate Gallery Publications, 1975)

Neve, Christopher, *Unquiet Landscape: Places and Ideas in 20th-Century British painting* (London: Thames & Hudson, 2020; first published 1990)

Raban, Jonathan (ed.) *The Oxford Book of the Sea* (Oxford: Oxford University Press, 1992)

Read, Herbert *Paul Nash* (Harmondsworth: Penguin Books, 1944)

Riding, Christine and Nigel Llewellyn, 'British Art and the Sublime', in Nigel Llewellyn and Christine Riding (eds), *The Art of the Sublime*, Tate Research Publication, January 2013

Robinson, Leonard, *Paul Nash: Winter Sea: The Development of an Image* (York: William Sessions, 1997)

Sloan, Kim (ed.), *Places of the Mind: British Watercolour Landscapes 1850–1950*, exhibition catalogue (London: Thames & Hudson, The British Museum, 2017)

Winter, Jay, *Sites of Memory, Sites of Mourning: The Great War in European Cultural History* (Cambridge: Cambridge University Press, 1995)

Woolf, Virginia, *The Letters of Virginia Woolf: Volume Six, 1936–1941*, eds Nigel Nicolson and Joanne Trautmann (London: Hogarth Press, 1980)

III

Seascape – ships sailing past the Longships: Alfred Wallis

'Alfred Wallis – Artist and Mariner', biopic and documentary, dir. Christopher Mason (1973)

Barkham, Patrick, *Coastlines: The Story of Our Shore* (London: Granta Books, 2015)

Benjamin, Walter, *The Work of Art in the Age of Mechanical Reproduction* (London: Penguin Books, 2008; first published 1936)

Berlin, Sven, *Alfred Wallis, Primitive* (London: Nicholson & Watson, 1949)

Bird, Michael, *The St Ives Artists: A Biography of Place and Time* (London: Lund Humphries, 2008 and 2016)

Checkland, Sarah Jane, *Ben Nicholson: The Vicious Circles of His Life and Art* (London: John Murray, 2000)

Fisher, Elizabeth and Nairne, Andrew (eds), *Alfred Wallis: Ships and Boats*, exhibition catalogue (Cambridge: Kettle's Yard, 2012)

Gale, Matthew and Richard Ingleby, *Two Painters: Works by Alfred Wallis and James Dixon*, exhibition catalogue (London: Merrell Holberton, Irish Museum of Modern Art, Tate Gallery St Ives, 1999)

Gardiner, Juliet, *The Thirties: An Intimate History* (London: HarperPress, 2010)

Gardner-Huggett, Joanna P., 'Myfanwy Evans: "Axis" and a Voice for the British Avant-Garde.' *Woman's Art Journal* vol. 21, no. 2 (Autumn, 2000–Winter, 2001)

Harris, Alexandra, *Romantic Moderns* (London: Thames & Hudson, 2010)

Jim Ede, *A Way of Life: Kettle's Yard* (Cambridge: Cambridge University Press, 1984)

Lee, Robert G. and Sabine Wilk, 'Forest as *Volk: Ewiger Wald* and the Religion of Nature in the Third Reich', *Journal of Social and Ecological Boundaries* (Spring, 2005)

Lewison, Jeremy, *Ben Nicholson: The Years of Experiment*, 1919–1939, exhibition catalogue (Cambridge: Kettle's Yard, 1983)

Matless, David, *Landscape and Englishness* (London: Reaktion Books, 1998, 2016)

Morton, H.V., *In Search of England* (York: Methuen, 2013; first published 1927)

Mullins et. al., 'Icons of the Sea – recollections of Alfred Wallis', *The Listener*, 20 June 1968

Mullins, Edwin B., *Alfred Wallis: Cornish Primitive Painter* (London: Macdonald, 1967)

Nash, Paul, 'Ben Nicholson's Carved Reliefs', *Architectural Review*, October 1935

Nicholson, Ben 'Alfred Wallis', *Horizon*, vol. 7, January 1943

Nicholson, Winifred, *Unknown Colour: Paintings, Letters, Writings* (London: Faber, 1987)

Powell, Jennifer (ed.), *Kettle's Yard House Guide* (Cambridge: Kettle's Yard, 2018)

Spalding, Frances, '"Powerful Emotive Agents": The Association between Ben Nicholson and John Piper', *The Burlington Magazine*, vol. 149, no. 1255, Art in Britain (October 2007)

Trentmann, Frank, 'Civilization and Its Discontents: English Neo-Romanticism and the Transformation of Anti-Modernism in Twentieth-Century Western Culture', *Journal of Contemporary History*, vol. 29, no. 4 (October 1994)

Whybrow, Marion, *The Innocent Eye: Primitive and Naïve Painters in Cornwall* (Bristol: Sansom & Company, 1999)

IV

Shipbuilding on the Clyde: Burners: Stanley Spencer

'Out of Chaos', film documentary, dir. Jill Craigie (1944)

'Seawards the Great Ships', film documentary, dir. Hilary Harris (1960)

'Stanley Spencer: The Colours of the Clyde', TV documentary, first broadcast BBC 2, 18 March 2014

Bell, Keith (ed.), *Stanley Spencer RA,* exhibition catalogue (London: Royal Academy of Arts, Weidenfeld and Nicolson, 1980)

Bell, Keith et al. (ed.), *Men of the Clyde: Stanley Spencer's Vision at Port Glasgow* (Edinburgh: Scottish National Portrait Gallery, 2000)

Bell, Keith, *Stanley Spencer: A Complete Catalogue of the Paintings* (London: Phaidon, Christie's and the Henry Moore Foundation, 1992)

Blunden, Edmund, *English Villages* (London: Williams Collins, 1941)

Bohm-Duchen, Monica, *Art and the Second World War* (Farnham: Lund Humphries, 2013)

Collis, Maurice, *Stanley Spencer: A Biography* (London: Harvill Press, 1962)

Dimbleby, Jonathan, *The Battle of the Atlantic: How the Allies Won the War* (London: Penguin Books, 2016)

Foss, Brian, 'Message and Medium: Government Patronage, National Identity and National Culture in Britain, 1939–45', *Oxford Art Journal*, vol. 14, no. 2 (1991)

Foss, Brian, *War Paint: Art, War, State and Identity in Britain, 1939–1945* (New Haven and London: Yale University Press, 2007)

Garlake, Margaret, (ed.), *Artists and Patrons in Post-war Britain: Essays* (Aldershot: Ashgate, 2001)

Glew, Andrew (ed.), *Stanley Spencer, Letters and Writings* (London: Tate Publishing, 2001)

Hemming, Charles, *British Painters of the Coast and Sea: A History and Gazetteer* (London: Gollancz, 1988)

Imperial War Museum archives: ART/WA2/03/051/1, 1939–41, GP/55/31(A)

Leder, Carolyn, *Spencer's War: The Art of Shipbuilding on the Clyde,* exhibition catalogue (Stanley Spencer Gallery, 2011)

Newton, Eric, *Stanley Spencer* (Harmondsworth: Penguin Books, 1947)

Orwell, George, 'The Lion and the Unicorn: Socialism and the English Genius' (first published by Searchlight Books, 19 February 1941)

Orwell, George, *Coming Up for Air* (London: Penguin Classics, 2000; first published 1939)

Parkin, Simon, *A Game of Birds and Wolves: The Game that Revolutionised the War* (London: Hodder & Stoughton, 2019)

Patrizio, Patrick and Little, Frank (eds), *Canvassing the Clyde: Stanley Spencer and the Shipyards* (Glasgow: Glasgow Museums, 1994)

Peters Corbett, David and Lisa Tickner (eds), *British Art in the Cultural Field, 1939–69* (Chichester: Wiley-Blackwell, 2012)

Pople, Kenneth, *Stanley Spencer: A Biography* (London: Collins, 1991)

Rothenstein, John (ed.), *Stanley Spencer: The Man: Correspondence and Reminiscences* (London: Elek, 1979)

Schama, Simon, *A History of Britain 3* (London: BBC Worldwide, 2002)

Spencer in the Shipyard: Paintings and Drawings by Stanley Spencer and photographs by Cecil Beaton from Imperial War Museum, exhibition catalogue (London: Artist Council of Great Britain, 1981)

Stourton, James, *Kenneth Clark: Life, Art and Civilisation* (London: William Collins, 2016)

V

Offshore: Peter Lanyon

Causey, Andrew, *Peter Lanyon: Modernism and the Land* (London: Reaktion, 2006)

Stephens, Chris, *Peter Lanyon*, exhibition catalogue (St Ives: Tate St Ives, Tate Publishing, 2010)

Treves, Toby, *Peter Lanyon: Catalogue Raisonné of the Oil Paintings and Three-Dimensional Works* (London: Modern Art Press, 2018)

Stephens, Chris, *Peter Lanyon: At the Edge of Landscape* (London: 21, 2000)

Garlake, Margaret, *Peter Lanyon* (London: Tate Gallery, 1998)

Garlake, Margaret (ed.), *Artists and Patrons in Post-War Britain: Essays by Postgraduate Students at the Courtauld Institute of Art* (London: Courtauld Institute of Art, Routledge, 2017)

Garlake, Margaret, *New Art, New World: British Art in Post-War Society* (New Haven, London: Yale University Press, 1998)

Andrews, Malcolm, *Landscape and Western Art* (Oxford: Oxford University Press, 1999)

Crouch, David and Mark Toogood, 'Everyday Abstraction: Geographical Knowledge in the Art of Peter Lanyon', *Ecumene*, vol. 6, no. 1 (January 1999)

Bakewell, Sarah, *At the Existentialist Café: Freedom, Being and Apricot Cocktails* (London: Chatto & Windus, 2016)

Merleau-Ponty, Maurice, *Phenomenology of Perception* (London: Routledge, 2005; first published 1945)

Acker, Emma, 'Artistic Identity in a Transatlantic Age: Patrick Heron, Peter Lanyon, and the New American Painting', *The British Art Journal*, vol. 10, no. 3 (Winter/Spring, 2009/10)

Clark, Kenneth, *Landscape into Art* (Boston: Beacon Press, 1961; first published London, John Murray, 1949)

Val Baker, Denys, *Britain's Art Colony by the Sea* (London: George Ronald, 1959)

Mitchell, W.T.J. (ed.), *Landscape and Power* (Chicago: The University of Chicago Press, 2002)

Cresswell, Tim, *Place: An Introduction* (Chichester: John Wiley & Sons, 2015)

VI
Crest: Bridget Riley

Bracewell, Michael et. al., *Bridget Riley: Painting Now,* exhibition catalogue (Los Angeles: Sprüth Magers, 2019)

Carson, Rachel, 'Undersea', *The Atlantic Monthly*, September 1937

Carson, Rachel, *Silent Spring* (London: Penguin Classics, 2000; first published 1962)

Carson, Rachel, *The Sea Around Us*, introduction by Sylvia Earle (New York: Oxford University Press, 2018; first published 1950)

Carson, Rachel, *The Sense of Wonder: A Celebration of Nature for Parents and Children* (New York: Harper Collins, 1998; first published 1965)

Carson, Rachel, *Under the Sea-Wind* (New York: Penguin Books, 2007; first published 1941)

Follin, Francis, *Embodied Visions: Bridget Riley, Op Art and the Sixties* (London: Thames & Hudson, 2004)

Hagood, Amanda, 'Wonders with the Sea: Rachel Carson's Ecological Aesthetic and the Mid-Century Reader', *Environmental Humanities*, 2, 2013

Hewison, Robert, *Too Much: Art and Society in Sixties 1960–75* (New York: Oxford University Press, 1987)

Kudielka, Robert (ed.), *Bridget Riley: Dialogues on Art* (London: Zwemmer, 1995)

Kudielka, Robert (ed.), *The Eye's Mind: Bridget Riley: Collected Writings 1965–1999* (London: Thames & Hudson, Serpentine Gallery, De Montfort University, 1999)

Kudielka, Robert et. al. (ed.), *Bridget Riley: The Complete Paintings* (London: The Bridget Riley Art Foundation, Thames & Hudson, 2018)

Kudielka, Robert et. al., *Bridget Riley: The Curve Paintings, 1961–2014,* exhibition catalogue (London: Riding House, De La Warr Pavilion, 2015)

Kudielka, Robert, 'Supposed to Be Abstract: Bridget Riley in Conversation with Roger Kudielka', *Parkett*, vol. 61, 2001

Lee, Pamela M., 'Bridget Riley's Eye/Body Problem', *October*, vol. 98 (Autumn, 2001)

Lepore, Jill, 'The Right Way to Remember Rachel Carson', *The New Yorker*, 26 March 2018

Moorhouse, Paul (ed.), *Bridget Riley*, exhibition catalogue (London: Tate Publishing, 2003)

Moorhouse, Paul, *Bridget Riley: A Very Very Person: The Early Years* (London: Riding House, 2019)

Morgan, Kenneth O., *Twentieth-Century Britain: A Very Short Introduction* (Oxford: Oxford University Press, 2000)

Riley, Bridget and E. H. Gombrich 'The Use of Colour and Its Effect: The How and the Why', *The Burlington Magazine*, vol. 136, no. 1096 (July 1994)

Seitz, William C., *The Responsive Eye*, exhibition catalogue (New York: Museum of Modern Art, 1965)

Sideris, Lisa H. and Kathleen Dean Moore (eds), *Rachel Carson: Legacy and Challenge* (Albany: State University of New York, 2008)

Sontag, Susan, *Against Interpretation, and Other Essays* (New York: Farrar, Strauss & Giroux, 1967)

Stephens, Chris and Katharine Stout, *Art and the 60s: This Was Tomorrow*, exhibition catalogue (London: Tate Publishing, 2004)

Stitt, Jennifer, 'For Rachel Carson, wonder was a radical state of mind', *Aeon*, 27 September 2019

VII

World Within A World, Duncasby Head to Lands End, Scotland Wales England, 1973: Hamish Fulton

Auping, Michael, 'Hamish Fulton: Moral Landscapes', *Art in America*, February 1983

Causey, Andrew, 'Space and time in British Land Art', *Studio International*, March/April 1977

Coverley, Merlin, *The Art of Wandering: The Writer as Walker* (Harpenden: Oldcastle, 2012)

Evans, D. (ed.), *The Art of Walking: A Field Guide* (London: Black Dog Publishing, 2012)

Bibliography

Fulton, Hamish, *Bird Song: A Selection of Walks Made on the British Isles: 1970–1990* (London: Serpentine Gallery, 1991)

Fulton, Hamish, *Horizon to Horizon* (Londonderry: Coracle Press for Orchard Gallery, 1983)

Fulton, Hamish, *One Hundred Walks: A Few Crows, Wide River, Ants*, exhibition catalogue (Netherlands: Haags Gemeetemuseum, 1991)

Fulton, Hamish, *Quotations Chosen by Hamish Fulton* (Edinburgh: The Fruitmarket Gallery, 1985)

Fulton, Hamish, *Words from Walks*, Summer 2019

Gros, Frédéric, *A Philosophy of Walking* (London: Verso, 2015)

Ingold, Tim, *Being Alive: Essays on Movement Knowledge and Description* (London: Routledge, 2011)

Ingold, Tim, *Lines: A Brief History* (London: Routledge, 2007)

Jamie, Kathleen, *Findings* (London: Sort of Books, 2005)

Nicholson, Geoff, *The Lost Art of Walking: The History, Science, Philosophy, Literature, Theory and Practice of Pedestrianism* (Chelmsford: Harbour, 2010)

Sandbrook, Dominic, *State of Emergency: The Way We Were: Britain, 1970–1974* (London: Allen Lane, 2010)

Sebald, W. G., *The Rings of Saturn* (London: Vintage, 2002; first published 1998)

Shoard, Marion, *The Theft of the Countryside* (London: Temple Smith, 1980)

Solnit, Rebecca, *Wanderlust: A History of Walking* (London: Verso, 2001)

Thoreau, Henry David, 'Walking', *The Atlantic*, first published May 1862

Tufnell, Ben et. al., *Walking Journey*, exhibition catalogue (London: Tate Publishing, 2002)

Watkins, Jonathan and Sarah Martin (eds), *Walking in Relation to Everything: Hamish Fulton*, exhibition catalogue (Margate and Birmingham: Turner Contemporary and Ikon, 2012)

283

VIII

The Last Resort: Martin Parr

Angelos, Ayla, 'All you see is lazy photography everywhere': Martin Parr in conversation with 'It's Nice That', *It's Nice That*, 9 September 2019

Bishop, William, 'Visions of a New Brighton: William Bishop interviews Martin Parr about the faded resort', *British Journal of Photography*, 18 July 1986

Blanchard, Tamsin, 'A Life Less Ordinary', *Observer*, 13 January 2002,

Bourdieu, Pierre, *Distinction* (Abingdon: Routledge Classics, 2010; first published 1984)

Dutton, R., *History of New Brighton Tower and Gardens* (England: InfoDial Ltd., 2017)

Elborough, Travis, *Wish You Were Here* (London: Sceptre, 2010)

Grenfell, Michael (ed.), *Pierre Bourdieu: Key Concepts* (Durham: Acumen, 2012; first published 2008)

Miller, Anthony M., *The Inviting Shore: A Social History of New Brighton Part 2* (England: Anthony Miller, 2017)

Miller, Anthony M., *The Inviting Shore: A Social History of New Brighton, 1830–1939, Part 1* (Birkinhead: Countyvise, 1996)

Parr, Martin and Quentin Bajac, *Parr by Parr: Quentin Bajac meets Martin Parr: Discussions with a Promiscuous Photographer* (Amsterdam: Schilt, 2010)

Parr, Martin, *Life's A Beach* (New York: Aperture, 2013)

Parr, Martin, *Small World* (Stockport: Dewi Lewis, 2007)

Parr, Martin, *The Last Resort: Photographs of New Brighton* (Stockport: Dewi Lewis Publishing, 1998, first published 1986)

Parr, Martin, *The Last Resort: Photographs of New Brighton* (Stockport: Dewi Lewis Publishing, 2009)

Phillips, Sandra S, *Martin Parr* (London: Phaidon, 2007)

Prodger, Phillip, *Only Human: Photographs by Martin Parr*, exhibition catalogue (London: Phaidon Press, 2019)

Smyth, Diane, 'New Brighton Revisited by Martin Parr, Tom Wood, and Ken Grant', *British Journal of Photography*, 12 July 2018

Theroux, Paul, *The Kingdom by the Sea: A Journey Around the Coast of Great Britain* (London: Penguin, 1984; first published 1983)

Urry, John, *The Tourist Gaze 3.0* (Los Angeles, London: SAGE, 2011; first published 1990)

Walton, John K., *The British Seaside: Holidays and Resorts in the Twentieth Century* (Manchester: Manchester University Press, 2000)

Walton, John K., *The English Seaside Resort: A Social History, 1750– 1914* (Leicester: Leicester University Press, 1983)

Williams, Val, *Martin Parr* (London: Phaidon Press, 2014)

IX

The Last Thing I Said to you is don't leave me here. 1: Tracey Emin

Bracewell, Michael, 'Morecambe: The Sunset Coast' in *Modernism on Sea: Art and Culture at the British Seaside*, Lara Feigel and Alexandra Harris (eds) (Oxfordshire: Peter Lang, 2009)

Brown, Neal (ed.), *Tracey Emin* (London: Tate, 2006)

Cusk, Rachel, *Aftermath* (London: Faber & Faber, 2019; first published 2012)

Dillon, Brian, 'Mad Tracey from Margate', *The Dublin Review*, Issue 22, Spring 2006

Elliott, Patrick, *Tracey Emin: 20 Years*, exhibition catalogue (Edinburgh: National Galleries of Scotland, 2008)

Emin, Tracey, *Strangeland* (London: Sceptre, 2005)

Fullerton, Elizabeth, *Artrage!: The Story of the BritArt Revolution* (London: Thames & Hudson, 2016)

Gupta, Tanya, 'Turner Contemporary: Did art transform 'no-go zone' Margate?', *BBC News*, 4 October 2019

Higgins, Charlotte, 'How Nicholas Serota's Tate changed Britain', *Guardian*, 22 June 2017

Kokoli, Alexandra and Deborah Cherry(eds), *Tracey Emin: Art into Life* (London: Bloomsbury Visual Arts, 2020)

Lister, David, 'From unmade bed to Whitstable beach hut, Tracey Emin makes an exhibition of herself', *Independent*, 25 September 2000

Lobel, Mark, 'Inside Tracey's Bed', *Varsity Online*, 6 October 2000

Meek, James 'Art into Ashes', *Guardian*, 23 September 2004

Moyes, Jojo, 'How We Met: Sarah Lucas and Tracey Emin', *Independent*, 11 October 1997

Muir, Gregor, *Lucky Kunst: The Rise and Fall of Young British Art* (London: Aurum, 2009)

Pollock, Griselda, 'Liquid culture, the art of life and dancing with Tracey Emin: A feminist art historian/cultural analyst's perspective on Bauman's missing cultural hermeneutics', *Thesis Eleven*, 156 (1), 2000

Rachel, Daniel, *Don't Look Back in Anger: The Rise and Fall of Cool Britannia*, (London: Trapeze, 2019)

Reynolds, Nigel, 'Tracey Emin enters her blue beach hut period', *Telegraph*, 13 September 2000

Rugoff, Ralph (ed.), *Tracey Emin: Love Is What You Want*, exhibition catalogue (London: Hayward Publishing, 2011)

Schama, Simon, *The Face of Britain: The Nation Through its Portraits* (London: Viking, 2015)

Searle, Adrian, 'Cooked Twice and Still Flavourless', *Guardian*, 12 September 2000

Shaw, Anny, 'Tracey Emin to turn Margate studio into a museum for her work when she dies', *The Art Newspaper*, 8 February 2019

Wainwright, Jean (ed.), *Ship to Shore: Art and the Lure of the Sea* (Southampton: John Hansard Gallery, SeaCity Museum, 2018)

Warner, Marina, 'A New Twist in the Long Tradition of the Grotesque', *London Review of Books*, vol. 22, no. 8, 13 April 2000

X
Vertigo Sea: John Akomfrah

Ahmed, Fatema, 'Artist of the Year: John Akomfrah', *Apollo*, December 2018

Akomfrah, John and The Otolith Group, 'Blackness and Post-Cinema: John Akomfrah and the Otolith Group in Conversation', *Frieze*, 23 September 2020

Alter, Nora M. 'Waves of Migration', *Artforum*, February 2016

Armitage, David, Alison Bashford and Sujit Sivasundaram (eds), *Oceanic Histories* (Cambridge: Cambridge University Press, 2018)

Barringer, Tim, 'Landscape Then and Now', *British Art Studies*, Issue 10, 29 November 2018

Basciano, Oliver, 'Work of the Week: John Akomfrah "Handsworth Songs"', *ArtReview*, 18 June 2020

Blasdel, Alex, '"A Reckoning for Our Species": The Philosopher Prophet of the Anthropocene', *Guardian*, 15 June 2017

Blum, Hester, 'The Prospect of Oceanic Studies', *PMLA*, May 2020, vol. 125, no. 3 (May 2010)

Boyle, Tiffany and Jessica Carden, 'Reclaiming Arctic Space', *PMC Notes*, no. 17, based on a research seminar presented at the Paul Mellon centre, 27 November 2020

Buck, Louisa, 'John Akomfrah: Sea Change', *The Art Newspaper*, 1 January 2016

Bucknell, Alice, 'Blue Planet', *Frieze*, 1 November 2017

Burke, Edmund, *A Philosophical Enquiry into the Origin of Our Ideas of the Sublime and Beautiful* (first published 1757)

Corfield Carr, Holly, 'John Akomfrah: Arnolfini, Bristol & Lisson Gallery, London', *Frieze*, 18 March 2016

Corless, Kieron, 'One from the heart' *Sight and Sound* 22:2, February 2012

Cosgrove, Denis, *Social Formation and Symbolic Landscape* (Wisconsin: University of Wisconsin Press, 1998; first published 1984)

Crist, Meehan et. al, *The Flood: Writing about Rising Seas from the London Review of Books* (London: London Review of Books, 2018)

Crist, Meehan, 'A Strange Blight', *London Review of Books*, 6 June 2019

Curiel, Jonathan, 'John Akomfrah and the Genocide on the High Sea', *SF Weekly*, 8 August 2018

Davis, Heather, and Etienne Turpin, *Art in the Anthropocene: Encounters Among Aesthetics, Politics, Environments and Epistemologies* (London: Open Humanities Press, 2015)

Davison, Nicola, 'The Anthropocene Epoch: Have we entered a new phase of planetary history?', *Guardian*, 20 May 2019

DeLoughrey, Elizabeth, 'Submarine Futures of the Anthropocene', *Comparative Literature,* 69:1, March 2017

Demos, T. J., *Decolonising Nature: Contemporary Art and the Politics of Ecology* (Berlin: Sternberg Press, 2016)

Earle, Sylvia, *Sea Change: A Message of the Oceans,* (London: G.P. Putnum's Sons, 1995)

Ellis-Peterson, Hannah, 'John Akomfrah: "I haven't destroyed this country. There's no reason other immigrants would"', *Guardian*, 7 January 2016

Equiano, Olaudah, *The Interesting Narrative of the life of Olaudah Equiano*, with a foreword by David Olusoga (London: Hodder & Stoughton, 2021)

Gaynor, Andrea and Ian Mclean, 'The Limits of Art History: Towards an Ecological History of Landscape Art', *Landscape Review* 11(1), 2005

Gifford-Mead, Emma and Ruth Hogan (eds), *John Akomfrah*, exhibition catalogue (London: Lisson Gallery, 2016)

Gillis, John R., 'The Blue Humanities', *Humanities*, May/June 2013, vol. 34, no. 3

Gilroy, Paul, *The Black Atlantic: Modernity and Double Consciousness* (Cambridge, Mass: Harvard University Press, Verso, 1993)

Kabra, Fawz, 'John Akomfrah in Conversation', *Ocula*, 5 July 2018

Kolbert, Elizabeth, 'Age of Man: Enter the Anthropocene', *National Geographic*, 5 July 2019

Llewellyn, Nigel and Christine Riding (eds), *The Art of the Sublime*, Tate Research Publication, January 2013

Malcolm, Andrews, 'Turner and the Mystery of the Sea', *Caliban*, 52, (2014)

Matless, David, 'The Anthroposcenic: Landscape in the Anthropocene', Landscape Now, *British Art Studies*, Issue 10, (29 November 2018)

Melville, Herman, *Moby-Dick, or The Whale* (London: Penguin Books, 2003; first published 1851)

Mentz, Steven, 'Toward a Blue Cultural Studies: The Sea, Maritime Culture, and Early Modern Literature', *Literature Compass* 6/5 (2009)

Mentz, Steven, *Ocean* (New York: Bloomsbury Academic, 2020)

Mercer, Kobena, 'Becoming Black Audio: An Interview with John Akomfrah and Trevor Mathison', *Black Camera*, vol. 6, no. 2 (Spring, 2015)

Morse, Erik, 'The Oceanic Ecologies of John Akomfrah', *ArtReview*, January/February 2016

Morton, Timothy, *Hyperobjects: Philosophy and Ecology after the End of the World* (Minneapolis: University of Minnesota Press, 2013)

Morton, Timothy, *The Ecological Thought* (Cambridge, Massachusetts, and London: Harvard University Press, 2012)

Neimanis, Astridas, *Bodies of Water: Posthuman Feminist Phenomenology* (London: Bloomsbury Academic, 2017)

Neuendorf, Henri, 'John Akomfrah on the Tricky Line Between Art and Cinema', *Artnet news*, 4 July 2016

Nilsson, Jakob, 'Capitalocene, clichés, and critical re-enchantment: What Akomfrah's *Vertigo Sea* does through BBC Nature' *Journal of Aesthetics & Culture*, 10:1 (2018)

O'Hagan, Sean, 'John Akomfrah: "Progress can cause profound suffering"', *Observer*, 1 October 2017

Oldham, Martin, 'Akomfrah and Turner make for a potent mix in Margate', *Apollo*, 1 November 2016

Oppermann, Serpil, 'Storied Seas and Living Metaphors in the Blue Humanities', *Configurations*, vol. 27, no. 4, Fall 2019

Pes, Javier, 'How Artist John Akomfrah Used Archival Film Footage to Tell the Forgotten Story of African Soldiers in the First World War', *Artnet*, 21 September 2018

Spence, Rachel, 'John Akomfrah: I'm not a huge fan of wars', *Financial Times,* 7 September 2018

Steinberg, Philip E., 'Of other seas: metaphors and materialities in maritime regions', *Atlantic Studies*, 10:2, (2013)

Syperek, Pandora and Sarah Wade, 'Curating the Sea: Guest Editorial', *Journal of Curatorial Studies*, vol. 9 no. 2

Weiz, Haley, 'John Akomfrah and the Image as Intervention', *Interview*, 27 June 2016

Wilson, Emily, 'John Akomfrah Discusses Channeling J. M. W. Turner and Disasters at Sea', *Hyperallergic*, 8 June 2018

ACKNOWLEDGEMENTS

My first thanks must go to Emma Paterson, who I feel incredibly fortunate to have as an agent, and to my publishers, Sceptre. Both believed in an ambitious idea and saw what it might become. Juliet Brooke has been the best editor I could have imagined, an unfailing and sustaining source of acumen, energy and enthusiasm throughout. I am very grateful to Irene Rolleston, Natalie Young, Lesley Hodgson, Nico Parfitt and Charlotte Humphery for all their careful work on these pages, too.

Thank you to the York Museums Trust, the Birmingham Museums Trust, The Bridget Riley Art Foundation, Parafin Gallery and Smoking Dogs Films for granting permission to use the images around which this book pivots, to Fran Roper for her assistance very early on and also to Edward Orlik.

To the Royal Society of Literature and the judges who awarded me a St Aubyn Prize for Non-Fiction in 2018: Iain Sinclair, Laura Bates, Aida Edemariam and Fiona St Aubyn – thank you for giving me crucial momentum during the tricky early stages. I will always be grateful to all the editors who have given me the chance to appear on their pages and helped hone my writing, especially Claire Wrathall at Art Quarterly who commissioned me to write about the sea.

This book took shape in libraries and is largely constructed out of knowledge discovered in borrowed books. I'm thankful to the staff at

Acknowledgements

the British Library, the Imperial War Museum Library and Archive, the Tate Library and Archive and above all the London Library and their generous Carlyle Membership scheme.

Many illuminating conversations and exchanges have also informed and inspired these chapters. Special thanks to Hamish Fulton, Alexandra Harris, Martin Lanyon, David Lawson, Carolyn Leder, Toby Treves, and to those who kindly facilitated these encounters – Ben Tufnell, Simon Martin, Robin Cawdron-Stewart and the Lisson Gallery.

To everyone who has asked after this book, shared with me their favourite art of the sea, their fondness or fear of the coast, thank you: your enthusiasm and interest have been a great encouragement. Alongside their friendship, some have also gifted me well-chosen books, thoughtful contacts, writing solidarity and the best sea swims: Anna Bridel, Isabel Buchanan, Emmie Francis, Tess Newall, Xa Shaw Stewart – special love and thanks.

I would not have been able to finish this book without generous gifts of time, space, quiet and a good internet connection. To David and the team at 10SJP – thank you for letting me disappear for stretches to write, and for the opportunity to become well acquainted with some phenomenal paintings. To Georgia and Sam who lent me their cottage as I wrote what became my first chapter, to all those who have helped with childcare, and to Tim and Nuala especially: it is no exaggeration to say that your generosity and kindness has allowed this book to exist.

To my parents. Your gentle encouragements along the way and insights on the manuscript were – as they are always – invaluable. This book is for you, for showing me what I can see if I truly look. To Iris, who brings wonder every day. And most of all to Jack, who would rather be somewhere safely inland, but who has been by my side, unquestioningly, throughout. You have made this book and my life better in more ways than I can say. Thank you.

INDEX

Index